Victorian Figurative Painting

Domestic Life and the Contemporary Social Scene

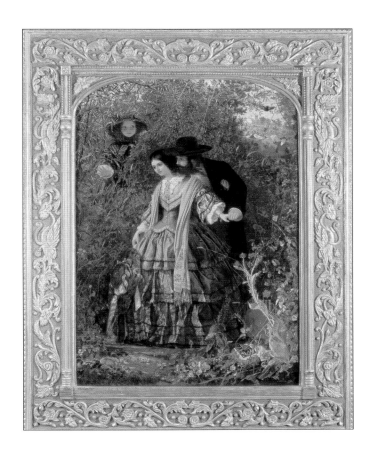

Mary Cowling

Victorian Figurative Painting

Domestic Life and the Contemporary Social Scene

ANDREAS PAPADAKIS PUBLISHER

ACKNOWLEDGEMENTS

I should like to extend an especial thanks to His Grace the Duke of Norfolk, Lord Lloyd-Webber, Sir Richard Proby, Christopher Forbes, Alan B. Gateley, and all those private owners who wish to remain anonymous, for allowing me to reproduce works of art in their collections.

I am indebted to my publisher, Andreas Papadakis, for his encouragement and support and to his staff, especially Vicky Braouzou for the design.

I cannot sufficiently thank Henrietta Pattinson for the generous amount of time she has spent in helping with this project, and for allowing me access to Sotheby's files. I am also deeply grateful to Martin Beisly of Christie's, William Drummond, Richard Green, Julian Hartnoll, Mrs. Holland-Martin, Rupert Maas, David L. Mason, Len Roberts, Peter Tilley of Dunhill's, and Christopher Wood for supplying me with photographs and for their invaluable assistance in tracking down elusive items.

I am grateful to the Syndics of Cambridge University Press for allowing me to include in Chapter 2, material first published in *The Artist as Anthropologist: the representation of character and type in Victorian art*, 1989. I should also like to thank all the Curators and Picture Librarians, too numerous to mention, without whose co-operation the publication of this book would have been impossible.

For Mother, and to the memory of Mouse

Cover: **W. Powell Frith**, *The Railway Station,* 1862, Royal Holloway University of London
Page 1: **William Henry Fisk,** *The Secret,* 1858. Private Collection. Bridgeman Art Library
Page 2: **George Dunlop Leslie,** *Pot-Pourri,* 1874. Private Collection. Photograph, Richard Green (Detail)
Page 3: **William Holman Hunt,** *London Bridge by Night on the Occasion of the Marriage of the Prince and Princess of Wales,* 1863-6. Ashmolean Museum, Oxford (Detail)

Designed by Vicky Braouzou
for New Architecture Group Limited

First published in Great Britain in 2000 by
ANDREAS PAPADAKIS PUBLISHER
An imprint of New Architecture Group Limited
107 Park Street
London W1Y 3FB

ISBN 1 901092 29 1

Printed and bound in Singapore

CONTENTS

W. Powell Frith, criminal type
The Derby Day
1858 (detail)

INTRODUCTION 6

CHAPTER I
Genre: Painters of Incident and Domestic Life 9

CHAPTER 2
The Urban Scene: Painters of the Crowd 89

CHAPTER 3
Workers and Poor in Town and Country 161

ENDNOTES 200

BIBLIOGRAPHY 203

INDEX 205

INTRODUCTION

On display at the Royal Academy of 1858 was a number of pictures which created a sensation and which have retained their reputations to this day. Foremost amongst these was the *Derby Day*, by William Powell Frith - so popular, that it required a rail to protect it from the pressing crowd. Augustus Egg's modern life trilogy, *Past and Present*, dared to illustrate that most unthinkable of crimes - the betrayal of a husband by an adulterous wife. Other memorable subjects were inspired by contemporary events, notably, the Indian Mutiny of the previous year. Henry O'Neil's *Eastward Ho!* showed troops embarking at Greenwich to relieve the soldiers and residents under threat, and Joseph Noel Paton's controversial *In Memoriam* was intended as a tribute to the women and children murdered in the conflict. Also on show were Henry Wallis's stark portrayal of a *Stonebreaker*, dead from exhaustion and hunger at the side of the road, and John Brett's Ruskinian rendering of a similar subject. A selection from the Academy of 1857 or 1859 would have made much the same point: that by the later 1850s, an increasing number of genre painters were attaining new levels of ingenuity in devising vital and dramatic subjects appropriate to the modern world.

The change from the previous decade is dramatic. In the early years of Victoria's reign, artists had favoured genre scenes inspired by popular histories and literary classics such as Shakespeare and Goldsmith; but by the later 'forties, critics were beginning to complain of their repetitiveness. Younger and more progressive artists like Frith and Egg took their advice, and were to transform the idiom by abandoning literature in favour of life itself. In so doing, they created an art which exactly satisfied the tastes of a large sector of the public.

The wave of prosperity which followed the industrial revolution had created a new market for art, especially amongst the burgeoning middle-classes whose tastes were to exercise so potent an influence on the development of Victorian culture. Aristocratic patrons had preferred the mythologies of European old-masters to modern British art; but the new patrons wanted subjects which were comprehensible rather than abstruse, and appreciated the fact that contemporary paintings could be authenticated – an important consideration at a time when the faking of old masters was widespread.

British collectors had long admired the rural and domestic subjects of Dutch seventeenth-century painters, and these, together with William Hogarth's satires of eighteenth-century urban life, were crucial to the development of Victorian genre. The Dutch inspired scenes which won David Wilkie lasting fame, were to remain popular with later painters like Thomas Faed; but even traditional subjects of this kind were revamped, in terms of both iconography and style, to suit the expectations of a more literal and positivist age. The influence of the Pre-Raphaelites, who first exhibited as a group in 1849, was felt by all the more progressive painters of the mid-Victorian period – even those who were critical of them; and by the mid-'fifties, a modified version of the hard edged, meticulously detailed Pre-Raphaelite style had become an established feature of Victorian genre.

The resulting technique was attractive to the new purchasers, and performed an additional function which was not always appreciated at the time; for its very precision was to give lasting historical value to the humblest of subjects. Unconsciously, many an unpretentious genre painter was to immortalize for posterity unique glimpses of the Victorian scene which would otherwise be lost to oblivion: aspects of life that contemporaries took for granted, such as domestic interiors, furnishings and fashions, as well as outdoor scenes, both rural and urban.

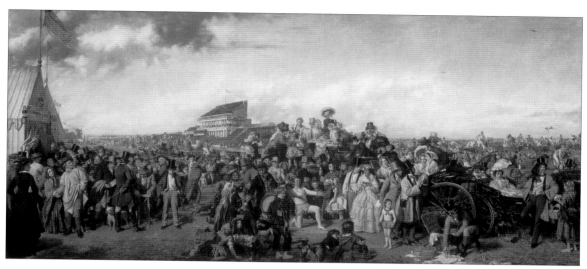

W. Powell Frith, *The Derby Day*
1858. Tate Gallery

Of especial interest are the ambitious figurative subjects painted in response to the rapid expansion of the urban population; a development best exemplified in the panoramic crowd scenes of W.P. Frith, whose veritable microcosms of Victorian life are amongst the greatest innovations of the period. In the work of Frith and his followers, the constituents of the urban crowd were carefully documented; a process echoed in the work of numerous illustrators, in *Punch* and other magazines, who had pre-empted artists in focusing on contemporary life and who probably encouraged painters in this direction.

Although genre remained largely uncontroversial, subjects with a serious moral and social import were not ignored. In the 1840s, Richard Redgrave and G.F. Watts had ventured to tackle problems such as poverty and prostitution, and by the 1850s, subjects of this kind had became established options. The condition of the workforce —whose poverty and discontent were widely perceived as a threat to social order – was a major concern which attracted a number of artists. Inspired by the social commentaries of Thomas Carlyle, Ford Madox Brown broke new ground with his ambitious and polemical *Work* (1852-63) in which he paid due tribute to the manual labourer. In this painting, the navvy is portrayed as the hero – and indeed, as the foundation – of modern industrial society.

While admitting to the divisiveness of social structure, *Work* maintains the optimistic spirit of the 1850s; but in the following decade, faith in solutions to social problems began to wane as subsequent ministries failed to address them. An increasing number of painters began to express sympathy and concern for the labouring classes - rural as well as urban - whose well-being had been sacrificed to the construction of the modern world. As their title would indicate, the Poetic Realists, who included Fred Walker and George Mason, evaded the harsher realities of the rural scene, where poverty and unemployment were on the increase; imbuing their subjects with an elegiac quality suggestive of the widespread nostalgia which was now felt for a way of life already in decline. Their urban counterparts, the Social Realists, were much more hard-hitting. Luke Fildes, Frank Holl and Hubert von Herkomer were amongst those who portrayed the poor more honestly than any previous artist had dared; confronting major social problems such as homelessness, poverty and crime, and in the process, creating some of the greatest masterpieces of the period.

There were many artists who chose softer options, Marcus Stone, W.Q. Orchardson, James Tissot, E.J. Gregory, and William Logsdail amongst them; but their contribution is no less valuable for that. All showed considerable ingenuity in devising new subjects in response to changes in taste and fashion, and above all, to changes in life itself. And in so doing they continued to immortalize the period in the best traditions of genre.

A point worth stressing is that it is more than facts which are recorded; for artists were able to capture with equal conviction the life of the mind and of the emotions: the psychological as well as the physical life of the era. Equally interesting is what is revealed of the artist's own feelings, attitudes, and assumptions with regard to the painted characters: factors impossible to exclude, totally, when an artist ventures to grapple with the life and inhabitants of his own time. This is the crux of the matter. What gives Victorian genre painting its significance is its engagement with real life: life as experienced by both those who produced the pictures, and those who responded to them with a degree of passion and involvement unparalleled today. It is this which explains their enduring power.

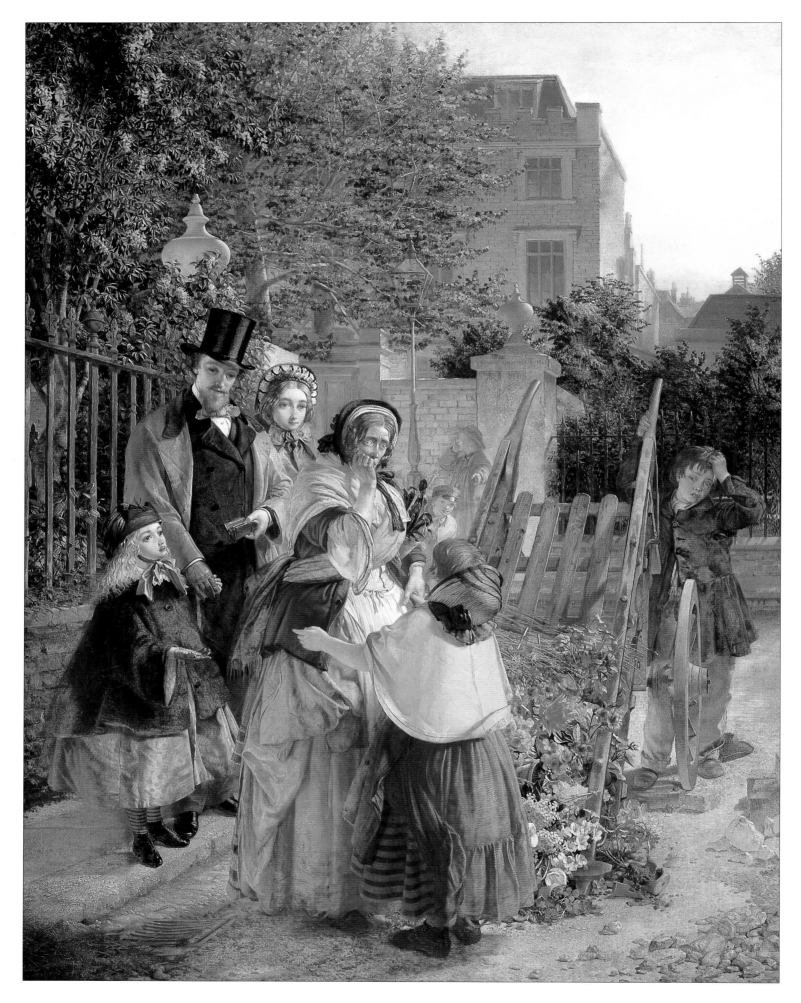

CHAPTER 1

Genre: Painters of Incident and Domestic Life

After pondering at length the nature of genre painting, Sydney Colvin concluded that all popular painting failed in its first duty - to be beautiful. Largely devoted as such painting was to the close imitation of incidents from everyday life, aesthetic considerations came a poor second. Colvin mentioned as typical of the class, the country bumpkins portrayed by artists like Thomas Webster and Erskine Nicol; the more sentimental rural subjects of Thomas Faed and his weaker followers; and 'studies of babyhood and nursery incident, so popular and so sure of a market, in which... some casual and trivial aspect' of childish nature 'is caught and vulgarised.'[1] It would be difficult to find a major review throughout the whole period which does not echo these criticisms. Some twenty years later, Harry Quilter condemned the preponderance of

> 'cheap tricks of sentiment, the catchpenny trivialities of millinered babies, faithful mastiffs, and comic poodles, or the large-hatted, India-muslined young woman, who, with a love letter, a pussy cat, or a sunflower, smiles sweetly from the Academy walls in half a thousand pictures.'[2]

As Quilter's words reveal, despite all criticism genre was to retain its popularity, adapting to the demands of the market and to the changing tastes of patrons who bought, unashamedly, for pleasure rather than for any more serious purpose. Amongst the great diversity of Victorian art, it is genre above all which has come to embody everything we think of as quintessentially 'Victorian'; its prosaic subject matter, sentiment, high finish and small scale, making it eminently accessible to that middle-class taste which did so much to shape Victorian art and literature.

The term itself comes from the French, *peintres de gens* - painters of people - and embraces all scenes of ordinary, everyday life, whether real, historical or literary. Contemporary critics agreed that genre was difficult to define; the word itself, as Frederick Wedmore claimed, - a necessary evil, 'which no-one loves and few can pronounce'. He suggested that 'Character and incident painting'[3] or 'the things of daily happening - homely and common experiences' might best describe it;[4] but acknowledged that no single definition would ever be wholly satisfactorily. Wedmore concluded that genre was such a mixed bag that one might just as well settle for art which could not be classified as anything else; - 'art of a kind not included in any other kind',[5] as another critic put it; and indeed almost all Victorian figurative painting, serious history apart, has been at times included in the category. More recently, classifications of Victorian art have diversified in response to closer analysis. Much of the work of the Pre-Raphaelites, of Frith and his followers, of the Social Realists and the British Impressionists, while qualifying as genre, is now more usefully examined within other more specialist categories.

The definition thus lies in approach and function as well as in subject matter *per se*. Genre painting is almost invariably uncontroversial, undemanding and intelligible. In an article suggestively entitled 'The Decline of Art', one writer described it as 'comparatively easy;' the kind of art which 'calls for no severe apprenticeship'. Readily appreciated, 'it has the advantage of a story; it admits of endless variety, and amuses tastes, however miscellaneous.'[6]

As easy on the brain as on the eye, the proliferation and popularity of genre in a burgeoning new market are understandable.

The danger was that it could so easily sink into triviality. In his biography of the great genre painter, David Wilkie, Alan Cunningham, had advised artists that they should produce paintings which

'in their conception and character coincide with the opinions of the great body of private patrons, and reflect their tastes and feelings; for to artists these are the representatives of the purchasing world at large.'

He was at pains to deny that this situation would necessarily prohibit 'independence of genius and originality of thought';[7] but there was danger in the aim for saleability when buyers' tastes were so often uneducated. The *nouveaux riches* who had profited from industry and commerce were keen to indulge in luxury items like painting. The passing of the first Reform Bill, in 1832, acknowledged them as a rising power in the land, socially and politically, and encouraged them to have confidence in their own tastes.[8] A letter to the *Art Journal* of 1872 from John Calcott Horsley throws some interesting light on that earlier period when, apart from the occasional individual like the shipbuilder, William Wells, and the horse dealer, Robert Vernon, art purchasing was strictly limited to the aristocracy. Horsley recounts the 'amused astonishment' of his uncle Callcott, the landscape painter, when in 1834 a certain Mr. McConnel commissioned two paintings – 'as though the fact of a gentleman from Manchester wanting pictures was an event to be legitimately wondered at!' But McConnel, 'exercising his own independent judgement' gave further commissions – to Turner and Etty as well as to William Collins, David Wilkie and others. From that time, patronage of modern British artists had passed into the hands of 'merchants, manufacturers, and other businessmen of the country', the majority of them provincial.[9]

William Powell Frith points to one reason for the preference among new collectors for modern art at several points in his *Reminiscences* (1888), with hair-raising stories of the 'Old Masters' perpetrated in previous decades on unsuspecting collectors. Seeking out suitable examples for a Winter Exhibition at the Royal Academy, Frith discovered in the provinces 'whole housefuls of rubbish' believed to be 'gems of art.' In a huge northern mansion he found a blatantly fake Titian, fake Gainsboroughs and an eighteenth hunting scene supposedly by the Italian idealist, Domenichino, who had died in 1641: a prophet of fashion, Frith wryly commented, eyeing the pink coats. Frith quotes Victor Flatow's recollections of the market in 'Old Masters' which were copied by young artists and then 'smoked and cracked' by the dealer.[10] The *Art Union* (later the *Art Journal*), founded in 1839, regularly protested against the market in fakes

and forgeries (fig.2). Even in the 1850s it was not possible to buy a genuine Albert Cuyp or a Van Dyck portrait for fifty-five pence; but such examples are recorded in the sales' lists.[11] It was the growing awareness of such dishonesty that persuaded buyers like Disraeli's Mr. Millbank, a successful Manchester manufacturer, to opt for Etty, Landseer and Wilkie, – artists of

'the modern English school. Mr. Millbank understood no other, he was wont to say! and he found that many of his friends who did, bought a great many pleasing pictures that were copies, and many originals that were very displeasing.'[12]

The real life Millbanks were an important factor in the art world from the mid-century onward. In 1861, the *Art Journal* acknowledged that 'The principle support of British Art proceeds from wealthy Lancashire.' Under the influence of the likes of Thomas Agnew, print-seller and dealer – whose firm was based in Liverpool and Manchester before his London branch opened in 1860 – they had been persuaded to abandon purchase of the dubious 'Old Masters' which they had favoured some twenty years ago, and to transfer 'Art-patronage from the dead to the living.'[13]

The *Art Journal* regarded such dealers as benefactors to the new collectors – mainly provincial 'merchants and manufacturers' – whose business activities left them little time for viewing and selecting pictures.[14] But others expressed concern at the effects of the new patronage. In a review of the state of painting in 1862, Tom Taylor commented at length on the effects of uncultured patrons and the unscrupulous dealers – 'a new and great power in art' – who advised them.[15] Taylor noted how the 'over-flowings of the wealth' from 'Lancashire mills, and Liverpool or London offices' were forcing gifted young painters to produce saleable rather than serious pictures; so that pictures of trivial subjects were rapidly becoming 'the staple of English art.'[16]

But the trend continued, and Taylor himself supported it when expedient. In 1862 he produced a lengthy pamphlet to 'puff' the sale of prints of Frith's *Railway Station*, a fact which his critics were not slow to point out. In his introduction to Leslie's *Recollections* (1860), Taylor had *approved* recent changes in patronage, through which 'so many of Leslie's pictures should have found a home among the mills of Lancashire and the smoking forges and grimy workshops of Birmingham', where

'They are eminently calculated to counteract the ignobler influences of industrial occupation by their inborn refinement, their liberal element of loveliness, their sweet sentiment of nature, their literary associations, and their genial humour.'[17]

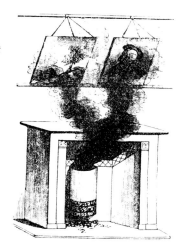

On the ceiling iron rods were placed, to which the copies of his pictures were hung, resting obliquely on rails fixed lower down, as Mr. Zachary found by experience that the copies were best cooked into antiquity by remaining over the stove at an angle of 45°

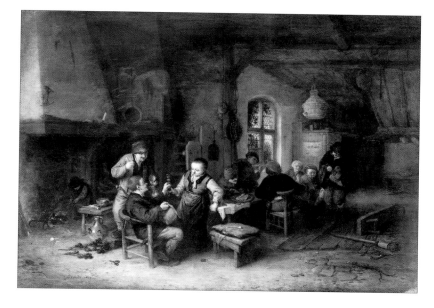

There was, in fact, a recognized distinction between the sincere treatment of everyday subjects and mere pandering to the market. Thackeray had deplored the blatant commercialism already rampant in 1844, comparing the exploitation of patrons by artists and 'dextrous speculators who know their market' to the way in which 'savages are supplied with glass beads' and 'children... accommodated with toys and trash'.[18] The test for Thackeray was genuine sentiment. He was quite prepared to be deeply moved by 'quiet scenes of humour or pathos,'[19] preferring them to abortive attempts at High Art. Another critic, defended the taste for the domestic subjects of Wilkie, Webster, the Faeds and others, explaining why

'Scenes of quiet felicity are more agreeable to the mass of mankind than high-wrought tragedies or stately histories... Art of late years has had for its healing office to diminish the tension on the mind; in our modern society, the intellect is under stress and strain... and thus persons in the severe conflict of life turn to literature and art for repose and relaxation.'[20]

John Sheepshanks and Robert Vernon included accessible subjects by artists like Wilkie, Leslie, and Mulready in their collections. Both would have endorsed Taylor's assessment of Leslie, for they regarded their collections as potentially educative; as important means of improving the minds and morals of the people - particularly the working classes. Vernon made his money through livery stables and horse dealing; Sheepshanks inherited money acquired in the Leeds cloth industry. Vernon's collection of one hundred and fifty-seven paintings and eight sculptures, was presented to the nation in 1847 as the basis for a National

Gallery of British Art, and is now in the Tate. Sheepshanks gift of five hundred and thirty-one paintings and drawings went to the South Kensington Museum in 1857. Two other great benefactors were amongst the Lancastrians who played so large a part in building up major collections of British contemporary art: Henry Tate (1819-99) and William Hesketh Lever, first Lord Leverhulme (1851-1925) both of whom began life in the grocery trade, and whose fortunes came from sugar cubes and soap, respectively. Both paid for galleries to house the collections which they donated, Leverhulme's forming the final addition to the model village for workers which he began to construct at Port Sunlight near Liverpool in 1889. Their purchases included some of the most important works of the era: Millais's *Ophelia*, Luke Fildes' *Doctor*, Waterhouse's *Lady of Shalott*; Rossetti's *Blessed Damozel*, Leighton's *Garden of the Hesperides*, and E.J. Gregory's *Boulter's Lock*.[21]

• • •

The ultimate forebears of British genre were the Dutch painters of the seventeenth, such as Adriaen van Ostade and David Teniers, whose work was much coveted by nineteenth century collectors (fig.3). It was in the eighteenth century that genre began to emerge as a powerful force in British art, with Hogarth as its greatest innovator and exponent. Artists as distinguished as Gainsborough explored the pictorial and human potential of rural genre as opposed to urban; others like George Morland devoted themselves almost entirely to it. From the beginning, the market for this class of painting was predominantly middle-class rather than aristocratic. Despite his lapses of

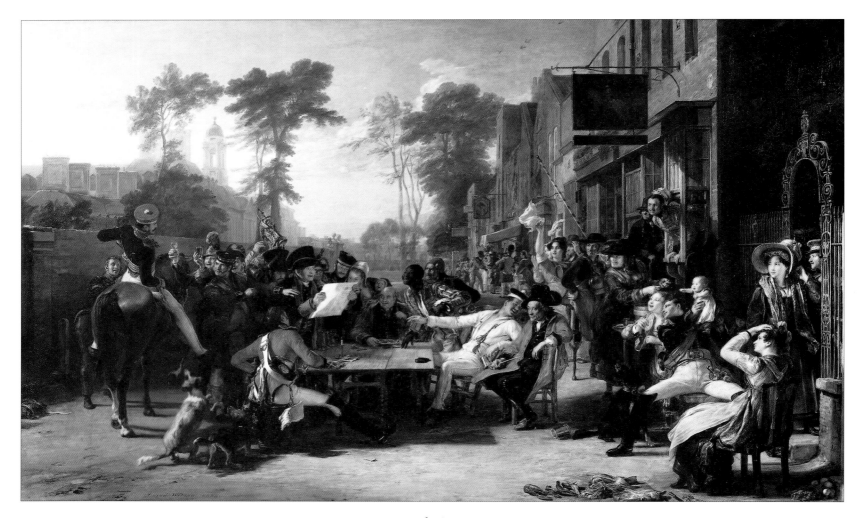

fig. 4
David Wilkie, ***Chelsea Pensioners reading the Report of the Battle of Waterloo***
1822. Apsley House

propriety, Hogarth provided the model for the most character-istic developments in Victorian genre. In the words of one of its leading practitioners, John C. Horsley, it was 'to that immor-tal genius... the prince of story-tellers on canvas, that we owe the origin of the whole school of subject-pictures.'[22] An exhibiting society founded in 1858 by the Pre-Raphaelites and a wide circle of friends which included Whistler and Frederic Leighton, was named the Hogarth Club in tribute to one who had forged a successful art of his own, in the face of indiffer-ence and even hostility to native British art.

His followers shared with him his one great interest: human nature. The vehicle of Hogarth's narrative was the human face and figure. Charles Lamb rightly stressed Hogarth's skill as a physiog-nomist and teacher of human nature; as an artist who acquaint-ed his public 'with the every-day human face' and taught it how

'to detect those gradations of sense and virtue... in the coun-tenances of the world about us; and prevent that disgust at

common life... which an unrestricted passion for ideal forms and beauties is in danger of producing.'[23]

Hyppolyte Taine noted as a distinguishing features of British art, how Hogarth and his followers turned narrative painting 'into a kind of psychology'.[24] In Hogarth's work, the meaning implicit in features and expression was further supplemented by the symbolic accessories with which he crowded his works. Hogarth's 'graphic representations are indeed books', as Lamb claimed, with 'the teeming, fruitful, suggestive meaning of *words*. Other pictures we look at, - his prints we read.'[25] This literary approach to painting was to be fully developed and refined by the Victorians.

Much of the work of the first great generation of nineteenth century British genre painters - which included Wilkie, Mulready, C.R. Leslie, and Thomas Webster - was produced before Victoria's accession in 1837. David Wilkie (1785-1841) was the immediate father of Victorian genre, successfully adapt-

ing the scenes and characters of Dutch genre to British tastes. He was a great originator; as one critic somewhat fancifully described him,

'the Leonardo of ordinary everyday character, which, being so faithfully represented and so generally understood, has procured for him admiration more general and real than any painter ever enjoyed.'[26]

Wilkie recognized that the British taste for art was 'of a domestic rather than a historical character' and decided to cater for it.[27] It was an astute decision, through which Wilkie was to rise rapidly to fame and to make a comfortable fortune. A local Scottish subject, *Pitlessie Fair* (1804), was his first venture into contemporary genre. One year after his arrival in London, young and unknown, Wilkie's *Village Politicians* (1806) scored a great success at the Royal Academy, and *Rent Day* (1809) earned him his Associateship. *Chelsea Pensioners reading the Report of the Battle of Waterloo* (fig.4) was commissioned by the first Duke of Wellington, an exceedingly generous patron, who paid 1,200 guineas for it: a record at that date for a British painting. It was in 1816, one year after Waterloo that the Duke asked for a picture of 'a parcel of old soldiers' drinking and reminiscing together outside a public house. Wilkie suggested the reading of a newspaper as a dramatic focus; and thus evolved the idea for one of the most important genre paintings of the era. Included are portraits of various known characters, representative of those regiments which fought valiantly in France, Spain and elsewhere;[28] and every other detail in the painting was researched meticulously. The result was that genre was successfully transformed into contemporary history. It was the first picture to require a protective rail at the Royal Academy - an event not repeated until Frith's *Derby Day* in 1858.

Not everyone applauded Wilkie. In their student days, Benjamin Robert Haydon had deplored Wilkie's preference for Jan Steen over Raphael. Haydon had confessed himself 'too big with 'High Art' to recognize the virtues of Wilkie's *Pitlessie Fair* and felt something 'akin to contempt for a young man with any talent who stooped to such things.'[29] But many patrons preferred them to the category of melodramatic and 'sublime caricature' which Haydon produced, and whose pretentiousness so irritated Thackeray.[30] Ironically, Haydon's own attempts at genre are now regarded as his most successful works; and in later life Wilkie himself was to lose much of his popularity by pursuing more ambitious subjects, fired 'with an ardent wish to base his fame upon something morally higher than domestic painting.'[31] A European tour in 1825-1828 confirmed his new

direction, one for which he proved ill-suited and which was widely regretted by admirers like Thackeray who condemned his later historical subjects and even worse portraits which, he thought, looked as if 'painted with snuff and tallow-grease'.[32]

Wilkie's success says much about the tastes and values of the period. Delightfully inoffensive, his work set the tone for later generations as regards both the choice of subject-matter, and the emphasis on high finish.[33] His peasant scenes, more usually set in the domestic interior than in the alehouse, have none of the coarseness of his admired Ostade; and his youths and maidens dance politely, if not gracefully, in the *Penny Wedding* (1818, Her Majesty, The Queen). Like the majority of his countrymen, he had no interest in 'the abstract and ethereal; he could only respond to what was real and tangible, 'something that could, as it were, be grasped with a hardy vigour, and made to live'. The fact that his characters are recognizably of a kind who 'have lived and acted, and mingled in the daily life of the world' was a major factor in his success.[34]

The Irish-born William Mulready (1786-1863), who with William Collins and B.R. Haydon was a contemporary and friend of Wilkie at the Royal Academy Schools, also admired the Dutch, but their stylistic influence on his art is less overt than in Wilkie's case. In Mulready's best work, the delicacy and precision of his drawing and his bright palette are more distinctively modern than Wilkie's; more specifically 'Victorian' in appearance. Mulready and others of his generation, including William Henry Hunt, illustrate a notable development in the direction of that mid-century realism which was to climax with the Pre-Raphaelites whom Mulready taught at the Royal Academy in the 1840s. Ruskin, while regretting his subject matter, thought that 'in delicacy and completion of drawing, and splendour of colour, he takes place beside John Lewis and the Pre-Raphaelites'.[35] Mulready's compositions are less stage-like than Wilkie's, giving more of an impression of a slice of real life. There is also a more sharply focused sense of individual psychology - a gift fully exploited to suggest the tribulations of boyish life and the inevitable conflicts with adult authority, as well as the prosaic but affectionate exchanges between mothers and children, and young lovers. Taine believed it impossible to assemble 'a greater mass of psychological observations onto a surface twelve inches square' than in Mulready's paintings.[36]

Although Hogarth was much admired as the father of modern British genre, that unfortunate eighteenth-century 'grossness' which taints his work banished much of it from respectable Victorian drawing rooms.[37] In the words of the *Art Journal*, Hogarth's 'intentional coarseness' and 'open effrontery' were no more tolerable to contemporary British taste than the

fig.5
William Mulready, *The Widow*
1823, Sir Richard Proby

double entendre familiar to French painting,[38] and censorship was exercised when necessary. An 1873 edition of Hogarth's prints eliminated two which had been included in 1822, on the grounds that their humour 'did not appear to compensate for their indelicacy'.[39] In this more respectable age, genre painters consciously aimed for 'a certain propriety, decorum, and delicacy of feeling';[40] and early in his career, William Mulready was one artist who learned the consequences of breaking the rules. Reactions to his *Widow* (fig.5) provide an interesting illustration of that prudery which had burgeoned under the influence of Evangelicalism. The scene has all the precision and sparkle of his later work, but in this case is too close in spirit to the none too subtle sexual innuendoes of Dutch genre. It recalls Jan Steen's *Dissolute Household* (fig.6) where the drunken lechery of adults is shown in process of corrupting the children of the household, who are merely amused by the situation, and take advantage of it by picking the pocket of a woman who slumps at the table in a drunken stupor. Mulready's picture is nothing

like so flagrant, but it shocked critics, one of whom exclaimed at 'the scarcely covert grossness of it.'[41] In a detailed analysis of this painting, Marcia Pointon notes that Ruskin may well have had it in mind as among those examples by Mulready which he later mentioned as 'unfit for pictorial representation', and it failed to sell for many years.[42] The offensiveness of the subject was not mitigated by the quotation included in the Royal Academy catalogue from Petronius's *Satyricon* – 'Thus mourned the Dame of Ephesus her Love' – referring to a widow who is seduced by a soldier, while supposedly grief-stricken at the tomb of her newly deceased husband.

The suitor of Mulready's widow lolls encouragingly against her; she remains still, but her expression is sensual and inviting. A jolly, roguish sort of man, he is already a great favourite with the younger children, who romp boisterously with him; but the eldest daughter sits with back turned, and the prim, sour faced older woman opposite is rigid with disapproval at this disorderly intrusion into a decent household. That his courtship is not

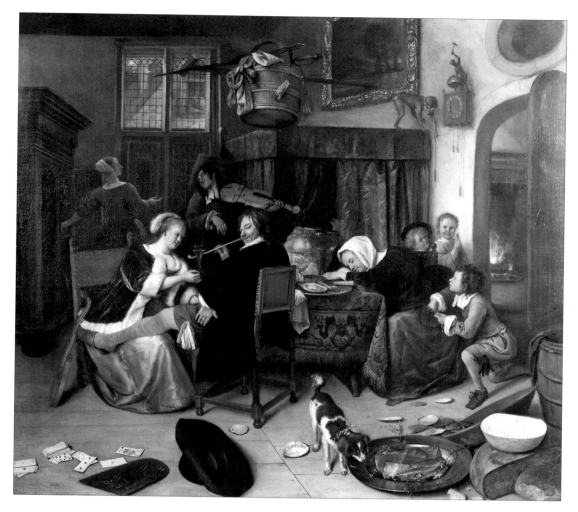

fig. 6
Jan Steen, *The Dissolute Household*
?1660s, Apsley House. Adrian von Ostade

entirely disinterested is symbolized in the empty purse which lies on the floor, and the financial transaction taking place in the shop visible through the window. Mulready may have supposed that the element of humour would redeem its vulgarity; and this, together with his talent for characterization, and the precise registration of colour, detail and texture, make the *Widow* a very successful picture, whatever the initial reaction.

Mulready did not err on the side of vulgarity again. Although his subjects were by no means always conventional in their appeal, he is largely identified as the composer of a long series of schoolboy subjects. As the *Art Journal* observed, since schooldays are generally regarded 'as pleasant times,' most people will feel interested in whatever brings them back again to memory.[43] In fact, childhood could be very tough in the Victorian age. Mulready's four sons spent much of their time fighting, no doubt encouraged by their father who was himself a keen amateur pugilist and whose own father had shared the same taste.[44] It is not surprising that his pictures of thuggish

youths bullying more sensitive boys ring true. His subjects were popular and inevitably had their imitators, notably in the gentler interpretations of Thomas Webster. The lesser known William Henry Knight was another who successfully followed Mulready. His first exhibit at the Royal Academy in 1846 was *Boys Playing Draughts*, his taste for such subjects no doubt encouraged by the fact that his father kept a school at Newbury. *The Broken Window; Who threw the stone?* (fig.7) shows two boys accused of the crime, the younger one in tears. His older companion hides a sling behind his back, while two others attempt to evade detection by cowering behind the village pump, their exposure threatened by the dog which holds them at bay. The indignant cobbler was praised by the *Art Journal*, which published an engraving of the picture in 1865, as 'a capital figure both in attitude and action... his head an admirable study of firmness and decision, combined... with anger.'[45] The expressions of the young spectators, revealing varying degrees of partisanship, show that Knight had studied

Mulready closely. Ruskin was also to comment briefly but favourably on Knight's 'exquisite and careful painting' in his *Academy Notes*.[46]

The third leading member of this early group of genre painters was Charles Robert Leslie (1794-1859), equally known today for his *Life of Constable* (1843) and *Autobiographical Recollections* (1865). Leslie came to London from America in 1811. Initially, he had ambitions to be a 'high' artist and was much encouraged in this by his compatriot, Benjamin West, whose successful career in England had been crowned by his appointment as President of the Royal Academy in 1792. But Leslie soon established a reputation for tasteful and amusing little scenes mainly inspired by British history and literature. Leslie had the gift of interpreting the characters of Shakespeare, Goldsmith and other literary favourites in exactly the spirit in which they were enjoyed by their most devoted readers, so that responses to him are invariably eulogistic. Leslie greatly admired the Dutch school, admitting that 'The more I see of [them]... the more I venerate them, and the more hopeless appears the chance of ever coming near them';[47] but it was Leslie's own peculiarly English sentiment which accounted for his success as 'the most gentle and the most refined' of all humorists.[48] Responses to him are uniform on this point. His contribution to English genre was welcomed as that of 'a man who read chastely, and worked with a new and intense feeling from our vernacular classics'.[49] Thackeray thought his works 'The very soul of comedy... no coarseness, no exaggeration... the merriment... pure, gentlemanlike... delightful';[50] and for Tom Taylor they were 'stamped in every line with good taste, chastened humour, and graceful sentiment – pictures which it makes us happier, gentler, and better to look upon'.[51]

Leslie's first great hit was with *Sir Roger de Coverley going to Church* (1819), painted for James Dunlop, a wealthy tobacco importer, after whom Leslie's artist son was to be named. Beloved archetype of the old English gentry, Sir Roger had been introduced to the second issue of the *Spectator* by Richard Steele in 1711. Scenes from English literature were to become so popular over the next half-century that it is easy to overlook the relative novelty of Leslie's decision to specialize in them. Taylor comments that in 1819, despite the success of Wilkie and a handful of predecessors, 'domestic subjects were tabooed to the mass of painters' and book illustration – Shakespeare excepted – regarded as little suited to artists. Those like Thomas Stothard and Robert Smirke who specialized in such work were badly paid and little patronized.[52]

Leslie was very successful as both a literary and historical genre painter. His patrons included the Queen and aristocrats such as Lord Egremont; his friends, Sir Walter Scott and John Constable. But his literary subjects are less appealing to a later generation; so that an example like the *Fair at Fairlop* (fig.10) is all the more welcome as a response to the life of his own times. Leslie loved suburban fairs and had haunted them in his student days. In 1840, he wrote that he was very busy with the picture and that he was 'painting land-scape a good deal out of doors, in most delicious weather – the most delightful of all employments to an artist.'[53] The moss-green meadow and clustered trees suggest the luscious growth of the Kentish Vale, and the dramatic contrasts of light and shade thrown by the swiftly passing clouds create a convincing feeling of the blustery, changeable weather of an English summer day – a lesson that Leslie would have learned from Constable. Entertainments include a beer-tent, an Aunt Sally under the tree to the left; archery, swingboats, a slide, donkey rides, gypsy fortune tellers and itinerant musicians. In the foreground stands the infant George Dunlop with his toy horse and cart, an evident favourite, since it also figures in the painting of the same date, set in the family garden – complete with washing line – now in the Victoria and Albert Museum.

• • •

The founding of 'The Clique' by Frith, Augustus Egg, Henry O'Neil, John Phillip and Richard Dadd, in 1837 – the year of Queen Victoria's accession – in favour of subjects more suited to contemporary taste, was an important venture; the first collective statement asserting the irrelevance of the values of the Academy to the real state of art and the market.[54] A friend, John Imray, recalls that at the weekly meetings of The Clique in Dadd's large studio in Great Queen St., the subjects chosen for sketching were literary incidents, chiefly from Byron or Shakespeare.[55] The 1840s was a boom decade for British genre. Frith, Egg and O'Neil enjoyed great success with amusing incidents from modern literature, as well as historical genre, and in the 1850s they were to progress to modern life. John Phillip specialized in Scottish, and from 1851, in Spanish subjects. The meetings ceased on Dadd's departure to paint a series of decorative panels for Sir Thomas Phillips, with whom he toured Europe, Egypt and the Middle-East in 1842-3. Imray believed that the stress attendant on this commission sparked off the fit of insanity in which he murdered his father on his return in 1843. The paintings Dadd produced during his confinement in an asylum are now greatly admired – as original and well-crafted as they are disturbing.

17

His watercolour of *Suspense or Expectation* (1855, fig.8), one of a series illustrating the *Passions*, shows a group of children in various degrees of fearful anticipation, as an elder boy boldly reaches up to light the touch paper of a toy cannon. The large scale of the gate and fence suggests the eye-view of a small child; and this, combined with the bright glare of the sunlight, gives the simple, everyday scene an ominous aspect, as does the contrast between their childish absorption in the game, and their weird, somewhat adult faces. In another example, the 'problem' referred to in the title (fig.9) alludes to the chess game in which the child is apparently engaged; but though his fingers hover over the board, his eyes are directed above it in an unfocused, maniacal stare. The table is littered with objects: crisply carved chess figures, fruit and nuts, a decanter, glasses, and the elaborately moulded vase to the left. The hideous profile of the sleeping man adds another disturbing element to a scene whose delicate handling and fragmented detail suggests the fragility of Dadd's own mental state. The undercurrents of this image - acknowledged as one of his most incomprehensible - are markedly at odds with the simplicity and innocence which we associate with Victorian child painting.

Technically, what we see in Dadd is a manic development of features common to all genre at this time: a high finish and concern for detail admirably suited to the expression of prosaic, anecdotal subject matter. As the *Art Journal* emphasized, in works of this kind, it was appropriate that each detail should speak 'clearly and emphatically... The execution... must be clean and sharp,' and the construction 'close and literal'.[56] As a key point in the narrative,

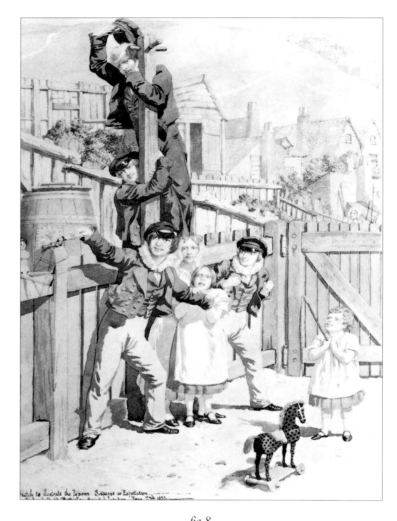

fig. 8

Richard Dadd, *Sketch to Illustrate the Passions, Suspense or Expectation*
1855. Watercolour. Private Collection. Photograph, Sotheby's

'faces should be individual; they should each tell a story, contain lines of history, and marks of joy and sorrow. The details, too, - the furniture, for example, in a room, - must have a meaning and even point a moral... As for the execution, the more real the better; detail gives verisimilitude to the narrative, and local truth enables the mind to realise the situation. The handling, indeed, as the glib telling of an anecdote, is in itself a prime element in success. Cleverness, dexterity, neatness, sparkle, and a keen edge, should mark every touch.'[57]

But as Sidney Colvin and other critics warned, too much realism was inimical to aesthetic values. To a foreign visitor like Hyppolite Taine, it seemed that the attempt to overload narrative with moral and psychological meaning – 'the exaggeration of cerebral and mental life' – as he called it - had 'distorted and blunted' the 'optical sensibility' of British artists like Mulready, Hunt and Millais. On more than one occasion Taine was to

criticise the overwrought quality of British genre, evident alike in its excruciatingly strident colour and excessive detail; and he concluded that 'pictures so very disagreeable to look at' had never before been painted.[58] Walter Armstrong blamed this situation on the typical middle-class patron who demanded, 'Not Art, but... imitations of things or scenes with which he is familiar... the real pump on the stage in another form.'[59] There is much truth in what Armstrong says, but the naïve taste to which he objects was to have unexpected benefits. In the 1850s, the precision we find in Maclise, Frith, Leslie, Ward, Webster, Horsley and others sharpened further. The serious intentions of the Pre-Raphaelites - their aim to attain 'a higher level of historical and genre painting' than the previous generation and their determination 'to put more thought and passion into their work', had far reaching effects.[60] Under their influence, genre painters were to develop that 'wonderfully keen eye, the born journalist-novelist eye for details of human

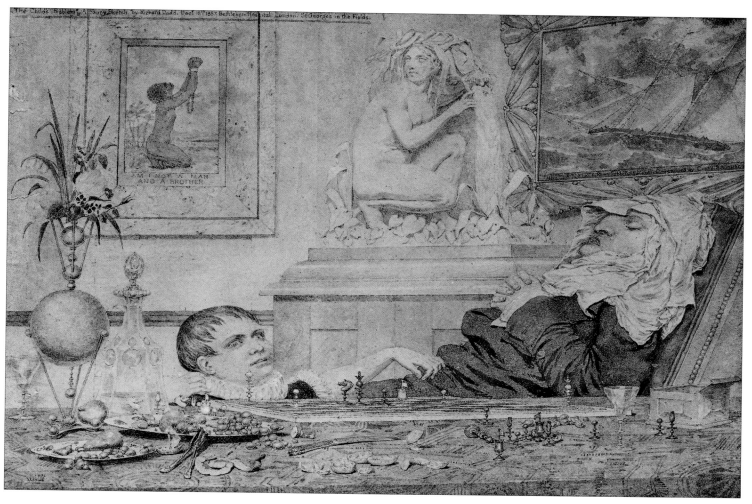

fig. 9
Richard Dadd, *The Child's Problem*
1857. Watercolour heightened with white. Tate Gallery, 1999

behaviour'[61] which has ensured the historical value of such painting for future generations. As early as 1852, David Masson had noticed a distinct 'touch of Pre-Raphaelite influence' in a dozen or so pictures at the Royal Academy, 'and one or two of these by artists of high note and settled reputation'.[62] Its effect on William Dyce and Daniel Maclise illustrates this point. Ruskin observed that by 1858 the influence of Pre-Raphaelitism had 'entirely prevailed against all opposition', and went on to consider

'the result of the new modes of study on minds of average or inferior power. For what was done in the first instance by men of singular genius, under intense conditions of mental excitement, is now done, partly as a quiet duty, partly in compliance with the prevalent fashion, by men of ordinary powers in ordinary tempers - resulting... not in brilliant, but only in worthy and satisfactory work'.[63]

The relative insignificance of what is recorded in many a humble genre painting does nothing to reduce its value for posterity. In his first lecture as Professor of Modern History at Oxford in 1842, Thomas Arnold had pointed out that even the most worthless novels and other third rate literature acquire in time 'an accidental value', helping the student to realize 'as vividly and as perfectly as possible, all the varied aspects of the period which he is investigating.'[64] That even the most trivial book as 'a piece of the life of its own day,' might in the future 'help some historian to illustrate truths unsuspected by its author',[65] was a truth increasingly acknowledged in this age of historicism; not least by Macaulay, who emphasized the importance of ephemera - broadsheets and popular songs included - in his own *History of England* (1849-55). Art and cheap illustration alike served the same function, revealing the mind of the period as well as supplying a visual record of so many facets of life that would otherwise be lost to us. Thus the often despised

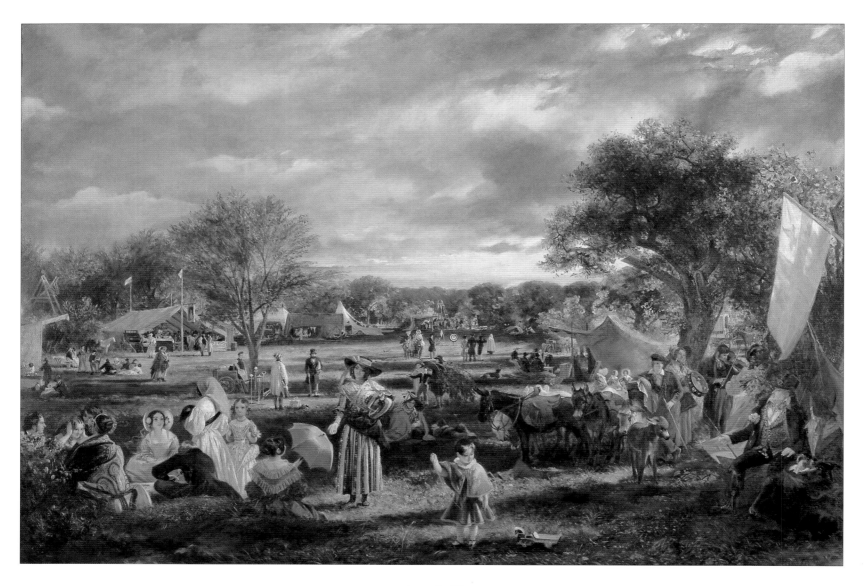

above: fig. 10
Charles Robert Leslie
The Fair at Fairlop
1840-1. Reproduced by kind permission of His Grace the Duke of Norfolk
Photograph, John Webb

opposite: fig. 11
Sophie Anderson
No Walk Today
1854. Sir David Scott Collection of Victorian Paintings
Bridgeman Art Library

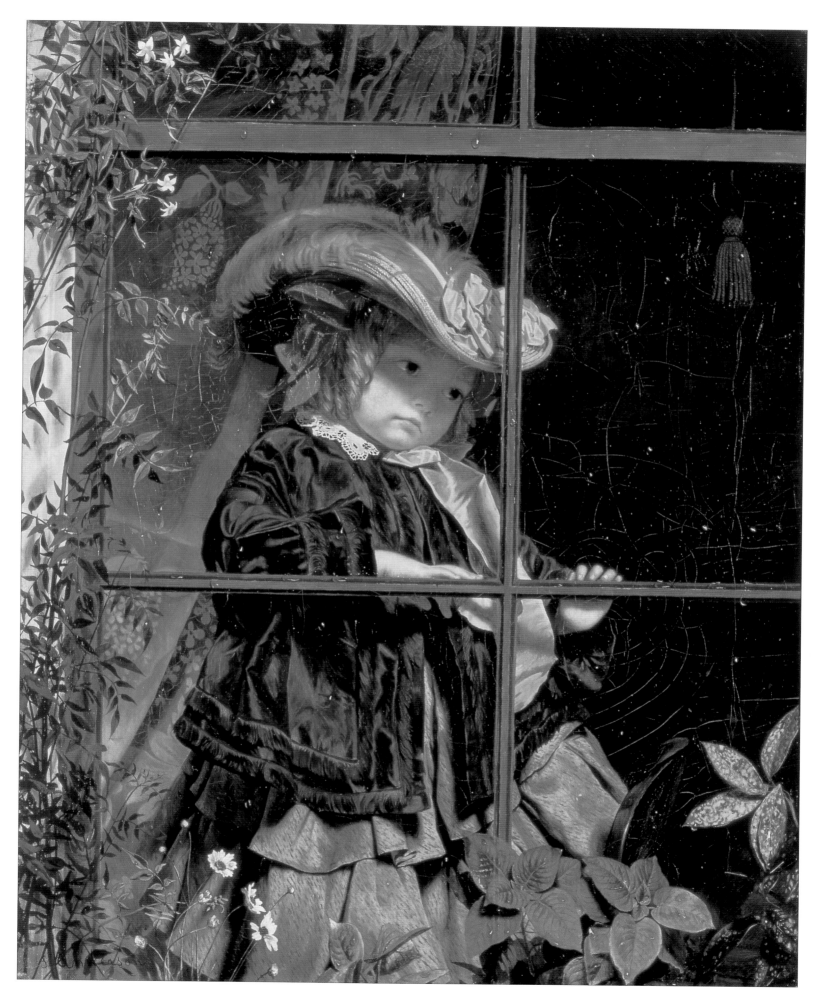

genre, as Frederick Wedmore pointed out, could perform an invaluable function, so long as it was dignified by truth.[66] This requirement extended to every detail. In an article investigating the value of 'The Servile Imitation of Nature', the *Art Union* argued that artificial, man-made nature

'may be stupidly selected, may predominate too much, may be essentially low and commonplace, but can hardly be imitated too closely… If it is worth doing at all, it is worth doing well. A false look will hardly ennoble a mean object.'[67]

It is for this reason that David Wilkie 'never trusted to memory', but made 'every button and hook sit for its portrait.' On one occasion he searched London for a particular kind of biscuit which eventually had to be made for him by a Scottish baker, so that he might have 'the satisfaction… of painting [it]… directly from nature.'[68] It was said of William Henry Hunt that he 'even borrowed a pin to draw from' rather than trust to feeling and memory, even for so simple an object;[69] and Frith was another who insisted that even 'for the most trifling detail the artist never trusts to his memory'. To ensure the verisimilitude of the *Salon d'Or, Homburg* (1871), he not only had the rooms photographed, but purchased a chair, a croupier's rake and roulette cases from the establishment. Frith also boasted of risking both 'robbers and infectious disorders' in a determined search for the kind of seedy table he wanted for his *Road to Ruin* series of 1881.[70]

Some genre painters were to tackle contemporary subjects which were significant in themselves; but in the case of the majority, the historical value is of the more incidental kind. Genre painting is often as much 'concerned… with the scene in which the drama is acted as with the drama itself';[71] so that when honestly painted it has preserved for us a unique record of many aspects of Victorian life: domestic interiors as they really were; Christmas celebrations; church services; incidents of street life in town and village; and not least, the details of fashion. Later in the century, the French critic, Ernst Chesneau, was to acknowledge this as a specifically English achievement, and an area in which the French had failed to equal them.[72] Frith had been a pioneer of unglamorized modern costume in painting *Ramsgate Sands*, which he rightly recognized as history in the making. He predicted that 'pictures of contemporary life and manners have a better chance of immortality than ninety-nine out of every hundred of the ideal and so-called poetical pictures produced in this generation.'[73] Although this statement is too sweeping, Frith was right about the documentary value of Victorian genre. J.J. Jarves cited as one of its leading features 'its stress chiefly on clothing and like

tangible evidences of our complicated, materialised civilization.' Rather than the nude of classical art, the typical model is now 'the superabundantly clothed human being employed in the ordinary avocations of a frivolous or laborious existence'.[74] Historians must be eternally grateful to those artists who grappled with all the appurtenances of the man-made world, however trivial; and, indeed, to novelists who described humdrum life in similar detail.

Of all mid-Victorian novelists, Anthony Trollope, prosaic, modest, and unsensational, was seen at the time as the literary equivalent of mid-Victorian painters of modern life; the novelist most frequently cited as conveying the actuality of ordinary Victorian life convincingly. A fellow writer, Nathaniel Hawthorne, aptly described Trollope's *The Bertrams* (1859) as

'solid and substantial… and just as real as if some giant had hewn a great lump out of the earth and put it under a glass case, with all its inhabitants going about their daily business, and not suspecting they were being made a show of.'[75]

In certain examples of genre, such as W.A. Atkinson's *Upset Flower Cart* or Sophie Anderson's *No Walk Today*, (fig.1&11) one feels that a fragment of the period has been preserved just as effectively. In an address to the Royal Academy students in 1858, Sir Charles Eastlake voiced his objections to the specific depiction 'of silk and velvet fresh from the counter' which he thought inimical to art, – too much like advertisements for '"manufactured articles"' of this kind.[76] But the very obduracy of stuffs and textures in paintings gives them a significance of a special kind now that the things themselves and those who wore them are already dust. The little girl in her green velvet jacket, red and gold satin ribbons and bulky, frilled skirt, stands on a highly polished chair to look with disappointment through the raindrop scattered window. No doubt she has been dressed 'just in case' the weather improves. No other image suggests so much the cloistered protectiveness of the domestic haven; its dark, womb-like depths shrouded and impenetrable. The white lace curtain's exotic pattern of birds and leaves contrasts with the inviting colours of nature, in the form of the magnificently painted jasmine, daisies, hydrangea and laurel leaves. The silk tassel of the blind adds a quiet but final note to a harmony of greens.

Atkinson's *Upset Flower Cart* – which once belonged to that great Victorian enthusiast Evelyn Waugh – is one of the most striking of all paintings of the period. The scene is set in a pleasant Georgian suburb in North London – the name of the 'Caledonian Road' clearly inscribed on the central gatepost. A young assistant has upturned the woman's barrow against a

brick, spilling the means of her livelihood – assorted geraniums, peonies, lilies and other plants – onto the road. In the distance, a local urchin relishes the drama, while an older one signals to his friends to come and see the fun. One precious flowering cactus tucked under her arm, the woman is overcome with horror, but the young girl points out to her the money proffered by her more affluent counterpart. The refined features and kindly expressions of the whole family indicate that they probably intend to render some assistance beyond the normal purchase.

But more attractive than any action is the sheer technical power with which this scene, flooded with the golden light of a Victorian early summer day, is evoked. The green railings, with their intricately pierced *fleur-de-lys* finials, dulled with rust, moss and grime, can scarcely contain the burgeoning lilac, laburnum, ivy and rhododendron. The pale, crumbling cement is clearly visible in the interstices of the red brick wall, and the artist has distinguished the smooth, worn surface of the pavement from its rough edging. Fabrics and textures are equally discriminated: the red quilted lining of the rich child's brown wool coat; her watered silk dress; the finely plaited straw hat and semi-transparent overskirt of the poor child through which the stronger stripes of her flannel petticoat are visible. The warm colours of the clothes – reds, yellows and browns – catch the sunlight and are reflected in the tumble of brilliantly coloured flowers. It is a truly radiant picture. Atkinson was one of the many artists clearly influenced by the Pre-Raphaelites, and the more specific inspiration of Madox Brown's *Work*, cannot be ruled out.[77] Like *No Walk Today*, it illustrates what to a French critic appeared as the distinguishing features of British genre: its 'matter of fact' elaboration;' that element 'of richness and glitter; a furbishing up, which is, as it were, its national stamp... It is of the earth, earthy; always exact... positive, or precise, like the people amongst whom it has had its being.'[78]

• • •

Amidst the enormous volume and variety of genre, domestic subjects were perhaps the most popular; paintings of the family at home, children at play, and others of the kind. Critics took pride in the fact that 'England, happy in her homes… and peaceful in her snug firesides,' should be 'equally fortunate in a school of Art sacred to the hallowed relations of domestic life.' As the *Art Journal* noted, to such an extent was this true, that it was almost a national development.[79] The French critic already quoted observed how British genre had

'the adroitness to adapt itself to the narrow exigencies of the dwellings it is intended to decorate. It excels in depicting interior scenes, appropriate to a country replete with families, where they have evening prayers in common: it seems made to adorn walls lit up by glowing coal-fires: it is essentially adapted to be a portion of comfortable chamber furniture'.[80]

The formula which Wilkie had developed for portraying scenes of cottage life, 'timeless, old-fashioned, or cosmetically prettified' and with 'Little that is distinctively modern' about them,[81] provided a useful model for artists like Thomas Faed (1826-1900). Faed settled in London in 1852 and carved out an especial niche for himself as a delineator of the more humble phases of Scottish life.[82] He was a worthy successor to Wilkie, and the most successful, although he opted for pathos rather than humour. His work, as one critic noted, was 'thoroughly… in harmony with the temper of his time.'[83] Faed's heart was certainly with the popular market; for he did not hesitate to place the Scottish vernacular poet, Robert Burns, 'on a higher pedestal than Homer'.[84]

It is a feature of genre that the focus should be on the personal and domestic affections, to the exclusion of any wider social or political commentary. Far from pointing to social divisiveness, it appealed, as the *Art Journal* noted, to the universal feelings and experiences which unite prince and peasant, palace and cottage.[85] The Victorians had great faith in the ameliorative effects of art; not least as a means of drawing the classes together through its appeal to shared experience and common feeling. A favourite title for paintings and a phrase that frequently recurs in art criticism is Shakespeare's 'One touch of nature makes the whole world kin'.[86]

Most of Faed's work conforms to the demands of popular genre; remaining palatably within the traditional mould in its lack of pointed social commentary, its contented peasantry, and picturesquely dilapidated interiors and costumes. Faed's frequent use of quotations from Burns helps distance his subjects from too obtrusive a reality, and the social inequalities he depicts tend to invite sympathy rather than overt criticism. Usually his work seems to have invoked the same kind of response as that of the Cranbrook School and other rural genre painters; artists like Thomas Webster and the Hardy brothers. In 1855, in discussing one of Webster's cottage interiors, *Good Night*, the home of 'the family of an honest yeoman,' the *Art Journal* was stirred to comment on the deprivations which this previously independent class had suffered; how its members had been 'converted into day-labourers... a victim to the Moloch of wealth' – to the dictates of 'capital and a system of extensive

fig. 12

George Smith

A Sewing Lesson by the Fireside

1867. Oil on panel. Christie's Images Ltd., 1999

fig. 13
William H. Snape
The Cottage Home
1891. Private Collection. Bridgeman Art Library

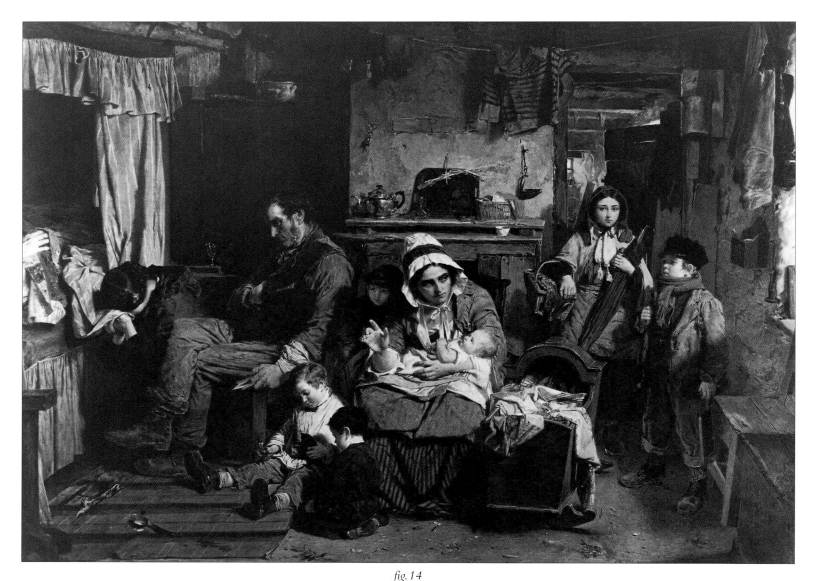

fig.14
Thomas Faed, *From Dawn to Sunset*
exhibited 1861. Unlocated. Photograph, Witt Library

farming'. But the writer decided that to 'get political, and perhaps angry' over such issues, 'would be out of place and unseemly here';[87] and this is applicable to almost all rural genre painting.

From Dawn to Sunset, (fig.14) exhibited at the Royal Academy in 1861, sums up everything that was most appealing about Faed's work. The *Times* voted it the picture of the year; far and away his best to date.[88] The *Art Journal* thought it an ingenious interpretation of Shakespeare's 'Seven Ages of Man'; a theme which had become in Faed's hands 'a deep domestic epic, worked out with marvellous skill... one of the most touching and impressive in the long annals of domestic sorrow.' With this painting, Faed had entered 'a new and higher walk of Art'.[89]

In the centre of the main living room of a cottage, a mother sits nursing her baby, the youngest of a large family. Two small boys are quietly absorbed in play on the cottage floor, and

another, little more than an infant, watches by his mother's side. The mother signals to an older girl and a boy who have just entered, to be silent. Instantly apprehending the solemnity of the occasion, they respectfully obey her command. To the far left, in a curtained bed the grandmother has just died; her wrinkled, work-worn, waxy hand already beginning to stiffen on the coverlet. The eldest grand-daughter weeps beside the corpse, while her father, prayer book in hand, sits back, resignedly. The *Art Journal* thought the head of the father 'equal to anything by any other British, or, perhaps... any other living artist',[90] and technically, in both characterization and the detailing of the interior, the picture certainly shows Faed at his most precise. The cracked plaster walls, the rough wood of the furniture, the striped cloth hanging on the line, and the silver teapot - their sole pretension to gentility; all are delineated with a

fidelity which rivets the attention. Although there is no action, the picture is full of character and the kind of understated incident that was expected of genre painters. The focus on family sentiment, on the archetypal experiences of birth and bereavement, also explain its appeal. By this date, Faed's work was recognized as 'a good investment'; and this particular one was bought by the dealer Louis Victor Flatow at a high price.[91] A later critic might complain that Faed's taste was for the obvious; that he did not hesitate to dot his 'i's; but such tendencies only serve to explain his popularity.[92]

In recent years, attention has focused on Faed's more overt social commentaries. He was made famous by *The Mitherless Bairn* (1855, Royal Pavilion, Brighton) which is of the sentimental type. The setting is a humble but decent cottage home, and a happy ending to the story is clearly implied. The pendant to it – *Home and the Homeless* painted for the philanthropist, Lady Burdett Coutts – is much more hard hitting. Here, a serious social problem is admitted, with no ready solution. The *Last of the Clan* (1865, Glasgow Art Gallery & Museum) shows the consequences of the eighteenth century Highland clearances, and was followed by other major depictions of poverty such as *The Poor, the Poor Man's Friend* (1867, Victoria & Albert Museum) and *Worn Out* (1868, Forbes Magazine Collection, New York). In 1987 Faed was included in a major exhibition as representing 'the acceptable face' of Social Realism and he makes an interesting link with that later development.

But in summing up his achievement, contemporary critics perceived him as a painter of domestic sentiment rather than a social realist. The former type was, after all, in the majority, and was also more palatable; to the extent that by the later part of the century, the peasants who inhabited them were beginning to look distinctly old-fashioned. In 1872, the *Art Journal* referred to his work as immortalizing a past way of life, inhabited by rustics of a distinctly poetic breed, 'rarely to be met with in these days of economic improvement';[93] and by the 1890s, it seemed beyond pretence that Faed rendered Scottish life at all realistically. His art was perceived as belonging to a time 'when people preferred Nature made pleasanter with sentiment', and no-one was the worse 'for this mild kind of idealization'.[94]

Most domestic genre painting opted for minor incident and ambience rather than any sort of dramatic narrative. George Smith (1829-1901) – whose work falls into the same category as that of Thomas Webster and Frederick Daniel Hardy – painted a whole series of interiors which share the same attractive features. In *Musing on the Future* (1874, Sotheby's), which shows a mother tenderly observing her young son, accessory details are equally important: the dim light falling on the red brick

floor, the ancient beams, the rows of geraniums in their hand-thrown pots, the sense of calm and sheltered stillness; all those timeless, unchanging elements of rural life which the townsman saw as symbols of a stability long lost to urban life. *A Sewing Lesson by the Fire* (fig.12) includes many of Smith's favourite ingredients. In a dingy cottage a young mother concentrates on her sewing, while her little daughter is distracted by the kitten, playfully arching his little paw over the ball of wool. Beside them the baby sleeps soundly in a wicker cradle, covered with a paisley shawl. The roughly plastered walls and ceiling as well as the fireplace itself, are stained with smoke; and the blue paint on the rough wooden door is almost entirely worn away, especially around the latch, signifying years of use. There is not a superfluous object in sight; no pictures or ornaments, only useful objects like the two baskets, the old-fashioned bonnets and man's hat, and the thick green cloth on the table. It is an image of poor but decent peasant life. The mother, her dark hair drawn back in a neat bun, is evidently devoted to her family, and the girl receiving a useful lesson, not least in learning to sacrifice play to future benefit; a point suggested by the tempting glimpse of sun and countryside which beckons through the glass panes of the door in the far room.

But even subjects like these moved with the times. William H. Snape's later *Cottage Home* (fig.13) makes an interesting contrast. Comparing the country life of the 1890s with that of the 1840s, one writer noted how much more affluent and better educated the late Victorian worker was; that there was scarcely a 'greater divergence between metropolitan bustle and some Cranford of today, than between our village at the present time and its former self.' In the earlier period in her own native Suffolk, isolated from the world at large, the populace had languished in ignorance, illiteracy and poverty. In the village

'there was neither reading-room, cricket club, annual flower-show, brass band, nor any other organisation, social, literary, or political. There were neither pictures on the cottage walls nor books on the cottage table... There is no doubt that a cheap tripper at Hastings... spends more on a single day's outing in 1897 than his forerunner... of fifty years ago, on recreation from the cradle to the grave'.[95]

In the later picture there is exactly the same sense of enlightenment, of contact with the world beyond and with matters intellectual, which is quite absent in the former where the activities are entirely domestic. A feeling of good sense and decency pervades a room in which a young girl listens attentively as her grandfather reads aloud. The whitewashed ceiling

and walls, damp-stained and cracked, indicate the material poverty of the occupant; but there are signs that he is richer in other ways. A number of educational and improving but cheap lithographic prints are pinned to the walls, including the 'Churchman's Almanac'. The lace curtains are clean, and a handsome old clock monitors the hours in this well-regulated little household. A chintz covered day-bed has evidently migrated from some grander home, much appreciated by a tabby cat whose companion tends her kittens. Suffused with the evening light, the warm tones of the red tiled floor and ochre painted walls are echoed in the row of well tended geraniums in the window. It is a favourable but convincing view of superior village life; one that has already expanded way beyond the geographical confines of thirty years previously, and which has benefited from the Education Act which established schools in rural as well as urban areas in 1870; the first of several which was to provide education for the working classes.

• • •

Central to the domestic scene were the wife, the mother, the dutiful daughter. In the Victorian age, woman's place was truly in the home – the sphere wherein she ruled supreme; the man's that of the wide world where the whole scope of human endeavour was open to him. In his own lectures on the separate roles of man and woman: 'Of King's Treasuries' and 'Of Queen's Gardens' (1864), Ruskin likens the woman's sphere to a walled garden or a hothouse; and points out that it is only within these protective confines that intrinsic female qualities might flourish, and woman exercise her special gifts as ideal daughter, wife and mother. This orthodoxy, based on the recognition that the complementary roles of husband and wife should be strictly observed, was frequently celebrated in art.

The idea of the home as a sanctuary, and as a sort of moral laboratory for the next generation, is crucial to our understanding of the Victorian home. The popular moralist, Samuel Smiles, called the home 'a training ground for young immortals, a sanctuary for the heart, a refuge from storms, a sweet resting-place after labour, a consolation in sorrow, a pride in success, and a joy at all time.'[96] Henry Mayhew wrote of the English home as

'a kind of social sanctuary... where love alone is to rule, and harmony to prevail, and whence every enemy... all the cares... of life are excluded... and where the gracious trustfulness and honied consolation of woman, makes ample atonement for the petty suspicions and heartlessness of strangers.'[97]

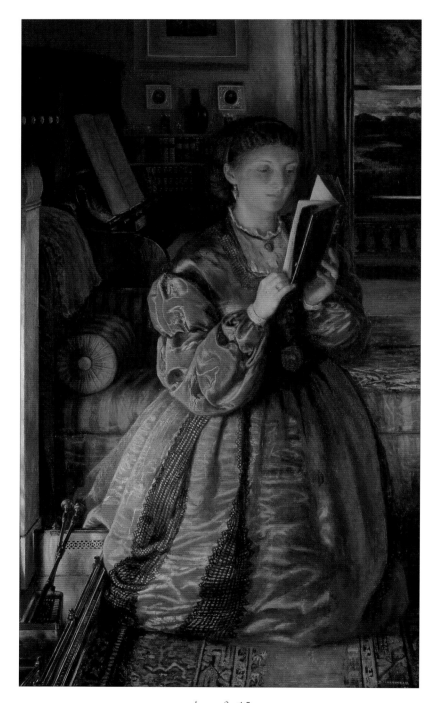

above: fig. 15
Robert Braithwaite Martineau
The Last Chapter
1863. Birmingham Museums and Art Gallery

opposite: fig. 16
Joseph Clarke
The Labourer's Welcome
c1858. Sheffield Art Galleries. Bridgeman Art Library

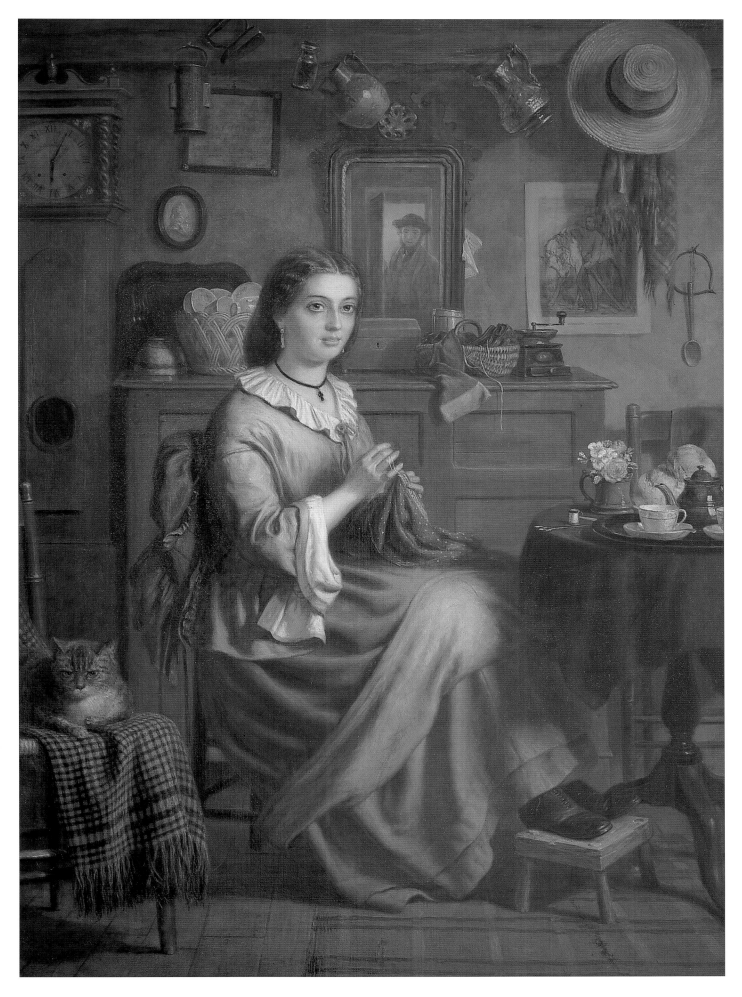

The moral tone of the home was the responsibility of the wife and mother. Mrs. S.C. Hall, wife of the proprietor of the *Art Journal*, defined the primary duty of womankind as the care of future generations. 'The strength and glory of England are in the keeping of the wives and mothers of its men', she wrote; it is within the English home, woman's special domain, where 'our heroes - statesmen - philosophers - men of letters - men of genius' are shaped.[98] Mrs. Hall was averse to the Women's Rights' movement which she described as 'pregnant with incalculable danger', believing that the displacement of women 'from their proper sphere' would 'not only convulse, but shatter the fabric' of society.[99] Smiles was equally adamant that 'Society may recover from revolutions... but when the character of woman is degraded, society is poisoned at its core'; for 'The home is the crystal of society - the very nucleus of national character... The nation comes from the nursery.'[100]

Woman thus provided an exact complement to the man, exerting a silent and unseen moral influence which was capable of 'purifying his heart, and heightening the tone of his aspirations'.[101] Such notions were by no means confined to the more conservative elements in society. Frederick Harrison, liberal lawyer and committed positivist, was another who paid tribute to the essential function of woman: that of the 'purifying, spiritualizing, [and] humanizing of society' through the moral influence which she exerted over husband and family.[102] Successful career women like Arabella Kenealy, who was a qualified physician, were generally agreed that the well-being of society depended on the majority of women retaining a domestic role. Dr Kenealy defined the feminine influence as a kind of atmosphere,

'a species of aura, magnetic charm, nerve-essence, call its impalpable and subtle existence by what name you will - ... it is a womanly potency imparting rest and infinite refreshment... With it her mere presence is a charm, greater than cleverness, more potent than speech, a stronger influence for purity and noble aim than is to be found in philosophies or creeds.'[103]

Those inbred qualities - psychological as well as physical - for which women were most cherished and valued were precisely those which unfitted them for public life. The comparative physical weakness of women was self-evident, and a corresponding mental weakness was also assumed. Traditionally, women had been regarded as, by nature, emotional and instinctive rather than rational and intellectual, and modern scientific research was called on in support of this. Sir James Paget, a leading physician whose patients included Queen Victoria, approvingly quoted J.-C. Lavater's belief that '"The most rational women are little, if at all, capable of thinking"';[104] and in a detailed examination of 'The Real Differences between in the Minds of Men and Women', one anthropologist concluded that a woman educated 'to the utmost of her capacity' could not reason on an equal level 'with an uneducated man'.[105] The application of evolutionary theory to physiological studies in the later part of the century only served to consolidate such ideas. Scientists pointed to evolution as inevitable proof of the beneficial and continuing divergence of the sexes. In one of a series of articles in which she warned of the dangers of women's emancipation, Dr. Kenealy referred to traditional feminine traits as a 'beautiful achievement of evolution which it is a crime to deface;[106] and the Cambridge physiologist, Professor George John Romanes, warned that woman's nature - the 'sweetest efflorescence of evolution' - was 'too precious an inheritance lightly to be tampered with'.[107] Patrick Geddes and J. Arthur Thomson, in their book on the *Evolution of Sex* (1889) concluded, in an unforgettable phrase, that to obliterate the mental or physical differences between the sexes, 'it would be necessary to have all the evolution over again on a new basis. What was decided among the prehistorical Protozoa cannot be annulled by Act of Parliament.'[108]

Some physiologists argued that evolution had been restricted in women in order to conserve energies for childbirth; others that the mental capacity of women was in inverse relation to fertility. In either case, the implication was that any activity that might challenge the prime function of motherhood was physically damaging. This was the strongest and most persuasive argument of all, and one with which most women as well as men, agreed. The frequent pregnancies of a large proportion of Victorian women were, indeed, incapacitating. Families of eight or more children were common. Edward Lear was one of nineteen, and Frith sired the same number. Eliza Lynn Linton, herself a successful writer, felt obliged to remind supporters of women's suffrage that 'the *raison d'être* of a woman is maternity... The cradle lies across the door of the polling booth and bars the way to the senate.'[109]

Artists not only painted subjects which upheld the orthodox view of woman's place, but also attempted to suggest something of the spiritual aura to which Dr. Kenealy refers as the hallmark of woman's nature; belief in which was central to the mystique which had built up around her. To materialize this spirit, in some way, and the feelings aroused by it is perhaps what gives to so much of Victorian art a claustrophobic and hallucinatory character, which goes beyond the avid rendering of what is tangible and physically present. Feeling seems to acquire a degree of materialization, and the material takes on a spiritual glow. In paintings by Egg, Egley, Hicks, Cope, Hayllar, Houghton and

others, one finds this aura, suggestive of the intensive feeling which subjects of this kind evoked in painter and public alike. Martineau's *Last Chapter* and Joseph Clarke's *Labourer's Welcome*, (fig.15&16) powerfully express the joys of the protective sanctuary that is home, radiant with its feminine presence. In both, the woman is shown happy and sheltered within it.

In Martineau's painting, a young married woman kneels by the glowing fireside of a darkening room, rapt in the final pages of her book. A stormy night sky with its turbulent clouds is visible through the window; but in this sheltered retreat, the atmosphere of physical warmth is echoed by the almost tangible feeling of contentment and security which permeates it. A quiet orderliness is visible in the carefully arranged pictures and books, the shining brass fender and fire-irons, and the neatly covered day bed. The woman's brown silk dress and simple but tasteful jewellery suggest that she may be awaiting her husband's return and the dinner they will share together. In a similar scene, Clarke shows that a similar degree of contentment is attainable in any well regulated household, however humble. In this case, the young wife has no leisure for reading, but looks up expectantly from her mending as her husband returns from work, no doubt ready to offer any 'honied consolation' that he might need. Unperturbed by his entrance, the tabby cat rests comfortably on a chequered shawl. The wife's neat dress and hair, the shining pewter hanging from the rafters, the polished clock and vase of simple flowers on the table; all bespeak her diligence and its happy consequences. The closeted cosiness within which the wife spends her days, as opposed to the outside world in which her husband works, is symbolized in the space between them, the husband distanced in the double frame of mirror and doorway.

It was, of course, perfectly acceptable for the wife to venture out-of-doors if domestic duties so demanded. James Clark Hook was one of the many artists whose success was ensured, as the *Art Journal* recognized, by appealing to 'the prevailing taste... in favour of whatever is associated with home';[110] but his preference was for outdoor settings. Hook's personal history echoes that of many a successful genre painter of his generation. In his youth he had trained under the academic history painter, William Hilton, at the Royal Academy. Although he gained no prize for his entry to the first Westminster competition in 1843, his cartoon was much praised, and in the following year he was awarded a gold medal at the Academy for his *Finding of the Body of Harold*. His success was crowned by a travelling scholarship which took him to Paris and Italy for two years, where he studied the old masters assiduously. But Hook was a fiercely independent character, and was soon to develop in his own direc-

tion. From boyhood he had loved the country and the sea-side; and it was these rather than history and literature which were to furnish him with the subjects that made him famous and assured him a comfortable living.

In 1853 Hook took a country cottage in Surrey, and was to move there permanently in 1857. He was now more readily able to devote his time to his preferred subjects, and at the Royal Academy of 1859, scored his first major hit with *Luff-Boy!* – a scene of fisher folk painted in Clovelly, North Devon. He had an especial *penchant* for portrayals of peasant families at the sea-shore; the wife and children often occupying themselves, or helping the father as he performs his daily tasks; at other times bringing his lunch, or waiting to accompany him home at the end of a day's work. As befits genre, the focus is less on work itself than on the domestic happiness which results from it, and from other activities which unite the family. In *From Under the Sea* (fig.17) the wife, child and rapturous baby greet the breadwinner of the family as he emerges from the copper mine on a pleasant summer evening. The *Illustrated London News* thought this example the most remarkable so far of the novel series of subjects which Hook had devised, with its unusual view of the steeply inclined rails running up to the cliff face, where the iron truck, drawn by an engine, has now stopped. To a contemporary eye the scene was highly original: the men's 'clothes and skins stained all over with the red metallic ore, the candles in their hats scarcely extinguished'. This particular critic drew a moral from the fact that one of the miners has a bunch of candles hanging from his buttonhole, in lieu of the usual flower sported by idle 'swells';[111] a remark which would have been deeply gratifying to Hook who was a committed socialist. Hook's painterly technique, his robust handling and brilliant colour, owe much to the Venetian painters whom he studied in his youth; although he adapted their sophisticated lessons to suit 'rustic subjects... English themes and English light, air, and homeliness'.[112] Hook's ability to express the tangibility of rock and water and the atmospheric effects of a fresh sea-breeze, is one of the most distinctive features of his work.

• • •

As suggested by the closeted, protective atmosphere which so often surrounds them, young girls were particularly cherished; their virginal innocence as yet unsullied by even the experience of married love, but combining with the promise of womanhood to enhance their attractions. Providing as they do the extremes of youthfulness and prettiness, in them are exaggerated all those characteristics - both physical and psychological -

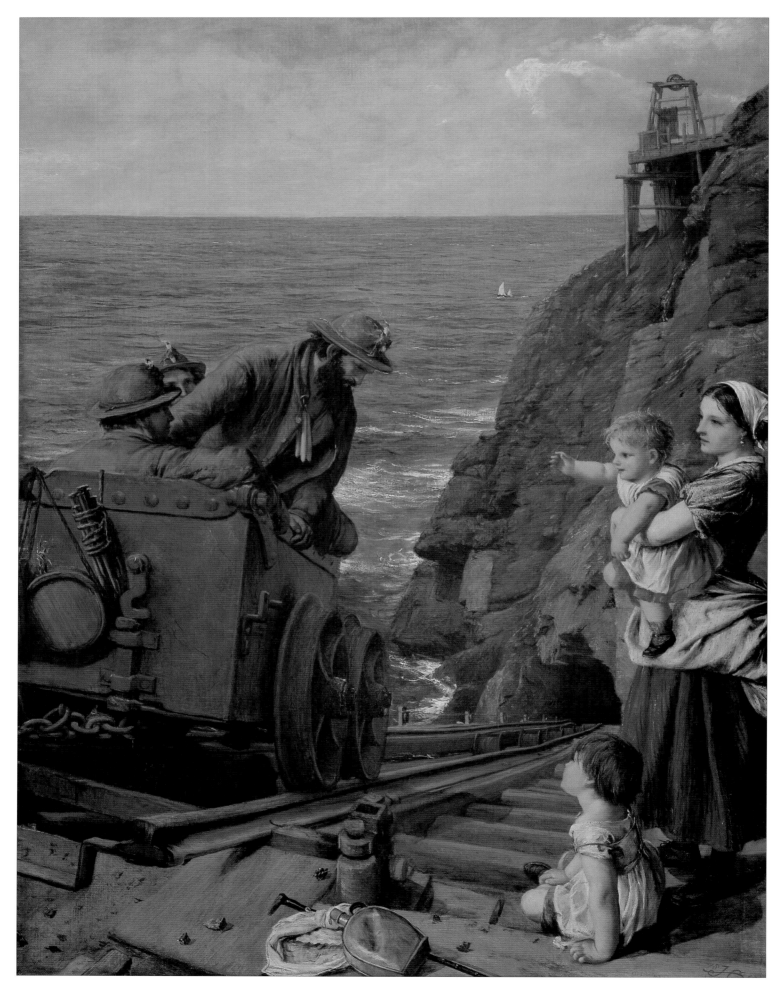

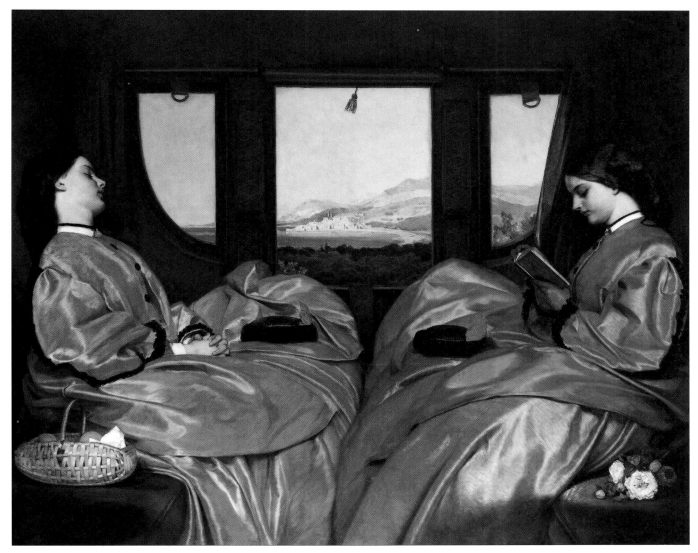

opposite: fig. 17
James Clarke Hook, *From Under the Sea,* 1864. Manchester City Art Gallery

above: fig. 18
Augustus Leopold Egg, *The Travelling Companions,* c1862. Birmingham Museums and Art Gallery

which were regarded as specifically feminine. The doll-like features and dainty figures of Victorian art and illustrations may appear unconvincing and sentimental now, but at the time they expressed what was most admired in the female sex: a childlike docility and unassertiveness which were regarded at the time as the essence of femininity.

Egg's *Travelling Companions* (fig.18) is a tribute to the beauty and femininity of young girls. Egg's pair represent the mid-century ideal with their none-too intellectual foreheads, round plump faces, and small retroussée noses. Although travelling through Italy, far from home, they remain sheltered and enclosed, snugly cocooned within the carriage; their bodies modestly concealed in voluminous dove-grey silk dresses. This painting is a celebration of everything that was most admired in English girlhood.

Paintings of courtship or of single girls dreaming about love appealed to popular sentiment, as also to the actual experience of most women. In Egley's *Talking Oak,* (fig.19) based on a poem by Tennyson, a young girl in a white flounced skirt and dashing, black-braided green jacket, has made her pilgrimage to the stately tree that for five hundred years has witnessed the lives and loves of the neighbourhood. It is a dazzling image of young beauty alight with thoughts of the courtship and marriage that will one day be her life's fulfilment. The pale delicacy of her skin contrasts with the rough, gnarled bark of the oak which she gently touches. Egley has captured perfectly the deep golden glow of a late summer afternoon, as it tinges the meadow and the already browning leaves. Amidst this scene she is the freshest and most delicate flower of all.

page 34: fig.19
William Maw Egley, *The Talking Oak*
1857. Detroit Institute of Arts. Bridgeman Art Library

page 35: fig.20
William Henry Fisk, *The Secret*
1858. Private Collection. Bridgeman Art Library

below: fig.21
Philip H. Calderon, *Broken Vows*
1856. Tate Gallery, 1999

William Henry Fisk's *The Secret* (fig.20) is a delightful and unusual rendering of the sudden revelation to a young girl of the workings of true love. It is interesting that Fisk wrote to Egley, congratulating him on the *Talking Oak*, and describing it as 'the true realization' of Tennyson's poem. But he felt obliged to point out that the oak leaves had evidently 'been painted sometimes when the sun was out and at other times when it was not shining', and made other minute observations about the faults of lighting; all of which the modest Egley recorded in his MSS Catalogue.[113] Despite Fisk's reservations, there is no dispute between them as to the feminine type which in each case perfectly fulfils the contemporary ideal. In Fisk's picture, the young woman is happily receiving a declaration of love, and probably a proposal of marriage, from a young man who has drawn her away from the family picnic; heedless of the portly father who calls vainly from the distance. Emerging through the bushes, the child marvels at this tender scene. Young as she is, she intuitively understands the magnitude of the occasion. One day, this will be her fate too; the only possible one for a respectable young woman of her class. The man's hat, beard, and the North American porcupine-quill handbag, presumably a present from him, suggest that he may have returned from making his fortune abroad.

Less fortunate is the girl in Calderon's *Broken Vows* (fig.21). It is impossible to take this sort of painting as seriously as originally intended; but it must be remembered that marriage was the only career open to most girls. The hurt and shame which attached to the girl who had been jilted were socially as well as personally damaging; and the predominance of a romantic belief in a first and only love made betrayal all the more shattering. Some girls chose to go into a 'decline' (a syndrome which we would now call *anorexia nervosa*), or to remain single after such an experience. Trollope's Lily Dale, in *The Small House at Allington* (1864) is a case in point. The lovely and characterful Lily - quirky enough to puzzle her more conventional acquaintances - insists that having committed herself emotionally to the worthless Crosbie, whom she thus already regards as her 'husband', she can never love another man. To the despair of her family and friends she condemns herself to the life of an 'old maid', and opts to spend the rest of her life with her widowed mother.

The trauma of being jilted is dramatized in this painting, in which a dark-haired girl leans fainting against a red-brick wall, clutching the heart that has been fatally wounded with a hand that bears an engagement ring. Her faithless lover flirts with a flighty girl in pink behind a fence which has formerly served as a trysting place for him and his former love, as the carved initials

on the fence rail reveal. Now she stands excluded from the source of all her previous happiness, the ivy which surrounds her symbolizing the memory that her love affair has already become. Her madonna-like features and hair, the neat, black-braided jacket and demure blue figured velvet skirt, the simple black hood and Puritan style lace colour and cuffs; all point to a sweet, modest and trusting nature which will suffer cruelly and permanently from such treatment. In reality, things worked out better for the model – Calderon's own fiancée – whom he married in 1860.

There are many paintings which make manifest Ruskin's ideal of 'Queens' Gardens'. This is as far afield as the young queen should venture; it is as safe as the interior, and provides the perfect setting for her beauty. Edmund Blair Leighton was one among many artists who created irresistibly pretty scenes of girls in gardens, most of them in Regency dress. Atkinson Grimshaw's *Rector's Garden* (1877, Preston, Harris Museum & Art Gallery), showing a girl in a diaphanous white 'aesthetic' costume tending roses is a successful example of the genre, which by the later century had become clichéd. Grimshaw was more inventive than most in varying the pattern. *Il Penseroso* (1877, Collection of Lord Lloyd Webber), depicts a young woman in similar dress closeted in a modern conservatory, amidst a luxurious wealth of flowering and foliage plants. Palms, ferns and the vari-coloured textured leaves of the caladium press close around her, as she sits at her elegant little table, Japanese fan in hand; as cloistered in her modern, fashionable environment as in any mediaeval garden.

Jane Maria Bowkett's example at least makes some pretence at being useful (fig.22). Clad in the requisite white muslin, she is absorbed in tending a tall lily which grows in a lichened clay pot. With her graceful figure and delicate features, the girl is as decorative as any of the plants which surround her - orchids, geraniums and fuchsias. The interior of the greenhouse, with its earthenware tiles and rough wooden walls, only serves to enhance the elegance and charm of this fine specimen of English girlhood.

George Elgar Hicks, whose ideas about woman's role are made clear in both his art and his writing, produced several subjects relating to the role of women. All illustrate the assumption that, in the words of a leading physiologist, woman was 'created for the purpose of being a help-meet to her husband.'[114] Hicks's clearest statement is made in *Woman's Mission* (1863), described by the *Times* as showing 'woman in three phases of her duties as ministering angel' to the male sex.[115] In this trilogy, she is depicted as *Guide of Childhood*, removing a bramble from the path of her little boy; as *Companion of Manhood* (Tate Gallery), where she supports her husband, overcome by bad news; and *Comfort of Old Age*, where she lovingly tends her father on his deathbed. In a booklet of 1896, the Rev. W. Cunningham, D.D., enlarged on this devotion to the male sex as a high mission for women: to 'live for man so as to ennoble him, and to help to make him more worthy of his place in God's universe.'[116]

Hicks's painting of a wedding is significantly called *Changing Homes* (fig.23); for the young girl moves from her parents' home into that of her husband. In both, her role is fixed; she is a 'relative creature', peripheral to and dependent on the more active male. Throughout her life, it is home which provides the arena for the exercise of her specific talents and virtues. As Hicks himself said, 'I presume no woman will make up her mind to remain single, it is contrary to nature.'[117] Eyes modestly lowered, the bride fingers her bouquet in bewitching embarrassment, as her tall husband bends masterfully over her. She represents perfectly that quality of submission, described by one physiognomist as that 'which wins the love of man,' just as he wins her love above all else through his 'strength, *manliness*'; providing her with 'someone to lean upon, look up to, be proud of.'[118] The bride's mother gazes on, emotionally, no doubt recalling her own wedding; and yet another is already signalled. To the right of the picture, a refined and dandified young man raises his eyeglass to gaze, bedazzled, at a pretty girl. Even the child bridesmaid who rushes to prevent a small boy from breaking a vase, demonstrates a sense of domestic responsibility which promises well for the future.

• • •

Motherhood was regarded as sacred. The pure love between mother and child held an almost mystical place in the gamut of Victorian emotions; the most universal and civilizing of all feelings and influences. James Grant called it the strongest human instinct in every human being, from the savage to the sage; so that 'The most untutored African regards his mother with as pure and ardent an affection as ever burned in the breast of Sir Isaac Newton'.[119] Exceptional personal circumstances made no difference to this perception. George Henry Lewes, – who lived with the less than maternal George Eliot for many years – nevertheless insisted that 'The grand function of woman... is, and ever must be, *Maternity*'. This he regarded 'not only as her distinctive characteristic, and most endearing charm, but as a high and holy office'.[120] The majority of successful professional women, including Eliot herself and Dr. Kenealy, quoted above, subscribed equally strongly to such notions as men did.

The powerful feelings surrounding motherhood account for the popularity of related subjects in art and illustration. In

1866, the *Art Journal* published an engraving by J.H.S. Mann's *Hush! — Asleep*, noting that such pictures would always remain popular, and that the annual exhibitions teem 'with pictures of young mothers with their children'. Few could resist the charms of 'Female beauty united with the innocent expression of young childhood', for

'It is almost a universal belief, that of all the feelings common to woman's nature, not one is so deeply rooted nor so unmindful of self as a mother's love. What sacrifices will not she make, what toil and anxieties will she not endure without a murmur for her child's welfare and happiness!'[121]

Through her moral influence, the mother supplied the bedrock of family life, and ultimately of society itself. Any threat to this from the cause for women's emancipation was bad enough; but the more immediate effects of an immoral wife and mother were incalculable. Smiles commended a 'shrewd' man for dismissing his intended wife after discovering her at home with her hair untidy and her dress unpinned[122] – omens of much worse faults. A similar unwomanly carelessness is indicated in one of Charles West Cope's pair of contrasting *Mothers* – the one 'who is ever watchful over the physical and moral welfare of her children', and the one who, 'addicted to French novels, and whose household is confusion,' neglects her duties. The *Art Journal*, which described the pictures as 'mirrors of real life', approved the moral contrast, and stressed the importance of keeping the paintings together; but this was not to be.[123] Not surprisingly, the painting of the good mother sold first; and although Cope recovered it and sold the pair to Agnews,[124] the one of the bad mother is now missing; perhaps in consequence off its offensive subject-matter. The remaining one (fig.24) epitomizes the life of the dedicated mother who follows Christ's instruction to 'Feed My Lambs' which appears on the carved panel, to the left. With her plump, rounded face and fine features, her fair hair modestly confined in a chignon, she conforms very much to the ideal, although her well developed nose suggests a degree of firmness also borne out in her expression. She hears the children's lessons, her gaze fixed intently on her son's face, his own attitude a little hesitant. At the same time she busily knits, while the baskets of mending close by further testify to her unceasing industriousness. Her example takes its effect in the little girl absorbed in her book, who gently rocks the baby's cradle. The family Bible lies on the table; no doubt the foundation on which this decent little family constructs its life, and providing a telling contrast with the French novel belonging to the bad mother. Only with reference to the beliefs which

fig.22
Jane Maria Bowkett
Young Woman in a Conservatory
c1873. Roy Miles, Esq. Bridgeman Art Library

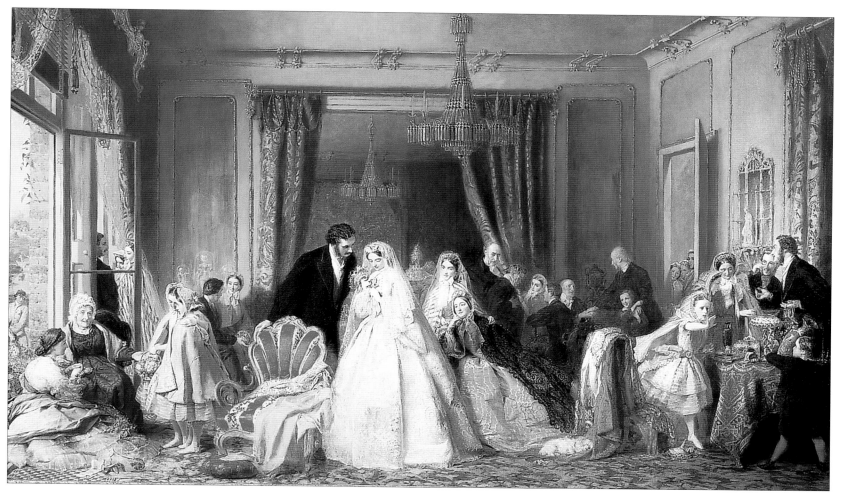

fig.23
George Elgar Hicks
Changing Homes
1862. Geffrye Museum. Bridgeman Art Library

attached to woman and her spiritual role within the home, is it possible to appreciate the original appeal of such images.

Cope's careless mother was bad enough; a seriously erring wife or mother beyond forgiveness. Since the 1857 Matrimonial Causes Act, divorce had been possible on grounds of 'Criminal Conversation': a private meeting between man and woman which provided the opportunity for 'intimacy' to take place. The exploitation of potentially sensational topics was more accessible to novelists than artists; their immortalization in paint more fraught with difficulties than any such attempt in words; but by neither could adultery be condoned.

For reasons of taste, the consequences of adultery were rarely depicted in art; the dangers of fornication rather more frequently. Some show the fate of women who have ventured outside the protective safety of the home, to indulge in *riské* and unconventional behaviour. Woman, as Ruskin said, 'By her office, and place... is protected from all danger and temptation.' But

only so long as she remains within its confines is she safe; otherwise, she will find herself in the same situation as the man who

'in his rough work in [the] open world, must encounter all peril and trial; – to him, therefore, must be the failure, the offence, the inevitable error: often he must be wounded... often misled; and always hardened.'[125]

Melodramatic depictions of 'fallen' women – such as Watts's *Found Drowned* (c1845, Watts Gallery, Compton), or Redgrave's *Outcast* (1851, Royal Academy of Arts), showing a young woman with her baby being expelled from the family home, give way to more interesting examples in the 1850s and 'sixties. E.C. Barnes dared to paint a picture baldly entitled *The Seducer* (fig.26). The scene is somewhat ambiguous; but it is unlikely that the encounter is fortuitous, as has been suggested. It is much more likely that the girl is having second thoughts about an

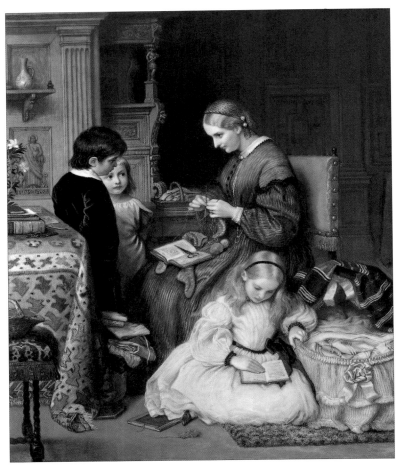

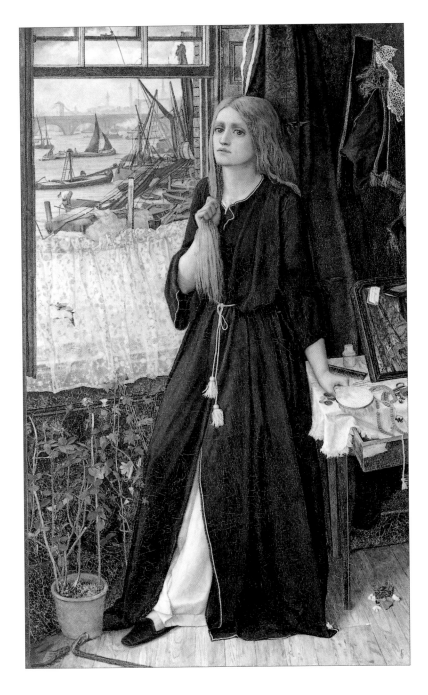

above: fig.24
Charles West Cope, *Life Well Spent*
1862. Christopher Wood Gallery

right: fig.25
John Roddam Spencer Stanhope, *Thoughts of the Past*
1858. Tate Gallery, 1999

opposite: fig.26
Edward Charles Barnes, *The Seducer*
c1860. Pre-Raphaelite Trust, Inc.

agreed elopement, and about a step which will be irrevocable. Rather than reacting to an importunate encounter, she appears to know the man, quietly signalling him to wait, as she gives some thought to the situation. With his bristling whiskers, jazzy cravat, death's-head tie pin, and serpent entwined cane, he is not a promising specimen. The red-bricked wall behind, topped with jagged glass, epitomizes the urban environment, raw and threatening; its roughness and hardness at the opposite pole from the sort of domestic environment where women were protected. In another example of this kind, Alfred Elmore's *On the Brink* (1865, Fitzwilliam Museum, Cambridge), a fashionably dressed woman is shown outside a continental casino,

reluctantly facing up to the consequences of a 'fast' social life; her indulgence having left her no option but penury or prostitution. Her anguished face, the insinuating attitude of the man bending over her as he makes a proposition, the lurid light; all point to a desperate situation of her own contrivance.

One painting which avoids any overt drama is Spencer Stanhope's *Thoughts of the Past* (fig.25). Here, the girl has exchanged her home for a squalid room - her only reward for a life of sin. There is no action, but the girl's psychological state is registered with painful sincerity. There is nothing of the sense of manipulation that often characterizes Victorian moral commentaries; but a sense of real suffering and of remorse for a life

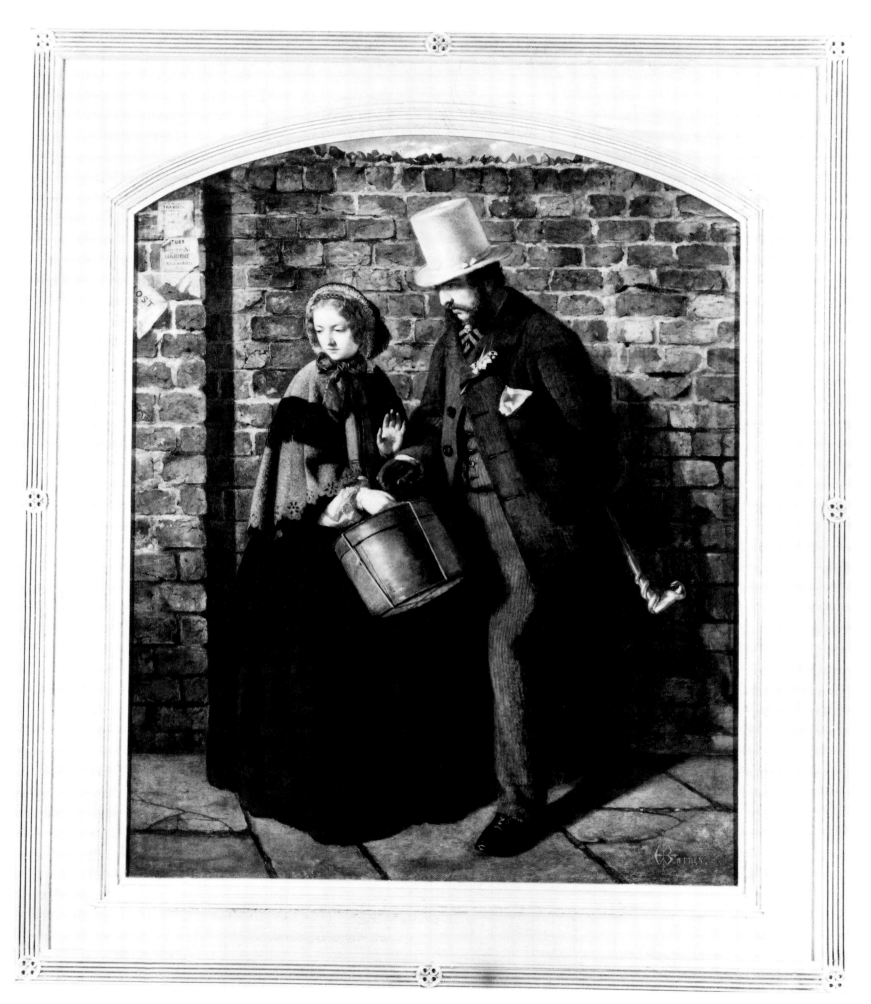

41

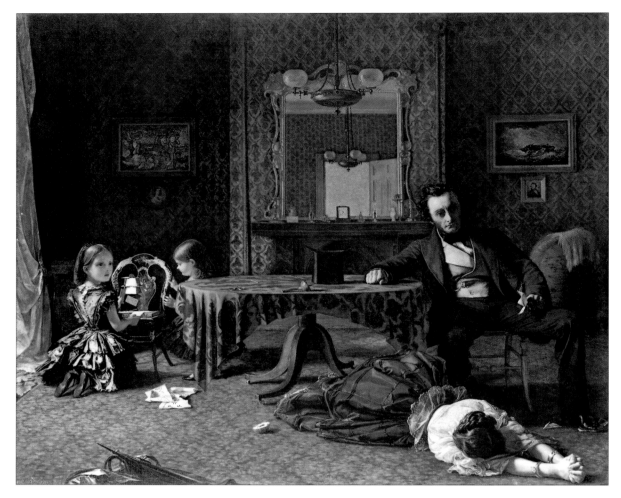

fig.27
Augustus L. Egg, *Past and Present: 1*
1858. Tate Gallery, 1999

wasted – perhaps through some mere act of idleness or vanity; a consciousness of the irreversibility of her situation and of a life already wasted. The prosaicness of the little scene - the dull grey light over the river, just as Stanhope saw it from the room beneath Rossetti's flat on the north side of Blackfriars Bridge; the lurid aniline-purple dressing gown; the hairbrush and cheap beads, pathetic accessories to her way of life; the broken veneer of the table drawer and the torn lace curtain; the straggling geranium in its pot. Such scattered and inconsequential details poignantly suggest the aimless reality of this girl's life. Originally intended as a diptych, it is unfortunate that the pair to it was never painted.

Although home was the safest place for women, there was danger even there for the less vigilant or virtuous. Married women with time on their hands were regarded as ideal prey by philandering young men, since they were sexually experienced, and any resulting pregnancy might be foisted on the husband. Young and attractive, neglected by her husband, Effie Ruskin was obliged to lay down very strict rules in order to keep predatory males at bay; and this was a by no means uncommon situation.

W.P. Frith contemplated a series of five paintings illustrating the seduction, elopement, and final repentance and death of an erring wife who is seduced by 'Her Husband's Friend', the title of the first episode. The idea was suggested to him by the novelist Mary E. Braddon; but Frith admits that he shied off from so painful and offensive a subject.[126] The most dramatic warning about the dangers of wifely infidelity is Augustus Egg's trilogy, *Past and Present*, where the married woman's adulterous affair is discovered by her husband. As in the case of Cope's bad mother, she has been corrupted by French novels; for one of Balzac's 'unsuitable' works lies on the chair, forming an ominous base for the children's house of cards. Rare as such subjects are in art, it is suggestive that the *Art Journal* critic admitted that the number of 'public prints with the details of such incidents' had reached saturation point, and that Ruskin described it as 'a piece of very commonplace vice' involving an ordinary married couple.[127]

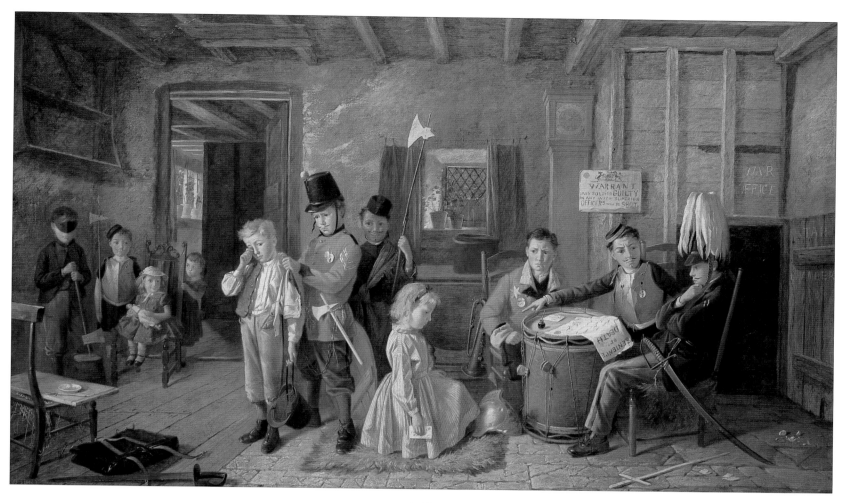

fig.28
Charles Hunt, *A Plea for Mercy*
1872. Christie's Images Ltd., 1999

In Egg's first scene (fig.27) dramatic as a stage set, the lurid reds and greens of the room reverberate to suggest the intense mental anguish of husband and wife; for the sacredness of the home has been poisoned and polluted. Rigid with shock, the husband's white face betrays the discovery of his wife's infidelity. Overcome with shame and remorse, the wife has flung herself onto the floor; but she does not turn to him, aware that her sin is unforgivable. On the wall, pictures of the expulsion from Eden and a Clarkson Stanfield shipwreck, *Abandoned*, as well as the unstable house of cards, symbolize the destruction of this little family; and in the mirror is reflected the open door through which she must now go, an outcast. The other two paintings in the series show simultaneous scenes some five years later. The father is now dead, and the girls, reduced to a shabby attic room, think sadly of their lost mother. She also thinks of them, gazing at the same moon from under the 'loathsome sewer arch'[128] under the Adelphi – last refuge of the destitute. Not all critics were so negative as the *Athenaeum* which found the series

beyond the bounds of acceptable taste, although the *Morning Post* also objected to the depiction of such 'morbid misery' as this. Ruskin thought the final scene impressive – a 'wretched and appropriate catastrophe' to such a series of events.[129] The *Daily News* described it as 'a fine ethical poem'; and there were other critics who echoed the *Sun*, which thought it Egg's masterpiece: 'a tragedy in one glance; a mournful narrative of sin and domestic sorrow told in a minute,' which held the critic 'spellbound.'[130]

• • •

During the 1850s a group of artists, established what came to be known as the Cranbrook Colony. Members included the close friends Thomas Webster (1800-86) and John Calcott Horsley (1817-1911), as well as relatives of theirs, the Hardy brothers and George Bernard O'Neill (1828-1917). A.E. Mulready (fl. 1863-c1886) who was later to specialize in vignettes of the urban poor, spent some years there during the

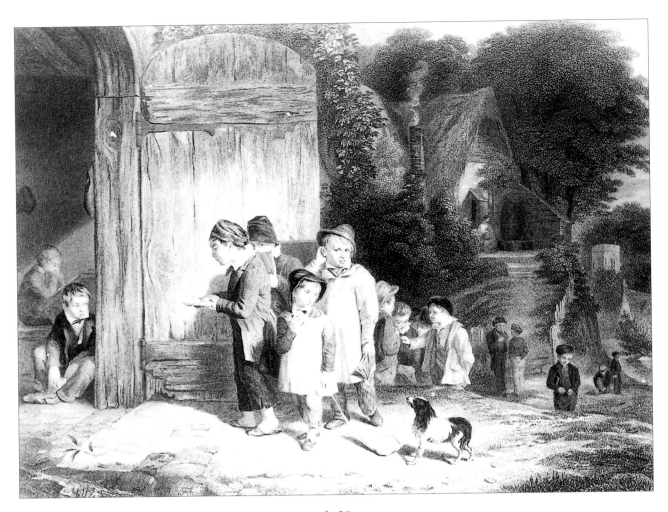

fig. 29
W. Ridgway, after Thomas Webster, *Going to School*
Art Journal (June, 1862)

1870s, with Horsley, who was his guardian. In this attractive Kentish village the artists devoted themselves largely to rural genre subjects, and with great success; maintaining both the gentle spirit and the unprovocative subject matter of Wilkie and, like him, reinterpreting the coarser spirit of Dutch genre to suit Victorian taste. Thomas Webster, best known for his *Village Choir* (Ex. 1847, V.& A.), was the central figure. The Cranbrook artists established a sure recipe for success and Horsley and Webster acquired substantial old houses in the locality; the former's being remodelled and extended by Norman Shaw in his days as a rising young architect.[131]

The artists were closely involved with the social life of the village, resulting in 'a directness of observation and sympathy of approach' which were largely denied to London based painters of similar scenes.[132] Their rural backwater provided them with all sorts of charming aspects of everyday life, particularly those involving children. Many painters at this time concentrated on the child's world. The idea of child nature as something specif-

ic and valuable; something to be cherished and celebrated rather than as a more or less tiresome prelude to adulthood, had developed only with the dawning of Romanticism in the late eighteenth century. Regard for the innocence and vulnerability of childhood was hastened by the consequences of industrialism, and the horrific revelations of the 'Blue Books' – Government investigations of conditions in the factories and mines which revealed the horrors of child labour. As Lionel Lambourne points out, the charge of 'sentimentality' against both the novelists and painters concerned with child subjects is over-simplistic; 'for it was precisely in their tendency to sentimentalise, to demand the response of compassion, that such works afforded powerful inducements to public humanitarianism.'[133] One can understand both the sentimental reaction and the cynicism towards it, given the realities of child life. The law of the jungle operated in schools, especially in the playground, and also within the large families which were then common. Children were left very much to fend for themselves, some-

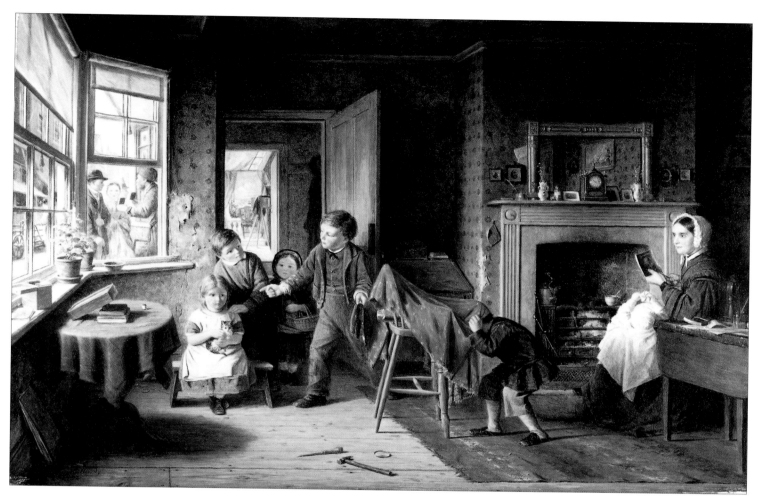

fig.30
Frederick Daniel Hardy, *The Young Photographers*
1862. Oil on panel. Tunbridge Wells Museum and Art Gallery

times at considerable risk. The painter, Mrs E.M. Ward, recalled the children of the great actor-manager William Charles Macready as 'the naughtiest children imaginable', inspiring fear and dread in others. One of the boys amused himself by setting fire to her dress, endangering her life, and such alarming 'pranks' were by no means unusual.[134]

Artists contented themselves with more conventional incidents of child life than such incendiary assaults. At Cranbrook, the little school was a useful focus. Webster was to follow William Mulready in concentrating on 'the sports and mischievous dispositions' of boys, throughout his working life,[135] although opting for more peaceable depictions than Mulready's. *Going to School* (fig.29) is of more than usual interest as an amusing epitome of youthful village types. The *Art Journal* critic was impressed by the degree of physiognomical truth and convincing expression in each of the figures. It was evident, he wrote, how closely Webster had 'studied them in all their various phases and character - the idle boy and the industrious boy, the dull

and the intelligent, the mischievous and the careful, the timid and the bold.' The early arrival, sitting by the door is intelligent look-ing, providing a marked contrast with the one approach-ing, 'whose half-idiotic countenance testifies to his mental calibre; he is poring over his allotted task, but it is evidently beyond his grasp'. The distinction between the well formed head of the first boy, and the low forehead and heavy jaw of the latter, clearly reflects those laws of physiognomy which play so important a part in Victorian narrative art. Observing that 'he is almost shoeless, and his trousers hang in tatters about his legs', the ingenious critic deduces 'that there is at home neither example nor precept of thrift and industry;' and that 'his father, if he has one, is a frequenter of the "Blue Lion," or the "Squire's Arms"'.[136]

Another Cranbrook member, Frederick Daniel Hardy (1826-1911), was adept at introducing an element of novelty into his paintings of childhood. At a time when large families were the norm, subjects involving children of various ages, mimicking adult occupations as in the *Young Photographers*

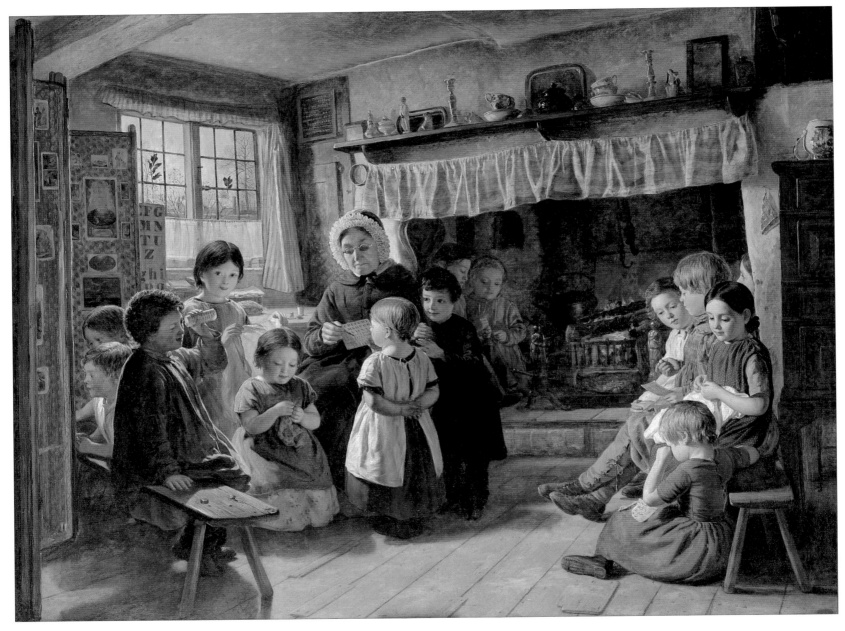

above: fig.31
Alfred Rankley, *The School Room*
1853. Christie's Images Ltd., 1999

opposite: fig.32
Frederick Smallfield, *Early Lovers*
1858. City of Manchester Art Galleries

page 49: fig.33
Arthur Hughes, *The Font*
1863. Alan B. Gateley

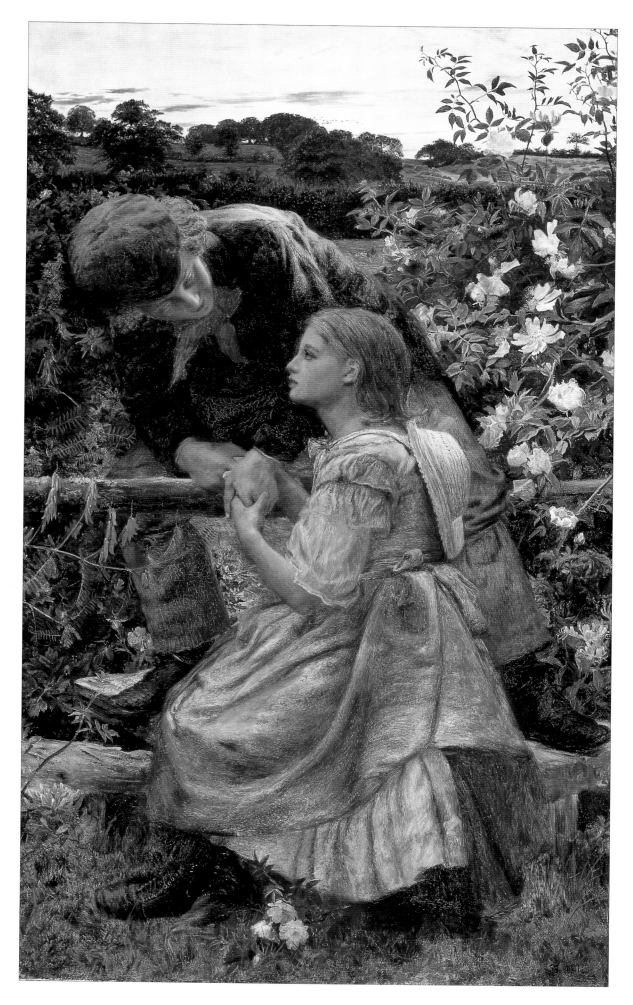

(fig.30) and *Playing at Doctors* (1863, Victoria & Albert Museum), were bound to strike a sympathetic chord and find buyers. James Dafforne acknowledged the latter as one of his best paintings; its 'quiet humour and... quaint character' closely allying it with Wilkie and Webster'.[137] In the former, a little girl nursing a kitten provides the model for the boyish, make-believe photographer who adopts a serious and responsible air in emulation of his father, whose own photographic business is conducted through the doorway to the rear. A board outside the studio advertises his portraits, and the proprietor himself is seen showing samples to a couple of prospective clients.

Among other numerous specialists in child subjects was Charles Hunt (1803-77), who often shows the reactions of children to events in the adult world and their eagerness to re-enact them as play. The excitement engendered by war and the perennial appeal to children of playing soldiers are illustrated in *A Plea for Mercy* (fig.28) 1872, made by a little girl on behalf of the 'condemned', whose death sentence, signed and sealed, lies before a pair of young officers whose frowns signify the perplexities of the situation. The 'executioner', complete with mask, axe and block, awaits their decision. In a more peaceable scene, Hunt makes a topical reference to the uprising against the British in the Sudan, which had resulted in the death of General Gordon at Khartoum in 1885. A cottage interior has been converted into a *Horpittal for Woonded Solgers* (?1886, Private Coll.) where little boys and girls take the parts of soldiers, nurses and visitors. The various degrees of absorption and the moods of the children are convincingly suggested, while the humble but spacious interior, flooded with pale, warm light is a joy in itself.

Alfred Rankley (1819-72) is best known for his tear-jerking *Old Schoolfellows* (1854, National Gallery of Scotland), showing the welcome arrival of a young man at the sickbed of another who has fallen on hard times. The *School Room* (fig.31) shows a typical Dame School, of the kind where the majority of children acquired something of the basics of reading, writing and arithmetic before the Education Act of 1870 had its effects. By 1876, a sufficient number of primary schools had been built for the Government to enforce compulsory, full-time attendance for children up to ten; in 1880, up to thirteen; from which time, purpose built schools became the norm. Prior to these reforms, the quality of schools depended entirely on local factors. Dame Schools were indeed 'elementary'; for a nominal fee, 'amongst domestic paraphernalia in a cottage kitchen', children at least might learn to read.[138]

It is exactly such a scene which is depicted here. The neat schoolroom is gently illuminated with the winter sun; a log fire glows in the hearth, and the bare trees outside and the holly sprigs in the window are further signs of the season. Two children study edifying prints on the large screen which keeps out the winter draughts, while a small pinafored infant recites the alphabet at the Dame's knee, hoping to avoid the fate of his tearful friend to the right in the brown dress. Careless of such threats, an older boy boldly makes a telescope of his script, while another two are more concerned with assessing the value of a champion marble than with learning. The crisp drawing reveals some interesting and appropriate details such as the stolid dame's frilled bonnet, her beloved bric-à-brac and the muslin valance on the mantelpiece. Hunt and Rankley are typical of the successful genre painters of the day in showing a facility for tackling a wide variety of subjects - historical and literary as well as contemporary.

The charm and innocence of young children, combined with picturesque landscape, provided the basis of many a 'pot-boiler'; but no such accusation could be levelled at Frederick Smallfield's *Early Lovers*, (fig.32) which, regrettably, seems to have been his only exercise in the Pre-Raphaelite mode. One of the most enchanting of all images of children in a rural setting, it captures exactly the intensity and absoluteness of child love.

Smallfield (1829-1915) was an exact contemporary of the Pre-Raphaelites and would have known John Millais, who was a fellow member of the Junior Etching Club. In 1858 the Club's members collaborated on a series of illustrations to the poems of Thomas Hood, and Smallfield's contribution was to provide the basis for this painting. The poem in question, Hood's 'Ballad', is a fond reminiscence of an early love which had bloomed in the 'Time of Roses' and which had been as beautiful as the roses themselves. A young girl of twelve or thirteen sits on the foot-rest of a stile, while her youthful boyfriend bends over her, to look questioningly into her face, firmly clasping her small hands in his larger and more rugged ones; perhaps illustrating the lines: 'Twas twilight, and I bade you go, But still you held me fast'. In this modest work, Smallfield reveals a special sensitivity to the minor keys of the English landscape and its subtle shifts of light and colour. It is an evening in early summer, and the sun has just disappeared behind the distant trees, faintly reflected in the wispy strips of purplish grey cloud. The deep pink honeysuckle twists its way through the paler briar rose, complemented by the deep magenta of the vetch and the remaining bells of foxglove to the left. Smallfield has paid close attention to the individual growth habits of all the plants, and the way in which twisted stems and delicate leaves hang on the evening air. He has captured exactly that pregnant moment as twilight falls on a still summer

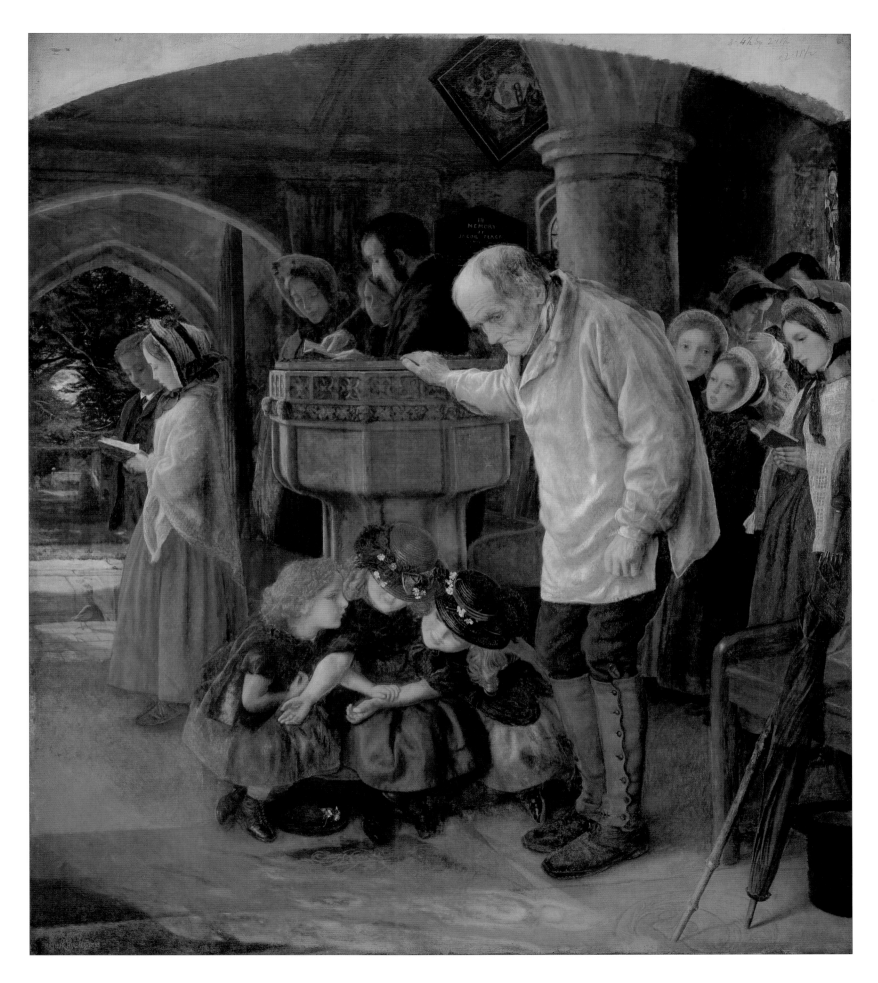

evening; when, as if bewitched, the colours stand out with an inner radiance against the darkening foliage. The figures themselves are tinged with the warm evening glow. The surface texture of the boy's rough clothes is shot through with deep brownish reds and purples while the girl's cotton dress and apron reflect paler tones of warm yellow, lilac and grey. While recalling *Autumn Leaves*, in both technique and atmosphere, Smallfield's painting lacks the philosophical overtones of Millais's work. All the same, the combination of natural observation and true, tender feeling make it one of the most successful of all minor Pre-Raphaelite works.

The attraction of the countryside for urban Victorians is obvious enough. For many of them, village life seemed to offer more than a peaceful retreat from their own hectic lifestyle; it also symbolized for them 'a healthy integrated society with a chain of command and a chain of responsibility'; exactly the kind of structure threatened by modern social and economic developments.[139] In 1854 'Cedric Oldeacre' had lamented the passing of the old way of rural life in his valedictory salute to *The Last of the Olde Squires*; one who exercised a paternalistic care over his labourers and tenants, and who set an example in his regular attendance at the ancient parish church. R.H. Ditchfield, author of a number of nostalgic books about the rural past, of a kind which proliferated at the end of the century, recognized as one of the charms of English villages 'the sense of their stability'; and perhaps nothing signified the stability of rural life more than the village church, where young and old, peasantry and gentry assembled each Sunday. Ditchfield pointed to the village church as proof that, in the face of momentous events,

'Nothing changes in our country life. The old tower of the village church that has looked down upon generation after generation of the inhabitants seems to say "Je suis, je reste." All things change but I. I see the infant brought here to be christened. A few years pass; the babe has grown to be an old man and is borne here, and sleeps under my shadow. Age after age passes, but I survive.'[140]

Such ideas underlie Arthur Hughes's scene of a church interior - *The Font*. It was accompanied by two poetic quotations in the Royal Academy Catalogue: 'Then By a Sunbeam, I will Climb to Thee' (fig.33) from George Herbert's 'Mattens', in which the poet ponders the love of God and the means by which he strives to draw our thoughts towards him; and another from Henry Vaughan's 'Childe-hood'. All ages are represented. Two little girls innocently and happily vie with each other

to catch the colours cast by the sunbeam (the image of enlightenment which Herbert uses in the poem) through a stained-glass window, while their more sober and responsible little friend tries to restrain them, reminding them that they are in church. Beside them, an aged yokel in country smock supports himself on the font, brooding abstractedly, no doubt thinking of a lost loved one. A middle-aged pair with their son appear behind the font; a young married couple are glimpsed to the rear, and a group of other young people sing their hymn together at the church door. Hughes's delight in detail is to be seen in the meticulously painted daisies with which the children have trimmed their shiny straw hats; their well polished boots; the glimpses of stained glass the colours of which are reflected onto the masonry; and the view over brick porch and stone path to the shady churchyard with greenish light falling through the yew branches on this warm sunny morning. It is a reminder that youth passes and death comes to all; but a very gentle reminder in a setting of cloistered and serene beauty.

• • •

As in Hughes's case, genre painters showed considerable ingenuity in their choice of subject and setting, seeking out suitable venues for bringing together varied characters. The few paintings which survive of commercial interiors provide a topical and novel variant on the domestic scene and have proved particularly interesting, historically, since they record details which would otherwise be lost to us.

Robert Braithwaite Martineau's hard edged Pre-Raphaelite style, which he learned from Holman Hunt, was well suited to the recording of the kind of minute detail which has proved so informative to later generations. Untroubled by financial pressures, Martineau could spend as much time as he liked on his paintings - ten years in the case of his scene of domestic financial ruin, the *Last Day in the Old Home* (1852-62, Tate). The less elaborate *Kit's Writing Lesson* (fig.34) was completed more quickly, at the same time that Hunt was working on the *Hireling Shepherd*. The scene is set in Dickens' Old Curiosity Shop, the window-like view into the interior heightening the sense of reality. Dickens' young Kit is learning to write under the direction of Little Nell as she sews one of her grandfather's shirts. Martineau has nicely captured the character of this 'shock-headed, shambling, awkward lad with an uncommonly wide mouth, very red cheeks... turned-up nose' and 'most comical' expression.[141] Brow furrowed in concentration, he bends awkwardly over his exercise book, his progress observed by his quietly authoritative little friend. Kit's curly ginger hair and ruddy

cheeks are echoed in the warm tones of the chenille table-cloth and the red apples; while the golden light that fills the shop suffuses panels of stained glass, suits of armour, statuettes, stuffed birds and other oddments.

There are a number of other well known views of shop interiors as well as shop windows, but glimpses of mid-century office life are much rarer. A revealing example is supplied by James Campbell who was a member of the Liverpool circle of Pre-Raphaelite painters, and later of the Hogarth Club. *Waiting for Legal Advice* (fig.35) shows the utilitarian waiting room of a solicitor's office, with its rough, untreated floorboards, walls pasted with a variety of notices, and a coal fire glowing behind the brass fender. The elderly client sits, stiff and grim faced, evidently prepared for battle, while his grandson looks wonderingly around this unfamiliar environment. The clerk's impudent features as well as the sporty checks of his trousers are a plain indication of his status as a fast young city 'gent'; and the knowing complicity with which he regards his colleague as he casually picks his teeth, indicates a worldly wisdom at odds with the righteous indignation of the old gentleman. It offers the kind of amusing physiognomical and ethical contrast often exploited in the *Punch* illustrations of John Leech.

● ● ●

One very successful group of genre painters was the so-called St. John's Wood Clique which included George Dunlop Leslie, Philip H. Calderon (1833-88), George Adolphus Storey (1834-1919), H. Stacey Marks (1829-98), and W.J.F. Yeames (1835-1918), still renowned as the painter of *And When Did You Last See Your Father?'*. Others, such as Fred Walker were loosely affiliated, but in terms of friendship rather than artistic ideals. Storey's daughter - who married the Pre-Raphaelite painter Charles Allston Collins - recalls this 'splendid, happy, unselfish and high-spirited' group who met almost daily for mutual criticism, encouragement and advice.[142] Close friends, the Clique's members enjoyed parties and expeditions together from 1862 onward, and summer holidays at romantic Hever Castle in Kent which they first rented in 1867. Their adopted crest - a gridiron - indicated 'that members were constantly on the grill' in the sense of criticizing 'each other's works in the frankest and most unsparing manner.'[143]

At one point in his account of nineteenth-century painting, J.E. Phythian describes them as owing nothing to the Pre-Raphaelites and their followers; but this is not entirely true, as Phythian himself admits elsewhere. The St. John's Wood Clique were more or less contemporary with the Pre-Raphaelites; they

were, however, more cosmopolitan; Marks and Calderon having followed their London training with a session at the *Atelier Picot* and the *Ecole des Beaux-Arts* in Paris. But despite this, Calderon is best known for his *Broken Vows* (fig. 21) which is very close to Pre-Raphaelitism in style and feeling; and Marks, too, was to learn much from the Pre-Raphaelites in terms of drawing and decorative design. In his obituary of Marks, G.D. Leslie recalls their meeting at the Royal Academy Antique School in 1853, when 'The electrifying effects of the Pre-Raphaelite Brotherhood and the writings of John Ruskin were stirring the hearts of everyone. At each succeeding exhibition the new school increased the numbers of its adherents,' including the 'painstaking and conscientious' Marks, who instinctively inclined to nature rather than conventionalism.[144] Ruskin was, indeed, right in pointing to their pervasive influence on 'lesser men'; for a higher standard of technique was now expected.[145] It is significant that in 1860, the *Athenaeum* began to find Thomas Webster's pictures, although 'always pleasing and simple', to have 'a certain weakness about them.' The critic explained his reaction as 'due to the great advance in the study of *genre* subjects that has taken place of late years'.[146] This is true as regards both style and subject matter. The 1860s was a flourishing period in which British art diversified and became more sophisticated technically. In the case of genre, artists had learned to play the market by evolving all sorts of original, amusing, and decorative subjects, and in an increasingly affluent society, there were large numbers of collectors happy to buy them. Millais's earnings reached £30,000 a year - equivalent to £2,000,000 in present day terms; and Leighton, Fildes, Marcus Stone, Holman Hunt and many others made substantial fortunes. Earlier paintings were also increasing in value. Whatever the truth about his decline in status, Webster's *Roast Pig*, bought in 1862 by the pen-nib manufacturer, Joseph Gillot, for 700gs, fetched 3,550gs in 1872.[147]

The St. John's Wood Clique specialized in literary and historical genre. Unchallenging and entertaining, their subjects ensured that their work was eminently saleable, none more so than that of George Dunlop Leslie.

Like his father before him, Leslie was much admired for his refined taste and sentiment, although his drawing is more academic, and as regards both content and treatment there is often a strong dose of aestheticism. Leslie successfully combined old-fashioned charm with a more sophisticated technique. John C. Horsley was happy to recount the compliment paid to his own art by an admirer, that its chief characteristics were 'Sunshine and pretty women';[148] and Leslie's father, Charles Robert, had

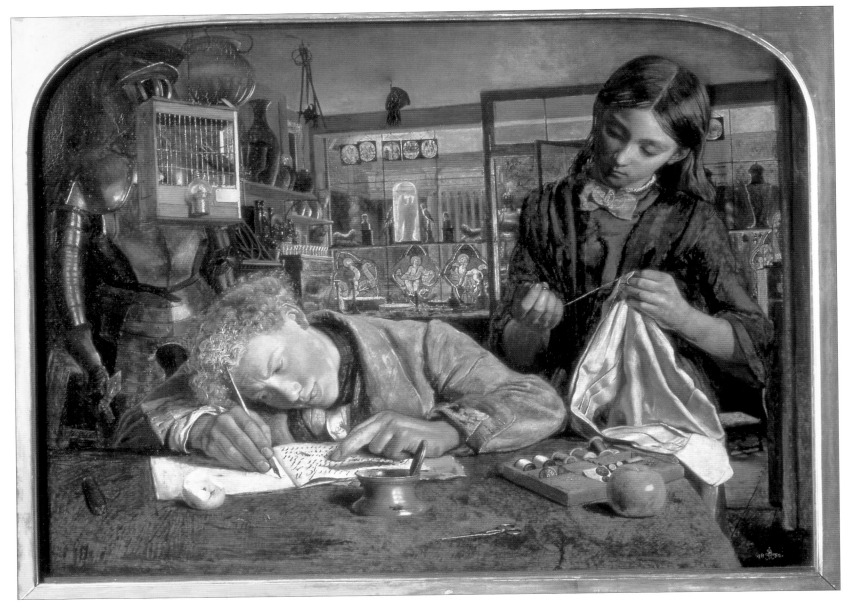

ABOVE: fig.34
Robert Braithwaite Martineau
Kit's Writing Lesson
1852. Tate Gallery, 1999.

OPPOSITE: fig.35
James Campbell
Waiting for Legal Advice
1857. Board of Trustees of the National Museums and Galleries of Merseyside
(Walker Art Gallery, Liverpool)

early recognized that his son's ability to 'paint a pretty face' would guarantee him a living.[149] Although he painted historical genre subjects, the son is, indeed, best known for pictures like *School Revisited* – much praised by Ruskin in 1875; and for *Pot-Pourri* (fig.37) and *Sun and Moon Flowers* (1889, Guildhall) in which pairs of lovely young girls, prettily dressed, engage in various feminine pursuits in domestic interiors and gardens. In the example shown, perhaps the best of the series, a china bowl of freshly made pot-pourri stands on a table; the sprigs of lavender and twist of orris root, as well as the pestle and mortar, evidence of its recent completion. A young married woman tests its perfume, while the other – perhaps a housemaid – awaits her judgement. Both are dressed in the costume of the late eighteenth century, with delicate muslin skirts and fichus, and overdresses in the kind of subdued colours beloved of the aesthetic movement; in this case, a soft leaf green and dark blue-grey. Leslie's technique is seen at its best in the warm, pale diffused light which filters through the linen blind, and in details like the bee perched on the left hand windowpane. The cane-backed Queen Anne chair and modest table, together with the magnificent specimens of imported china, and the formal garden which appears as a gentle harmony of pale greens and yellows glimpsed through the window, are the kind of elements from which he created his gracious, old-world subjects. Like his father before him, Leslie was noted for his refined taste, which enabled him to render 'the sweet naivetée and innocence of pure maidenhood with rare delicacy' and which allowed him 'an entrée to an eighteenth-century arcadia to which none of his rivals has found the key.'[150]

Leslie's work was not perceived as trivial. Wilfrid Meynell defined its specific function as supplying what was perhaps the most pressing need of the age: 'the need for sweetness and cheerfulness of heart.' Meynell felt that 'The painter... who, towards the end of a melancholy century, gives us... images of free and serene happiness, has understood his art and his time'. The artist himself agreed on this point, confessing that his aim had

'always been to paint pictures from the sunny side of English domestic life... The times are so imbued with turmoil and misery, hard work and utilitarianism, that innocence, joy, and beauty seem to be the most fitting subjects to render such powers as I possess useful to my fellow-creatures.'[151]

Stacey Marks's humourous subjects had an equally wide appeal, ranging as they did from modern life to comic historical scenes, of which *Toothache in the Middle Ages* (1856) is typical; but above all, he came to be identified with paintings of

fig.36
Henry Stacey Marks, *A Treatise on Parrots*
Board of Trustees of the National Galleries and Museums on Merseyside
(Walker Art Gallery)

anthropomorphized birds - parrots, storks and other character-ful species. Marks was a versatile artist whose gifts for decorative work found various outlets; not least in his contributions to the external frieze of the Albert Hall; his series of bird panels for the dining room at Eaton Hall for the Duke of Westminster; and various items of painted furniture, including a buffet which is now in the Victoria and Albert Museum.

In his subject pictures, Marks's use of history was essentially decorative and picturesque; his artefacts employed as still-life props rather than seriously to evoke the past,[152] and in paintings like *The Ornithologist* (1873) and *A Treatise on Parrots* (fig.36), the old-fashioned settings have been chosen simply to enhance the quaintness of the subjects. In the former, Marks depicts an elderly gentleman in process of rearranging his collection. A stolid servant, evidently accustomed to his master's odd ways, resignedly attends him, a stuffed flamingo and heron under his arms. It is typical of Marks's humour that the activities of the pair appear to be a focus of earnest observation for the mixed group of stuffed birds included. In fig.36, Marks makes clear the fussy, spinsterish nature of the scholar, secluded in a study which is panelled and sedately furnished in eighteenth-century style. His serious, questioning gaze, as he ponders one of his specimens, as well as the full waste-paper basket, are evidence of his mental labours. The man epitomizes the earlier period's idea of natural history, as a matter of indoor study and philosophical speculation, rather than of observation in the field. A comic note is introduced in the live parrot, bottom right, which turns to fix a mischievous eye on the spectator.

• • •

A number of leading genre painters preferred exotic locations. John Phillip (1817-76) - a member of the earlier Clique formed by Frith and others - and inevitably nicknamed 'Phillip of Spain' - went on to specialize in Spanish genre subjects after a first visit in 1851. Phillip earned unstinting praise with paintings like *The Early Career of Murillo* (1865, Forbes Mag. Coll., N.Y.), the masterpiece of his third visit to Spain in 1860. John Bagnold Burgess (1830-97) and Edwin Long (1829-91) followed his example, drawn by the picturesqueness of the 'living history' which they felt could be found in that relatively primitive and unspoiled country. To a modern eye, their more laboured recreations are perhaps less sympathetic than the visual fireworks of John Frederick Lewis (1805-76), who eschewed the sober domesticities of Britain for the colourful gardens and harems of Spain, North Africa and the Middle-East. Lewis's Spanish subjects had made his reputation in the late 1820s and

'thirties. In 1840, he settled in Egypt, and was to cause a sensation with his *Hhareem*, exhibited in the Old Watercolour Society in 1850, as much for its daring exoticism as for its technique. In his *Academy Notes*, Ruskin almost always praised Lewis; at various times comparing him, in his slightly crazy way, with Carpaccio, Van Eyck, Veronese and Tintoretto; and in a lengthy critique of 1858, crediting him with having worked in a Pre-Raphaelite manner twenty years before the movement arose. Harry Quilter, while recognizing the limitations of such strictly imitative art, thought its execution of a 'delicacy... scarcely conceivable';[153] and there are few who would disagree with him. Lewis's brilliant colour and fine drawing, eminently suited to his chosen scenes, changed not at all throughout a long and active life. With no hint of criticism, Gleeson White refers to his *Lilium Auratum* (fig.38) as looking twenty years earlier.[154] The setting is that of a garden overlooking the Bosphorus, visible through the orange trees by the garden wall in the background. From a path lined with tall white lilies, overblown poppies, purple pansies, and pale pink fuchsias, an odalisque and her servant approach an entrance heavily swathed with white roses. The former carries a narrow necked lustre vase of specimens already culled, while her mischievously smiling attendant follows with further supplies. In their multicoloured, richly textured robes, the two women equal the flowers in their exoticism.

The visual beauty and historical associations of Italy had long attracted British artists. Painters like Thomas Uwins (1782-1857) specialized in Italian genre; others, such as Charles Lock Eastlake (1793-1865), included it within a much wider Italian inspired repertoire. Later in the century, William Logsdail, Luke Fildes and Henry Woods painted some ambitious scenes of Italian - more especially, Venetian - genre. Technically superb and attractive as these are (Fildes' *Alfresco Toilet*, 1889, Lady Lever Gallery, Logsdail's *The Piazza*, Venice 1883, Birmingham, and Wood's *Venetian Christening Party*, 1896, Towneley Hall, Burnley, are typical), they do not appeal in the way that native subjects do. Unfamiliarity is exacerbated by the artist's own emotional detachment, as well as by the inevitable tendency to glamorize the picturesque appurtenances of a foreign culture. Contemporary critics also noted their repetitiveness, artificiality and 'want of the reality of life'.[155]

Subjects which might genuinely engage the artist lay closer to home. Artists and critics began to realize that when wedded to serious subject matter, a sincere and thoughtful treatment could raise contemporary subjects to the level of History. In the 1830s, John Eagles - an enthusiastic opponent of incompetent attempts at High Art - had argued against its assumed eminence

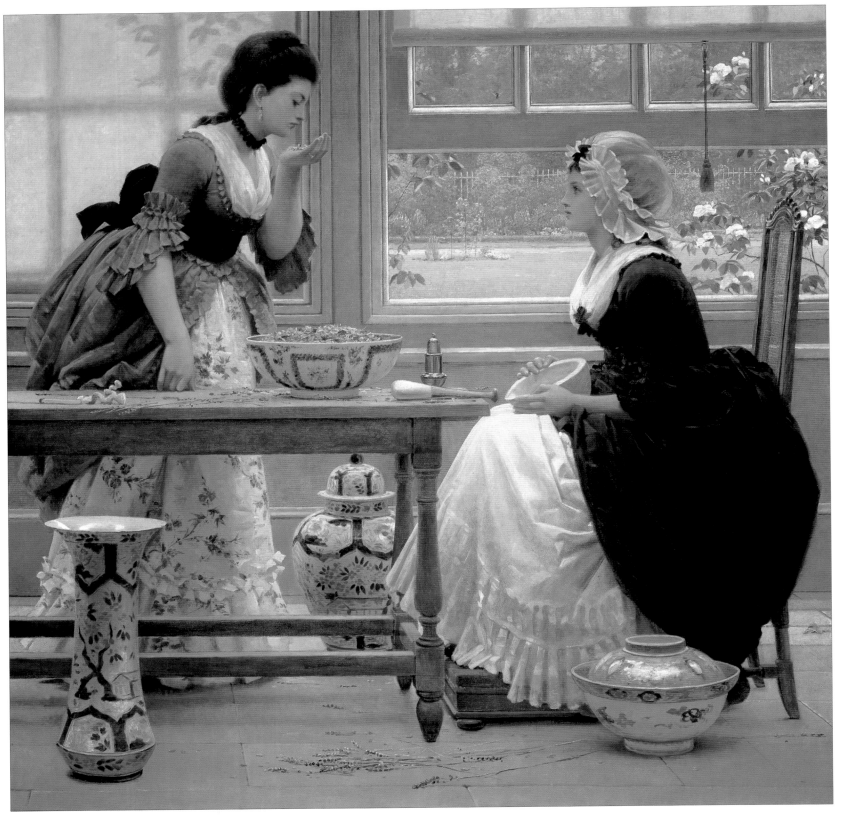

ABOVE: *fig.37*
George Dunlop Leslie, *Pot-Pourri*
1874. Private Collection. Photograph, Richard Green.

OPPOSITE: *fig.38*
John Frederick Lewis, *Lilium Auratum*
1871. Birmingham Museums and Art Gallery.

56

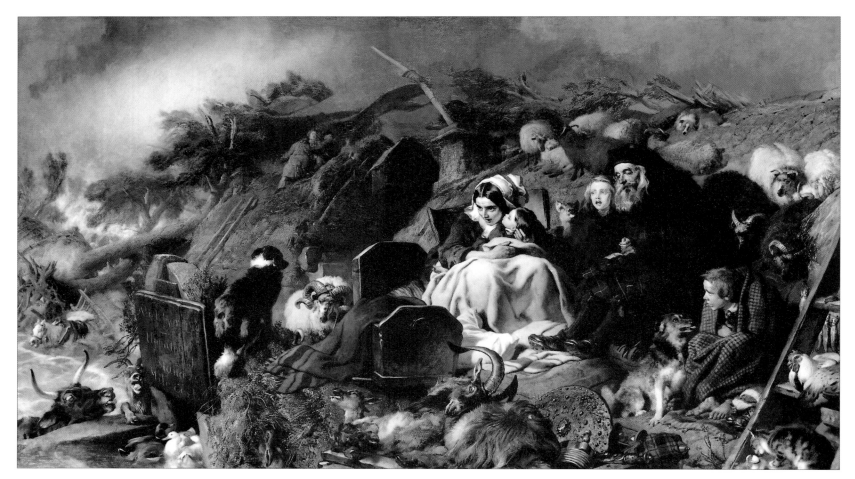

ABOVE: fig.39
Edwin Landseer, ***A Flood in the Highlands***
1860. Aberdeen Art Gallery and Museums

and the 'invidious distinction' which its practitioners insisted on.[156] Like Thackeray, Eagles preferred an art which bore a closer relation to life, and to those gentler and subtler emotions which were a genuine part of it. Charles Lamb had earlier made the point that the 'quantity of thought which Hogarth crowds into every picture' - his *Gin Lane*, for example, - made it superior to an accepted historical masterpiece like Poussin's *Plague at Athens*. Lamb objected to the way in which

'We call one man a great historical painter, because he has taken for his subjects kings or great men, or transactions over which time has thrown a grandeur. We term another the painter of common life... an artist of an inferior class, without reflecting whether the quantity of thought shown by the latter may not much more than level the distinction which their mere choice of subjects may seem to place between them; or whether, in fact, from that very common life a great artist may not extract as deep an interest as another man from that which we are pleased to call history.'[157]

While admitting the value of History Painting, as such, W.M. Rossetti also questioned its assumed superiority over genre. He recognized that the only age which any artist is uniquely qualified to paint, is his own. Only of this can he provide an eye witness account, and it is this which makes his work of unique value to both the present and to a later generation. No-one can do it afterwards.[158] In his defence of genre, published in 1883 Frederick Wedmore felt confident that a later generation would find in it 'that portion of our art which is truly historical.' He believed that 'The theatric revival of the past which has been pleasing to academical tastes' would be ignored; and people would 'pronounce that our historical, our worthiest, nay, often our most imaginative painting [was that which] dealt with... [such themes as] Mr. Fildes "Village Wedding," Mr. Gregory's "Piccadilly: Drawing-Room Day," and Mr. Wyllie's "Toil, Glitter, Grime and Wealth on a Flowing Tide."[159]

Leading genre painters from the 1840s onward, including Richard Redgrave and Thomas Faed, had risked disapproval in attempting serious social subjects. In the following decade, the

Pre-Raphaelites had played a major part in revitalizing genre painting through an emphasis on serious and meaningful subjects inspired by everyday life, and a hard edged technique which itself bespoke a sincerity and rigor new to art. In the eighteen-fifties and 'sixties the scope of genre was greatly extended to include more realistic and dramatic subjects, sometimes inspired by contemporary events. Although best known for his animal painting, derided by the youthful Pre-Raphaelites as 'monkeyana', Edwin Landseer (1803-73) included genre and even history paintings in his *oeuvre*, a fair number of which refer to the life of the Scottish Highlands which he first visited with C.R. Leslie in 1824. Precocious and from an artistic family, Landseer had exhibited at the Royal Academy in 1815, at the age of twelve, and within three years had begun to acquire the aristocratic patrons who – along with Royalty – were to remain his chief support. Major new collectors such as Robert Vernon, John Sheepshanks and William Wells, with whom he became a close friend, also bought important paintings from him. Elected Royal Academician at twenty-eight, Landseer's was to acquire an almost legendary reputation through the sale of prints, for which his subjects were ideal. He was knighted in 1850, and was the only Englishman to be awarded the Grand Medal of Honour at the Paris International Exhibition in 1855.

The subject of Landseer's *Flood in the Highlands* (fig.39) is said to have been inspired by accounts of the Highland floods of 1829, which were extremely severe.[160] The chaos of objects and the dramatic lighting mirror the psychological distress and physical discomfort of the family who have sought safety on the roof of a farm building, accompanied by an assortment of animals; all united in their desire to escape the rising waters.

During the years in which Landseer worked on this painting (mid-1840s – 1860), serious genre subjects, often inspired by real events, became an established option. In 1862, William Michael Rossetti commented on the growing number of artists escaping the normal bounds of genre by opting to show 'domestic or modern life under conditions of crisis or casualty.' In this particular year, Yeames's *Rescued* and Barwell's *Unaccredited* Heroes are the chief examples; the latter referring to pitmen risking their lives to rescue their fellows, a subject which, as Rossetti pointed out, gained force from the recent Hartley Colliery accident.[161] Such examples might well now be classed as Social Realism, rather than as mere genre, which points to the necessarily shifting boundaries of art historical classifications. As the critics recognized, there was often some difficulty in distinguishing between contemporary history and genre; although with a major event like the Crimean war, the distinction does

remain. The Crimean War (1854-7) was the first major European conflict since the Battle of Waterloo in 1815. In the intervening period, illustrated papers had been introduced, making it the first campaign to be covered both by special correspondents and war artists, and giving its reportage an immediacy never before experienced. The War produced some interesting paintings. Jerry Barrett's *Queen Victoria and Prince Albert visiting the Crimean wounded at Chatham Hospital* (1856) and *Florence Nightingale receiving the Wounded at Scutari* (1857, both National Portrait Gallery) are perhaps the most ambitious in this category. Lady Elizabeth Butler (1846-1933) specialized in war subjects, taken from the recent past as well as from the present. Her two most famous paintings are the dramatic frontal view of the charge of the Scots Greys at Waterloo: *Scotland for Ever* (1881, Leeds City Art Gallery) inspired by an eye-witness account, and *The Role Call after an Engagement, Crimea* (1874, Her Majesty the Queen). *In the Defence of Rorke's Drift: January 22nd 1879*, (1880), commissioned by Queen Victoria, she was painting history that was absolutely contemporary.

Lady Butler painted other pictures which would qualify as historical genre, and there were many other painters who preferred to depict the human, personal implications of great events rather than the events themselves. Figure 40 shows one of a series of three paintings relating to the Crimean war by John Dalbiac Luard (1830-60), a much loved friend of Holman Hunt and John Millais. The scene records Luard's visit to his brother, Richard Amherst, a Captain in the Seventy-seventh Regiment who, it is assumed, is the standing figure at the centre. Luard includes himself to the right of the painting, sitting in a folding camp chair and puffing at a cigar. The walls of the hut are covered with illustrations of the conflict evidently cut out of the *Illustrated London News*. The seated figure to the left is Captain William Gair, who is in process of unpacking a tea-chest of groceries from the Army and Navy Stores. More precious than these is a miniature portrait which he has just unfolded, as Holman Hunt, explains, 'of some one, sacred for his eyes alone', and which he is tenderly placing inside his breast pocket. The other resident of the tent is the large tabby cat, 'Crimean Tom', rescued after the raising of the Siege of Sebastopol and adopted as a pet by Captain Gair who took him home to London. After his death, Tom was stuffed and now resides, close to the painting, in the National Army Museum.[162]

Some artists chose to portray the effects of war, not through those actively involved, but on those who remained at home. Other paintings of this type by Luard - *The Call to Duty* (1855, Private Collection) and *Nearing Home* (1858, untraced) - showed an officer taking leave of his family on being summoned by his

ABOVE: Fig40
John Dalbiac Luard
A Welcome Arrival
1857. Courtesy of the Director, National Army Museum, London

OPPOSITE: fig.41
Sir Joseph Noel Paton
In Memoriam
1858. Collection: Lord Lloyd-Webber

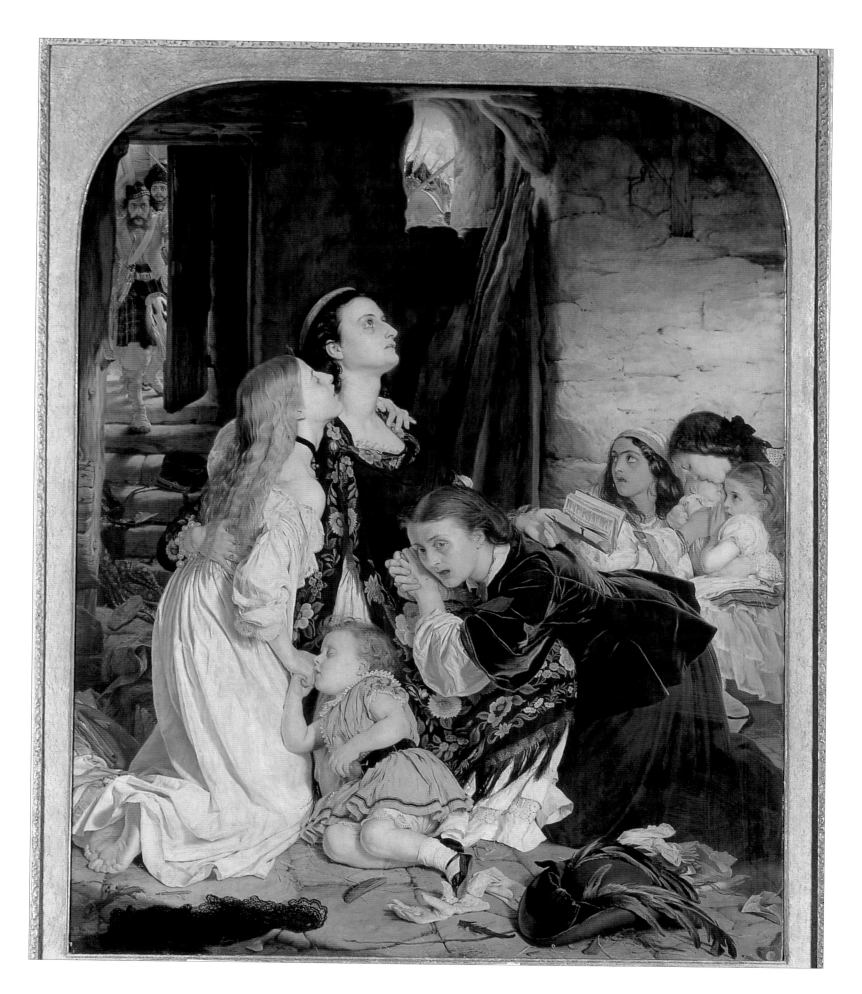

61

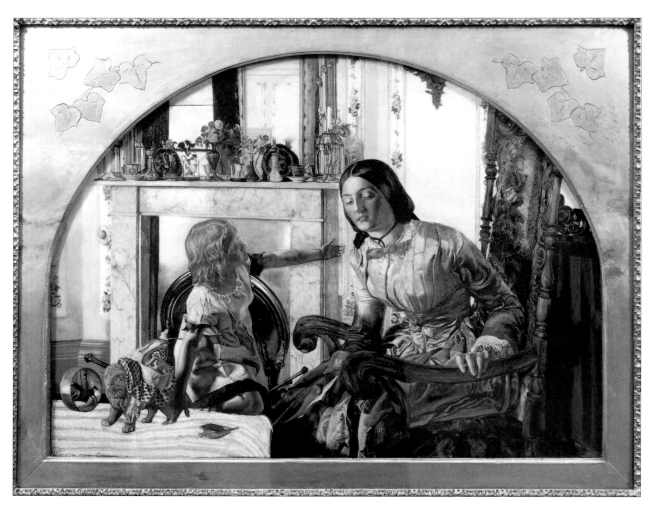

fig.42
Frederick George Stephens, *Mother and Child*
1854-6. Tate Gallery, 1999

Regiment, and a wounded officer on shipdeck comforted by his wife. In *Mother and Child* (fig.42), Frederick George Stephens focuses on the moment when news of her husband's death in the Crimea, shatters apart the little domestic world of a young mother. She sits paralysed with shock. The child's attitude is captured with convincing realism. Caught in mid-gesture, he continues to clamour for attention to his game of soldiers, oblivious to his mothers feelings. The comfort of the well-furnished interior with its marble fireplace, and embroidered hangings, and the normality of a morning's play make the intrusion of tragic events all the more dramatic. A necklace of her husband's hair around her neck is now all that remains to her.

At the Royal Academy of 1858, several paintings referred to the Indian Mutiny, which had begun in the summer of the previous year. These included Abraham Solomon's *The Flight* (1858), Frederick Goodall's *The Campbells are coming: Lucknow September 1857*, and Sir Joseph Noel Paton's *In Memoriam* (fig.41). As one critic noted,

'The most touching and earnest pictures of the year have taken their burden of sorrow from the events and calamities which have of late months pressed so heavily upon the hearts and homes of the English nation.'

Luard's *Nearing Home*, and war subjects by O'Neil and Paton, as well as Armitage's allegorical *Retribution* (Leeds City Art Gallery), were amongst those praised as 'Coming warm from the artists' heated imagination, appealing earnestly to the spectators' harrowed sympathy'; all of them 'remarkable for their truth, their passion, and their pathos.' The *Blackwood's* critic thought these pictures rose to the dignity of

'national works... because they utter the sorrows and yet the heroism of a great nation – because they become incorporated in the national history of a people and of a period; painting history, as she passes in retribution by, handing down to future ages the dread events of present times.'[163]

In Memoriam was painted in response to the Cawnpore Massacre of 1857. It was a horrifying story. After holding off the Sepoys (British employed Indian soldiers) under their local leader, Nana Sahib, for three weeks, a small contingent of the British army under Sir Hugh Wheeler won a promise of safe conduct to Allahabad for the women and children in their charge. Instead, the barges provided by Nana Sahib were set alight, and many of the victims sabred on the spot; the rest imprisoned and cruelly maltreated. In mid-July, when Nana Sahib heard that his troops had been defeated, he ordered the execution of the survivors. When the majority of Sepoys refused to slaughter helpless women and children, they were hacked to death by a 'band of ruffians' who had no such qualms.[164]

The event was to spawn great bravery as well as savagery. It led the historian, James Anthony Froude, to conclude that 'heroism was not a thing of the past' and to question whether the achievement of Major General Havelock, who died after defeating Nana Sahib and helping to relieve Lucknow, and of Sir John Lawrence, Chief Commissioner for the Punjab, was inferior to anything performed by any 'knight of the Round Table'.[165]

Paton initially intended to show the final minutes of agony as a small group of British women and children, cowering in a cellar, await their inevitable fate; but this proved too harrowing for a shocked nation. Richard Redgrave records how, day by day, hearts in Britain had 'been wrung by the sufferings, the long-endured sufferings, of mothers and little children in India,' events which 'stirred us as one man in England.'[166] So deeply affecting was the picture that Paton was obliged after the Exhibition to introduce rescuers in the form of Highlanders, a change approved by all including the Queen herself.[167]

In Paton's image, the strong-featured matriarch alone remains composed and resolute, her mind steadfastly fixed on the hereafter. The young women who cling to her, openly express their terror, while the oblivious babies plead the cause of outraged innocence. The fashionable appurtenances of civilized life, pathetically scattered on the floor, provide an ironic comment on their condition. *Blackwood's* praised Paton's significant use of detail:

'the lace-trimming to the dress of the sleeping child, the crochet-worked sleeves, the cross and ribbon bound round the neck, the gold-clasped book of prayer - all speak of the love and the care of a home destroyed - all contrast the luxury of a high civilisation with the barbarism of a savage invasion.'

The critic also approved Paton's handling of the subject, commending the moving and convincing expression and character, and the 'refined appeal, not to vulgar passion, but to tender sympathy.'[168]

Other critics felt that nothing could redeem the choice of subject. The *Illustrated London News* was amongst the journals which protested against the representation of an episode so irretrievably horrible that it made 'one wish that the pen of history could for once be plunged in Lethe.' No purpose could be served, the critic thought, in recalling the terror, anguish and despair that was suffered in that 'miserable murder-hole' in which Paton had depicted the last moments of the ill-fated group. Given the fate of the poor victims, the critic concluded, even the words of the Biblical inscription which Paton had quoted 'read almost like mockery.'[169] But others, like the *Blackwoods's* critic, commended Paton for his tasteful handling of a difficult theme; and this was one of the paintings cited by W.M. Rossetti as having escaped the bonds of feeble domestic genre; fulfilling his dictum that 'Modern art, to be worthy of the name, must deal with... passion, multiform character, real business and action, incident, historic fact.'[170]

In the previous year, Paton had illustrated the effects of the Crimean War in *Home* showing the return of a crippled and exhausted veteran. Henry O'Neil summarized the heroism and tragedy of the Indian Mutiny through its impact on the families left behind, in *Eastward Ho! August 1857* (fig.43) - exhibited, like Paton's at the Royal Academy, 1858, and *Home Again* (1859, Private Collection). The setting is Gravesend, the point of embarkation for British troops. O'Neil concentrates on the emotional trauma experienced by those parting with their loved ones, and with the almost equally fraught occasion of their return. Both pictures were praised for the convincing and touching quality of the emotions expressed. The first picture, described by the *Illustrated London News* as 'almost a national epic',[171] earned the artist 'a popularity almost unimpaired by criticism... It drew tears, it made pulses beat faster', and drew a crowd throughout its exhibition.[172] Critics exclaimed at the boldness and originality of the setting beneath the towering black side of the ship, 'rough and scaly with tar... the ironwork red and ochrey with rust';[173] and at details such as 'the very grain of the wood and the iron of the bolt-holes and fastenings' all faithfully recorded.[174] The ship's hull certainly provides a dramatic foil for the tangle of agitated figures scrambling to say a last farewell. To a French eye, the realism of this everyday scene was extraordinary. Ernest Chesneau acknowledged the invaluable record of everyday life which British artists were assembling in their genre works. In this case, he noted the artist's

'courage to remain true, both in feature and costume, to the rough, coarse type of character he has chosen. This sincerity extends itself to marvellous coiffures, faded tartans, checked

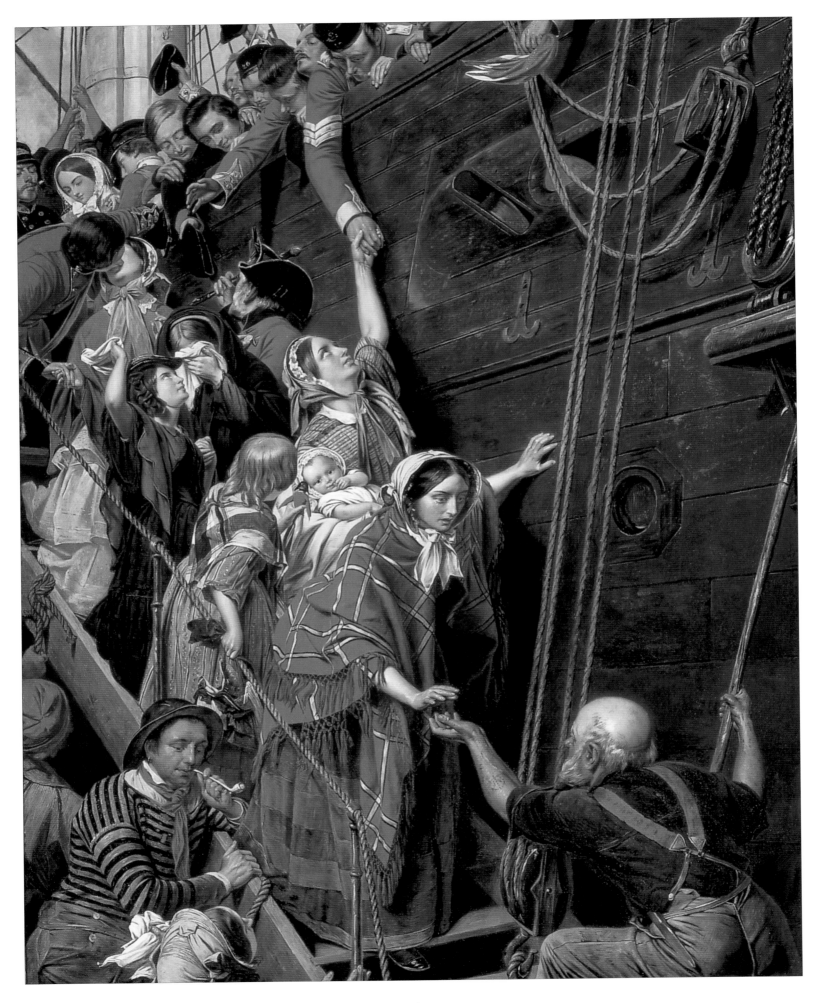

opposite: fig.43
Henry O'Neil, *Eastward Ho! August 1857,* 1858. Private Collection. Christie's Images Ltd. 1999

above: fig.44
Luke Fildes, *The Doctor,* 1891. Tate Gallery, 1999

handkerchiefs and washed-out dresses. He has entirely set aside grace and elegance, and by his very truthfulness and powers of observation, he renders his picture intensely pathetic.'[175]

Amongst the leavetakers, a Chelsea Pensioner holds up his medal, urging his grandson to feats of bravery, oblivious to the more tender emotions around him, as expressed in the final handclasp of the bearded sergeant and his wife; the final kiss between a young subaltern and his loved one; the widow too overcome to do anything but bury her face in her hands and leave her daughter to return the son's wave. A rough but kindly sailor helps a woman to descend the gangplank, while his younger workmate, more cynical and selfish, prefers to smoke his pipe. In *Home Again* (Private Collection), a reduced replica of which is at the National Army Museum, most of the main figures reappear. The bearded sergeant is on crutches, but his family are overjoyed to see him. The widow embraces her son, now a junior officer, handsome in his cap and red sash. The

young rifleman has returned with the Victoria Cross which he proudly shows to his grandfather, and another soldier kisses his young baby for the first time. But one Highlander is greeted with bad news from his daughter, who offers what little comfort she can; for the legible words on a letter suggest that his wife has abandoned him. The popularity of O'Neil's pair is indicated in their ready sale, in the number of replicas and variants he was asked to paint, and in the commercial success of the mezzotints issued in 1860 and 1861.

• • •

Luke Fildes found other means of elevating genre than turning to contemporary historical events. Best known for his *Casual Ward*, a polemical statement about urban poverty and homelessness, with *The Doctor* (fig.44). Fildes transformed the conventions of cottage genre through monumental treatment, a sophisticated technique and a novel but serious interpretation

above: fig. 45
Marcus Stone
In Love
1888. City of Nottingham Museums

opposite: fig. 46
James Tissot
The Bridesmaid
1883–5. Leeds City Art Gallery
Bridgeman Art Library

of his subject. It was commissioned by the Sugar King, Henry Tate, whose collection of pictures by living artists was to form the basis of a National Gallery of British Art.

The Doctor was widely acknowledged as the great popular success of 1891 and was reviewed in detail in all the journals and newspapers. Avoiding the melodramatic and sensational, it was noted as having every quality to ensure popularity. As one critic explained, 'it tells a story... an obvious one. It needs no explanation, no effort of memory. Its meaning is clear at a glance. It appeals to the humblest, the most ignorant among us'; while at the same time, there is 'a certain nobleness in this... very ordinary scene... born of human sympathy and of the mystery of life and death.'[176]

In a humble but respectable cottage, a doctor watches intently for the outcome of his treatment of a child whose illness has reached its crisis. Child mortality remained high in the Victorian age. Fildes lost a small son of his own, and another son records how 'The character and bearing of their doctor throughout the time of their anxiety made a deep impression' on both parents.[177] The painting thus reverberates with genuine feeling, and was to inspire more than one sermon. The Rev. Thomas Lund praised the painter for daring to 'stain his canvas with his own blood', giving the picture 'an unmistakable quality... which arrests and awes us, as though we were in some holy presence... No one can doubt that the artist is chronicling some episode of his own life'.[178]

Many child death scenes had been painted before, but what makes this one so original is the focus on the doctor as both humanitarian and man of science. It was intended as 'a noble tribute to a noble profession'[179] and is, indeed, an interesting response to the growing status of the medical profession at this time. In *Unto this Last* (1861), while recognizing the importance of scientific knowledge, Ruskin had stressed integrity as the essence of the medical man, and the profession responded enthusiastically to a painting which emphasized this as the guiding principle in the case of even the humblest patient. Predictably, Fildes was besieged by doctors wanting to sit for this modern hero, but he chose to evolve his own composite type, using professional models as well as photographs of himself. On its exhibition, a considerable debate as to the nature and outcome of the disease arose in the medical press, Fildes having sensibly refrained from voicing his own opinion as to the outcome.[180]

The focal point of the painting is the expression on the doctor's face, 'on which is written with indescribable subtlety the consciousness of its own limitations, the yearning to help, the trained self-control',[181] as well as 'the silent self-composure of brave, though not presumptuous, professional skill.'[182] The doc-

tor's consciousness of responsibility is patent, as the poor parents wait anxiously in the background, faintly lit by the dawn light and the dim lamp. With his hand resting comfortingly on his wife's arm, the father nervously looks round at the doctor, 'as if he were the arbiter between life and death.'[183] The mother sits at the table, head sunk; emotionally and physically exhausted.

The painting made a tremendous impact both within the medical profession and beyond. In an address to newly qualified physicians, a leader of the medical profession recommended Fildes' doctor as an ideal example to follow, reminding them that

'A library of books written in your honour... would not do what this picture has done and will do for the medical profession... Above everything... remember always to hold before you the ideal figure of Luke Fildes' picture, and to be at once gentle men and gentle doctors.'[184]

In his sermon, the Rev. Lund classified it as 'one of the noblest instances of religious Art, worthy to be set... in some daily-frequented church' as 'a translation of the Divinest Life into the daily practice of nineteenth century men and women.'[185] To such heights might genre be raised by an artist of Fildes' ability.

• • •

There were artists, like the St. John's Wood Clique already mentioned, who chose softer options; notably in the shape of glamorous and elegant scenes of historical or contemporary fashionable life. The inaugurator of this phase was the French born James Tissot (1836-1902) who fled to London at the advent of the Franco-Prussian War in 1870, and who was to score a great success with his worldly and urbane subjects – much to the envy of his Impressionist friends. In his hands, Degas' stringent observations of urban life become placid, pretty, even inane; but their exquisite detail and self-conscious, coquettish charm have ensured their lasting success. At once glamorous and prosaic, and bringing with them a breath of the Parisian boulevards, Tissot's glimpses of higher class life at home, in the ballroom, on holiday, on board ship, are masterpieces of the uneventful moment. One critic complained of the lack of human interest in his work, observing that no-one could 'pretend that it produces any food for thought or emotion, save that of admiration for technical skill'. To this critic his feminine flounces were of no more value than the real thing seen in Bond St.;[186] but the fact remains that no-one could surpass Tissot in painting them, as his magnificent *Bridesmaid* in

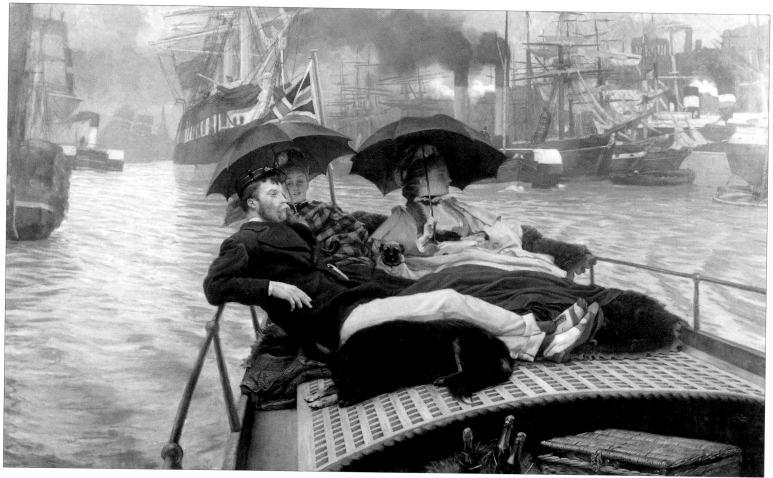

fig. 47
James Tissot, *On the Thames*
1876. Wakefield Art Gallery and Museums

her elaborate pale blue dress demonstrates (fig.46). This is certainly the major part of his appeal. Ruskin was another who objected to the triviality of his fashionable scenes, but no-one else has bequeathed 'so complete a record of the time, nor has managed to do so with such a grace or such amazing devotion to truth and detail... down to the last button, the tiniest little frill, the tilt of the bonnet'.[187]

In recent years claims have been made on behalf of a serious underlying psychological element in Tissot's work, but an objective analysis of the visual evidence provides little support for this. Tissot had his private sorrows and was later to turn to religion, and, indeed, to religious art; but there is little or no sign of any underlying unease in the bulk of his work. He was no master of anatomy and movement, and it is this which probably explains the lack of animation in his figures, rather than any deliberate attempt to make them appear enigmatic or angst-ridden. It is more likely that Tissot recognized his limitations; focusing attention on fashion and its accessories, and on the decor and architecture which provide the backgrounds for his elegant figures. Contemporary critics certainly regard-

ed him as a painter of externals; and his reputation would survive on this alone.

The *Bridesmaid* is one of Tissot's most successful pictures, both aesthetically and technically. Flounces and buttons apart, the artist has also captured, very effectively, the respectable but flirtatious nature of the relationship between the pair whose effervescence is perhaps partly due to post-nuptial champagne: the lively attitude of the woman, in mid-phrase as she prepares to enter the cab; and the man's evident appreciation of her graceful movements as he hands her in. Tissot has also recorded for posterity the street itself with the pub on the corner; the bustle of horses and carriages; and even within a relatively brief compass, the mixture of classes that might be encountered on any pavement. Included are a baker and other traders, and the ubiquitous delivery boy, cheekily shouting out an 'encouraging' remark. Also notable are the admiring and wistful expressions of the two shop girls as they watch, utterly engrossed in this gorgeous being from another sphere.

Among Tissot's most interesting paintings are those with nautical backgrounds, reminiscent in subject of the series which

Whistler painted in the early 1860s. *On the Thames* (fig.47) is one of a series in which fashionable people are set against a revealing view of the busy river, crammed with steam and sailing ships, barges and launches. Tissot evidently enjoyed the contrast between the serenely reclining women with their comfortably ensconced pug dog, and their male companion in his nautical cap and stylish two-tone shoes. Three bottles of champagne and a hamper promise an enjoyable picnic in the Thames reaches beyond the black smoke of the working boats. Tissot has captured convincingly the effect of the launch surging at speed through the high waters, and the relaxed attitude of the figures as they survey the lively scene. With its heavily polluted sky and the dull glare of light on the grey water surface, the painting offers an authentic glimpse of the Thames as it really was in the high Victorian period.

Tissot was also responsible for encouraging a new phase of historical genre, which coincided with the so-called 'Queen Anne' taste in architecture and interior design. He had begun his artistic career as a painter of historical genre, and, in the later 1860s, had begun to focus on the gracious days of the late eighteenth and early nineteenth centuries. After his removal to London in 1870, he was to adapt this genre to suit the English market.[188] G.D. Leslie's work of this type has already been mentioned, and Marcus Stone (1840-91) was another who scored a marked success with his scenes of period elegance. Stone had learned his craft in the studio of his father, Frank, who died when Marcus was barely eighteen. He was afterwards much assisted and encouraged by regular contact with his father's wide artistic and literary circle, which included former members of 'The Clique'- Frith and Egg - as well as writers like Dickens whose novels were amongst those which Marcus illustrated in the 1860s.

Like Tissot, he was originally a painter of literary and historical genre; *On the Road from Waterloo* (1863, Guildhall) showing Napoleon pondering his fate at a country inn, is typical of this early phase. But from 1876 he was to devote himself to subjects which united the ever fascinating psychology of lovers' meetings with the grace and elegance of old world fashions; thus perfecting a pictorial formula which appealed to the growing nostalgia for a pre-industrial age. His domestic dramas are of an eminently gentle and well-bred kind, invariably relating to the joys and tribulations of love. Stone's delightful garden settings are exquisitely tailored to the requirements of the 'beautiful types of humanity, picturesque in dress and pose', who pass their quiet and graceful lives within their confines.[189] *In Love* (fig.45) is his most accomplished painting and the artist's own favourite. Stone favoured the costume of the French Revolu-

tionary period, as picturesque but modest enough to be 'intelligible and attractive' to modern viewers.[190] The scene is a cool, green garden in a never-never land untouched by political fervour. Watched over by a statue of cupid, radiant with sunlight, the temptation suggested by the fallen apples is not to be resisted. The young man gazes enraptured, in absolute, intent adoration. The girl, well schooled in the modest behaviour most likely to subdue the strong, closely attends to her needlework. A slight tension in the dainty foot which emerges from the frilled hem of her virginal white dress, is the only sign that she is conscious of the effects of her charms.

In Stone's escapist fantasies even estrangement becomes palatable, as examples like *In the Shade* (1879) and *There is Always Another* (1888, Tate) illustrate. They were to earn him great popularity and considerable wealth. From 1877 Stone lived in a beautifully furnished house designed by Norman Shaw, still standing in Melbury Road, Kensington, where other successful artists including Leighton, Holman Hunt, Hamo Thornycroft, Luke Fildes and G.F. Watts were close neighbours.

But it is significant that despite the sentiment, Stone's work was recognized as distinctively visual and aesthetic. The domestic dramas of Orchardson were also referred to as, primarily, 'decorations... alluring patterns'[191] These are not terms which one would apply to the busy, hard-edged, illustrative genre paintings of an earlier generation. While never eschewing the narrative element, these later painters show a greater sensitivity towards abstract values. There is more of an emphasis on the formal elements of painting, and on the act of painting itself; evidence both of the influence of aestheticism and of French painting techniques.

Stone's eighteenth century and Regency idylls were the most original and successful, but period elegance was exploited by many leading genre painters: Orchardson, whose own home was furnished in his favourite Regency style, John Pettie, Dendy Sadler, Phil Morris, G.A. Storey, G.H. Boughton, Heywood Hardy, Edmund Blair Leighton, and many others. Leighton's muslin-clad maiden often stands amidst herbaceous borders in old-fashioned gardens with high, red brick walls; or are shown catching the eye of a male admirer on emerging from the portals of an elegant town mansion (fig.48). The air of modesty and old-fashioned reticence which attaches to such scenes is very much a part of their charm. The taste for all things eighteenth-century was widely propagated through illustrators like E.M. and Charles Brock, Randolph Caldecott, J. Bernard Partridge and Hugh Thompson. Leaders of what was appropriately called the 'Georgian' or 'Cranford School', they epitomized the continuing nostalgia for a world of horse-drawn

'He shook hands with Miss Jessie.'

page 71: fig.48
Edmund Blair Leighton, *My Next Door Neighbour*
1894. Richard Green

above: fig.49
Hugh Thomson, Illustrations to Mrs. Gaskell's *Cranford*, 1903 (1851-3)
Randolph Caldecott, *'To See a fine Lady Get on a white Horse'*,
Ralph Caldecott's *Second Collection of Pictures and Songs*, n.d.

carriages, ancient hostelries, Queen Anne furniture, modest maidens, kindly Squires and a contented peasantry (fig.49).[192]

The highly popular Dendy Sadler (1854-1923) was another who concentrated on the well-bred bourgeois world of the late Georgian period. Sadler developed a special line in 'Darby and Joan' subjects, showing elderly couples in exquisitely furnished Queen Anne interiors – evidence of long lives spent together in mutual harmony. Such paintings epitomized for late Victorians an ideal of domestic life, unambitious and unperturbed; one as yet unaffected by those developments which had already created a less hospitable world. In the Towneley version (fig.50), the couple sit at their dinner table, the husband proposing a fond toast to his wife. Every detail points to an old-fashioned world of refinement, good manners and delicate feeling: the carved, early eighteenth century mantelpiece; the corner cupboard of blue china, the embossed oriental screen, the heavy linen table-cloth set with silver and crowned with an epergne of fluffy chrysanthemums – a flower often included by Sadler, and which alludes to 'the still blossoming winter of their lives'.[193] Here, there is no glimpse of the outside world, apart from the seascape over the mantelpiece, indicating the former seafaring career of the husband. Presiding over their table are their portraits when young, in the dashing style of Gainsborough. Delicate pastel colours complete this irresistible image of a secure domestic world, long lost; in Frederick George Stephens opinion 'one of the most tender of the artist's pathetic and anecdotic designs.'[194]

• • •

In this later period, the physical dangers confronting ordinary people in the more dramatic paintings of Paton and O'Neil, give way to the psychological tensions, tiffs and estrangements of sophisticated couples, of which Sir William Quiller Orchardson's edgy domestic scenes are the best known. Some pictures of this class fall within the category of 'problem' pictures, where a deliberately enigmatic or ambiguous presentation makes exact interpretation difficult. Overt action is avoided, and the viewer left to guess at both the cause of conflict and its outcome.

Orchardson (1832-1910) was one of a group of Scottish painters which included John Pettie, who shared rooms with Orchardson in London in 1862-5. Both had studied art at the Trustees Academy, Edinburgh, under the Paris trained Robert Scott Lauder, whose emphasis on technique and tonal quality is evident in their work. Although they clung to narrative, as Gleeson White noted, it is 'not so much their subject as their "painting" which entitles these works to rank with the most important of our time.'[195] It is unlikely that Orchardson would

fig.50
Walter Dendy Sadler, *Darby and Joan*
c1895. Towneley Hall Art Gallery and Museums, Burnley

have agreed with him; for he insisted to his daughter 'that fine art must be fine in subject as well as in manner... and that what most appealed to him personally was the dramatic moment.'[196] Walter Armstrong was correct in predicting that among genre painters, Orchardson would probably come to occupy 'a very high place in the history of modern art';[197] and his originality was widely acknowledged in his lifetime, not least by French critics at the International Exhibition of 1867. Although like Tissot and Stone, initially a painter of historical and literary subjects – his first great hit was his picture of *Napoleon On Board the 'Bellerophon'* (1880) – Orchardson's gifts for restrained composition, economical story-telling, and his penchant for psychological suggestion, were to gain added significance with his subjects based on marital conflict, the first of which was *Mariage*

de Convenance (1884, Glasgow). Gleeson White noted with interest his preference for 'the interior of a spacious salon, with ample space of empty floor', and its pictorial function – the sense of physical and psychological isolation which it achieves; and how this is allied with 'straightforward storytelling, with no comment, no "touching" incidents, and no confusion'. As the critic recognized, the 'solitary fact... presented bare and unadorned' is his great strength.[198]

Orchardson painted a number of historical scenes of the 'drawing room' variety. The *Rivals* (fig.51) is set in an elegant late eighteenth century salon, covered with a superb Aubusson carpet. Three young men, their poses variously suggestive of languor, earnest enquiry and a degree of confidence, vie for the attention of a young woman who reclines on a sofa. Her

fig. 51
Sir William Quiller Orchardson
The Rivals
1895. National Gallery of Scotland

fig.52
Hon. John Collier
The Prodigal Daughter
1903 (detail) Lincolnshire Co. Council: Usher Gallery, Lincoln

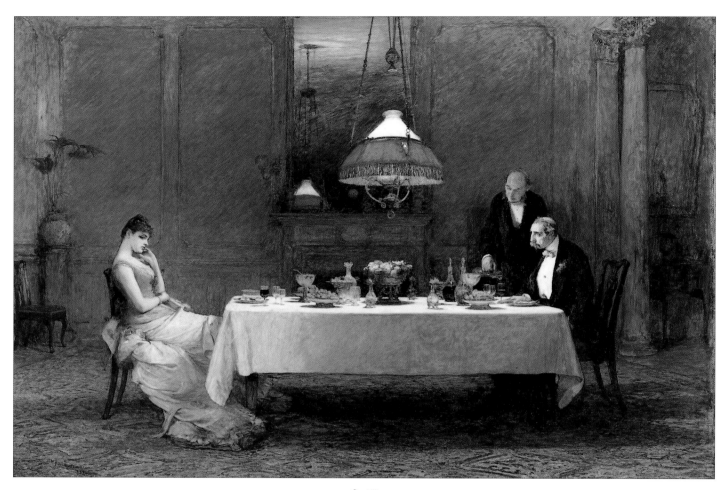

fig.53
Sir William Quiller Orchardson, *Mariage de Convenance*
1884. Glasgow Museums: Art Gallery and Museum, Kelvingrove

expression – reserved, haughty and even bored, does not auger well for her suitors. It was the translation of such scenes of moody, silent exchanges to a modern setting which was to earn Orchardson his reputation for originality. *Mariage de Convenance* (fig.53) is the first of a pair which make a rather daring statement about modern marriage. In a lofty dining room, husband and wife sit at opposite sides of a long table. Their separation is psychological as well as physical. Slumped into her chair, the wife is clearly bored and restless, her thoughts elsewhere. Her elderly husband observes her sullenness with some anxiety; and well he might; for in the subsequent painting, *After!* (1886, Aberdeen Art Gallery) he is shown alone, gazing sadly into the fireplace, the table laid only for one.

Orchardson was a clever and an eminently stylish painter; but his technique is by no means as impeccable as his enthusiasts would suggest. Quilter complained that the arm of the young wife in *Mariage de Convenance*, although his best picture so far, looked 'like a badly-cut piece of stick', and he also objected to Orchardson's unrealistic colours, which, indeed, are largely confined to shades of ochre – or the 'mustard-pot' as another

critic suggested.[199] Orchardson's work has its faults, but his originality and modern piquancy have always been pleaded as more than adequate compensation.

Sir Frank Dicksee is best known for exercises in poetic Pre-Raphaelitism, such as *Harmony* (1877, Tate) but, like Orchardson, he also painted pictures with a modern slant. The *Confession* is a typical 'problem picture', the exact meaning of which remains elusive (fig.54). The fashionable emphasis on psychology, on personal problems and emotional and sexual conflict irritated some critics, who found such paintings self-conscious, contrived and – despite their essential introversion – theatrical; and indeed, they reflect the same sort of concerns which were surfacing in the controversial plays of Ibsen, whose *Doll's House* premiered in London in 1889. The *Art Journal* thought the *The Confession* a painful subject, and rightly observed how 'its curious indefiniteness of effect seems somehow to add to the hopelessness of the whole subject.'[200] The girl is evidently in the last stages of consumption, her thin, pale hands as transparent as her creamy, diaphanous gown. The man's clenched and knotted hands and his tensely folded arms

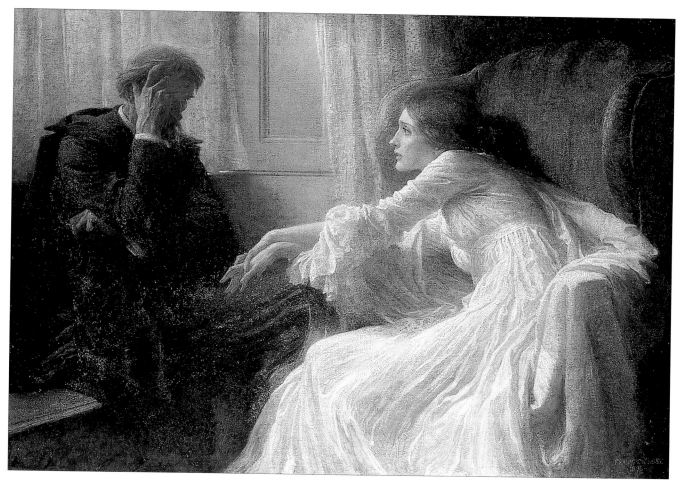

<fig.54>

Sir Frank Dicksee, *The Confession*
1896 (Detail). Roy Miles, Esq., Bridgeman Art Library

betray his emotional state, and form a telling contrast with the calm demeanour of the fading woman. She observes the effects of her confession with a melancholy concern, but also with resignation and a certain detachment; for life's problems are already losing their significance for her.

The *Prodigal Daughter* by the Hon. John Collier (1850-1923) is equally enigmatic. After studying at the Slade under Edward Poynter, Collier moved on to Paris and Munich to complete his artistic education, acquiring a sound technique in the process. He was to earn something of a reputation for 'problem pictures' – a term he disliked; claiming merely to depict 'little tragedies of modern life', and always endeavouring 'to make their meaning perfectly plain.'[201] If so, he did not always succeed. In this example (fig.52) Collier's setting is reminiscent of a stage set; the rich reds and golds and dramatic lighting, heightening the tension between the three protagonists. The virtuous domesticity of the parents is shattered by the sudden apparition of the girl in her garish costume; or by her sudden declaration that she is about to leave; for it is by no means clear which is intended. Her father sits before his Bible, white hair and beard aglow in the lamplight, rigid with shock; the mother anxious and conciliatory; the girl, defiant and aloof. The question of whether she has become a prostitute or merely a flashy actress is also left open; although, admittedly, there was little distinction.

Albert Chevallier Tayler's *Sisters* (fig.55) shows no such ambiguity. Tayler was a member of the Newlyn School of painters who were inspired in both style and subject by French Naturalism. Like so many artists of his generation, Tayler had trained in Paris; in his case, in the studio of the respected academic painter, Carolus-Duran. As in Collier's work, the results are apparent in the soundness and sophistication of his technique, clearly visible in the bold but precise handling of the *Yellow Ribbon* (fig.56), where a study of muted whites and bluish greys is lit up by the warm tones of the girl's skin, and the flash of colour from the ribbon itself. But again like Collier, Tayler did not always eschew feeling and drama in favour of objectivity, as some of their colleagues did.

Chevallier had converted to Catholicism in 1887, and frequently made religious references in his work. In *Sisters* there is little doubt that he intends a serious moral point. The poor, vir-

above: fig.55
Albert Chevallier Tayler
Sisters
1905. Christie's Images Ltd., 1999

opposite: fig.56
Albert Chevallier Tayler
The Yellow Ribbon
1889. Richard Green

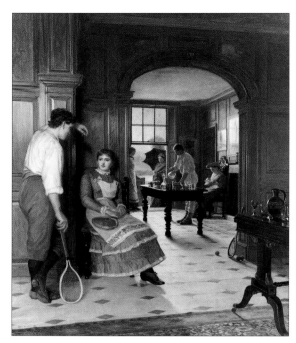

above: fig.57
Edith Hayllar, *A Summer Shower*
1883. Oil on board. The Forbes Magazine Collection, New York

opposite: fig.58
Edward John Gregory, *Boulter's Lock, Sunday Afternoon*
1897-8. Board of Trustees of the National Museums and Galleries on Merseyside
(The Lady Lever Art Gallery, Port Sunlight)

Meynell noted, was a distinctively modern type himself. The son of an engineer, born in the modern seaport town of Southampton and largely self-educated, Gregory had avoided the delusion that the modern age was to be avoided. His approach was eminently visual and direct; focusing on 'The outward aspect... of the things and persons of the day' rather than 'their inner significance'. Meynell praised Gregory for having created out of much that was only 'trivial and accidental in the life of the moment', an art that was not only precise, but in its own way beautiful, and which would serve as a valuable record for the future.[203]

Gregory's visits to the continent included a stay in Italy in 1882, although like Logsdail, the influence of continental techniques on his art was limited compared with its effects on the Newlyn group. He had studied with Herkomer in Southampton and London, and was a contributor to the *Graphic* for several years, although unlike his teacher and other fellow illustrators he did not incline to serious social commentary. Much of Gregory's work was in watercolour, and he covered a wide variety of subjects including portraiture; but he was clearly attracted to river scenes for their effects of light and atmosphere, as well as the life associated with them. Walter Armstrong marvelled at the technical virtuosity of his *Intruders*, showing swans besieging a houseboat on the Thames, in which he thought the sense of reality and mastery of light and texture equal to that of any painter in Europe.[204]

Boulter's Lock, Sunday Afternoon (fig.58) is his undoubted masterpiece, and, as a social record, the most interesting for posterity. The scene is of an attractive stretch of the River Thames near Maidenhead, a popular centre for the contemporary craze for boating, which on peak days attracted as many as eight-hundred boats and seventy-two steam launches. Gregory spent years on this multi-figure painting, which accounts for the fact that two of the dresses depicted appear to date from about 1885, the rest from about ten years later.[205] Highly original and ambitious, it must have substantially assisted his election as Royal Academician in 1898.

Gregory has captured the busy, chaotic appearance of a flurry of rowing and sailing boats as they pull aside to make way for the steamers; the sun-dappled eddies of the surface water reinforcing the sense of movement. It is late on a summer's afternoon, and the warm, golden sun intensifies the rosy reds and browns which colour the boats, sunshades and parasols.

The atmosphere is appropriately festive as people of all ages come together to enjoy the sun and air in their holiday clothes. To the right, the substantial, bearded figure of Gregory himself reclines in a rowing boat, observing the busy scene. But on the

tuous sister, tending a fish stall, points accusingly to her richer sibling who has taken the easier path of vice, while the old mother hides her head in shame. A servant deferentially handles the prostitute's bag, as she defiantly and scornfully turns up her nose at her poor relations and their honest but unsavoury occupation. With a large green feather in her hat, ermine stole, and patent shoes, she clasps what is undoubtedly a full purse. Although sincere in intention and sophisticated in technique, Tayler's treatment of the subject is overtly theatrical. It makes an interesting contrast with Spencer Stanhope's earlier painting (fig.25), where action is avoided in favour of a feeling which is intense but internalized, and which appears all the keener for it.

• • •

To our eyes as to those of contemporaries, the work of Edward John Gregory (1850-1909) and William Logsdail (Chapter 2 fig.21&57) seems decidedly modern. With no hint of the complex psychology or strong sentiment which attracted other artists at this time, they present a more robust view of late Victorian and Edwardian life in all its vulgarity and hedonism. Gregory was perceived as an 'audacious and... brilliantly endowed... chronicler of the prosaic world',[202] and as Wilfrid

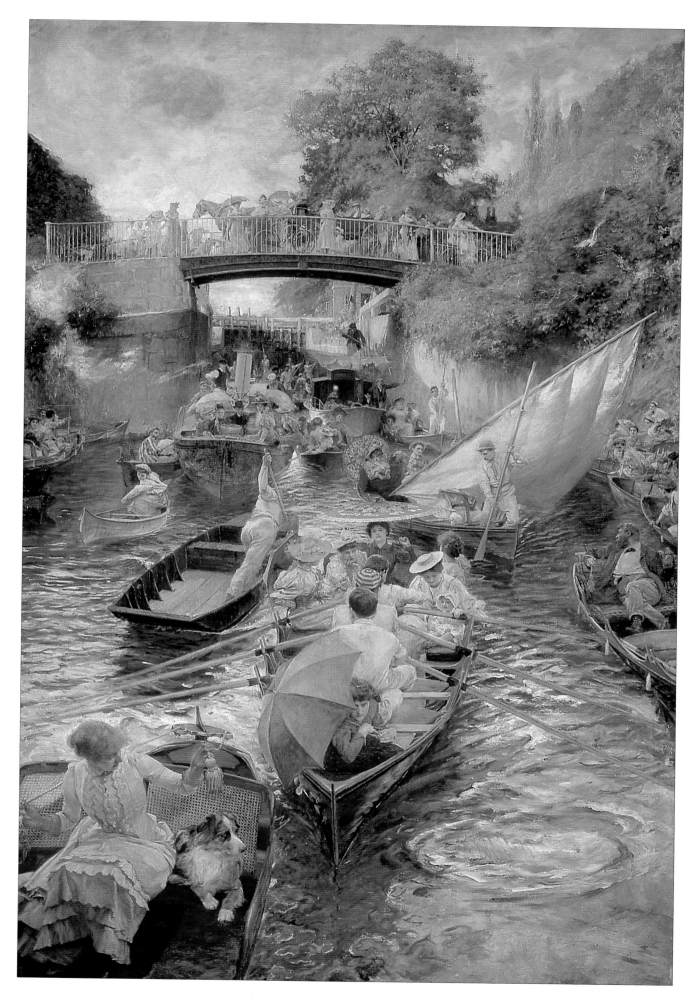

picture's exhibition the critics were by no means uniformly complimentary. The *Academy* thought it a thoroughly undesirable subject, claiming that 'the bridge itself is enough to make one look another way.'[206] Presumably the critic found this unadorned piece of engineering utilitarian and unpicturesque. Although Gregory made some adjustments to the actual scene, his phenomenally gifted eye enabled him to record with great precision the vigour, the flashiness and sheer actuality of late Victorian and Edwardian life as no other artist has; an achievement which would not appeal to every contemporary.

Genre was constantly reinvigorated by artists who kept pace with fashionable developments in social life and recreation. The invention of lawn tennis in 1874 by Walter Clopton Wingfield provided a new social opportunity for young men and women, although it did not allow for the complete escape from chaperones that bicycling did. The latter does not seem to have appealed to artists; perhaps because of its ungainliness as well as its inconvenient speed; but tennis as well as cricket inspired several artists. Of the two, tennis provided more opportunity for graceful movement and elegant dress. An exquisite example of a muslin tennis dress of the period, on display at the Victoria & Albert Museum, gives some idea of the spectacle that female players must have provided.

Edith Hayllar's example is too enchanting to omit (fig. 57), although reference to the game is oblique. Inside the panelled hall of a small country house, the artist's own Castle Priory, Wallingford, couples of various ages take refreshment as they shelter from the inevitable *Summer Shower*. To the left, a sturdy youth leans protectively over a pretty girl in pink dress and embroidered apron. The effect of a sudden fall of heavy rain, greying the sky, with the sunlight shining through on to the tiled hallway, exactly captures the atmosphere of a changeable English summer day. The lack of drama as the players patiently wait for the weather to improve and the suggestion of contented, affectionate, uneventful family life, add distinction to this little domestic scene.

Although painted ten years earlier, Sir John Lavery's *Tennis Party* (Fig.60) is much more advanced, technically. After training in Glasgow and London, Lavery (1856-1941) joined the *Académie Julian* in Paris and in 1883-4 practised plein-air painting at the artists' colony at Grez-sur-Loing in the Forest of Fontainebleau which attracted artists from both Europe and America. Much of his work is heavily indebted to Impressionism and to Bastien-Lepage, the French Naturalist who provided the model for the 'square-brush' technique which was widely adopted by British artists from the 1880s onward. But unlike many of his colleagues, Lavery did not imitate Bastien in his choice of peasant subjects, and he was soon to desert naturalism for scenes

of fashionable life and portraiture. His best known work is probably the monumental and superbly painted group portrait of King George V and his family (1913, National Portrait Gallery). The *Tennis Party* shows him in his most Impressionist vein, capturing the measured elegance of a white-clad couple in an image where form and tonal values, not character, are the focus. The extended shadows of a sunny afternoon are cast by the tall, shady trees under which the older spectators are staidly seated. The long swath of smooth, cool grass-green is broken in the foreground by thick streaks of creamy paint dragged on by a dry brush to suggest the effects of dappled light. Almost all the faces are blank, except for that of the moustachioed male player, whose individualized features strike a somewhat jarring note in this otherwise coolly objective painting. A distinctively modern touch is the attitude of the young man to the left, lighting a cigarette as he leans against the rail, casual and cocksure.

A quite different response is to be found in Charles March Gere's painting of the same subject (Fig.59), pointing to the great diversification of art at this later period. Like Lavery, Gere has adopted the panoramic form to accommodate the scope and movement of the game, but there the similarity ends. His scene

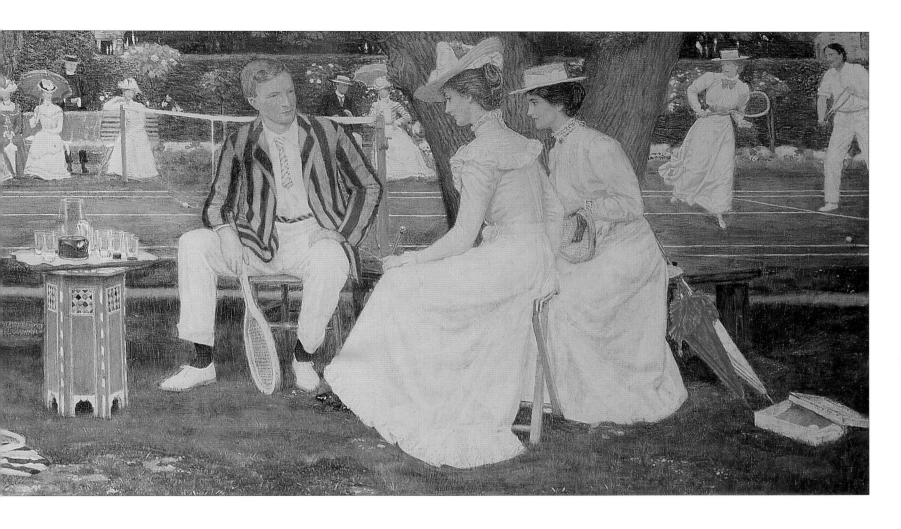

is a personal record of a family occasion, containing numerous portraits.[207] Gere (1869-1957) was a member of the Birmingham Group whose allegiance lay with the Pre-Raphaelites and the Arts and Crafts Movement. He was a versatile and gifted designer whose work ranged from stained glass and metalwork to embroidery and book illustration. With fellow artist-designers such as his brother-in-law, Henry Payne - who appears playing tennis to the far right - he was a member of the Society of Painters in Tempera and one of the team who worked on the murals at Madresfield Chapel, Malvern. His sister Margaret, playing tennis to the far left, was also a successful artist and designer.

The grass court is set in the garden of the ivy clad Sandhurst Villa, Leamington Spa, the Gere family home, edged by neatly clipped hedges, standard rose trees and brightly coloured bedding plants. Under the shade of a mature tree, a youthful foursome converse during a break from the game. The red and blue striped blazers of the men - Robert Gere in red, Arnold in blue - form an attractive motif, giving weight to the overall design and providing a foil for the uniform white of the ladies' dresses. Gere's decorative sense is revealed in his evident delight in pattern and in repeating colours. The bright scarlet of the blaz-

er, parasols and dress of the lady in the background, recurs in other motifs scattered throughout the painting: in the fruit-juice on the table, the men's belts, the net posts, the roses and bedding plants; even in the single stripe of the girl's canvas seat which peeps out beneath her dress, and on the handle of the tennis racket on the grass. The shape of the folded parasols to the far right has attracted Gere as much as the contrast of red against white; and the angle they form nicely balances that of the arm of the young man to the far left. Equal attention is paid to the ladies' straw hats tilted at a jaunty angle; the upswept curves of the woven brim of the fair girl's hat echoed in the coils of her hair. The delicate inlay and fretwork of the occasional table; the varying shape of the stripes on the folds of the red blazer; and the quiet geometry of the white lines of the court beyond; all of these features contribute to the serene and ordered character of the composition.

It was the Victorians who had turned the brutally competitive and uproarious games of the eighteenth century into civilized activities imbued with the 'sporting' spirit of the true gentleman. Mark Girouard points to the official recognition of the moral value of games by the Royal Commission on Public

above: fig.61
After Philip H. Calderon, *Captain of the Eleven*
(painted c1883). Chromolithograph. Bridgeman Art Library

opposite: fig.62
John Robertson Reid, *A Country Cricket Match*
1878. Tate Gallery, 1999

Schools (1864) which reported that 'the cricket and football fields... are not merely places of exercise and amusement; for they help to form some of the most valuable social qualities and manly virtues', chivalry and honour among them. The writer includes an amusing photograph of the artists' cricket team led by Edwin Austin Abbey, an American artist who settled in England and who regularly invited the team to his country house near Fairford, Gloucestershire. The ideal of sound gamesmanship was celebrated well into the twentieth century, in the popular school stories of Frank Richards and others.[208]

Of all cricketing pictures, P.H. Calderon's *Captain of the Eleven* (fig.61) showing a boy of twelve or so earnestly focusing his mental and physical powers on perfecting his batting, remains a great favourite, widely reproduced even today; but its true significance, as is the case with so many genre paintings, is easily overlooked. As cricket historians have pointed out, 'it is questionable whether...[its] essential meaning... could be fully understood by any one who was not conversant with the place of cricket in English life or of what its values represented to the Victorian mind.' Cricket is represented as 'a serious activity' in this modest painting, which, as the writers explain, 'would be nothing without the boy's determined expression of concentration or the correctness with which, in evident obedience to the

expert coaching of the time, his hands grasps the bat and, above all, keep it straight.'[209]

A social rather than moral approach characterizes John Roberston Reid's more ambitious cricketing scene (Fig.62). Reid (1851-1926) was one of the many talented Scottish painters who made their fortunes in London. From his training under George P. Chalmers and the landscape painter William MacTaggart he acquired a certain robustness, and as is the case with many British artists of his generation, his work also owes something to French Realism and Impressionism. Reid briefly attempted historical genre before turning to out-of-doors subjects in Surrey, enchanted by its picturesque scenery and rural life. He was unusual in painting entire pictures outside, including the figures. The result, as one critic claimed, was that 'On the walls of an exhibition they stand out from their surroundings by reason of their truth of tone and peculiar charm of out-of-door light.'[210]

Reid was an admirer of the French plein-air realist, Bastien-Lepage. He learned much from his technique and painted some peasant subjects, but like John Lavery, his taste was for 'the brighter side of life... not the darker side with its pains and problems'.[211] In *A Country Cricket Match*, painted at Ashington in West Sussex, the game is visible only in the far distance, for this is above all a social event. The visitors, considerably grander than the locals, wear a variety of attractively striped caps as they wait by the pavilion, which also serves as the central point of all local cricket matches: the beer tent. Elderly yokels are firmly ensconced around a table where steady and serious drinking is underway and clay pipes much in evidence. The features of the trio to the left of the table betray the contented fatuity of satiated imbibers, their brains pleasantly dulled as they bask in the warm sunlight. A 'fast' young cricketer flirts with a hefty serving wench in a pale pink dress, who laughs as he playfully pulls at her neck ribbon; while his more serious companion, avoiding such distractions, waits with bat on shoulder, his thoughts concentrated on the game ahead. All ages are represented. A young girl and a boy in a smock hang around in the desultory manner usual to children on such adult occasions; the latter oblivious to the more lively youth under the table, who amuses himself with a terrier pup. An elderly woman in bonnet and tippet is accompanied by another boy with a basket of foodstuffs. The girl looks at its contents with evident interest but - presumably through penury - refrains from making a purchase. In the foreground, the bright green grass is starred with oxe-eye daisies, while in the distance rise the farm buildings marking the parameters of this narrow but close-knit rural community. A pleasantly mundane touch is the line of washing across the

yard, billowing brightly under a cloud scudded sky. A brilliant sunburst lights up the spectators and players in the middle distance, including a parson in his wideawake hat and a baby in a wicker pram. Despite a considerable degree of characterization, the overall treatment of the scene is objective, and as in the case of Orchardson and Gregory, Reid's emphasis is primarily that of the visual artist. On the shaded table, the still-life - including sparkling glasses and green bottle - is almost worthy of Manet. The tent itself suggests exactly the effects of old, thick, worn and many times folded canvas, its overall grey and cream shot with pink and green. The girl's sunbonnet is also tinged with green reflections, and there is an interesting colour contrast between the dark blue indigo of her apron and the dark greenish-blue of her umbrella. The overall effect is that of a genuinely *plein-air* painting; the atmosphere that of a sunny but fresh summer day.

In the light of what has been said about the historical value of genre, it is worth quoting from the cricket historians already mentioned. In his view of the distant match, Reid has registered a detail which 'he could not have guessed would be of interest long afterwards… the fact that the square-leg umpire still stands with a bat in his hand like his eighteenth-century predecessors'.[212] This practice had been abandoned in first-class cricket but survived 'in the country long after the need for touching the bat to score a run had passed.'[213] In his picture of an unremarkable event, Reid thus records an outmoded practice that, unaware to him, would be unknown more than a century later outside specialist circles.

• • •

Whatever Sydney Colvin's strictures, genre had too much to offer ever to lose its popularity. It covered every aspect of life, and as the examples discussed would indicate, it did not stand still, but responded to developments and changes in life itself, attracting a diverse range of artists including many of the highest calibre. As Frederick Wedmore concluded in his own survey of genre painting, its interest lies in its very diversity; in the individual responses to life of so many different artists, which make it impossible to reduce it to any one system. 'How did these various men look at life and touch it? What struck them? What did they express?'[214] Herein lies the interest for the historian.

John Orlando Parry

Street Scene

1835. Watercolour. Alfred Dunhill & Co

CHAPTER 2

The Urban Scene: Painters of the Crowd

'Some people go as far as to say "It is the picture of the age,"
and no mean judges are they'; so William Powell Frith wrote to
his sister shortly after the opening of the Royal Academy exhi-
bition in 1858, where his *Derby Day* was creating a sensation.[1]
A policeman was called in to stand guard, and a rail set up to
control the spectators. *The Railway Station*, exhibited singly in
1862, was equally successful, earning more than a full column
in many of the newspapers which reviewed it.

Frith's ambitious panoramas of the London crowd illustrate a
new element in contemporary art which had evolved in paral-
lel with the rapid growth of the urban population. The large
industrial and commercial city - busy, aggressive, fast-moving,
teeming with life - was a new and relatively sudden develop-
ment to which the more adventurous artists responded. It is a
category of painting which has proved to be of great docu-
mentary value, supplying later generations with a visual record
of the classes and individuals which made up the urban crowd.

As with all genre painting, the tradition derived ultimately
from the Dutch seventeenth century painters, and in England,
from Hogarth's illustrations of the rough-and tumble street life
of eighteenth century London (fig.2). As one Victorian editor
observed, rather than remain in the studio, Hogarth's 'inclina-
tions were to roam abroad and enjoy life'; he thus turned the
seething town into an academy and took notes from the crowd.[2]
He was much admired by his Victorian successors, and Frith
was to emulate him directly in his later moralizing series paint-
ings, *The Road to Ruin* (1878) and the *Race for Wealth* (1881).

During the first half-century the population of Britain dou-
bled to almost 18,000,000, much of the increase occurring in
the great centres of industry. In that period, the population of
London increased sixfold to 6,580,000, and in a provincial town
like Liverpool leaped from 82,000 to 395,000. The change was
reflected in new categories of art and literature in which urban
subjects and urban types began to figure prominently. The
London crowd, especially, was a phenomenon frequently
recorded in words as well as in painting and illustration. The
reactions of such foreign visitors as Frederick von Raumer and
Heinrich Heine to the sheer size of it are suggestive enough;
but resident observers like Henry Mayhew and John Binny
could not take it for granted either. It was the variety and con-
trast of the crowd which struck them most. To them, London
was 'a city... where the very extremes of society are seen in
greater force than anywhere else.' It was this antithesis which
constituted, as they concluded, 'the topographical essence of
the Great Metropolis', distinguishing it 'from all other towns
and cities in the world'.[3]

There was help at hand for the artist who wished to make
sense of the vast crowd and the millions of anonymous individ-
uals who composed it; for a new scientific discipline had arisen:
Anthropology, or Ethnology as it was also known. The found-
ing of the Ethnological Society in 1843 points to the profes-
sional status which it was in process of acquiring in Britain at
this time,[4] but the new 'Science of Mankind' was to arouse
widespread general interest and to have a profound effect on the
perception of the growing population at home, as well as in dis-
tant parts of the globe.

The first task which confronted anthropologists was the classi-
fication of the various races of mankind. Anatomical features, of
which the shape of the skull was the most important, physiolo-
gy, skin colour and hair texture were all carefully measured and

DEVONSHIRE. CORNWALL. CORNWALL.

BRONZE TYPE, FROM CUMBRIA. SC. HIGHLANDS.

WEST OF KERRY. ARANMORE I. SC. HIGHLANDS.

above: fig2
After William Hogarth, *The Four Times of Day: Noon,* 1738

right: fig.3
British racial types. John Beddoe, *The Races of Britain*, 1885

tabulated. These studies provided the basis for further comparative studies of the psychological, sociological and cultural characteristics of the various races, nations and tribes of the world.

A distinguishing feature of the discipline in its early days was that anthropologists applied the same methods of study to the home population as to those in distant parts of the world. It was now that the practice was established of interpreting any distinctive physical type in terms of racial heritage, and the populations of Britain and of other European races were studied on the assumption that they could be classified in this way. The term 'Race' was much abused – as it is today - and loosely applied to nations and other human groups such as Normans, Saxons and Celts, the historical groups which made up the nations of Europe, and which were believed to have remained physically and psychologically distinct. Stereotypes were established which maintain a certain currency today; reference is still made to the 'Celtic' temperament as one which is more emotional and imaginative than the plodding and more analytical

'Saxon' or 'Teuton'. In the Victorian age, the population of Britain became a major field of study for anthropologists; and was sufficiently diverse to persuade a number of professionals such as Daniel Mackintosh, Hector MacLean and John Beddoe, to concentrate on it exclusively. All three made tours of observation through various urban and rural areas, recording their findings in great detail; and in Beddoe's case, compiling elaborate tables of statistics, the most famous being his 'Index of Nigrescence', by which he measured the degree of darkness in hair and skin. Beddoe used such methods to trace the migration of the various races, including the ancient Britons, whose descendants rated high on the index.

The kind of unexceptional and exotic faces which represent the 'Races of Britain' in anthropological studies by Beddoe and others (figs.3 & 4) strikingly illuminate the expectations which even the most ordinary human face aroused in Victorian times; and not only in professional anthropologists; for the ideas developed in racial studies were widely disseminated and soon

fig. 4

British racial types (detail). D. Mackintosh, 'Comparative Anthropology of England and Wales'
Anthropological Review, January 1866. Saxon 19–21; Anglian 17, 18, 22; Scandinavian 23; Frisian, 24; Jutian 25; Danish 26–8

began to condition the perceptions of everyday life. The meaning of the term 'Anthropology' was extended to cover its practice by amateurs, ordinary citizens for whom the making of 'anthropological' observations in public places became a popular pastime. The London crowd was of particular interest; an important constituent of what one writer called the 'The Ethnology of Europe'; for London provided 'an amount of physical, mental and occupational variety' such as would be met with 'nowhere else in the world'.[5] In their own survey of the London population, Henry Mayhew and John Binny claimed that an excursion through its contrasting areas was as informative 'as a geographical excursion through the multiform regions of the globe'.[6] A writer for *'Household Words'* (1855) made much the same point: 'We have no need to go abroad to study ethnology', he urged, for 'A walk through the streets of London will show us specimens of every human variety known.'[7] At every street corner the interested observer had the opportunity to observe his fellow men; to 'read the possibility of each pas-

senger, in the facial angle, in the complexion, in the depth of his eye'; to interpret the faces as 'linear hieroglyphs' passing 'page after page... panorama-like... in the streets or in the market-place, at the social meeting, or in the crowded assembly.'[8]

The essential link between art and anthropology in the Victorian age is the emphasis which was placed on the physical aspect of mankind, and the belief that so much could be read from it. Anthropology was a useful adjunct to an art which paid detailed attention to rendering the outward forms of the human face and figure. In all Victorian figurative art, from history painting to humblest genre, a high degree of legibility is attached to the human face, or to use a term the Victorians favoured, the physiognomy.

Physiognomy – the reading of character from the facial features – pre-dated anthropology by many centuries. The practice dates back to ancient times, when it was regarded as a useful aid to medical diagnosis, and in some form it emerges in most cultures, worldwide. Belief in physiognomy persisted, despite the

fig.5
Heads transcribed from paintings (detail)
J.C. Lavater, *Essays on Physiognomy*, 1870 (1775-7)

fact that no exact system of matching variations of feature with specific characteristics had ever been evolved. In more recent times, interest had been rekindled by the work of Johann Caspar Lavater, whose copiously illustrated *Essays on Physiognomy* was first published in five volumes in 1775-7 (fig.5). Throughout the civilized world, the book won considerable respect as a serious attempt to throw light on this elusive science, and it remained in high repute with later physiognomists; but like earlier works it lacked system, a fact which clearly emerges in Lavater's intelligent but intuitive responses to individual faces and features. It was not until the following century that scientific investigations into the physical and psychological nature of mankind became sufficiently advanced to give physiognomy a new lease of life. Studies in comparative anatomy and physiology; the development of organology, as phrenology was first known, by the distinguished physiologist, Franz Josef Gall, as well as the rise of anthropology and evolutionary theory, all contributed towards a revival and reassessment of physiognomy.

After twenty years of investigation, Dr. Gall had begun to lecture on the subject in Vienna in 1796. His principles were expounded in various publications, notably his multi-volume *Anatomy and Physiology of the Nervous System* (Paris, 1810-19) and the *Functions of the Brain* (Paris, 1825). Gall's theories were popularized by his associate, Johann Georg Spurzheim, in his *Phrenology in connexion with the Science of Physiognomy* (1833) and in the lectures he gave throughout Europe. Launched as a scientific system which related each function of the brain to a specific organ, it appealed to the positivist mentality of the nineteenth century (fig.6). In Britain, its greatest exponent was George Combe whose works included a series of articles for the *Phrenological Journal* on "Phrenology applied to Painting and Sculpture" (1844-7), issued in book form in 1855. Gall's system was adapted to suit all levels, and numerous publications of the handbook variety were issued (fig.7). Naive as it may seem in retrospect, phrenology was a genuine attempt at psychological analysis; and, like physiognomy, art, and the

Names, Numbers,
AND
LOCATION OF THE ORGANS.

1. Amativeness.
A. Conjugal Love.
2. Parental Love.
3. Friendship.
4. Inhabitiveness.
5. Continuity.
E. Vitativeness.
6. Combativeness.
7. Destructiveness.
8. Alimentiveness.

9. Acquisitiveness.
10. Secretiveness.
11. Cautiousness.
12. Approbativeness.
13. Self-Esteem.
14. Firmness.
15. Conscientiousness.
16. Hope.
17. Spirituality.
18. Veneration.
19. Benevolence.

20. Constructiveness.
21. Ideality.
B. Sublimity.
22. Imitation.
23. Mirth.
24. Individuality.
25. Form.
26. Size.
27. Weight.
28. Color.
29. Order.

30. Calculation.
31. Locality.
32. Eventuality.
33. Time.
34. Tune.
35. Language.
36. Causality.
37. Comparison.
C. Human Nature.
D. Suavity.

above left: fig. 6

Illustrations showing the relationship between the organs of the brain and the skull, *Précis du Système du Dr. Gall,* 1829

above right: fig. 7

The popularization of Gall's system. Diagram showing the location of the organs of the brain, *Annual of Phrenology and Physiognomy,* 1876

contemporary novel, it illustrates an increasing awareness of the individuality and complexity of human character. Phrenology spurred physiognomists to discover for their own science what even the great Lavater had failed to supply: a system of rules.

Again, this was to be supplied by anthropology. In their racial studies, anthropologists had established a hierarchy of human types in which intelligence and other psychological factors were directly linked with variations in human morphology. The adaptation of physiognomy for modern scientific purposes rejuvenated the more ancient practice. It had always performed an essential, dramatic function in narrative painting; but its association with anthropology gave it a consistency and a scientific credibility which it had previously lacked.

Numerous manuals were produced in the Victorian age explaining the rules of physiognomy and how to apply them. Occasionally, an entire book was devoted to a specific feature, such as Eden Warwick's widely reviewed *Notes on Noses,* first

published in 1848 and reissued in 1864; and Joseph Turnley's *Language of the Eye* (1856). The most extreme attempt at physiognomical analysis was James Redfield's (fig.8), but though much admired it was far too complicated to be of practical use. What people really wanted was something more accessible, and which might be applied even by the casual observer. This meant ignoring the minute subdivisions in favour of the general shape of the head and face. The comparative anatomy which anthropologists had developed in racial as well as animal studies, provided useful models in evolving certain basic clues to character. Pieter Camper's famous 'facial angle' for making comparative measurements of the cranial capacity, first expounded in a serious dissertation published in 1791, was widely adopted in simplified form (fig.9). The shape and size of the forehead were believed to indicate intellectual ability; the apex of the head the moral qualities; and the base of the head the 'animal propensities,' or passions. Physiognomists and phrenologists concurred on all of these points.

above: fig8
James Redfield, *The New System of Physiognomy*, 1866

below: fig9
Grades of intelligence as indicated by the size and shape of the forehead
S.R. Wells, *New System of Physiognomy*, 1866

far below: fig.10
Profiles of two Irishwomen, S.R. Wells, *New System of Physiognomy*, 1866

Fig. 142.—GRADES OF INTELLIGENCE.

Here, side by side, are two outlined profiles—portraits, we will suppose, of two Irish girls—the one (fig. 255), "the daughter of a noble house," whose ancestors have been, from time immemorial, lords of the soil, and who inherits the mental and physical results of ten generations of culture and refinement; the other (fig. 254), the offspring of some low "bog trotter," whose sole birth-right is the degradation and brutality transmitted through as many generations of ignorance and vulgarity, among the denizens of mud huts, and in oppression, dependence, and poverty.*

Fig. 254. Fig. 255.

The facial features were equally informative (fig.10). The kind which had supplied the classical ideal - those furthest removed from any resemblance to the animal world - remained in favour, but with the scientific justification which comparative anatomy claimed to supply. A straight or aquiline nose, and perpendicular profile and chin were thought to signify refinement and a superior moral type in terms of human development; coarse or heavy features, especially with a prognathous or protruding jaw, undesirable, even vicious qualities. The artist George Elgar Hicks echoed many a distinguished anatomist and physiologist when he explained the significance of head shape in his *Guide to Figure Drawing*:

'The erect forehead being peculiar to man, more than any other feature distinguishes him from the brutes. Its elevation is indicative of intellectual power, a projecting one of idiotcy [sic], and a low and receding one of deficiency of intellect.'[9]

Hence, the low brow and thick neck which still identify the thug in children's comics, and the apparent suitability of the high domed cranium to the clergyman (fig.11).

In the examples illustrated, which are typical, a strong class bias is immediately apparent. The Victorians firmly believed that social classes, as well as individuals, were physiognomically distinguishable, and there was some excuse for this belief. Although prejudice and expectation played a large part, there is no doubt that the appearance of the Victorian lower classes was heavily affected by poverty, disease and other factors which were easy to confuse with innate physiognomical ones. To a contemporary eye the evidence appeared incontestable. One author described the 'Passing Faces' in the street as having 'their social condition and their histories, stamped on them as legibly as arms are painted on a carriage-panel'; and to another they appeared as if 'labelled in big capitals' which made it possible to identify the 'rank of each in the social scale as readily as you can tell a general from a captain by his shoulder straps'.[10] Physiognomical class distinctions were further substantiated through the racial connotation they were given. As mentioned above, by the 1840s, Anthropology had established the practice of interpreting any distinctive physical type in terms of racial heritage. Although some overlapping was expected along the boundaries of classes, it was generally agreed that aristocrats had inherited their long heads and aquiline features from the Norman invaders of the eleventh century; the middle-classes the stolidity of both physique and temperament associated with their Teutonic or Saxon ancestors; while the lower classes - direct descendants of the Ancient Britons - retained much of the aboriginal nature and dark complexion attributed to the Celt.

References to such beliefs permeate all sorts of Victorian social commentaries as well as the novels of the period. They explain why, in the Preface to the illustrated edition of his monumental *London Labour and the London Poor* (1861-2), Henry Mayhew cites the prognathous or protruding ape-like jaw and low moral characteristics which he detected in the London street people, as features shared with nomadic tribes the world over, clearly distinguishing them from the more highly evolved, respectable ranks of society. Two anthropologists whose observations were reported in the *Anthropological Review* of 1866, echo Mayhew's conclusions. In Scotland, Hector MacLean noted what he classified as a low 'Celtic' type, the pure type seldom met with except 'among those of inferior station'. Its usual physiognomical manifestations included low stature, 'dark skin and complexion; the head... long, low, and broad; the hair black, coarse, and shaggy... forehead receding, with lower part of face prominent; nose broad and low'. The type exhibited moral qualities such as 'Warmth of feeling, fierce temper... a considerable amount of cunning', and a will to work only for gain, although, like Mayhew's low street types, otherwise 'indolent and indisposed to application.'[11] In his own summary of the 'Gaelic' physiognomy, observed in his survey of England and Wales, Daniel Mackintosh specified 'A bulging forwards of the lower part of the face...forehead retreating; large mouth and thick lips... nose short, frequently concave, and turned up, with yawning nostrils' (fig.12). Mental characteristics included lack of reasoning power, 'but great concentration in [the] monotonous or purely mechanical occupations' for which they were so evidently suited.[12]

This unflattering form of physiognomy is regularly employed in contemporary painting and illustration. At its worst, it merges with the criminal physiognomy. William Small's British Rough' from his *Heads of the People* series which appeared in the liberal magazine, the *Graphic*, illustrates this tendency, as do several examples from J.F. Sullivan's *British Working Man* (figs.14 & 13). The habit of conflating the working and criminal classes, as well as the belief that the evolution of human types was discernible from century to century, frequently surface in G.A. Simcox's remarks on the 'Transformation of the British Face' which he traced through painting and sculpture from the Mediaeval period onward, in a series of articles in the *Magazine of Art* in 1880. He was particularly impressed by the truthfulness of a 'plebeian type' which he discovered in a mediaeval manuscript at the British Museum, and which he identified as having 'so much in common with the type that one finds now among the classes whose development has been arrested - burglars and garrotters and ratcatchers and coalheavers'.[13] A useful type in

above left: fig.11
Good and bad heads and profiles contrasted
L.N. Fowler, *Self-Instructor in Phrenology and Physiology*, c1886

above right: fig.12
D. Mackintosh, Celtic type, 'Comparative Anthropology of England and Wales,' *Anthropological Review* (January 1866)

below: fig.13
J.F. Sullivan, A callous working-class criminal (Detail)
The British Working Man, 1878

far below: fig.14
William Small, 'The British Rough',
Heads of the People drawn from life, *The Graphic* (26 June, 1875)

fig. 15
George Elgar Hicks,
A pickpocket at work, The Post Office - One Minute to Six
1862 (detail). Private Collection

the depiction of crowd scenes, it marks the boy pickpocket in George Elgar Hick's *Post Office* (fig.15), whose brow is so low as to be almost non-existent. The same type is chosen for the low, criminally inclined costermonger in Frith's *Railway Station* (fig.34), who was recognized instantly as 'a choice fruit of the Westminster slums'.[14] The arrested criminal to the right of the picture is of a higher class - and looks it. He is more refined and intelligent; some sort of fraudster, perhaps; not a born criminal but an educated but weak man who has gone astray.

The word 'Type' which recurs so frequently is a significant one. 'Type' is as common to Victorian literature and art criticism as to anthropology, and carried the same meaning whether applied to the real or to the painted figure. Although physiognomy acted first and foremost as a means of distinguishing one

individual from another, it also provided the means by which individuals sharing certain characteristics might be grouped together. In fact, 'type' was often used as loosely interchangeable with others such as race, species, variety and genera, which were equally credited with a physiognomical basis. This is made clear by the anthropologists J.C. Nott and G.R. Gliddon in their edition of S. G. Morton's *Types of Mankind*, where they admit that they 'recognize no substantial difference between the terms types and species - permanence of characteristics belonging equally to both'.[15]

Whatever the context, the word 'type' always implied a distinct physical and moral entity, and was particularly useful when the crowd demanded a more specific means of classification than race or class. The anthropologist, writer and artist all sought out striking types in their perambulations. Hippolyte Taine explained how he deciphered the characteristics of specifically English types which aroused his interest on his visits to London. His method was firstly, to

'note the most salient features or expressions, study them in all their variations and shades, graduations and mixtures; check that they are to be found in sufficiently numerous individuals; by this means, isolate the principal [sic] characteristic traits, then compare, interpret and classify them.'[16]

It was this same method which enabled the anthropologist, Daniel Mackintosh, after months of 'systematic observations' throughout North Wales, to succeed in reducing the diversity of countenances found there to four basic types, and which allowed Elizabeth Eastlake, wife of the Royal Academy President, to detect 'two prominent national physiognomies' during her visits to Scotland.[17]

A whole literary genre - much of it illustrated - developed in response to the interest in urban anthropology. At its most popular and unscientific level, it provided the motivating force for Dickens' *Boz* and other *Sketches*, as the writer travels through the city, observing and light-heartedly classifying its various human types. These were often illustrated by George Cruikshank Senior (1792-1878), one of the most prolific commentators on London life. *London in 1851* (fig.16), shows the crowd at Regent's Circus converging *en route* for the Great Exhibition at Hyde Park. Cruikshank here celebrates the sheer size and exuberance of the crowd which created almost as much of a sensation as the Exhibition itself. Later his talented great-nephew and name-sake was to produce whole series of caricatures of familiar characters and types. It is significant that Dickens main illustrator, Hablot K. Browne (1815-82), adopt-

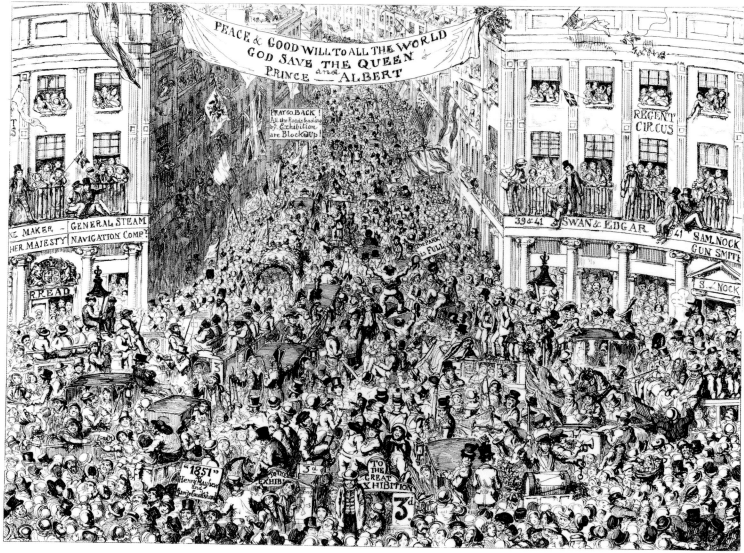

fig.16
George Cruikshank Snr., 'London in 1851'
Henry Mayhew, *1851; or the Adventures of Mr and Mrs Sandboys*

ed the pseudonym of 'Phiz' - short for physiognomy - in order to emphasize his role as a student of character. In the 1850s, the novelist and journalist George Augustus Sala and the artist Charles Bennett toured London, testing a variety of venues which promised an interesting mixture of urban types: the railway station, the play, Billingsgate, Covent Garden, Belgravia and other likely places (fig.17). Henry Mayhew is best known for his extensive survey of *London Labour and the London Poor*, begun as newspaper reports in 1849 and culminating in an illustrated four volume edition (1861-2). Mayhew and John Binny pursued the same anthropological interest in *The Criminal Prisons of London* (1862), where the aim was to make a 'scientific classification of the criminal classes'.[18] *London Characters*, a more frivolous book by Mayhew, appeared in 1874.

Among artists of the earlier period, John Leech was the most extensive social commentator. He collaborated with Albert Smith on a series of illustrated *Natural Histories* of London types in the 1840s and 'fifties, and from 1841 until his death in 1864, was the leading illustrator of *Punch* which was devoted to the contemporary scene. Leech took an avid interest in the behaviour and physiognomy of all classes of humanity and was adept at exploring the comic potential of the minor confrontations which had become so much a part of modern city life. Despite their humour, there was much truth in the cartoons of Leech and his fellow artists. John Ruskin recommended the work of three *Punch* artists: Leech, Tenniel and Du Maurier, as a reliable source for the study of moral and social types; which he thought 'a much more useful and interesting subject of inquiry'

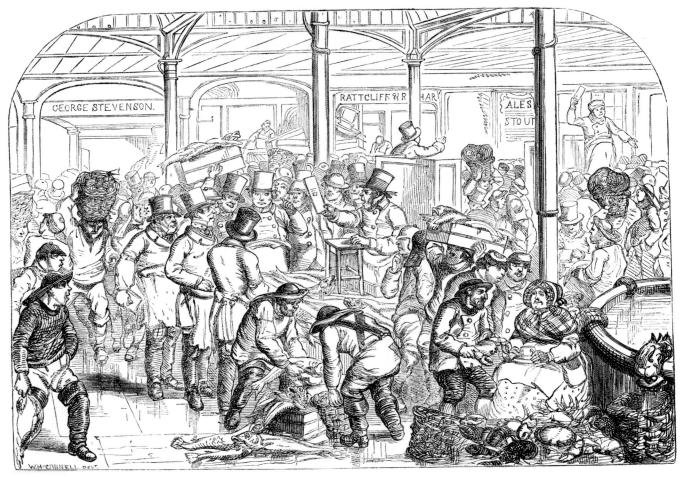

fig. 17
William McConnell, *'Billingsgate Market'*
George Augustus Sala, *Twice Round the Clock*, 1859

than the study-bound preoccupations of anthropologists obsessed with

'the gradations of snub nose or flat forehead which became extinct with the Dodo, or the insertions of muscle and articulations of joint which are common to the flesh of all humanity.'[19]

The *Illustrated London News* published a stream of engravings dealing with the various types to be found in London's public places. In fig.19, the artist records the social and physiognomical contrasts amongst the 'Specimens of the Crowd' watching the Royal Wedding. These include an amiable town rough who offers an Eton College boy a 'pull' on his pipe - an offer which is not appreciated. Alfred Hunt was one artist who regularly contributed illustrations of London life. 'Easter Morning: The Excursion Van' (fig.18) shows a typical crowd drawn together for a Bank Holiday trip to Hampton Court. The family to the right, identified as that of a greengrocer in the accom-

panying text, corresponds closely with the bustling tradesman's family in Frith's *Railway Station* which will be considered in detail below.

Recognizable types like these played an essential role in modern-life painting and were especially useful in crowd scenes. Taine had compared his own method of discerning types, not only with 'botanists and zoologists' but with 'painters and novelists' who, acting more instinctively than the naturalist did, selected certain characters in order to provide 'a resumé of their times and environment.'[20] But the narrative artist had certain advantages over the anthropologist. He had more licence to select and organize the crowd; to make it more interesting, amusing and instantly recognizable; and to establish dramatic relationships between its constituents.

• • •

The full effects of industrialization began to be felt in the 1840s when a railway network was established throughout the coun-

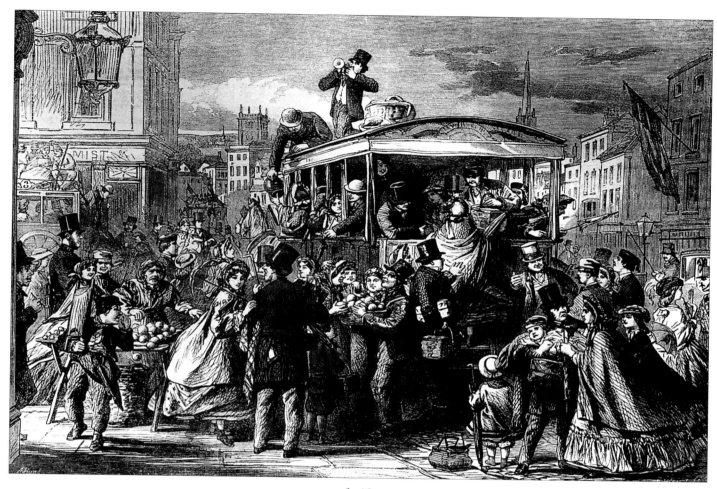

fig. 18
Alfred Hunt, 'Easter Monday: The Excursion Van'
Illustrated London News, 19 April 1862

try. It was now that the modern world was truly born. The contrast with the previous decade is striking and is clearly reflected in art. Throughout the 1830s, most urban scenes retain a certain elegance and picturesqueness of a kind which we associate with the Regency period rather than the Victorian. The majority show little interest in the size, variety and anonymity of the urban crowd.

John Orlando Parry's *London St. Scene* (fig.1) is an interesting exception largely due to its function as a design for the kind of backdrop which Parry used in his music hall acts; for this was his primary occupation at the time. Parry was a man of many talents. His formal musical education had taken him to Italy, and he had worked as a professional harpist and singer.[21] It is all the more striking that so original and interesting a picture should be the product of an amateur.

In this design, Parry aimed for a realistic effect, and in so doing, he suggests the potential of the genre as it was to develop some twenty years later. His scene indicates the increasing diversity of street life and the general rawness and raffishness of

the rapidly growing city at this early period. The stately dome of St Paul's Cathedral forms an ironic contrast with the roughly fenced demolition site and cheap red brick building covered with advertisements in the days before fly posting had been regulated. Leaning against a lamp-post, a policeman - wearing the swallow-tail coat and top hat which were to be replaced in 1864 by helmets and tunics - addresses a soldier, unaware that he is being robbed of a handkerchief by a daring pickpocket. To the right, a bonneted woman presides over a stall laden with turnips and other vegetables, and applies the bellows to a brazier where potatoes, or perhaps apples, are roasting. This, and the clothes of the characters depicted would suggest that the season is chill, despite the sunshine. The poster hanger is watched by a youthful chimney sweep, a butcher's boy, and a snub-nosed coal-heaver or dustman in his protective fan-tail headgear; while a miserly looking man peers covetously at the large joint of meat in the errand boy's tray. The garish posters - a rare record of such ephemera at this time - look forward to those in Madox Brown's *Work* and the later paintings of A.E. Mulready. They

AT WINDSOR, A FEW SPECIMENS OF THE CROWD

give some idea of the variety of sensational entertainments on offer just two years before Victoria came to the throne, ranging from Shakespeare's *Othello* and a dramatization of Bulwer-Lytton's *Last Days of Pompeii*, to the Industrious Fleas and Woman Tiger Tamer. Amongst the entertainers advertized are Parry himself, whose name appears on a poster next to the one being hung, and on another attached to the wooden brace supporting the wall. Towards the top of the wall, in the poster bearing the name of Miss Combe, he pays tribute to his future wife. A little to the right of the poster hanger appears the name of the French actor, Robert Macaire - successful satirist of the regime of the 'bourgeois king', Louis Philippe; and to the bottom right, that of the American minstrel, Jim Crow. Negro minstrels were popular entertainers in the Victorian age. They appear in Derby Day crowds by both Frith and Alfred Hunt (fig.28&31) in the 1850s and in William Logsdail's London scene, completed in 1890 (fig.74), as well as in illustrations. Parry powerfully evokes the effect of bright sun and clear atmosphere on this urban day in 1835.

One of the charms of Parry's scene is its genuinely random quality; effectively suggesting an accidental, desultory and fleeting confluence of city types, some working, some idling. This 'slice of life' approach is what gives it a particularly modern look. Understandably, professional artists chose to give more of a dramatic focus to their street scenes. James Holmes chose one of London's busiest corners - Charing Cross - (fig.20) close to the Golden Cross Inn which was once the major changeover point in the West End for both mail and stage coaches. Although the inn has been demolished, Hubert Le Sueur's

equestrian statue of Charles I survives, and now stands in Trafalgar Square. Holmes focuses on an episode familiar to all Londoners of the time - an argument about a fare. The cabman signals the boy who is handling the young woman's luggage to wait, while a gentleman gallantly intervenes on her behalf. A black boy in livery, perhaps at the man's suggestion, notes down the details of the cab's registration, and a couple of urchins are evidently much amused by the fracas. In the distance, with old Northumberland House rising behind him, a coach driver is about to sound the departure of his packed vehicle on his horn. Those outside include a jolly rustic couple, the man in a smock; while the much coveted seat next to the driver is occupied by a 'fast' young man - perhaps a student - in elegant silk hat and fur trimmed coat, who puffs at a pipe.

Holmes's is altogether more elegant and gracious in tone than Robert William Buss's scene painted in 1841 (fig.25), in which the artist approaches more closely the kind of conflict between different social types which as to provide such interest for artists and illustrators of the 1850s. In this case the statue is of George III by Matthew Cotes Wyatt, completed five years previously and which may be seen today in Cockspur St. The banner to the top left, on which the name of 'Victoria' is decipherable, suggests that the crowd has assembled to watch the Royal Wedding - for in 1840 the young Queen married Prince Albert. The windows are crowded with spectators; youths clamber up the gas-lamp to obtain a better view, one losing his hat in the process. Their choice position is threatened by a policemen whose braided cuff and truncheon emerge below them. A diversion is created at the centre of the group where a

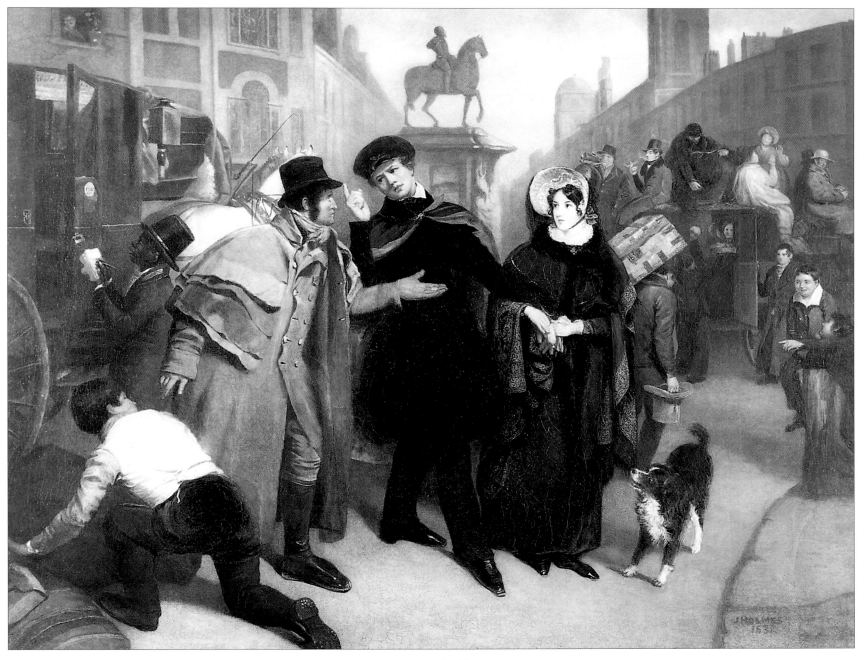

opposite: fig. 19

The Royal Wedding at Windsor, 'A Few Specimens of the Crowd',

Illustrated London News (22 March, 1879)

above: fig. 20

James Holmes

Charing Cross

1832. Guildhall Art Gallery, Corporation of London

sooty young chimney-sweep thrusts himself amongst his well-dressed neighbours, two of whom – a portly man in primrose waistcoat and a woman in a pink silk dress – remonstrate with the heedless boy for endangering their clothes. Heedless of their protests, the cheerful youngster fixes his attention on the scene before him; his face a picture of delight. To the left, an overdressed foreigner with waxed moustache turns to observe the cause of the commotion beside him, failing to observe the pickpocket extracting his watch. Buss's eye-level view of a small, unruly group, cut off abruptly at either side, cleverly suggests a crowd which extends indefinitely. Structurally, it anticipates Walter Boyd Houghton's scenes of the 1850s and early 1860s (fig.70).

• • •

The greatest innovator in the painting of crowd scenes was W.P. Frith. In the 1840s Frith had established himself as a successful painter of historical and literary genre; but he was ambitious, and took what he knew to be a calculated risk by moving into a new and challenging field. Possibly encouraged by the *Punch* illustrations of his close friend, John Leech, Frith broke new ground with *Life at the Seaside* (1854, Her Majesty the Queen); a distinctly unglamorous view of the crowded beach at Ramsgate, a favourite resort for Londoners. It is impossible for us to appreciate how unpicturesque the scene appeared to a contemporary eye; but Frith records various reactions of disbelief and horror at his proposal to paint it. While pretending to admire it, behind Frith's back one client described it as 'a tissue of vulgarity', and a fellow artist roundly dismissed it as 'a piece of vulgar Cockney business unworthy of being represented even in an illustrated paper.'[22] The idea of portraying ordinary families on a beach, dressed in drab modern clothing in the unflattering glare of the sun was new to art, and the picture was refused by half a dozen patrons before it was bought, initially, by Lloyd's, the picture dealers. But Frith – and some supportive artist friends – were proved right on its reception at the Royal Academy, where public enthusiasm voted it the picture of the year. Its purchase by Queen Victoria set the seal on his success and encouraged him to embark on the much larger and more heterogeneous crowd of the *Derby Day* in 1858.

As visual documents of contemporary life, Frith's ambitious attempts were to remain unchallenged. Their sheer size, panoramic format and the number and variety of types and classes included enabled Frith to reveal more of the complex social structure of the London crowd than had ever been attempted (fig.28&34). Frith's method of composing his crowds was crucial to his success. Contemporary photographs of the Derby, including one commissioned by Frith (fig.21), show how unpicturesque and monotonous the outline of crowds tends to be, although in real life this is disguised by constant movement. To compensate for the immobility of his painted crowds, Frith took considerable care in shaping and grouping them. The panoramic structure of the paintings sets in motion a complex and absorbing process of observation. Something of the exploratory eye movements demanded by the meandering crowd as encountered in real life is imposed on the spectator, and an impression of the size and complexity of life most convincingly created. In the *Railway Station*, beneath the gloomy canopies of Paddington, the crowd of first, second and third

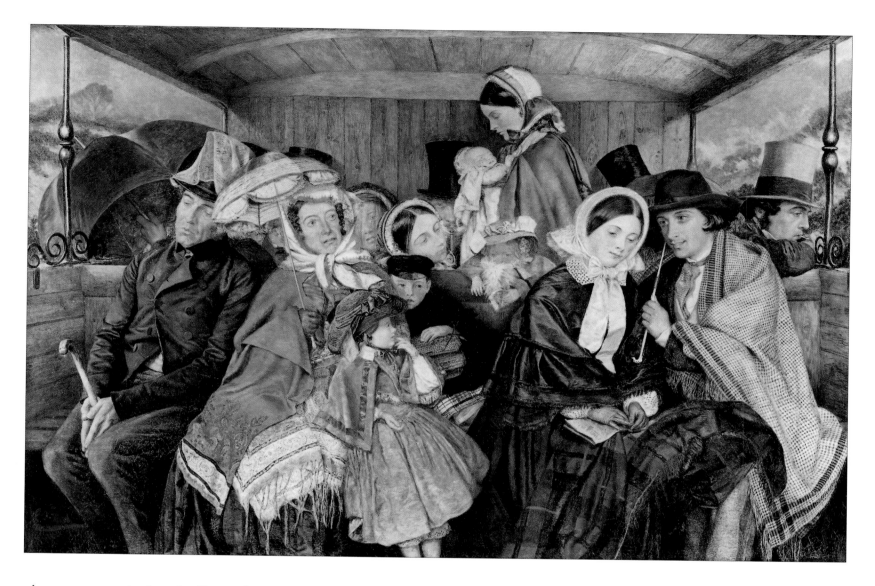

class passengers is cleverly disposed in small groups, each with its own narrative function; the whole woven together in Frith's expert way. The urban ugliness associated with a railway station made the setting a daring choice, but its modernity, and the appeal to familiar experience were potent forces. Exhibited singly, the *Railway Station* caused as great a sensation as the *Derby Day* and was enormously successful as a commercial venture. Henry Graves, who took over the publication of prints of it from Louis Victor Flatow, is said to have made £40,000 from the venture.

The crowds which Frith painted were a recent phenomenon; in size, in composition and in the very means which brought their constituents together; for all resulted from modern transport. The railway system was the most significant development of the Victorian period. It transformed the country, and the consequences were human as well as economic. The railway was responsible for the record crowds that assembled at the Derby; for it was through its ability to convey not only the

human crowd but also horses in sufficient number and over long distances, that the event swelled to the proportions which have ever since distinguished it. In 1838, one year after Victoria's accession, the first special trains began to run from London to Epsom. The crowd that we see in *Ramsgate Sands* was also the result of more frequent and cheaper trains to the seaside. Charles Rossiter's *To Brighton and Back for 3/6* (fig.22), celebrates the benefits of cheap-day-return tickets which made the seaside accessible even to the working classes. Huddled in the interior of a crowded, open third-class railway carriage is an assortment of young lovers, and parents with babies and children, cheerfully wielding umbrellas against the rain and steam. A lifelike motif is the infant attempting to clamber over the back of the seat, to make friends with the little girl in front of her.

The groups brought together by trains and omnibuses were not always so harmonious. The frequent incongruity of such chance meetings was cause for considerable comment in art and literature. In Disraeli's *Sybil*, Lord de Mowbray and Lady

above left: fig.23
John Leech, 'Perfectly Dweadful', *Punch* (27 September, 1856)

above right: fig.24
John Leech, *Class confrontation at the Sea-side,* *Punch* (21 June, 1862)

opposite: fig.25
William Buss, *The Crowd,* 1841. Guildhall Art Gallery, Corporation of London. Bridgeman Art Library

Marney agree that railroads are very dangerous sources of levelling, the lady excitedly regaling her friend with the story of an incident which brought together 'a countess and a felon'.[23] It is a horror of just this sort of encounter which leads the gentleman in fig.23 to choose to miss his train and remain, uncontaminated, on the platform. In one of several amusing cartoons, John Leech suggests the kind of class confrontation which might occur on the beach and the discomfort it might cause for those with social pretensions (fig.24). In this example, Percy de Gosling - a young swell - has made the mistake of visiting Brighton on Whit Monday, and is disconcerted to find himself accosted by landladies and boatmen and surrounded by low-class day trippers.

The omnibus - of which there were three thousand in London by 1850 - was another unpredictable meeting place. Egley's *Omnibus Life in London* (fig.27) provides us with one of those hard-edged, hallucinatory glimpses of Victorian life which seem to encapsulate the past exactly as it was; in this case, at one particular moment in 1859 in Westbourne Grove. It is a novel and topical subject, showing one of those microcosms of modern life which were created by the constant flux within the crowd. The dramatic viewpoint draws the spectator deeply into the crowded interior, to focus on the various individuals who make up this heterogeneous assemblage. It includes, front left, a respectable but flustered servant clutching at a superfluity of baggage; a somewhat fastidious, gentlemanly type in grey; two women, one of them an attractive widow eyeing the pretty girl opposite sympathetically; a young city clerk - a favourite type of John Leech's and one who was to play a prominent part in Frith's *Derby Day* - vacantly sucking his cane as he gazes entranced at the same girl; and to the right, Egley's own young wife accompanied by her docile daughter and sturdy infant son, struggling wilfully on her lap, armed with his tin drum and sticks.

It is an invaluable record of social types and the fashions of 1859, but it was also recognized by Frederick George Stephens as a nice little piece of psychology: 'a subtle little bit of character cleverly worked out';[24] and it is indeed a revealing insight into how women were perceived in the Victorian age. Carried away by the superlative detail, one might be forgiven for overlooking the psychological drama which Stephens noted, and which centres on the pretty young married woman who folds her parasol prior to entering the bus. On this occasion she hesitates, surprised; for her entrance has failed to cause the usual stir. Engaging the attention of the occupants of the bus is someone even prettier: the young woman at the far end of the right-hand seat; the epitome of sweet, innocent girlhood; her exquisite features protected but not concealed by a white veil. For all her greater assurance, the young married woman cannot begin to compete.

Even the *idea* of women competing in such circumstances strikes a foreign note now. Much as we admire prettiness, woman's role is no longer merely decorative. No girl, however attractive, would cause such a stir today, nor expect to. The virtues celebrated in the younger girl are also revealing of the time: delicacy, shyness and above all, modesty; virtues which were central to the Victorian feminine ideal, and highly attractive to men, but which are at a marked discount today.

The omnibus itself is of considerable historical interest. An enlargement of Egley's picture is displayed in the Museum of Transport to illustrate the history of the omnibus – further evi-

dence of what has been said in the previous chapter about the historical value of genre, as well as its ability to embody and reveal the mind of the period – its values, attitudes and opinions.

Several artists were to follow Egley in painting omnibus interiors, although none quite equal his in human interest. An example dating from some thirty years later is something of an oddity (fig.26). No doubt to pay tribute to the Liberal politics of the 'People's William', John Morgan (1823-87) has included William Ewart Gladstone – four times Prime Minister – in the small group who occupy an omnibus travelling along Piccadilly, and which includes a widow with her children, a young mother,

W. MAW EGLEY.

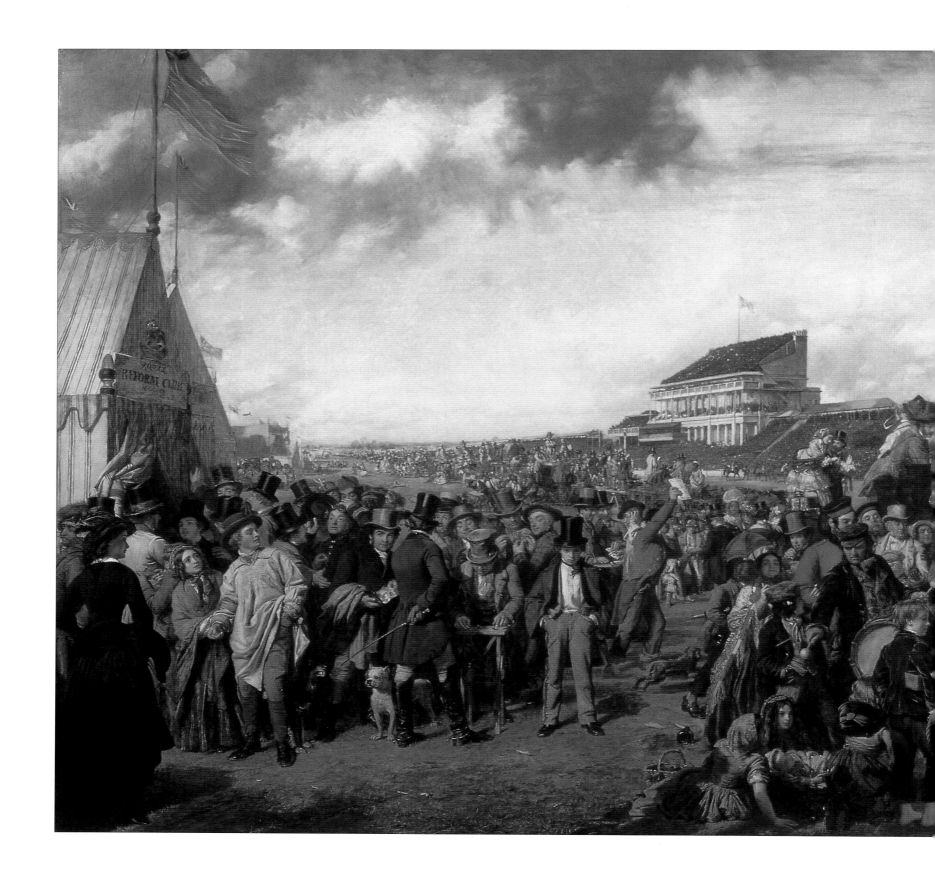

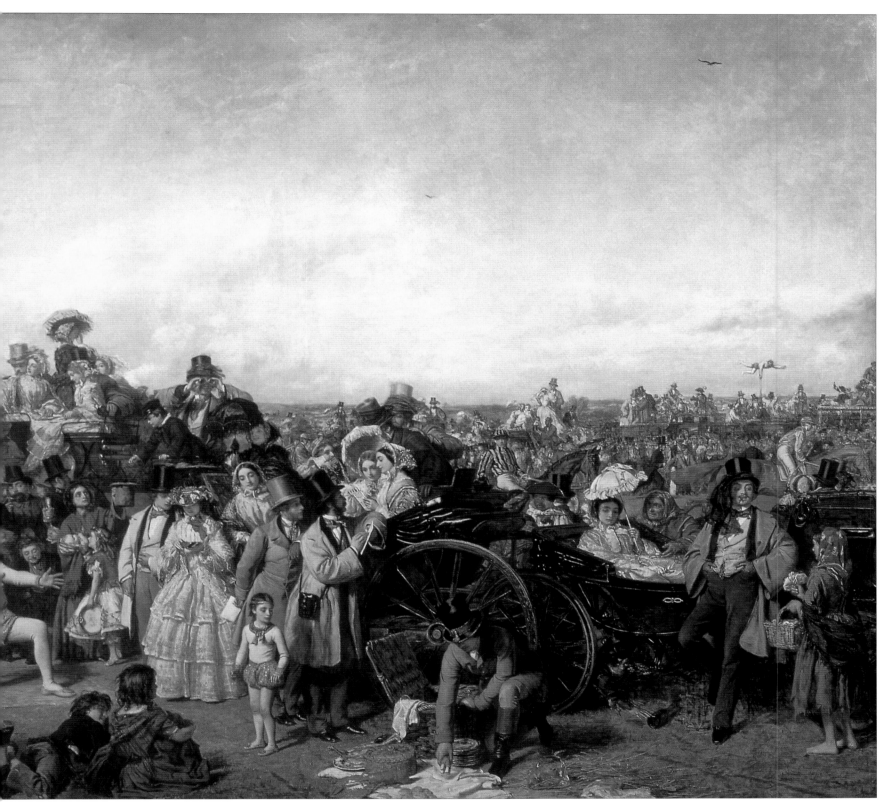

fig.28
W. Powell Frith, *The Derby Day*
1858. Tate Gallery, with outline plan identifying the main characters on page 110

page 111: fig.29
Thimble-rigging gang (Detail of fig.28)

fig.30
(Detail of fig.28)

| | | | | | | |
|---|---|---|---|---|---|
| 1 | Lady in riding habit | 19 | Thimbler operating with 'pea' (made from a piece of bread) | 38 | Gypsy girl |
| 2 | Her gentleman companion | 20 | Jewish swindler | 39 | Soldier |
| 3 | Low-class type, possibly coster monger or an Irishman | 21 | Scottish swindler | 40-1 | Respectable middle-class country farmer and his wife, outraged by the pick-pocketing gang |
| 4 | Gambling tent official | 22 | Young city gent, cleaned out by thimble-riggers | | |
| 5 | Low-class boy firing at a target | 23 | Card sharper | 42 | Pickpocket |
| 6& 7 | Country bumpkin & wife. | 24 | Card sharper | 43 | Acrobat |
| 8 | Upper-class university student, entering the gambling tent | 25 | Duped country bumpkin | 44 | Pickpocket |
| 9 | A 'man about town' attempting to restrain him | 26 | Irishman selling Dorling's Race Cards | 45 | Urchin – possibly member of pick-pocketing gang |
| 10 | Gambling tent official | 27 | Urchin | 46 | Pickpocket |
| 11 | Foolish young aristocrat, also tempted | 28 | Cook | 47-8 | German tourists |
| 12 | Fussy gentleman protesting against the fraudulent thimble-riggers | 29 | Bookmaker | 49-50 | Raffish gentleman, getting drunk |
| 13 | Policeman, admitting that he cannot interfere | 30 | Urban youth | 51 | Girl on stilts, member of acrobat family |
| 14 | Man in fez: portrait of Richard Dadd, artist friend of Frith | 31 | Sergeant | 52 | Raffish gentleman offering her champagne |
| 15 | Murderous 'Thurtell' type | 32 | Drummer- low-class urban type attached to acrobat group | 53 | A female demi-monde companion, restraining him |
| 16 | Fake country squire | 33 | Gypsy girl | 54-8 | Members of the same dissolute party |
| 17 | Morally outraged gentleman | 34 | Ditto with baby | 59-61 | Respectable gentleman, boy and lady |
| 18 | Fake Quaker | 35 | Poor girl – urban type | | |
| | | 36 | Urchin with lighted rope, selling cigars | 62 | Acrobat's wife |
| | | 37 | Urchin | | |

63	Acrobat's daughter neglecting her dancing to kiss the baby
65-6	A sweet young couple – 'David and Dora' types
67	Acrobat's boy
68	Aristocratic lady
69-70	Aristocratic officers
71-2	Aristocratic ladies
73	Lady consulting two gentlemen about the race
74	Gentleman examining her race card
75	Ditto
76	Manservant to the aristocratic party
77	Urchin stealing a bottle
78	Jockey
79	Ethiopian Serenader
80	Gypsy
81	Fallen woman – soon to be abandoned
82	Gypsy fortune teller
83	Aristocratic roué
84	Flower seller
85	Jockey
86-8	Spectators

and a male passenger – perhaps a doctor – with a leather bag. Gladstone's familiar granite-like features appear somewhat out of place; and indeed, it is unthinkable that a man of his vast wealth should have chosen to travel in this way. Another example is G.W. Joy's *Bayswater Omnibus* (1895, Museum of London), in which the chief central motif is the contrast drawn between a poor mother with her children and the fashionable woman next to them, who observes them compassionately.

Interesting as such microcosms are, Frith's panoramas are by far the most informative. The Derby was regarded as the major national holiday of the year; according to one of Dickens' illustrators, Hablot K. Browne, 'the most popular and greatest holiday, perhaps, in the world',[25] an occasion when even Parliament closed down for the day. It was the Derby which drew the biggest crowd that ever gathered on British soil; and it was this, not the race, which was the focus of interest. Added piquancy

derived from the fact that all classes, mostly Londoners, mixed with a freedom unknown on any other day of the year. As the *Illustrated London News* commented in 1863, the Derby provided 'the most astonishing, the most varied, the most picturesque, and the most glorious spectacle that ever was or ever can be, under any circumstances, visible to mortal eyes.'[26] Commentators acknowledged that it was 'the endless varieties of the human species assembled within the radius of a mile and a half' which gave value to the occasion, providing 'The... student of human character' with 'abundant material for observation'.[27] Louis Blanc spoke for all foreign visitors in admitting that its chief attraction was that 'every variety of our species was to be found there in close quarters'.[28] Frith felt the attraction of this 'kaleidoscopic' crowd as strongly as the majority of the British public did, providing him as he said with the opportunity to paint 'the infinite variety of everyday life'.[29]

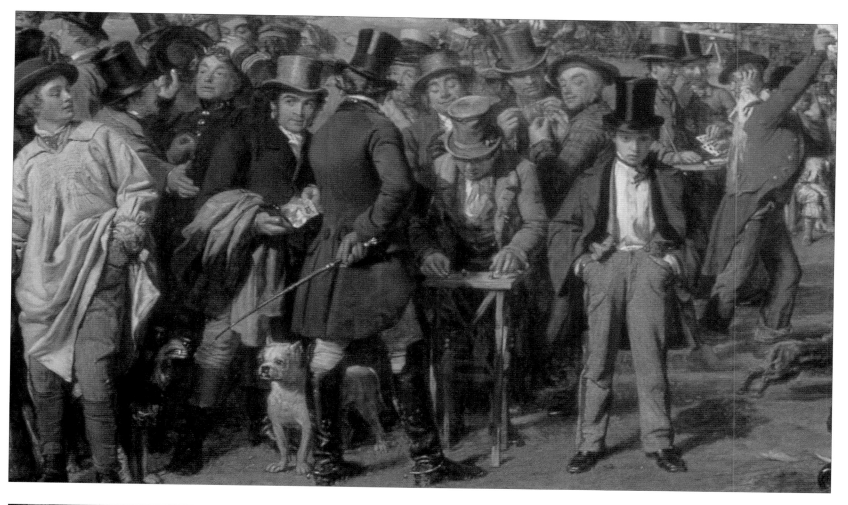

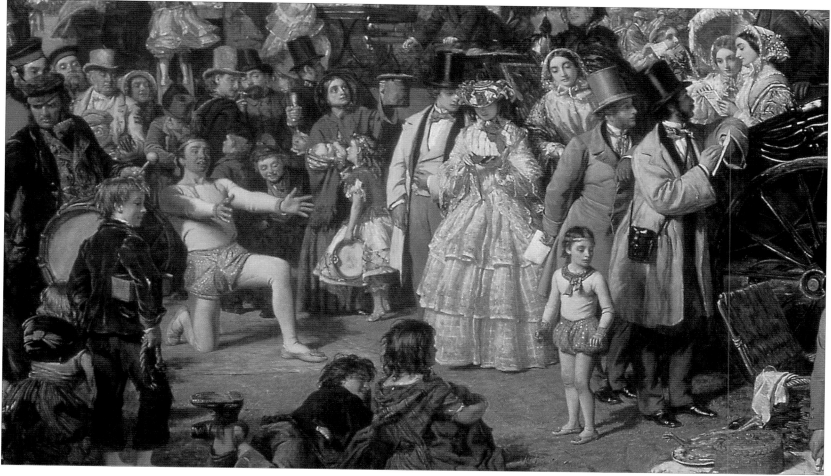

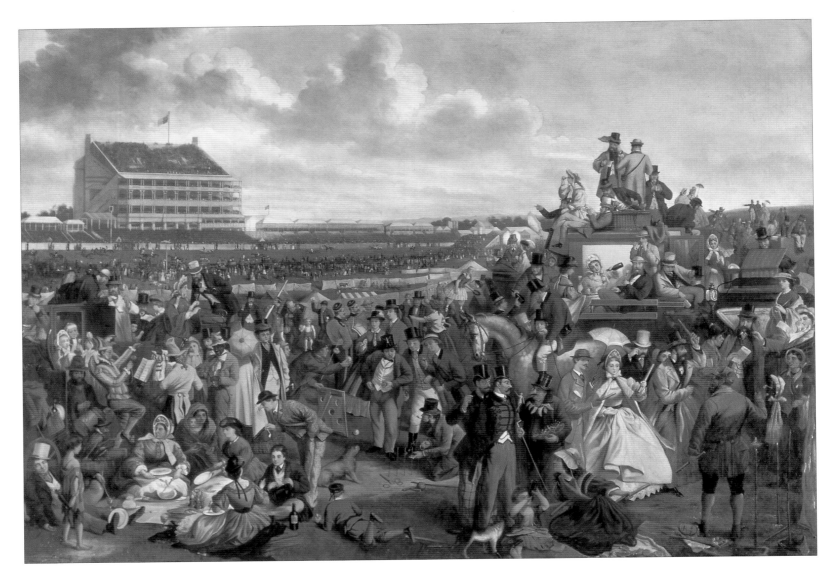

fig.31
Aaron Green, after Alfred Hunt, *Epsom Downs*
1863. Stoke on Trent Art Gallery

The scrutiny of Frith's painted crowds was an absorbing and time-consuming business. It was claimed to be a good hour's work even to skim the *Derby Day*;[30] a claim which underlines the difference in knowledge and understanding which separates Frith's time from our own. Frith included all the familiar types who flocked to the Derby every year; from aristocrat to itinerant entertainer, from policeman to pickpocket (fig.30). The more striking types include the gang of fraudster's engaged in thimble-rigging to the left, one of them sneering at their pale-faced, top-hatted little victim; a perspiring policeman urged by an indignant spectator to 'do something about' such blatant trickery; a stolid besmocked yokel sorely tempted by the thimblers, but restrained by his more sensible wife; and affluent but foolish young men entering the gambling tent. The centre-foreground (fig.30) is occupied by a group of youthful gypsies,

one of whom carries a box of cheap cigars, together with a tarred rope which was used as a lighter. Another boy sports the fashionable clothes of the urban working-classes: fur cap and corduroys; his status as an aspiring dandy signified in the cane tucked jauntily under his arm. The drummer who accompanies the acrobatic team glowers at him, warning him to stand back, as the act is about to commence. The focal point of the painting is the beseeching gesture of the father whose son has been completely distracted from his usual act of turning a somersault on his father's chest by the sight of the delicious picnic which a footman is in process of laying for the 'carriage-folk' behind. His sister is equally distracted, neglecting her tambourine to kiss the baby cradled in the arm of her careworn mother. Ignoring the policeman close by, a group of pickpocketing urchins is at work amongst the crowd gathered to watch the acrobats; their

above left: fig.32

Richard Doyle, 'A View of Epsom Downs on ye Derbye Daye', *Manners and Customes of ye Englyshe in 1849*

above right: fig.33

George Cruikshank the younger, *Derby Day Types,* c1878. Coloured scraps. Bodleian Library, Oxford

victims a pair of tall-hatted German visitors, somewhat bewildered by this boisterous British carnival. An unsophisticated elderly couple from the country are visibly shocked by such criminal activities. A sweet young girl in pretty flounced dress searches her purse for a coin to place in the proffered top-hat, while her young boyfriend, moved by her sympathetic gesture, observes her, adoringly. Behind them, a drunken party is well under way amongst the group in the 'drag' - a four-horse coach with seats both inside and on top; but one of the women is sufficiently alert to prevent the men from giving champagne to the little girl on stilts. To the right another contrast of rich and poor appears in the episode of the girl shyly offering flowers to the languid gentleman who lolls against his carriage, neglectful of his unhappy mistress who, understandably, shrinks from the gypsy's offer to read her palm. In the distance, the jockeys begin to assemble at the starting post, while some amusing episodes include a fight breaking out over the three-card trick and a drunken man prostrate on the grass, his top-hat tilted over his face.

Frith's attempt to capture the social aspect of the event was never to be equalled. The press responded to it as a faithful transcript of the actual scene; and indeed, descriptions of the Derby which appeared annually in Victorian newspapers are often indistinguishable from those which occur in reviews of the picture. Of other paintings of the Derby Day, Alfred Hunt's version, known through a copy, appears to be the closest to Frith's (fig.31). Although much less ambitious, it concentrates similarly on the amusing confrontations which occur between

characters and classes on this occasion. Included, in the left foreground, are two bemused foreigners - a pictorial motif always guaranteed to delight the xenophobic Victorians - in this case besieged by a man selling false noses, which he wears round his neck like a grotesque garland, and the penny wooden dolls traditionally worn in gentlemen's hatbands on Derby Day. Swells and their ladies take a shy at the Aunt Sally, and a picnic party to the right is beset by various entertainers and gypsies. The negro serenaders regularly appear in paintings and illustrations of public celebrations, and were included by Henry Mayhew amongst the many peripatetic types whom he investigated in *London Labour and the London Poor*.

The illustrated papers almost invariably rose to the occasion, rarely failing to make the most of the human interest that the Derby Day had to offer. Doyle and Cruikshank (figs.32 & 33) include the aristocrat with his paramour; the entertainers and gypsies; the city 'gent' - the young clerk or shop assistant in ubiquitous topper and check trousers - and fraudsters practising their card and thimble tricks. The journey to and from the racecourse was of equal interest; the latter being notorious for its drunken revelry and frequent accidents. The scraps designed by the younger George Cruikshank (great-nephew of the elder), provide an especially attractive record of the characters and escapades popularly associated with the event.

The *Derby Day* was a hard act to follow, but Frith found a worthy successor in the *Railway Station* (fig.34). The most important painting ever made of the mid-Victorian urban milieu, this was to be the last and the most memorable of his

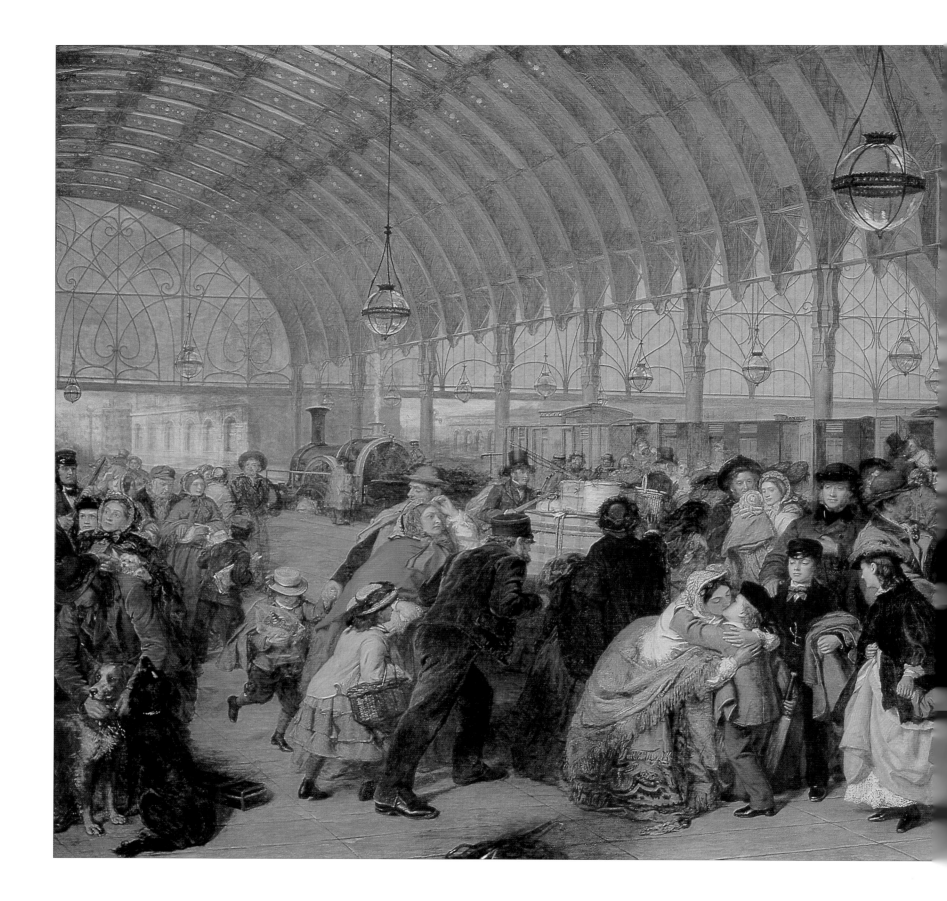

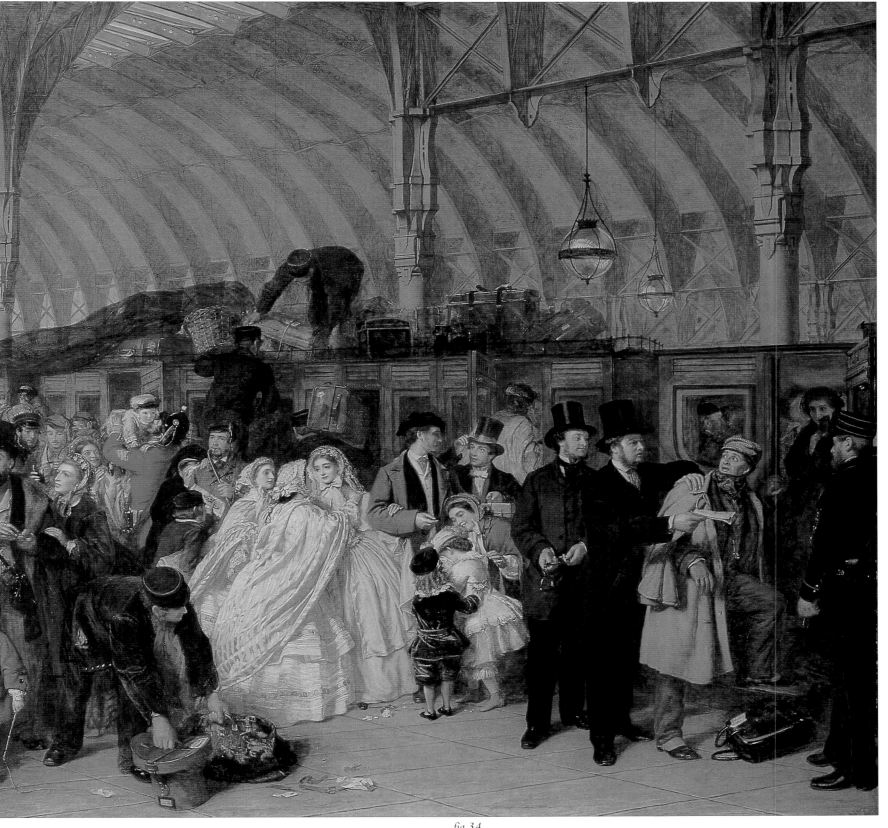

fig.34

W. Powell Frith

The Railway Station

1862, Royal Holloway University of London with plan identifying the main characters on page 116

1	Porter
2	Gamekeeper
3	Station Inspector
4	Lady trying to smuggle dog into train
5	Indignant daughter
6	Bookworm
7-8	low-class travellers
9	Infirm father
10-11	His daughters
12	Newspaper boy
13	Sailor
14-15	Low-class women
16	Railway worker
17	Inquisitive old gentleman (Louis Victor Flatow) talking to the driver
18	Driver
19	Bustling matron
20	Henpecked husband
21-2	Son and Daughter
23	Porter
24	Middle-class lady
25	Sportsman departing for a fishing trip
26-8	Soldiers
29-31	Two women with baby
32	Gentleman in reduced circumstances
33	His daughter, off to take up her first position
34-5	Country couple
36	Young middle-class lady
37	Lady fussing over her baggage
38	Sailor
39	His tearful wife
40	Their baby
41-2	Ship's boys
43	Materfamilias: Mrs Frith
44-5	Second son and eldest son, both off to school

46	Paterfamilias: W.P. Frith
47	Daughter
48	Youngest son
49	Cabby - demanding more money
50	Sailor
51-2	Middle-class couple
53	Middle-class mother
54	Daughter
55	Her husband - naval officer
56	Foreigner besieged by cabby
57	His protective wife
58	Porter
59	Inspector Craig: portrait of a Paddington official
60-1	Recruit: respectable navvy or country man
62	Lady entering carriage
63	Recruiting sergeant's wife
64	Recruiting sergeant
65	Their baby
66	Villainous recruit - criminal type
67	Widowed mother
68	Newspaper boy
69-71	Porters
72-3	Bridesmaids
74	Bride
75	Bridegroom
76	Bride's young brother
77	Bride's young sister
78	Nurse
79	Bridegroom's manservant
80	Lady entering carriage
81-2	Two detective sergeants, portrayed from life: James Brett and Michael Haydon
83	Criminal - arrested for forgery or fraud
84	Selfish old gentleman, oblivious to the event
85	Criminal's wife
86	Guard

below: fig.35

A swell is accosted by a member of the lower orders

Fun (6 September 1862)

opposite top: fig.36

Station crowd,

Illustrated London News (2 August, 1856)

opposite bottom: fig.37

William McConnell, Station crowd.
G.A. Sala, *Twice Round the Clock,* 1859.

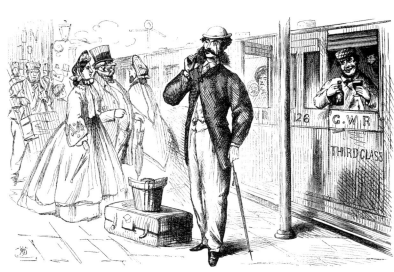

THIRD-CLASS CIVILITY.

Swell :—"Aw—Portaw! Portaw!"
Obliging Traveller :—"Hi! 'ere yer are, my toolip! 'ave a pull?"

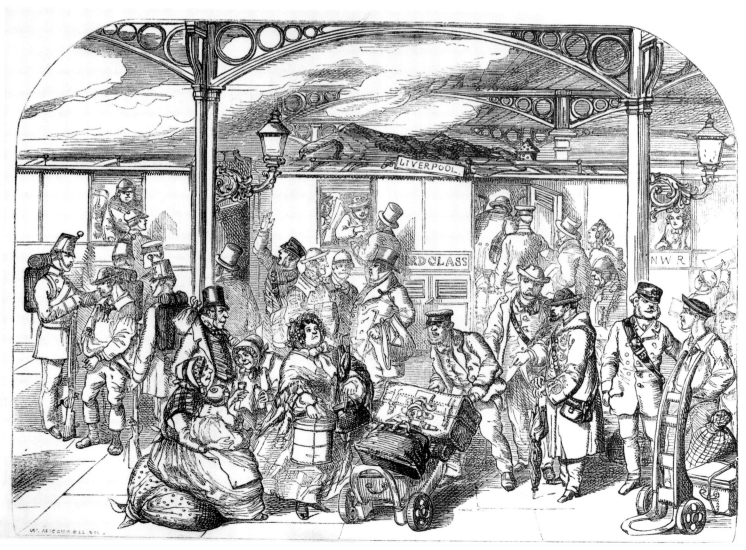

panoramic pictures of modern British life. The setting reflects that affirmative response to industrial progress which had been celebrated in the Great Exhibition of 1851, but which was scarcely to outlast the decade. The main appeal is, again, to the interest in contemporary human types, all of them identifiable, and described in detail in a hefty pamphlet by Tom Taylor which accompanied the painting's exhibition.

From an anthropological point of view, the choice was apt. Hippolyte Taine was amongst those who recommended 'a railway-station platform'[31] as a good viewing point for the observation of character and class; and Tom Taylor suggested that the painting itself should be examined in just the same way 'as we might scan some actual crowd on a railway platform, if time and train would stay for us'.[32] All were aware, as one of the critics said of 'the amusing variety of character invariably to be met with at such a place and at such a juncture',[33] and were able to bring to the painting habitual expectations developed from experience with real life railway station crowds. All town dwellers would have felt an affinity with this scene: with its types, incidents and dramas; 'for who has not', as the *Art Journal* critic asked, 'some time or other, watched the varied groups assembled at a railway station?'[34]

The novel combination of modern technology and anthropology made railway scenes popular with illustrators. Sometimes the artist merely records contrasting types, as in fig.36: the agitated middle-class gentleman to the left, the disdainful swell, the foreigner in the wide brimmed hat, and the fast sporting type at the right, evidently up to no good, whose criminal associate is seated in the carriage. William McConnell's platform crowd (fig.37) is confined to the third class, and includes, like Frith's, a group of soldiers with a raw recruit, a pair of foreigners, a sailor, a rather less helpful porter than those Frith shows, oblivious of the overladen woman whom he almost runs into; and various other people whose physiognomies reflect their low social status. At other times, the artist favours an amusing social interchange, such as that between the swell who is directly accosted by the hospitable third class traveller in fig.35.

Frith's cleverly organized groups surge across the painting to culminate at the far right in the dramatic arrest group. The lofty pillars and roof girders of Paddington station, and its handsome glass lanterns (painted for Frith – who confessed to being hopeless at perspective – by a young architect, W. Scott Morton) soar above the crowd. Diligent porters busy themselves amongst the passengers and lift excess baggage onto the carriage roofs. The engine – copied from a photograph of a real one called 'The Sultan' – gathers steam, watched by the small figure of Louis V.

Flatow, the print dealer who planned every detail of the painting in conjunction with Frith, in what was a carefully calculated business venture. To the far left, a sportsman secures his dog's lead in preparation for the journey. Behind him, an elderly respectable woman has been caught out in trying to smuggle her Maltese terrier onto the train under her cloak. Her daughter, in smart 'pork-pie' hat, looks daggers at the official who insists that the beloved pet must travel in the dog-wagon. To the right of them, a family in a panic and a lady with a trolley-full of luggage pushed by a straining porter, lead the eye towards the central group, which portrays Frith and his own family (fig.38). Clad in a fashionable paisley shawl and off-the-brow bonnet, Mrs Frith kisses a younger son goodbye as he sets off for his first term at boarding school, clutching a new cricket bat. The eldest son is less sanguine; he has been to school before and knows the worst. His father clasps an encouraging hand on his shoulder, while the boy valiantly fights back the tears. His sister fixes her eyes pleadingly on his face, longing to kiss him, but not daring to risk upsetting his precariously maintained equilibrium. The youngest boy, whip in hand, gazes in wonderment at this, his first view of a railway station. Behind them, a young wife, with her baby, wishes her sailor-husband a tearful goodbye as he sets off on a long voyage. In happier mood, the family of the recruiting serjeant prepare for a briefer parting as he returns to barracks with his new recruits, identified by the tassels in their caps. In front of them, a cabby bullies a distraught foreigner for further payment, while the wife prepares to do battle. To the right, a young bride and her sister bride's-maids form the most brilliant highlight of the whole scene, as she prepares to leave for her honeymoon and a new life without them. Her little sister weeps, unable to comprehend why she should go, while an infant brother plays the 'little man' in his grave attempts to comfort her. He is assisted by a buxom nurse who bends solicitously over the girl, attempting to laugh away her tears. With an assumed air of dignity and nonchalance, the young husband hands his wife's jewel-case to his manservant – conscious of his newly acquired responsibilities. In contrast with their bright future is that of the arrested criminal. The business-like black suits of the two police-serjeants throw into high relief their pale, satisfied faces as they lay hands on their man and present the warrant, handcuffs at the ready. Both the criminal and his wife, who is already inside the compartment, recoil in horror, while an elderly gentleman, seated comfortably inside, remains selfishly oblivious to the drama enacted so close to him.

• • •

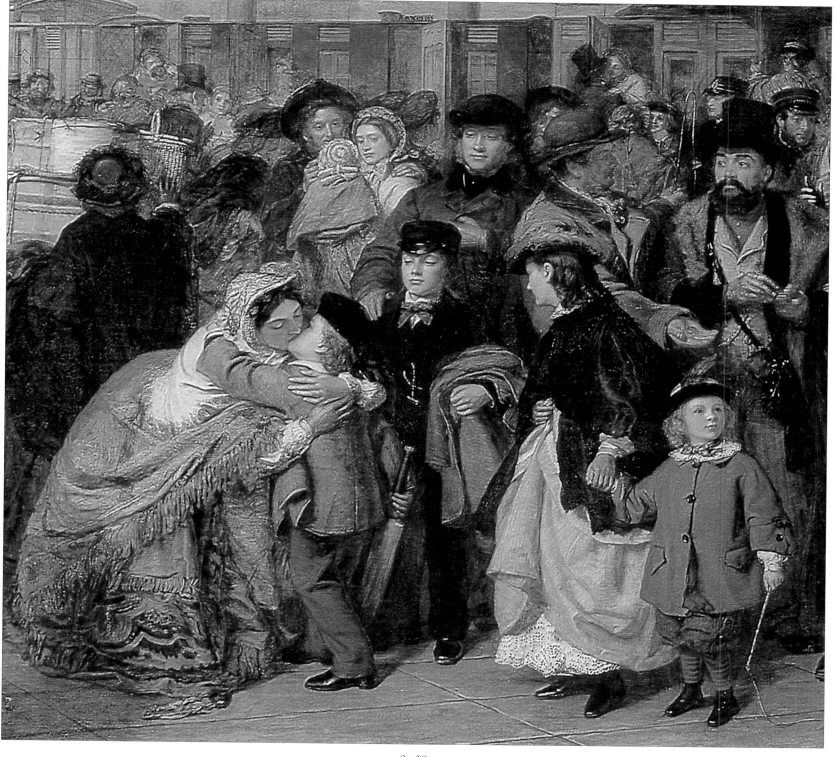

fig.38
Detail of fig.34

THE YOUNG GENT WHO IS GOING TO MAKE A RAPID FORTUNE
BY BETTING.

right: fig.39
**John Leech,
'The Young Gent who is going to make
a fortune by betting',**
Punch, 1852, 250

far right: fig.40
An overdressed 'Gent'
Fun (7 June, 1862)

There are more than eighty identifiable figures in both the *Derby Day* and the *Railway Station*, each individually characterized and involved in one or other of the group situations through which Frith so cleverly organizes and dramatizes his crowd. To examine just two types in detail will give some idea of the interest which such a picture offered to an informed contemporary eye, well acquainted with all those depicted.

One of the most striking of the vignettes which make up Frith's *Derby Day* crowd is that of the criminal gang of thimble riggers, and the young city clerk whom they have cheated of his last penny, not to mention his watch and shirt studs (fig.29). Frith was an avowed physiognomist, describing the face as 'a sure index of character'.[35] He was also a master of expression. In this group, the debauched, jeering faces of the fraudsters contrast appropriately with the child-like bewilderment of their young victim. The little city 'gent' was an instantly identifiable type; a great favourite with the *Punch* artist, John Leech, who, like Frith, had a sharp but sympathetic eye for the characters and types of the day. 'The Young Gent who is going to make a fortune by betting' at the Derby of 1852 (fig.39), corresponds exactly with Frith's and Egley's (fig.27), in dress, as in youthful folly and affectation; and an example from *Fun* provides a wonderfully degenerate specimen, complete with cigar, monocle, and overladen watch chain (fig.40). James Campbell supplies a further example of the type (Chapter 1, fig.35).

Frith had brought to bear on the Little Gent every popular idea and preconception. In 1847, that omnivorous observer of London types, Albert Smith, had written a book significantly entitled *The Natural History of the Gent* - one of a whole series of 'natural histories' about contemporary types - classifying the species as 'a race by themselves', one which had been neglected so far by what Smith called 'social naturalists'.[36] Making good the omission, Smith proceeded to investigate the gent in all his varieties, since when he had received constant attention from both artists and writers.

The little gent, in real life, was recognized as a new urban type generated by the modern commercialism of London; living proof, it seemed, that town conditions stimulated both physical and psychological diversity. Charles Kingsley singled out the Gent as specifically 'a creature of the city; as all city influences bear at once on him more than on any other class'; with the result that he exhibited 'the best and the worst effects of modern city life'. Kingsley enlarged on how

'The perpetual stream of human faces, the innumerable objects of interest in every shop window, are enough to excite the mind to action, which is increased by the simple fact of speaking to fifty different human beings in the day instead of five. Now in the city-bred youth this excited state of mind is chronic, permanent. It is denoted plainly enough by the difference between the countryman's face and that of the townsman. The former in its best type... composed, silent, self-contained, often stately, often listless; the latter mobile, eager, observant, often brilliant, often self-conscious.'[37]

As late as 1900, one anthropologist pointed out the tendency of such town-bred types towards nervous excitability, and a lack of 'self-reliance, and... those solid and lasting qualities which characterise their country-bred brethren.'[38] Frith deliberately contrasts the little gent with the solidly built, stolid-fea-

tured young countryman on his right, thus emphasizing his fee-
ble frame and delicate features. Facility rather than depth of
both intellect and feeling, were associated with the type; hence
the *Athenaeum's* reference to his 'very narrow brain',[39] which
betokens quickness of intellect rather than force or endurance.
The delicate face, small jaw and frail physique are carefully cho-
sen in accordance with physiognomical expectation. His
expression, too, is appropriate. Although the most refined sen-
sations were denied him, he was allowed a quite complex
degree of the kind of fretful emotion associated with so highly
strung a type. Reactions to the mingled expression of Frith's
gent suggest this to have been admirably indicated, variously
interpreted as that of 'almost heart-broken despair', 'comical
despair', 'speechless wonder', rueful bewilderment', and 'blank
stupefaction'.[40]

All sorts of other ideas and associations which attached to the
type of young gent were brought into play. Frith had chosen
well in placing him in his present predicament. The 'cockney
gamester' or 'dandy shopman in his Sunday suit', throwing
down his money 'with all the eagerness of certain gain' was a
familiar dupe at the racecourse.[41] His folly and simplicity; his
reputation for attempting to play the man while remaining
somewhat ingenuous and inexperienced; his known precocity
in the pursuit of worldly vices – which inclined, as Charles
Kingsley said, to 'vulgar foppery and betting'; all helped to
explain the painful situation of Frith's example: that of having
been robbed of all his wealth by the thimble riggers.

Appealing to what was popularly assumed true of his physi-
cal and moral nature, Frith had produced a type who would be
immediately recognized and understood; one who brought
with him from life all sorts of ideas and associations which
helped to explain and make credible his position within the pic-
ture. Added interest derived from his topicality. Very much a
product of the Early Victorian period, he was soon to become
'extinct'. Writing in the 1880s, Lord Brabazon looked back on
this very type, 'the effeminate shop-clerk, against whom *Punch*
at the time of the Crimean war, used never to be weary of lev-
elling the shafts of his ridicule'; a type already weeded out, as
the author explained, in the evolutionary process, as the result
of the tendency towards more exercise and healthier habits
which prevailed later in the century.[42]

Every figure in Frith's two paintings might be analysed in this
same way. Suffice it to choose one more type, equally well-
marked, and even more notorious: the criminal type. Not only
do examples appear in both the *Derby Day* and the *Railway
Station*, but the criminal illustrates particularly well the dynam-
ic nature of the type; its ongoing development through the

accumulation of evidence acquired in real life, affirmed in art,
and supported by scientific enquiry.

Frith had good reason to render the criminals who make up
the thimble rigging gang convincingly (fig.29). On his first visit
to the Derby in 1856, he had been saved only by the interven-
tion of his friend and fellow artist, Augustus Egg, from a simi-
lar group including a fake cleric – a Quaker like the one in the
painting. The critics were unanimous on the point of their
authenticity, one describing them as 'veritable types of their
class'; another as 'heartless bloodsuckers' and 'ghouls'.[43] The
'sham countryman', and 'Jew swindler' handling the watch and
chain with the Scotsman, were all identified; and it is interest-
ing that the *Art Review* recognized the thimble rigger at the
table as 'Irish'.[44] He has a physiognomy popularly regarded as
just that – with snub nose, heavy face, long upper and promi-
nent lower lip. He is of the same type which Doyle also select-
ed as suitable for the thimble rigger in his own illustration of
the *Derby Day* (fig.32). All share the kind of features mentioned
by anthropologists who refer to the 'Celtic' type. In Frith's
painting, the man selling race cards to the right of the thimble
riggers also has an 'Irish' physiognomy, the jaw distinctly prog-
nathous, and with the long upper lip also associated with a
'race' rated low in the scale of human development.

Frith had made clear the moral ugliness of such types
through their physiognomies. The coarseness of their features
and facial muscles, the texture of their skin, and their various,
but uniformly unpleasant expressions, all identify them. The
eyes – the most spiritual feature of all – are comparatively small;
the flesh of their faces coarse-grained and dissipated. All have
heavy faces, that of the Jew showing to best advantage. As he
peers closely at the Gent's watch chain, his jowls gather in
creases over his cravat. The sanctimonious expression of the
Quaker; the mocking leer of the Scot, as he looks with con-
tempt at his victim; the ill-bred cockiness of the Irishman; and
the avariciousness of the Jew, all help to reinforce the disrep-
utable nature of this group: a band of pariahs who prey on the
respectable and the gullible. The trick centred on the use of a
false pea, made from a piece of rolled bread which could be
picked up on the edge of the thimble, details of which were
given in the *Illustrated London News* in 1842. The thimblers pic-
tured (fig.41) share exactly the same physiognomical charac-
teristics: heavy faces, lumpen features and ravaged skin. That
such villains should be rendered as the ugliest persons in Frith's
painting seems reasonable, even now, and it has remained a con-
vention of illustration and of drama. But we are aware, apart
from the possible effect of consistently evil thoughts and acti-
vities on the expression, that there is no relation between facial

fig. 41
Thimble-riggers
Illustrated London News
(11 June 1842)

beauty and moral excellence. In Frith's time, it was one of the first assumptions of physiognomy, and a most useful aid to the reading of types in narrative painting.

The criminal was regarded as constituting a race apart. Mayhew and Binny thought the type 'as worthy of study in an ethnological point of view, as those of the people of other countries'; as distinct from the average law-abiding citizen 'as the Malay is from the Caucasian tribe'.[45] Moralists agreed on this point. Harriet Martineau talked of habitual criminals as 'a sort of criminal race, – an order as clearly marked to the eye of the police and the prison-inspector as the gypsies are to us all'.[46] Henry Maudsley agreed that the criminal class 'constitutes a degenerate or morbid variety of mankind, marked by peculiar low physical and mental' characteristics which distinguished them from their fellows as clearly as 'black-faced sheep... from other breeds'.[47] Such ideas culminated in Cesare Lombroso's attempt to establish criminal anthropology as a true science. Drawing on evolutionary theory in his renowned study of *Criminal Man*, Lombroso argued that the born criminal was an atavistic form of humanity – a 'throw-back' to a more primitive type, and always identifiable by certain physiognomical signs or 'stigmata'. Although features varied widely, deformity was the unifying characteristic. In a review of Lombroso's book, the *British Medical Journal* agreed that the criminal was recognizable as a distinct type,

'presenting physical as well as mental characteristics which separate him from ordinary men. That this is true to a certain extent, no one who has seen anything of criminals, or who has ever paid a visit to the chamber of horrors of a waxwork exhibition, can possibly doubt.'[48]

Few would have disputed this point. As one writer for *Household Words* roundly put it:

'Between the head of a Shakespeare or a Bacon, and that of a Newgate murderer, there is as much difference as between a stately palace standing apart and a rotting hovel in a blind alley.'[49]

Such comments are by no mean unusual. The harshest judgements were meted out on purely physiognomical grounds. Harriet Martineau expected the predisposition towards evil to be manifest to such a degree, that a policeman could recognize even at a distance not only those who had been, but those who 'ought to be, or will be, convicts';[50] and Charles Dickens judged the cast of the head of the noted resurrectionist and murderer, John Bishop, as

'exhibiting a style of head and set of features, which might have afforded sufficient moral grounds for his instant execution at any time, even had there been no other evidence against him.'[51]

The criminal physiognomy is always in some way disproportionate or irregular. Any deformity might be incorporated into the system, but the basic features are a proportionately large jaw and face in relation to forehead and skull, indicating a predominance of the senses and, consequently, a disposition to crime. Predictably, the criminal type shades into the low-class type, as also towards the 'lower' races, but with the animal tendencies exaggerated. J.F. Sullivan's illustrations to the *British Working*

Man (1878) make this clear, and Leech, John Tenniel and Du Maurier supply numerous examples. This animal type of face, is the kind which Frith gives to his *Derby Day* and *Railway Station* villains, though without the exaggeration allowable in illustration; and a youthful example with low forehead and protruding jaw is illustrated in Hicks's pickpocket, mentioned above, who appears to the left of the *Post Office* (fig.63). Frith himself makes considerable reference to his interest and belief in criminal physiognomy in his writings, and critical reactions provide ample proof that he successfully conformed to the popular image of the type.

In the *Derby Day*, the real villain was distinguished amongst a group of picturesque rogues as the potential killer. In the *Railway Station*, a comparatively small background figure, he was immediately pounced on and heartily condemned by all the critics. In the *Derby Day*, the character in question is to the left of the thimble riggers (fig.29). He wears a green coat and is brandishing a banknote, encouraging others to place a bet with the fraudulent gang. To a modern eye he is not conspicuously villainous, but to contemporaries skilled in recognizing the criminal physiognomy, his character was unmistakable. It is also possible that Frith had been rather clever here. Not only had he ensured that the physiognomy identified the criminal, but through it and the man's evident social standing, he deliberately seems to have recalled a man who, though hanged thirty-four years previously, was still regarded as the archetypal cold-blooded murderer - John Thurtell. Dickens, writing in 1856, refers to him as 'one of the murderers best remembered in England'; and as late as 1887 Frith himself could claim the circumstances of Thurtell's crime to be 'so well known as to render any recapitulation of them... unnecessary.'[52] Most pertinent of all is Thurtell's association with Physiognomy and Phrenology. Interest in the new science of Phrenology was at its height in 1823, and both its supporters and detractors saw Thurtell as the ideal guinea pig for proving or disproving the science's claims. Sir Thomas Lawrence, then President of the Royal Academy, was amongst those who requested permission to make a cast of Thurtell's head, and William Mulready's drawings of Thurtell and other murderers are preserved in his portfolios at the Victoria and Albert Museum. Within hours of Thurtell's death, casts had been taken by the celebrated phrenologist James Deville, whose collection in the Strand was to be recommended by the *Art Journal* in 1852. And Frith himself had a particularly good reason for remembering Thurtell; for he reports that the original casts from his head and body were kept at Sass's Academy, where Frith and so many other artists of his generation received their early training, Sass having been a good friend of Deville. Frith reports the eyelashes as still adhering to the plaster, the practice being to initiate newcomers into the school by forcibly rubbing their noses into them. That the memory of John Thurtell was firmly impressed upon many an art student by this method cannot be doubted.[53]

In the *Derby Day*, the man with the note was instantly recognized as a distinct physical, moral and social type, as was his associate with the whip who wears a plum coloured coat. The *Athenaeum* actually conflates the two figures at one point, an understandable error. Although turned away, making it impossible to 'read the character of the man in his face', another reviewer had no doubt of his companion that

'we know him by his build, his attitude, his attire. You feel that he is a man who would stick at nothing, and not the sort of individual you would prefer to go out with for a quiet moonlight ride, especially if you had money about you.'[54]

The writer appears to be recalling the circumstances of Thurtell's crime, since the details correspond exactly.

The physiognomy of the man with the note is clearly shown, and together with his dress - that of a fake country farmer - it was enough to identify him as a particularly evil member of the thimble-rigging gang. The *Athenaeum* actually referred to him as 'a Thurtell sort of man', his notes 'perhaps bloodily got'; and elsewhere he was identified as a daring thief and potential murderer.[55] A close description of Thurtell's physiognomy, which appeared in the *Medical Adviser* (17 January 1824), and drawings made at his trial, are of a similar type to Frith's; and there is even some slight resemblance between these and the highly glamorized wax head of Thurtell - an artist's impression and not a mask - which still survives in Madame Tussauds's store (fig.42).

One begins to understand how such types were perpetuated. As one who coincidentally conformed to the popular conception of the criminal type, Thurtell gave credence to the idea. He might thus supply a likely model for any artist who wished to represent a type of the criminal class. Frith, believing as he did in physiognomy, would have sought out a model according to his usual practice of searching religiously for a type which conformed sufficiently to popular expectation.

It was the public's familiarity with such firmly established physiognomical ideas that enabled the *Railway Station* villain to be recognized with equal certitude. The real villain of the piece is not the more gentlemanly criminal - the fraudster or forger - undergoing conspicuous arrest to the right of the painting, but a comparatively small background figure (fig.43). His head is covered by a sealskin cap, itself a sign of low standing; but the

rest of his face, which is heavy, immobile, coarse and altogether indicative of low development, is obviously intended to bear an unfavourable relationship in size to his forehead and general cranial capacity. His heavy brows, bulbous nose and protruding, sensual lips, mark him as a reprobate. The critics certainly read the type so. The uniformity of their reaction, and the amount of information divulged by him, show just how powerfully a well marked physiognomy could operate in narrative art.

The man's bad 'breed' explained his degenerate nature, manifesting itself as Tom Taylor claimed 'in look and dress alike - the low brow, flattened nose, and gapped teeth'.[56] This must have been an assumption on Taylor's part, for the teeth are not visible. In his own study, Lombroso concluded that the criminal's teeth were always abnormal, gaps being one of a number of associated features.[57] In Taylor's time, the idea was simply one of many attached to the criminal type, under the assumption that every feature must somehow indicate abnormality. The physiognomical signs were clear. His 'coarse, ungainly, and inanimate face' clearly betokened 'a brutish nature'[58] and enabled the critics to draw conclusions as to his social background, his bad habits, and his probable career. Taylor felt confident in identifying him as

'a choice fruit of the Westminster slums; a costermonger, perhaps, by calling, but by habit a haunter of villainous free-and-easys, and an oracle of low sporting taps and gin-shops... an occasional skittle-sharp, and possible burglar, of the class described in the newspapers as "well-known to the police."'[59]

Described also as an 'ugly gallows bird', a debauched 'wasted town sot', 'a London scamp reduced to extremities' and 'a roue of the public-house and the stables'; a bad end was almost universally predicted for him. The *St. James's Chronicle* concluded that 'the bearing and demeanour of the man' gave little hope for an end to a career 'of crime and folly'. William Michael Rossetti was somewhat kinder in judging him to be 'less an ingrained rascal than a low fool with a natural tendency to continue sinking'; but the consensus was highly unfavourable.[60]

• • •

In the case of the criminal type, Frith had drawn a powerful and uniform response from the critics through observing the physiognomical conventions. His references to social class equally appealed to popular belief and prejudice.

Frith had chosen his subjects well. The mixing of classes which was inevitable in such a public event as the Derby was further enhanced by the fact that, for the one day only, conventional class barriers were dropped. This 'temporary saturnalia of social equality', as the *Illustrated London News* described it, was the one day of the year when people were prepared to 'positively hob and nob with those palpably inferior to them in station... Liberty, equality, and fraternity' being qualities 'very strongly insisted upon on the Derby Day'.[61] The Derby Day was a unique event: 'the great leveller'; the day when 'poverty elbows pride, and wretchedness stalks cheek-by-jowl with wealth... the snob pushes by the gentleman, and the cad insinuates himself amongst the cream of the land.'[62]

It is a pertinent fact that the upper-classes were in the habit of touring the encampments of Irish gypsies and other itinerants before the races began, viewing the inhabitants as a novel and foreign species. The *Illustrated London News* wrote of them as 'a genus apart... a congeries of nomadic tribes, real Arabs of the desert', recalling once again the anthropological terms in which both individuals and classes were habitually viewed.[63] And indeed, the contrasts were marked. In the splendour of their rich and formal clothes, which did much towards imposing a distinctive expression and bearing, together with the consequences of superior diet, health and cleanliness, the upper-classes might well appear to be a separate species from the lower.

Most illustrations of the event refer to the mixing of classes on this unique occasion. Almost a decade earlier, Richard Doyle had made many of the class references which Frith was to include, as also George Cruikshank in his later series of scraps (Figs.32 & 33). Other contemporary cartoons reflect the same interest. The journey to and from the Derby, especially the journey home where every stage of inebriation added to the fun and which consequently had become a legend in itself, was viewed with the same eye for marked class distinctions (fig.46); the physiognomies of the classes distinguished as clearly as the vehicles which reflect their status. The same interest is invariably confirmed by the commentaries attached to the illustrations. The road became a carnival where 'all Sorts and Conditions of Persons, great and small,'[64] were joined together in communal mirth, as Doyle and Leigh observed, providing a series of social contrasts with which no other country could compete. The *Illustrated London News* regularly pointed to the social significance of the stream of mixed vehicles that packed the roads both to and from Epsom, ranging from the stylish four-in-hand from a West End hotel, to a costermonger's cart with noisy Whitechapel group, and an elegant open phaeton, with its dazzling cluster of parasols, bonnets and summer muslins.[65]

When assembled on the Downs the crowd presented a virtual microcosm of contemporary society. The social contrast was

above left: fig. 42
Wax model of the murderer, John Thurtell,
1824. Formerly on display at Madame Tussaud's

fig. 43
W. Powell Frith, Low-class criminal type
The Railway Station, 1862 (detail)

a phenomenon which Frith was careful to preserve in his painting: upper-class people are placed beside the very lowest types, and members of the middle-classes mingle with both. To give just a broad indication of this: on the far left, in the *Derby Day*, outside the gambling tent, a lady of the *demi-monde* in the riding habit of a 'pretty horse-breaker' - the nick-name given to the high-class prostitutes who paraded daily in Rotten Row, in carriages or on horse-back; two green young aristocrats foolishly about to enter the tent; a respectable gentleman protesting to a police-man; a simple country couple; and the gang of cheats and vagabonds centred on the thimble-riggers, are all shown in close proximity. In the centre of the painting, a gathering of gypsy children and the family of poor acrobats occupy the foreground. Immediately behind them are placed the aristocratic parties in the carriages. The small crowd watching the acrobats includes respectable onlookers such as the German visitors, identifiable through hats, pipes and beards; and the stolid farmer and his wife, their provincial morals outraged at the sight of the gang of pickpocketing boys.

The inclusion of vicious, low-class types added considerably to the sensational element of the painting. Although some commentators approved of racing, on the very grounds that it tended to 'promote intercourse between different classes of society',[66] others were less sanguine as to the results of that mixing. J.E. Ritchie wrote disapprovingly of the turf as the place where 'our sporting nobles associate on an equality - chat and smoke with jockeys and trainers and other low-born people';[67] and the artist Henry O'Neil agreed on the dangers of the better classes mixing with 'jockeys, pugilists, and billiard-markers';[68] viewing such behaviour as a threat to domestic ties and social stability. In his famous diary, Charles Greville records the sight of Lord Stanley, later fifteenth Earl of Derby and Prime Minister of England (whose great-grandfather had founded the race), at Newmarket in 1851 'in the midst of a crowd of black-legs, betting men, and loose characters of every description, in uproarious spirits, chaffing, rowing and shouting with laughter and joking.' Stanley's evident enjoyment of the 'coarse merriment' he excited was something of which many people other

TASTE.

First Swell. "THAT'S A DEUCED NEAT STYLE OF PIN, CHARLEY!"
Second. "YA-AS—IT'S A PRETTY THING. A'VE GOT SET A SHIRT STUDS—AND AW—WAISTCOAT BUTT'NS TO MATCH—LOOK STUNNING AT NIGHT—'SURE YAH!"

above: fig. 44
Upper-class swells, John Leech, *Punch* 1853, 168

right: fig. 45
Lower class ugliness, John Leech, *Punch,* (26 April 1862)

than Greville would have disapproved.[69] The turf was acknowledged as a dangerous place where 'the lowest rise and the highest fall', where 'Boots becomes a squire, an earl's son becomes a felon'.[70] But although, as the *Illustrated London News* admitted, it was 'a most revolutionary gathering... clearly subversive of the proper distinctions which should always in a well-governed country exist between class and class', and a danger to the British Constitution if allowed to continue for more than three days; in its present limited state it could do little harm, and presented 'a most delightful and exhilarating scene'.[71]

No other subject could compete with the Derby on these grounds. In Frith's painting of the station crowd, far more of the characters are of the middle-classes; but within the limits of the situation, Frith maintained as much of a social and moral contrast as was credible. It was not until Gladstone's Cheap Trains Act of 1844 that third-class passengers were allowed to travel in covered coaches and with the first and second, instead of being attached to goods trains; and it was not until about 1860, two years after Frith's painting was exhibited, that third-class passengers were allowed to use the faster trains timed to leave Paddington at reasonable hours of the day.[72] Only in very recent years, then, had the station offered

so wide a cross-section of society, a fact which gave an added topicality to Frith's choice.

In *London Characters*, Mayhew and Binny were to point to the levelling qualities of the modern street; for it is there that 'the private soldier stops the Commander in Chief to ask him for a light,' where 'over-dressed shopmen sneer at seedy dukes', and where 'the flunkey ogles the lady'.[73] Such confrontations were a fact of modern city life; and what happened in the street was even more evident within the confines of the railway station. The picture fulfilled all expectations. The most aristocratic group of all, the bridal party, forms a brilliant contrast with the sombre arrest group to the far right, the members of which are middle-class, and with the low-class villain just behind them. Frith's own family, sedate and eminently respectable, contrasts with the evidently disorganized tradesman's bustling in from the left. Many different levels of society are indicated by various other characters: soldiers, sailors, sportsmen, and visitors from the country. Of the more obtrusive, the cabby – a belligerent 'bull-dog' type, thrusts himself amongst his social superiors, demanding more money from a nervous foreigner and his combative wife; and the railway officials make a more respectful foray amongst them. The result was judged to be a faithful

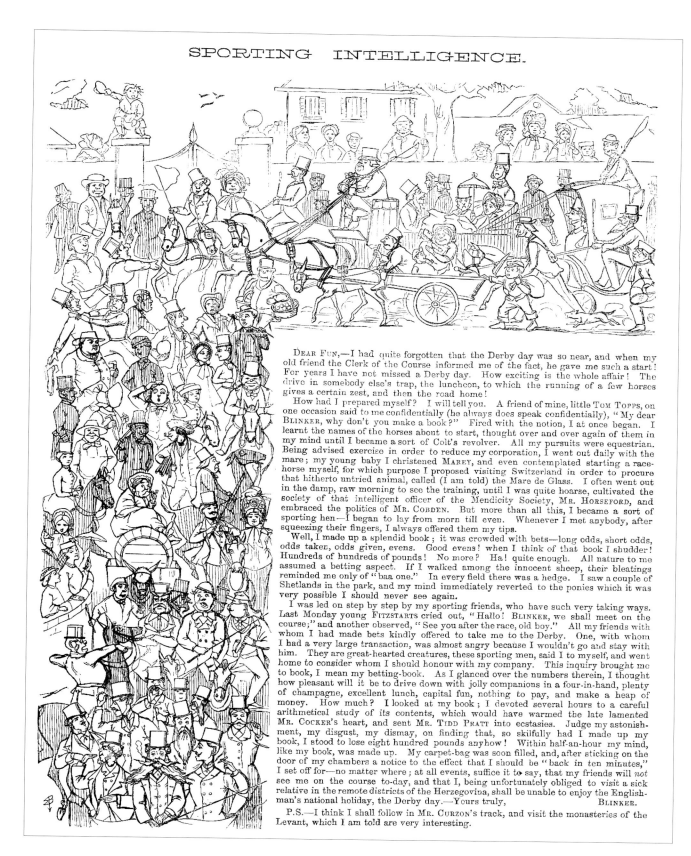

SPORTING INTELLIGENCE.

DEAR FUN,—I had quite forgotten that the Derby day was so near, and when my old friend the Clerk of the Course informed me of the fact, he gave me such a start! For years I have not missed a Derby day. How exciting is the whole affair! The drive in somebody else's trap, the luncheon, to which the running of a few horses gives a certain zest, and then the road home!

How had I prepared myself? I will tell you. A friend of mine, little TOM TOPPS, on one occasion said to me confidentially (he always does speak confidentially), "My dear BLINKER, why don't you make a book?" Fired with the notion, I at once began. I learnt the names of the horses about to start, thought over and over again of them in my mind until I became a sort of Colt's revolver. All my pursuits were equestrian. Being advised exercise in order to reduce my corporation, I went out daily with the mare; my young baby I christened MAREY, and even contemplated starting a race-horse myself, for which purpose I proposed visiting Switzerland in order to procure that hitherto untried animal, called (I am told) the Mare de Glass. I often went out in the damp, raw morning to see the training, until I was quite hoarse, cultivated the society of that intelligent officer of the Mendicity Society, MR. HORSEFORD, and embraced the politics of MR. COBDEN. But more than all this, I became a sort of sporting hen—I began to lay from morn till even. Whenever I met anybody, after squeezing their fingers, I always offered them my tips.

Well, I made up a splendid book; it was crowded with bets—long odds, short odds, odds taken, odds given, evens. Good evens! when I think of that book I shudder! Hundreds of hundreds of pounds! No more? Ha! quite enough. All nature to me assumed a betting aspect. If I walked among the innocent sheep, their bleatings reminded me only of "baa one." In every field there was a hedge. I saw a couple of Shetlands in the park, and my mind immediately reverted to the ponies which it was very possible I should never see again.

I was led on step by step by my sporting friends, who have such very taking ways. Last Monday young FITZSTARTS cried out, "Hallo! BLINKER, we shall meet on the course;" and another observed, "See you after the race, old boy." All my friends with whom I had made bets kindly offered to take me to the Derby. One, with whom I had a very large transaction, was almost angry because I wouldn't go and stay with him. They are great-hearted creatures, these sporting men, said I to myself, and went home to consider whom I should honour with my company. This inquiry brought me to book, I mean my betting-book. As I glanced over the numbers therein, I thought how pleasant will it be to drive down with jolly companions in a four-in-hand, plenty of champagne, excellent lunch, capital fun, nothing to pay, and make a heap of money. How much? I looked at my book; I devoted several hours to a careful arithmetical study of its contents, which would have warmed the late lamented MR. COCKER's heart, and sent MR. TIDD PRATT into ecstasies. Judge my astonishment, my disgust, my dismay, on finding that, so skilfully had I made up my book, I stood to lose eight hundred pounds anyhow! Within half-an-hour my mind, like my book, was made up. My carpet-bag was soon filled, and, after sticking on the door of my chambers a notice to the effect that I should be "back in ten minutes," I set off for—no matter where; at all events, suffice it to say, that my friends will *not* see me on the course to-day, and that I, being unfortunately obliged to visit a sick relative in the remote districts of the Herzegovina, shall be unable to enjoy the Englishman's national holiday, the Derby day.—Yours truly, BLINKER.

P.S.—I think I shall follow in MR. CURZON's track, and visit the monasteries of the Levant, which I am told are very interesting.

fig. 46

The road to the Derby

Fun (7 June, 1862)

fig. 47
W. Powell Frith, Aristocratic group
The Derby Day, 1858 (detail)

selection from London life: 'just the mingled classes which may be seen every day at our chief railway stations – and every one of them extraordinarily true to life.'[74] Even in the less prominent figures, Frith was acknowledged to have observed the contrasts to be found at railway stations when the train was about to depart.

The highlight of each painting is the aristocratic group. In the *Derby Day*, the aristocratic type, both male and female, was instantly recognizable (fig.47). The male examples bear a remarkable resemblance to a similar group illustrated in *Punch* in 1853, although Leech's view is satirical (fig.44). This long-headed, bony, so-called 'Norman' type of physiognomy, is equally observable in less attractive members of the upper-classes – for even ugliness had its class bias. In 1866 a writer in the *Cornhill* Magazine discussed the two contrasting types of ugliness – the genteel and the vulgar – in terms of evolution. The

genteel, defined as 'positive or redundant', has an excessively convex profile, with an aquiline nose. The vulgar form has a concave profile, and a flat, or snub, nose. As the writer explains: 'The one seems to have passed through the limits of beauty, the other never to have arrived at them.'[75] The former is a result of over-development; the latter has failed to evolve much beyond the lowest human level. In 1879 Grant Allen commented on how frequently *Punch* artists contrasted the two, accepting them as accurate representations of scientifically established human types.[76] This is a point worth emphasizing. Although amusing and exaggerated, cartoon characters were believed to have a firm basis in fact. Ruskin's admiration for the accuracy of the types drawn by John Leech, John Tenniel and George Du Maurier has already been mentioned. Du Maurier became the leading *Punch* artist after Leech's death in 1864, and in 1873 was credited by Ruskin as providing the most accurate record cur-

WHAT OUR ARTIST (THE INTENSELY PATRIOTIC ONE) HAS TO PUT UP WITH!

Just as he is pointing out to Monsieur Anatole Duclos, the Parisian Journalist, how infinitely the English type of female beauty (especially amongst our Aristocracy) transcends that of France, or any other Nation,—who should come up from the beach but Lady Lucretia Longstaff, and her five unmarried daughters!

"——AND AS FOR THOSE IDIOTIC OLD FRENCH CARICATURES OF *LES ANGLAISES*, WITH LONG GAUNT FACES, AND LONG PROTRUDING TEETH, AND LONG FLAT FEET—WHY, GOOD HEAVENS! MY DEAR DUCLOS, THE TYPE DOESN'T EVEN *EXIST*!"

fig. 48
Upper-class ugliness. George Du Maurier, Lady Lucretia Longstaffe and her five unmarried daughters
Punch (8 Sept. 1888)

rently available 'of the three Etats, or representative orders, of the British nation of our day.'[77] George Du Maurier includes many examples of the 'chinless wonder' in his *Punch* illustrations. In fig.48, the popular conception of upper-class ugliness takes the form of Lady Lucretia Longstaffe and her five unmarried daughters, while the low class equivalent is to be seen in John Leech's clod-like country boy, whose low forehead, turned up nose and lumpen cheeks bespeak coarseness of mind as well as body (fig.45). The Longstaffe's ugliness is a result of inbreeding, of over-refinement; while Leech's boy is an extreme example of an undeveloped type.

The same class distinctions as to form and feature even extended to the animal world. In fig.50, Edwin Landseer amusingly contrasts the highly bred deerhound, whose fine bone structure and profile echo those of his human counterparts, with the stout bull terrier lolling comfortably on a distinctly

proletarian doorstep. Responding to the latter as to a human being, Ruskin described him as one of the two most perfect exemplifications of vulgarity, allied with cunning, that he had ever encountered.[78] The tendency to find parallels between owners and their dogs is perfectly illustrated in the 'bull-dog' type who approaches a most unlikely customer in fig.49.

In his own portrayal, Frith strikes a happy medium between the essential qualities of strength and delicacy which were believed to be perfectly balanced in the true aristocrat. Slim, and tall in stature, the men have straight profiles, rounded but firm chins, aquiline noses - finely modelled with pronounced bridges, chiselled tips and delicately curved nostrils. The critics were all enthusiasm. A group of this kind was expected to provide the social highlight of every important race meeting, and Frith was not one to disappoint. There was no mistaking the 'high birth visible in every turn and feature'.[79] The male members of the

"Now, Marm, will yer buy? She's a good 'un at a cat, a ripper at a rat, and can tackle any dorg double her size fifty mile round. Ah! she's a booty!"

above right: fig.49
Bull-Terrier pups and matching owner, *Fun* (24 May 1862)

above middle and left: fig.50
Edwin Landseer, *High and Low Life,* 1829, Tate Gallery, 1999

group, identified as 'dashing Guardsmen' by one critic, and as officers of a kind by others, conform very closely to the prevalent view of what constituted the male ideal. The ladies exhibit a softer, more feminine version of the high class physiognomy. The quieter, more dignified lady to the right has, appropriately, a longer and more aquiline nose than her friend, whose nose is delicate but also slightly retroussé; a feature which accords with her more ardent expression and livelier attitude; but both are variations of the same feminine ideal. And physical beauty if deserved, seemed to entitle one to so much more. The refined features and expressions of the men, the elegance and grace of form, and the fact that they are worthy of paying homage to some of the 'loveliest of the blooming maidens of Mayfair', who could not be taken as anything other than 'unquestionable ladies',[80] were all signs of their superior moral worth. When one critic admired the 'bevy of fair... ladies gaily exchanging bets with some manly, handsome fellows, who look as though anyhow they must win',[81] this is certainly implied. In both the physical and social stakes, this group are the winners, and by implication they are virtuous also. The *Morning Herald* enthused over their superior condition, as if it were the fulfilment of natural law, praising them as 'persons of the highest respectability, accomplished manners, enjoying perfect health, and such natural beauty as can belong only to the pure and virtuous'.[82]

The aristocrat was regarded as the finest efflorescence of the superior Caucasian race. Centuries of good breeding explained the refined physiognomy and the high 'organic quality' observable in every aspect of the physical makeup. John Ruskin attempted on more than one occasion to define the difference between the gentleman and the vulgarian, in each case appealing to physical determinism. Ruskin devoted a chapter of *Modern Painters* Volume V, to the subject of 'Vulgarity', defining it as 'want of sensibility' – 'a deadness of the heart and body, resulting from prolonged, and especially from inherited conditions of "degeneracy"'. The 'Dulness of bodily sense and general stupidity' which characterizes the vulgarian, results in an 'inability to feel or conceive noble character or emotion.' Conversely, high organic quality – the fine racial inheritance of the true gentleman – provides a sensitivity of organization manifested in

'that fineness of structure in the body, which renders it capable of the most delicate sensation; and of structure in the mind which renders it capable of the most delicate sympathies – one may say, simply, "fineness of nature."'[83]

Instantly recognizable, organic quality was something 'inherited and not acquired'.[84] As Ruskin so forcibly put it, whatever a low born individual might achieve in the way of self-improvement, 'a wicked or foolish gentleman is still a gentleman – and an amiable or wise plebeian, still a plebeian – and the advantage of pure blood and descendant habit is not to be counterbalanced by any other – This is not flunkeyism – it is physical law.'[85]

opposite: fig.51
William Powell Frith, a dissolute aristocrat
Derby Day, 1858 (detail)

Holman Hunt, who suffered torments through the plebeian connotations of his own snub nose, identified Lord Lytton as a prime example of the pure Norman type. Hunt appears to have got somewhat carried away in describing Lytton's high-toned beauty as 'bespeaking a line of ancestors uncontaminated... since, shall we say, the Conqueror, or Adam';[86] but the Victorians had a soft spot for the aristocracy. Popular novels are full of similar examples. Lord Lynedale, in Charles Kingsley's Alton Locke, combines the ideals of delicacy and strength; delicacy deriving from the old 'Norman' race, as Kingsley explains, strength from a proletarian strain; for occasional 'cross-breeding' of the two classes was allowed to have occurred in the past in order to invigorate the aristocratic Norman, and to counteract its tendency towards over-refinement. Somehow, the aristocrat was expected to imbibe only the rude strength of the proletarian or peasant race and not its features.

Exceptions could be explained in terms of an immorality incompatible with the aristocrat's status, and consequent physi-cal degeneracy. In the *Derby Day*, the roué who leans against the carriage to the far right, callously ignoring his female companion - is a degenerate specimen, in contrast to the virtuous group further to the left (fig.51). However reprehensible the position of his female companion, might be, the critics reserved their invective for her lover - a thorough blackguard. The 'red, sickly eyelids' and 'nauseous, bloodless skin' of this 'weak headed drunken fop' and 'miserable jaded lover', made his appearance 'almost painfully vicious'. The *Morning Herald*, wishing on him the retribution which he so patently deserved, detected 'consumption on his cheeks' as well as 'exhaustion in his colour'.[87]

To a contemporary, there could be no mistaking his female companion. For one thing, it was a well-known fact that rich men, young and old, attended the Derby with women who were not their wives. In the collection of Derby Day characters in fig.33, top right, the artist jokingly acknowledges this kind of association as a part of the occasion. In the case of Frith's example, her physiognomy as well as her expression, and other atten-

dant clues, clearly identify the woman and her unfortunate position. Physiognomically, she is far less beautiful, according to current conventions, than the high-class ladies nearby or the other innocent ladies in the painting. Her low forehead, broad face and nose, dark hair and heavy eyebrows all hint at a passionate nature. She is a superior version of the female type included in Levin's *Covent Garden* (fig.65). Her expression is one of intense misery and remorse for the fact that it has been her own weakness that has brought her to this inevitable position. Recoiling from the gypsy fortune-teller who importunes her, it is clear that her future is black indeed. The heartless indifference of her lover as he lolls against the carriage with his back to her, completes the story. With all these clues, it is not surprising that the critics recognised her immediately as 'a splendidly dressed but evidently wretched English "traviata" under the protection of a heartless rich coxcomb'; as 'the guilty mistress already neglected'; and, rather more kindly, as a 'frail and fashionable lady'.[88]

Frith was really playing to the gallery, here. Sexual misconduct in women could never be condoned, a fact which provides the focus of Egg's trilogy of the same year (*Past and Present*, Tate Gallery) and out of which the popular novels of the day, such as Mrs. Henry Wood's *East Lynne* (1861), made great capital. Even if some sympathy might be felt for the erring woman, the general conclusion would be that her fate was an inevitable consequence of her sin; a situation which added considerably to the sensational element of the painting. The irony of this little group is heightened by the contrast it makes with the serene and ordered tenderness of the gentlemen to the left, and with the quiet contentment of the ladies which, like their beauty, is so thoroughly deserved. Vice has disturbed neither their beauty nor their equanimity, and their men friends are all attention.

In the *Railway Station*, the bridal party represented the highest class, but as the critics noted, less successfully (fig.52). The young man's features, though pleasant, lack the nobility expected of such a type. One critic thought him a coxcomb, while another referred to the beauty of both bride and groom as 'not quite the type it should have been.'[89] William Michael Rossetti also thought them a failure, acknowledging the benefits to be derived from the contemplation of good specimens of aristocratic beauty: 'The value of this group in redeeming the prose of the whole subject might', he says, have been 'considerable, if the figures were superior in beauty and refinement - but this is not the case... The whole family, though clearly intended to be aristocratic, have in reality an underbred air and get-up'. In his final summing up of the painting, Rossetti again expressed his regret that 'there is no... single figure... eminent for beauty or elegance' which might have raised the picture beyond the commonplace.[90]

Although widely admired, the aristocracy was not universally envied. Successful middle-class types were well satisfied with their own achievements, largely responsible as they were for the developments in industry and commerce which gave the Victorian age its essential character. The man of action did not necessarily aspire to the excessive refinement of the upper-classes, perceiving his own innate qualities as in many ways more admirable. In their own survey of the London crowd, Mayhew and Binny had found the physiognomies of middle-class bankers, lawyers, and similar types to be clearly distinguishable from the 'finely chiselled features of an English aristocrat'.[91] Energy, good sense and practicality were the sort of virtues associated with them. A self-styled 'Manchester Man,' boasted that in the men of commerce and industry, 'you discover nothing of that receding mouth which is somewhat indicative of high breeding, but betokens vacillation and want of will';[92] and Sir Francis Galton concluded that the 'thorough-bred looking Norman' had become 'unimportant to modern civilization', driven out by a new breed which was shaping the modern world and which was more powerful, both intellectually and physically.[93]

Frith was an avowed republican; a man of practical good sense who would not have envied either the life or the physiognomy of the aristocracy. He placed himself and his own family at the very centre of the picture, proudly representative of the middle-classes that formed the backbone of Victorian society (fig.38). A self-made man who could afford to send his own sons to Harrow, Frith chose to show the family in various states of emotion as the two boys set off for the start of a new term. Frith and his family were of a physical type to guarantee general approval from the British public. Socially poised and affluent, their bodily build and fair complexion also identified them as typically 'Saxon'. Mrs. Frith was admired as 'a comely English lady of true national type'; the middle boy as 'of genuine Anglo-Saxon mould, with fair complexion and golden locks'; and Frith himself as having a 'fair, ruddy Saxon face'.[94] The 'blonde, frank, and manly faces inherited from Saxon ancestors', as popularly conceived,[95] were as much admired in art and literature as in real life. The Saxon was regarded as the essential English type, the typical John Bull, and receives pride of place in Mackintosh's collection of racial types (fig.4, Nos.19-21). Mackintosh describes the typical Saxon as having regular features, with round, broad face, prominent light eyes and light brown hair. All other anthropological descriptions, as well as those from the novel, approximate to this. The general picture was thought of as that of the 'average' Englishman, so far as he existed: a man of medium height, build and complex-

ion. Anthropologists like Mackintosh were agreed on the 'Extreme moderation' of both his talents and faults; his soundness, straightforwardness and dependability all reflecting solid, middle-class values.[96]

Uniting so many admirable qualities, and so many attractive and representative characters: the dedicated, loving mother, the dependable, capable father, the affectionate and well-behaved children, Frith's conception of the average middle-class family, in the form of his own, was an instant success. It was fortunate that the public knew nothing of Frith's second family – his long-term mistress, whom he was later to marry, and the several children he had by her.

Frith did not fail to make considerable capital out of a family of a different class which appears to his immediate right, and to the left of the composition (fig.53). This family, though middle-class, is distinctly labelled 'Trade', a fact indicated as much in the facial features as in the undignified mode of progress. The woman provided much entertainment value in the form of a popular type, that of 'The Bustling Matron'. The fact that she is of the trade bracket, and her evident, and suitable, vulgarity, frequently recur in the reviews. She is seen as the perfect embodiment of that well-known type of the 'full-blown matron... the woman we all know and dread, the woman who always fancies she is too late', in a state of unnecessary panic 'clamorously dragging her meek husband and unresisting children' towards the train.[97]

The family illustrates perfectly what the *Cornhill Magazine* had to say about the catching of a train as a reliable test of good breeding, the point in question being the degree of equanimity with which the task might be accomplished:

'Watch different orders of persons proceeding to take the train... Persons of an inferior condition of life appear to be deeply tormented with the idea that they will fail to catch it... the whole business is with them one of haste and disquietude.'

Members of a higher grade of the middle-class while not manifesting 'so much incoherent solicitude as all this', remain 'fidgety and uncertain'; but a member of the superior class, with fine manners, is always perfectly cool in such circum-stances, and quite devoid of any such 'symptoms of gratuitous distress'.[98] The distinction is wonderfully exemplified in fig.54, where the third class passengers fall into riot and disorder, and most of the second class either awkwardly slouch along the platform or frantically scamper to get into the train, in contrast to the resolute calm of the first class passengers. Families similar to Frith's bustling tradespeople appear to the right-hand side of

below: fig.53
William Powell Frith, a family of the 'Trade' class
The Railway Station, 1862 (detail)

opposite: fig.54
'The Railway – First, Second and Third Class',
Illustrated London News (22 May 1847)

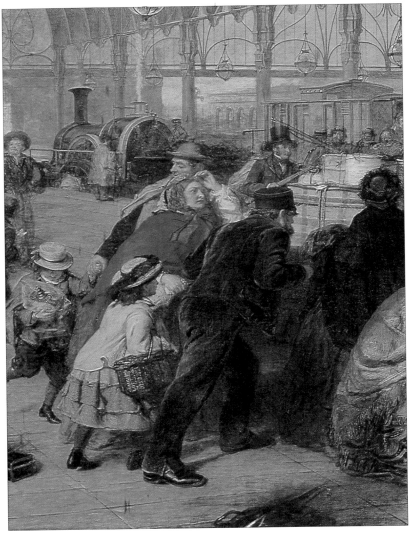

EPSOM RACES—1847.

THE RAILWAY—FIRST CLASS.

(Continued from page 325.)

crease, concludes the reader. Alas! for the *hosts* who could testify far otherwise. At the head-quarters of resort in the town of Epsom—where whilom, during the meeting week, you might as well have sought for a bed for yourself or a stall for your horse, as for that *lusus naturæ* that Diogenes looked for with his lantern—only one guest slept the night before the Derby, and three horses constituted the cavalry department! But what of that?

"Tempora mutantur nos et mutamur in illis."

SECOND CLASS.

HARRISON. Sc

THIRD CLASS.

135

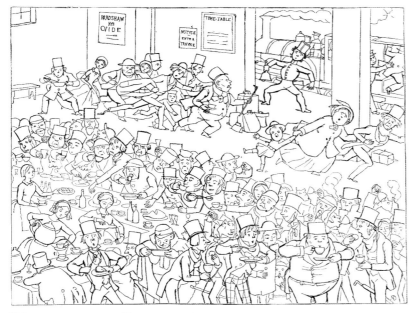

MANNERS·AND·CVSTOMS·OF·Yᵉ ENGLYSHE·IN·1849· Nᵒ 21.

A·RAYLWAY·STATYON· SHOWYNGE·Yᵉ TRAVELLERS·REFRESHYNGE·THEMSELVES·

above: fig.55
Richard Doyle, A railway station refreshment Room
Manner and Customes of Ye Englyshe in 1850

opposite: fig.56
William Powell Frith, a criminal arrested
The Railway Station, 1862 (detail)

Dickie Doyle's 'Railway Refreshment Room' (fig.55) where almost everyone is thrown into confusion as the train is announced, and in Alfred Hunt's illustration of Easter Monday excursionists, for the *Illustrated London News* (fig.18). The commentary on Hunt's group, identifying them as a tradesman's family in something of a panic, suggests that such behaviour was exactly what was expected of a family of that type and class.

The same satisfaction which was felt for the industrious and dependable porters was extended to two men of higher status: members of the middle-class, and maintainers of that state so dear to its fellow members: law and order. As in the case of the inclusion of his own family in the centre of the painting, and of Inspector Craig, a Paddington official (Key to fig.34, no.59), Frith had turned to life for his models: two Detective Sergeants, Michael Haydon and James Brett who had joined the City of London Police in 1841 and 1842 respectively, and who had acquired a reputation for pursuing and capturing criminals in the fraud and forgery line (fig.56). Taylor was eager to point out that these men were not 'conventional types of their class' as any one might expect them to be, 'but the real men... two of the most active and distinguished members of the force';[99] but even as portraits, Frith would still have been able to emphasize

those qualities which fulfilled the popular conception of the class to which these men belonged. Strong features, suggestive of energy and practicality characterize both of them; and Frith was judged to have rendered their expressions most admirably and appropriately, the *Standard* commending their 'blandly-smiling and agreeably-satisfied faces'.[100] The respectability of the pair is apparent even in their shiny top-hats and shoes, neat suits, and general demeanour; and one can sense the thankfulness of a law-abiding member of the middle classes for such a service as they were seen to provide. In Taylor's words: 'It is just such comely, well dressed, well-appointed persons' who, in real life, look after the kind of criminal whom they arrest here.[101] It is evident that they suffer from none of the defects which one anthropologist cited as affecting the feebler, city-bred type, unfitting them for police work.[102] Taylor placed the two in the Mr. Bucket class, and Dickens' introductory description of that character accords well enough with Frith's detectives: 'a stoutly built, steady-looking, sharp-eyed man in black, of about the middle age'; a 'composed and quiet listener' with 'nothing remarkable about him at first sight'.[103] Conscientiousness, quiet determination and tenacity were Mr. Bucket's distinguishing features, so that the comparison with Frith's detectives is well founded. James Brett attracted a particularly interesting response which illustrates the skill with which a contemporary critic was able to seek out the significance of even the slightest physiological detail and what it reveals as to character. The *Daily Telegraph* critic noted how 'the pressure of the detective's thumb upon the edge of the handcuffs he is holding' reveals 'the exact amount of the constriction of muscle', which in turn indicates exactly the level 'of mingled carefulness and confident ease'[104] appropriate to the occasion.

In the *Railway Station* the picturesque villains and gypsies of the *Derby Day* give way to more sober, everyday working-class types in the form of the station porters and inspectors and the decent young country-bred recruits, whose superior physiognomy distinguishes them from the proletarian criminal type already discussed. Scattered throughout the crowd, Frith presents the ideal type of urban worker - positively dedicated to providing a service; willingly assisting with bags or patiently waiting at the carriage door.

The critics found the porters convincingly true to life, providing the measure of Frith's conformity with what they looked for in men of this type. As one critic observed,

'Few figures in this elaborate painting are depicted with closer fidelity than are these horny-handed officials. We merely add this to show that, however truthful Mr. Frith may have

FIRST CLASS POLITENESS.

SECOND CLASS POLITENESS.

THIRD CLASS POLITENESS.

fig. 57
'Railway Politeness', *Punch* (8 March 1845)

been in the delineation of more interesting looking people, he has not failed to detail with exceeding minuteness those of less social status',[105]

Tom Taylor went so far as to say that

'The inspectors, guards and porters of the Paddington Station owe Mr. FRITH a testimonial. He has here painted types of them which, without being in any way untrue to nature, are impersonations of the ideal qualities of the class – strength, neatness, activity, civility, and attention to duty... all these men are doing precisely what they should be doing, and just as they should be doing it. If ever there were the right men in the right places, these Great Western Officials are.'[106]

Other critics similarly approved of Frith's image of the ideal worker; praising the men for being 'imperturbable... conscious of duty and office'; working 'busily but collectedly'; and maintaining a 'systematic composure' in all they did.[107]

Workers were not always perceived as so praiseworthy, and the physiognomy varied accordingly. Porters were often the butt of the satirist, who showed them to be a less angelic breed than Frith would suggest (fig.57). The behaviour of *Punch's* examples ranges from obsequiousness to downright rudeness, according to the status of the customer; and J.F. Sullivan presents a very unflattering picture of grasping, wheedling porters, with physiognomies to match, who prey upon the trusting nature of an elderly lady (fig.58).

In Frith's own painting some members of the lower classes fare less well than the porters. The cabby, for example, was generally regarded as a selfish, pugnacious type. As one who pursued a more independent line of business than the railway porters, he often displayed a healthy disrespect for his social superiors – a characteristic which Frith chose to emphasize. Frith's cabby is shown disputing his fare, a perennial habit, which Ford Madox Ford Hueffer amusingly describes in his recollections.[108] In this case, since the victim is an overdressed foreigner, another favourite type, no-one would have objected. The *Daily Telegraph* praised the cabby as 'the very type and model of his class... as unmistakably subdued to the element he works in as are the guards and porters occupied about the train'; a comment closely echoed in the other papers.[109] Frith had chosen the most salient type, the one which would most conform to how a cabby was expected to look, and which best summed up the popular conception of him. Taylor referred to him as 'an impersonation of British bull-doggedness'[110] and,

fig. 58

J. F. Sullivan, 'No Gratuities' – A Tale of the Railways,' *The British Working Man,* 1878

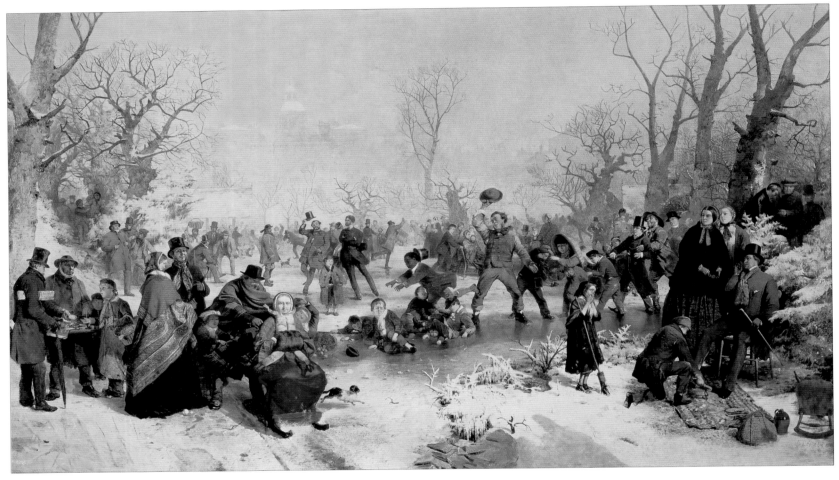

fig.59
John Ritchie,
A Winter's Day in St. James's Park
Private Collection. Photograph, Bridgeman Art Library

fig.60
Detail of fig.59

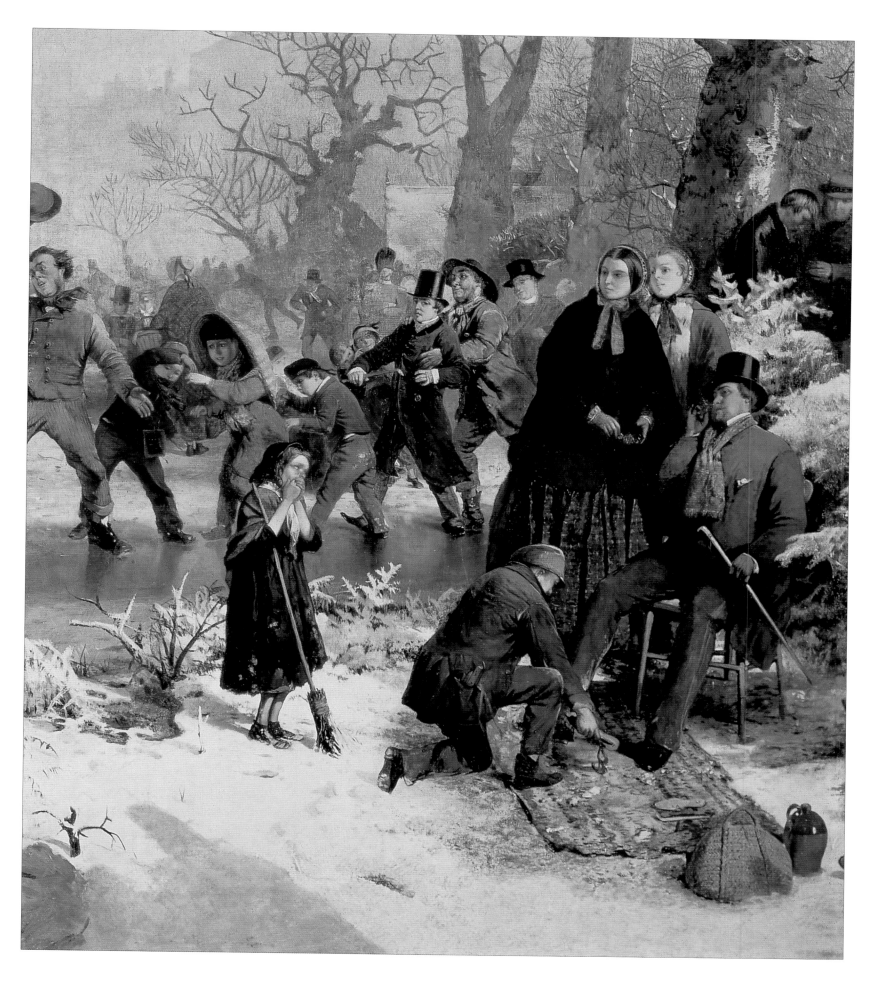

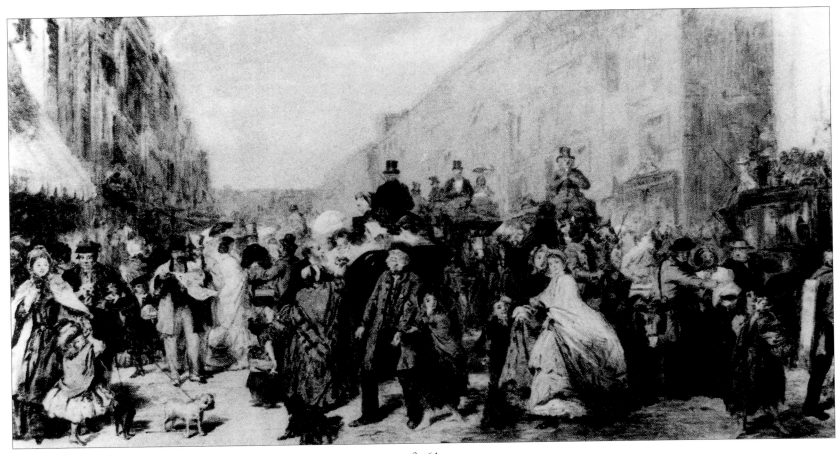

fig. 61
William Powell Frith, *Sketch for the Times of Day: Noon, Regent St.*
1862. Private Collection, untraced. Witt Library

indeed, he is a variety of the bull-dog type whose combative nature is indicated in many cartoons of the time.

To a twentieth century critic like Roger Fry, Frith's *Railway Station* represented the nadir of British art: 'an artistic Sodom and Gomorrah' from which the more poetic of the Pre-Raphaelites understandably 'fled... to save their souls by escaping at all costs... from the hideous present' glorified in such works.[111] Frith's paintings are far from being aesthetic objects, but they are of incalculable interest: veritable documents of contemporary society and important repositories of ideas and beliefs which have proved invaluable to later historians. Most regrettably, Frith's plan for three more London scenes only reached the sketch stage. *Morning: Covent Garden, Noon: Regent St.* and *Night: the Haymarket*, are full of the kind of characters and incidents which Frith delighted in recording. The busy *Regent St.* scene (fig.61) includes a dog-seller, a beggar girl with her blind grandfather, a crossing sweeper, and a puzzled foreigner with a map. Even in sketch form, the characteristics and costumes of the figures are clearly distinguished; as in, for example, the dog-seller's furtive expression, his 'fast' fur cap and side whiskers, the cheeky smile of the little crossing sweeper,

and the belligerent attitude of the burly cab driver. Frith's gifts for organizing a series of incidents into a convincing narrative, and for characterization, are as clear in this sketch as in his finished crowd scenes.

• • •

Frith was to have many followers, although they worked on a less ambitious scale. John Ritchie's pair, *A Summer Day in Hyde Park, A Winter Day in St. James's Park* (figs.62&59), and *Hampstead Heath* (1859, Private Collection), show Londoners enjoying various forms of outdoor recreation. In his Hyde Park scene, Ritchie gathers together a wide range of characters and classes on the edge of the Serpentine. Familiar types include the flirtatious soldier addressing himself to the nursemaid or young mother on the bench, to the disapproval of the elderly female beside her; a top-hatted gentleman, to the far left, reading a newspaper report of the Indian Mutiny; and a mixture of poor and rich children playing in close proximity - the former on a swing, improvised from a piece of rope tied to the railings. Others are shown engrossed in fishing and boating, and a

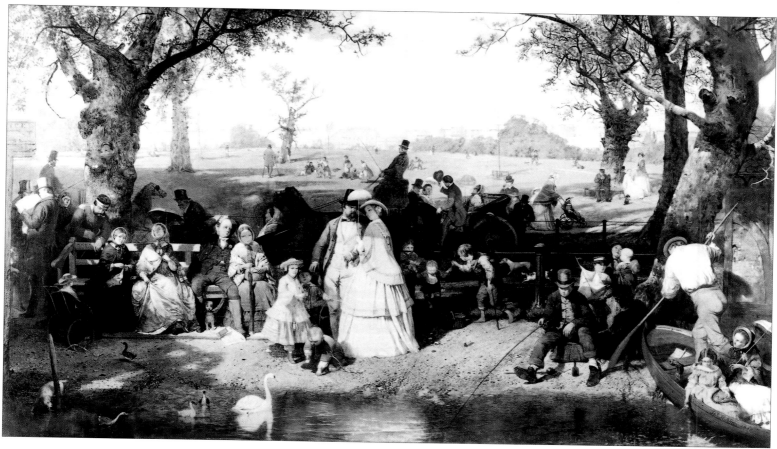

fig. 62
John Ritchie, *A Summer Day in Hyde Park*
1858. Museum of London

youthful pickpocket exercises his own trade to the left of the soldier. Behind the foreground figures, fashionable people greet each other as they take the air in their carriages and on horseback.

In his winter scene Ritchie includes a number of errand boys and older men who have taken time off from their labours to enjoy a skate on the frozen lake. The long shadows suggests that it is late afternoon. To the right, a scruffy but amiable costermonger assists a young swell to remain upright. Dressed in 'topper' and tight green coat, and grasping a jaunty cane, the gorgeous being evidently feels that his dignity has been affronted by the favour bestowed on him. A black page stumbles into a group of youngsters who have already collapsed on the ice, spilling a basket of oranges in the process. To the right, an elegant gentleman is being fitted with a pair of skates, observed by a thin little girl who blows on her cold, red hands. With the aid of a broom she hopes to make a few pennies by clearing paths through the snow. To the far left, a grocer's boy tentatively tenders payment for a pie or similar delicacy, hoping that it is sufficient. Beside him, a comfortably dressed family of three generations, the mother in red tippet

and paisley shawl, indulgently observe grandmamma who is enjoying a ride in a sledge-chair, warmly wrapped in muff and rug, while a King Charles spaniel leaps out of her way. Ritchie has captured exactly the feeling of a cold Dickensian winter. The ice is scattered with dry, powdery snow, which weighs down the grass and thistles by the side of the lake; icicles cluster thickly, and the branches of the leafless trees lie stark against the still air. Through the chill grey mist, the snowy rooftops and clocktower of William Kent's Horseguards, and J.B. Watson's picturesque Lodge, designed as an observation post for the Ornithological Society, appear in delicate outline.

Amongst Frith's contemporaries, George Elgar Hicks also had a keen eye for physiognomical distinctions. His London scenes include *Dividend Day. Bank of England* (1859), *Billingsgate Fish Market* (1861) and *Swindon Station* (1863), showing an interior view of the waiting room; the latter evidently inspired by Frith's *Railway Station*. This is probably also true of *Changing Homes* (Chapter 1 fig.23), which may have been suggested by the wedding episode in Frith's painting. Hicks's best known work (fig.63), the *General Post-Office. One Minute to Six*, was partly suggested by an article which had appeared in Dickens's

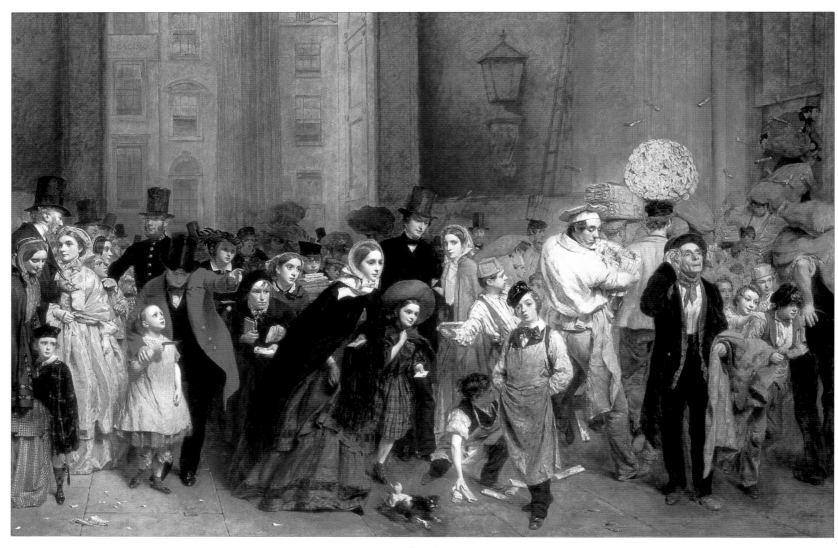

fig. 63
George Elgar Hicks
The General Post-Office – One Minute to Six
1860. Private Collection. Bridgeman Art Library

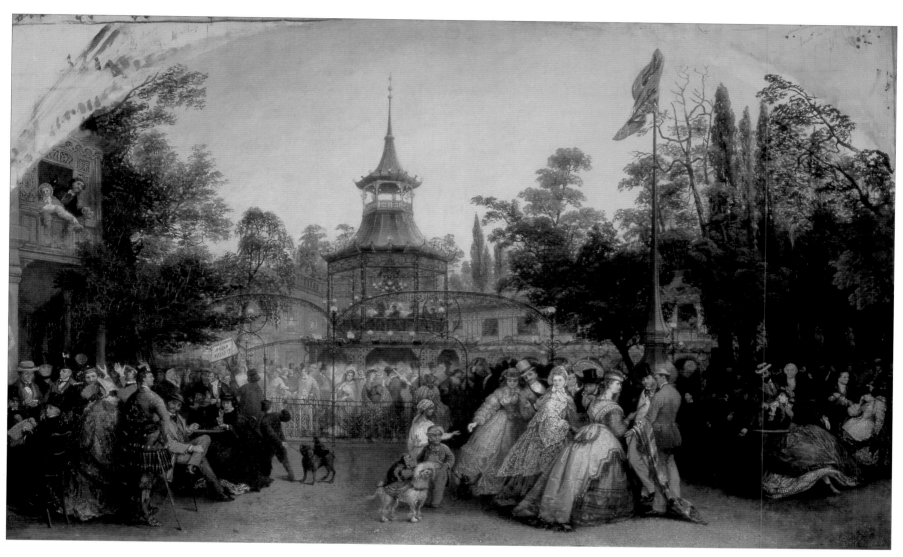

fig. 64
Phoebus Levin
Cremorne Gardens
1864

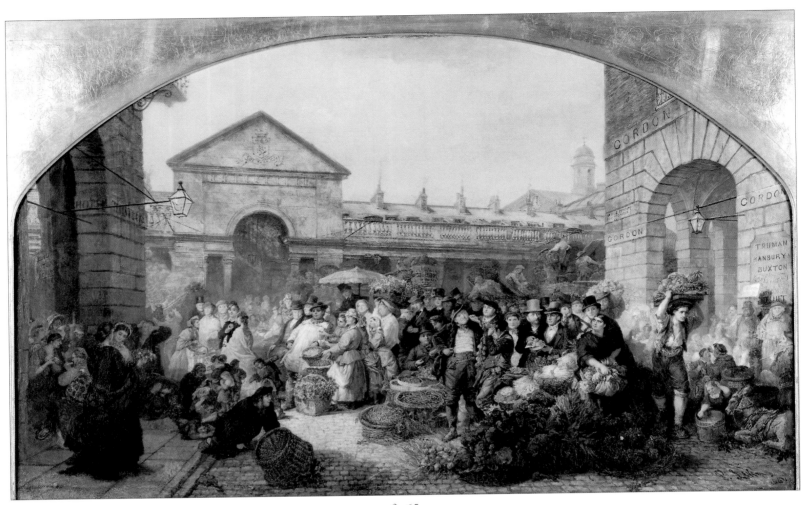

fig.65
Phoebus Levin, *Covent Garden*
1864. Museum of London

Household Words, describing what was, in the Victorian age, the busiest postal occasion of the year: St. Valentine's Day. Hicks clearly sought to suggest the chaotic nature of the crowd as it dashes to catch the post, although at the expense of the dramatic coherence of Frith's examples. To the far left, a small boy in Highland dress, shrinks nervously against his mother, awed by the bustle and the noise, while a vigilant policeman apprehends a suitably low-browed pickpocket engaged in robbing a well-dressed couple. A kindly red-coated official points a little girl in the right direction; beside him, a tough looking, determined youth and a servant girl press close on the heels of a fine-featured, well-dressed woman accompanied by her young daughter in a broad-brimmed hat. Numerous boys, both active and idle, many of them in the paper caps which were regularly worn for work, press towards the openings to the far right, where 'huge slits gape for letters, whole sashes yawn for newspapers,' and through which items are being hurled before the shutters close on the stroke of six.[112] His job done, an apron clad boy wanders from the scene, coolly whistling, his cap jauntily angled, while an elderly man mops his brow, relieved that he has managed to deliver the contents of his sack on time.

The Pre-Raphaelites were pioneers of serious pictures of contemporary life, but their painstaking technique meant that they rarely tackled crowds. Millais's vignettes of modern life, dating from the 1850s, do, however, provide interesting glimpses of them. Perhaps, like Frith, inspired by the *Punch* illustrations of his close friend, John Leech, they exhibit a response that is heart-felt but unsentimental, fired with that rare power of which Millais was capable when his emotional and intellectual energies were channelled towards some worthy object. In examples like his vignette of the *Derby Day, the Race Meeting*, showing the ruin of an aristocratic group (1853, Oxford, Ashmolean) and the *Blind Man* (fig.66), symbolist and realist tendencies combine in a way that gives them an added potency. In the latter, the idea of these rampant horses grating to a halt before the imperious gesture of the slight young

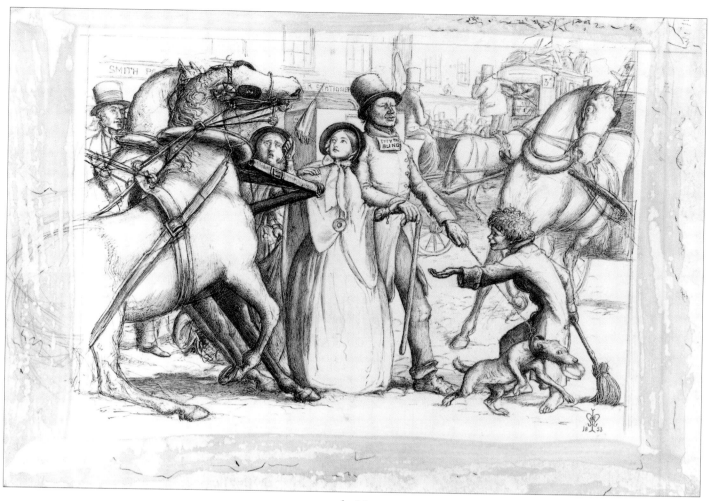

fig. 66
John Everett Millais, *The Blind Man*
1853. Pen and sepia ink. Yale Center for British Art

woman, becomes explicable in terms of the moral courage which inspires her. The sense of physical pressure from all sides; the conventionally beseeching gesture of the imp-faced crossing sweeper; and above all, the blank fear of the snake-like dog, ears flattened, eyes rolling, straining to escape the measured pace of girl and oblivious charge; all contribute to a sense of the threatening brutality and anonymity of city life towards the maimed and unfortunate.

In *London Bridge by Night on the Occasion of the Marriage of the Prince and Princess of Wales* (fig.67) - Victoria's eldest son, Edward, and the beautiful Alexandra of Denmark - Holman Hunt fixed on a significant and topical event for the focusing of his crowd. Enthused by what he called the 'Hogarthian' exuberance of the celebrations, Hunt set out to record for posterity what he saw as a 'scene of contemporary history.'[113] It is possible that he was inspired by the huge success of Frith's recent *Railway Station*, especially since he was in touch with Frith at this time.[114] The *Saturday Review* marvelled at Hunt's perversi-

ty in choosing so 'unmanageable' a subject, but Hunt's usual fanaticism carried him through. The result was acknowledged as a remarkable success: as 'profoundly faithful' a record of the London crowd of the day as had ever been produced.[115] Always the perfectionist, Hunt made an on-the-spot sketch, and checked every decorative detail, using stereoscopic photographs of the scene as an *aide memoire*. Hunt also sought to add *gravitas* to this scene of contemporary history by making symbolical allusions, throughout, to the historical relationship of Britain and Denmark; but few observers would have noticed these in the face of the tumultuous crowd. Several portraits are included: Thomas Combe - patron of Hunt, Millais and Charles Allston Collins - appears to the far left in a top-hat, identifiable by his full beard; while his wife shares the top of a van with Millais's parents and the artist, Robert Braithwaite Martineau. On the balcony of the Fishmongers' Hall, bottom right, the author of *Tom Brown's Schooldays*, Thomas Hughes, helps his little daughter get a better view, alongside one of Millais's sons

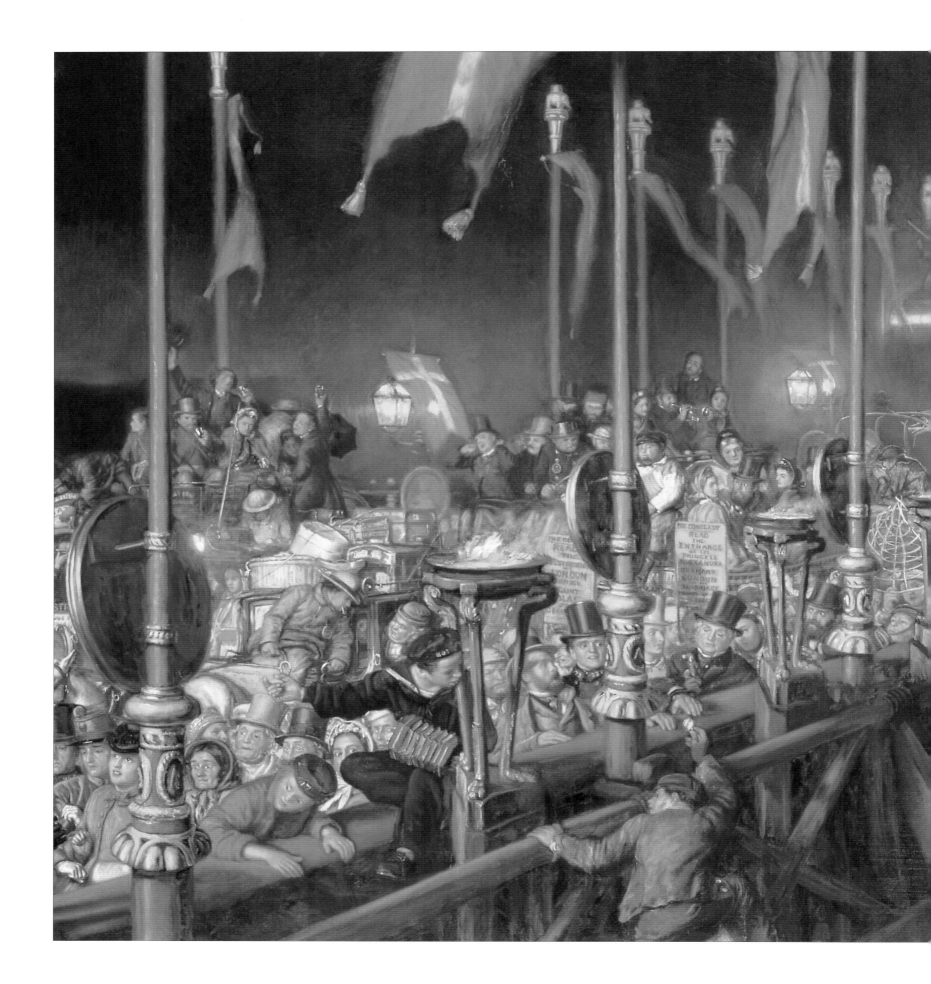

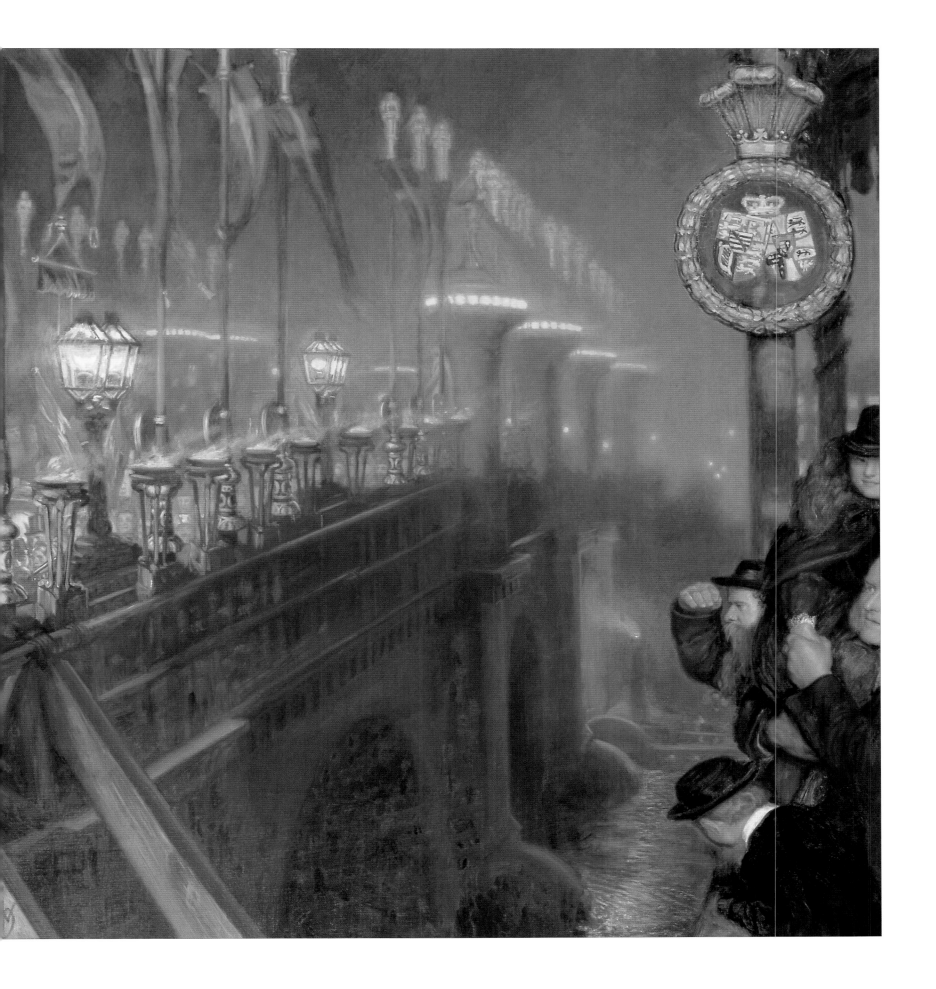

fig.68
Detail of William Holman Hunt, *London Bridge by Night on the Occasion of the Marriage of the Prince and Princess of Wales*
1863-6. Ashmolean Museum, Oxford, fig.67 (pages 148-49)

and the bearded visionary, Henry Wentworth Monk.[116] The inevitable pickpocket is included, lurking behind the parapet, and in process of handing over his watch to his associate – a well dressed youth, who poses as a respectable member of the crowd. Their activities have already been noted by a policeman who closes in on them (fig.68). Hunt has successfully suggested the seething turmoil of the crowd, caught in the glare of the street lamps; and details like the youth wielding his trophy – a crinoline discarded in the crush – bring the Victorian period to life to a degree rarely seen in the art of the period.

Hicks was accused of prissiness, a fault that could hardly be levelled at Hunt's muscular style, nor at Phoebus Levin, whose paintings of *Covent Garden* (fig.65) and *Cremorne Gardens* (figs.64&70) provide insights into disreputable elements of the London crowd which most artists preferred to ignore. His view of Covent Garden is taken from James St., looking towards the central arcades. To the far left he includes figures ravished by poverty and a flighty looking prostitute with a bouquet; a little

further back, a raffish youth in jaunty cap suggestively offering an apple to another prostitute; to the right against the wall, a blind negro; within the arcade, a long-haired woman being ejected, fighting, from a pub; and in the foreground, a large, gypsyish, low-browed market woman who turns sullenly from her baskets to take her instructions. Almost all of the buildings which Levin depicts are clearly identifiable today. Cremorne Gardens was a notorious nightspot on the north bank of the Thames, opposite to where Battersea Gardens now stand; much frequented by Rossetti and his friends in their youth. Levin's scene includes in the right foreground a group of flashily dressed prostitutes with their male admirers, one of whom gives money to a pair of Indian boys whose monkey is mounted on a large dog. Behind them, a stout wife knocks off the hat of her husband whom she has caught chatting up another prostitute, and to the far right, a young woman collapses at a table in a drunken stupor.

In a number of off-beat paintings and drawings, artists like Millais, Arthur Boyd Houghton and John Lee captured some-

fig.69
Detail of Phoebus Levin, *Cremorne Gardens*
1864, fig.70 (pages 152-53)

thing of the pressures of city life. Houghton is responsible for some of the most eccentric of London scenes. His *Itinerant Singers* (1860), *Recruits* (1859) and the *Deserter* (1859, all Kenwood House) illustrate a range of types from the London underclass not usually seen outside illustration. One of his more affirmative examples, *Holborn in 1861* (fig.70), suggests the sheer chaos and physical competitiveness of urban life in a view of a London street corner where more than fifty figures are crammed into a small canvas. In the immediate foreground, navvies shovel earth from a pit, while local children merrily pitch into a heap of sand to the right. Two policemen keep an eye on the scene, one of whom, framed in the shop doorway, appears to be investigating the rather suspicious looking character in dark glasses. A family of starving vagrants, possibly Irish, pass through the crowd, while towards the right, two unmistakable foreigners in conical hats - who are working as street musicians - may well be Italian political refugees. As in much of Houghton's work, a strong sense of loneliness and alienation also emerges in John

Lee's strange, compelling glimpse of city life, the *Bookstall* (fig.71) where all but the small boy appear absorbed within themselves. Lee presents us with only a fragment of the city populace, but one which reflects the sense of anonymity within the crowd that is a feature of the age. The setting may be Church St., Liverpool, the artist's home town, but it is a scene appropriate to any large city.[117] The bookseller sits, mute and detached, closely muffled in his tartan shawl and rough beaver hat, his billy-can beside him and his lunch tied up in a patterned handkerchief. The shortsighted customer peers closely at a small volume, his blue handkerchief and umbrella contrasting with the bright tawny shawl and gown of the woman behind, who appears anxious and abstracted. The sense of psychological fragmentation is enhanced by the intense physicality with which every aspect of the scene is rendered, to a degree where the texture of brick, fur and cloth appears almost tangible.

In the later part of the century there is a decline in the robust response to urban life, and in the naive drama, humour and

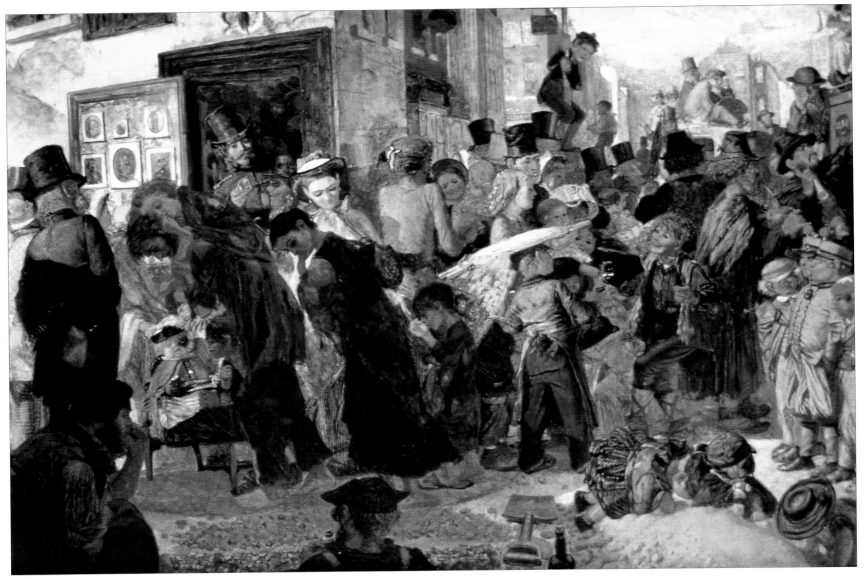

above: fig. 70
Arthur Boyd Houghton
Holborn in 1861
Private Collection. V.P. Publications, Cheltenham

opposite: fig. 71
John J. Lee
The Bookstall
1863. Christie's Images Ltd., 1999

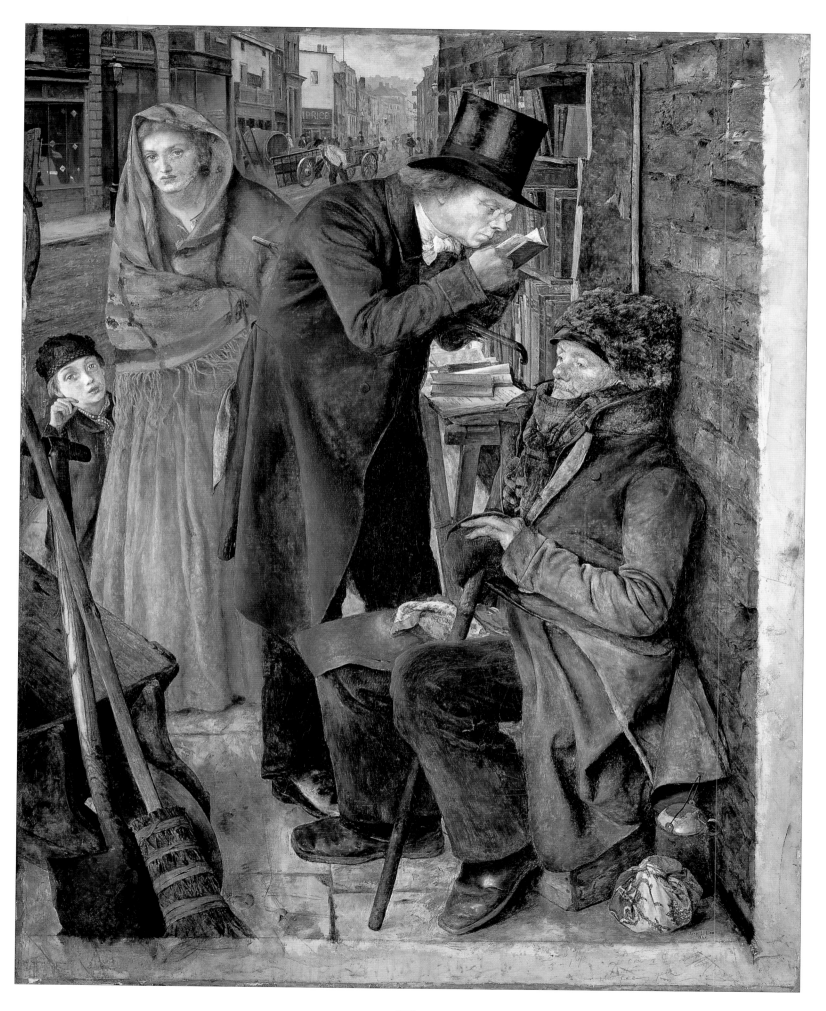

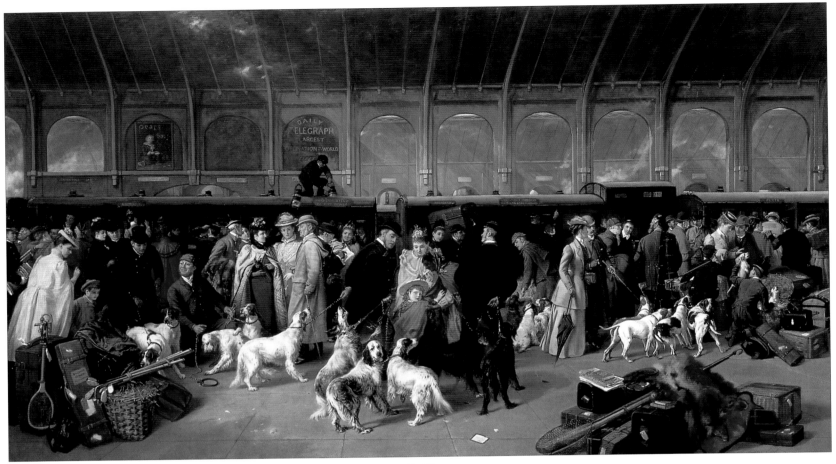

fig. 72
George Earl, *Going North, King's Cross Station*
1893. National Railway Museum, York.

curiosity so characteristic of mid-century scenes of contemporary life. It is instructive to compare the *Railway Station* with George Earl's updatings of the same subject: *Going North, King's Cross Station* and *Going South, Perth Station* (figs.72&73). Earl had exhibited a similar pair at the Royal Academy in 1876-77, but these are now lost.[118] Like other members of his family, he specialized in animal and hunting pictures, and these more ambitious compositions may be seen as a natural extension of his interests. In the first painting we sense the excitement of the sporting set as they prepare to board the train which will carry them to Scotland for the start of the grouse-shooting season on the 'glorious twelfth' of August. Heaps of tennis racquets, golf clubs and fishing tackle are much in evidence, and the mettlesome setters, hounds and spaniels promise good sport. To the left a little boy enjoys their unruly escapades, while the little red-cloaked girl retreats to the comforting embrace of her nurse, or ayah, who has evidently accompanied the family from India. The luggage and sports equipment, bottom left, may perhaps belong to them, since the gun-case is clearly labelled 'Bombay to Southampton'. To the far left, a young wife kisses her husband a passionate goodbye, drawing a somewhat disapproving glance from a bearded elderly gentleman. Two fashionably dressed ladies, one of whom carries a precious lap-dog under her cloak converse with a distinguished looking male companion in a grey hooded greatcoat. Towards the right, the artist himself appears in matching brown coat and deerstalker, with a scarf around his face, an evident allusion to some infirmity, since he is accompanied by a nurse. A boy offers yellow-backed novels for sale to a couple whose footman removes a litter of lively yapping pups from their travelling basket. Earl has most successfully suggested the sense of flurry and of minor chaos as everyone attempts to marshal their belongings and enter the train. Some carriages are labelled as travelling to Perth via the Forth Bridge; others, to Aberdeen via Perth and the Tay Bridge. An interesting touch is provided by the advertisements on the far wall for Pears's Soap, showing John Millais's *'Bubbles'*, and others for the *Daily Telegraph* and Russell's Watches. In the second painting, Earl adopts a viewpoint which is closer to Frith's in his view of Perth station in dramatic perspective. The pale autumn light shines through thin smoke drifting under a

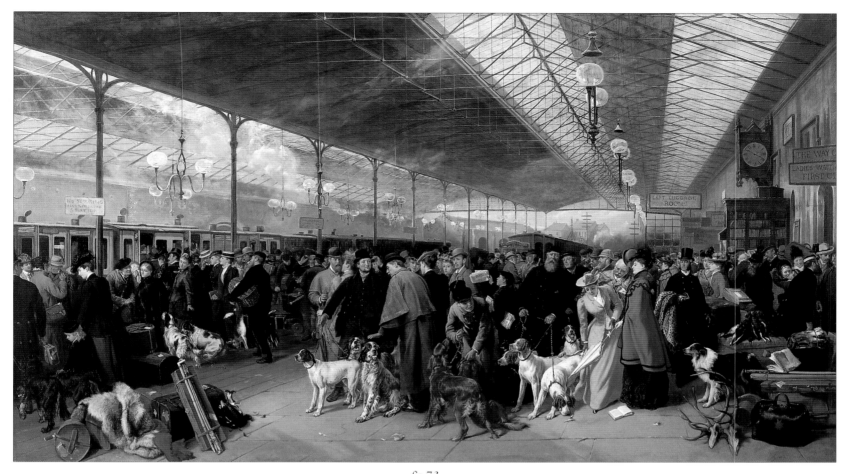

fig. 73
George Earl, ***Coming South, Perth Station***
1895. National Railway Museum, York. Science and Society Picture Library

delicate web of steel, as the sporting community – laden with the spoils of the chase – prepares for the twelve hour return journey to London Euston.

The pair make an interesting contrast with Frith's picture of more than thirty years earlier. Earl's paintings lack the dramatic urgency and full-blooded sense of engagement with his characters which is the essence of Frith's *Railway Station*. Times had changed. By the end of the century, the urban crowd was no longer a new phenomenon and had lost much of its excitement. Artists of Earl's generation could not respond as Frith had done, but opt for more sophisticated methods of treatment. Earl does not infuse any overt dramatic meaning into his groups; there is little narrative, as such, and a deliberate lack of focus. In this sense, the artist remains closer to real life, in cultivating the very randomness and sense of disorganization which one would expect to encounter in a typical railway station crowd.

Other interesting examples from this later period would include William Logsdail's unsentimental portrayals of the London crowd which must be very close to how late Victorian London really looked. Logsdail was a versatile artist; a painter

of landscape, portraiture and of literary and decorative subjects as well as modern life. But he is chiefly remembered as the painter of London street scenes, such as *The Bank and Royal Exchange,* the *St. Martin-in-the-Fields* (1888, Tate Gallery) and *The Ninth of November,* 1888 which shows the Lord Mayor's annual procession (fig.74). In the latter two, Logsdail opts for a rainy day and drably clad inhabitants whom he refuses to glamorize. There is a new kind of objectivity in the work of Logsdail and other contemporary genre painters like John Gregory which is characteristic of leading British artists from the 1880s onward, and is largely the result of continental influences. Like Frank Bramley who was to become a leading member of the Newlyn Colony of *plein-air* painters, Logsdail had studied at Lincoln Art School under E.R. Taylor and later at Antwerp. For some years from 1880, Logsdail used Venice as a base from which he travelled extensively. But the French 'square-brush' technique, which was to become the hallmark of the Newlyn School and the British Impressionists, was adopted only to a limited extent by Logsdail, and most British genre painters.

Tempted as he was by the city's liveliness and variety, Logsdail was well aware of the problems attached to painting commonplace London scenes, and eventually confessed himself defeated. In 1890, the *Art Journal* agreed about the difficulties involved but had only praise for Logsdail's unalloyed success in handling them. Struck by the rawness of perception which characterized his view of the Lord Mayor's procession the critic described it as

'the most courageous choice we have ever heard of. Mud, fog, squalor, have formed admirable subjects for painters of all nations and almost all times; so have smartness and costume and tawdriness and official dressing up, in their place. But the combining of the two, and the selection of English serving-men for the wearing of the gold lace and the colour, ... [make] of this picture an experiment unparalleled.'

The innate vulgarity of the men is not spared by the artist, who has given a certain dignity only to the nearest and youngest man. Although noting the *plein-air* effect might be slightly exaggerated, the critic concluded that 'no-one but a painter of masterly power' could have surmounted 'the all but infinite difficulties - of technique no less than of feeling - inseparable from the treatment of Lord Mayor's Day in the rain.'[119]

With measured step, the footmen advance before the mounted guard immediately preceding the Lord Mayor's coach; the features of the two to the left highly individualized, their expressions making plain their mental inertia. The one to the right, more handsome and self-assured, strikes an attitude more appropriate to the occasion. We share the viewpoint of the crowd - a rough looking rabble who jostle each other along the pavements. On the left, the spectators lining the roof of the Bank of England provide a lively counterpart to Westmacott's sculpted figures on the pediment of the Royal Exchange and the stately row of urns receding into the distance. A negro minstrel in frilled shirt and huge brass buttoned coat, and an orange seller, are amongst those who are held back with some difficulty by the policeman. A tall soldier, self-consciously smart in cape and swagger stick, approvingly eyes the pretty young woman next to him. Further to the right, an irritated spectator firmly pushes down the top hat of the man in front of him which is obscuring his view. On the far right, another 'topper' which has taken a tumble is rescued by a small boy, while the attention of the alert little mongrel is riveted on something more interesting to a canine mind than brocaded liveries, or even horses. The procession heads westward, the figures reflected in the glistening wet pavement. The urns and some of the handsome street lamps are gone, but otherwise, the scene remains much the same today.

For another crowd painted a year previously, Logsdail had chosen the same setting taken from a higher viewpoint on the Mansion House façade. In this example the atmosphere and season differ strikingly (fig.75), and the French technique is more in evidence. It is a vibrant scene, brought vividly to life with light and colour. Patches of bright whites, greys and pinks give it an impressionistic look, and are used to advantage in successfully suggesting the scintillating effect of the warm light of an early summer day. But much of the painting is detailed and precise, especially the right hand group which includes portraits of Logsdail's neighbours in Primrose Hill; all but one, artists and their female relatives (fig.76). Prominent amongst this animated group is the water-colour painter, Tom Lloyd, in jaunty striped blazer and cap, tennis racquet under his arm. At the front left of the omnibus J.W. Waterhouse sits next to his wife who wears a pink dress, her distinctive, characterful features recognizable from many of her husband's paintings. In grey bowler hat, Patrick Feeney, landscape painter, gazes with indulgent and amused expression at Waterhouse's stepsister, Mrs Somerville; and Fred Villiers, war correspondent, listens in from behind. Next to her, in gracefully draped blue dress, Feeney's wife (Waterhouse's sister-in-law) her eyes closed, inhales the sweet scent of a pink carnation. Behind them, the heavily whiskered features and stout figure of Joseph Wolf, animal painter, betray his German origins; while to the far right appear the more alert features of Lance Calkin, portraitist. Logsdail himself, seen in three-quarter profile to the left of Tom Lloyd, was painted by Waterhouse.

The busy thoroughfare is crowded with hum-drum vehicles, including a hansom cab, a brewer's dray and various crate-laden carts. To the rear, another omnibus carries an advertisement for Sarson's vinegar. At the left hand side of the picture, a policeman orders a little girl carrying a baby to 'op it', attracting the attention of a well-dressed lady who looks on with some concern. The girl's down-at-heel oversized clogs and tattered shawl suggest that she has been caught begging. An ironic touch is the lady's fluffy white dog, smartly dressed in a sky blue bow, who is quite evidently cleaner and better fed than the poor girl and her infant charge.

A letter written by Logsdail in 1917, again raises the issue of the value of modern-life scenes of this kind. In his pains to achieve authenticity, Logsdail not only made studies on the spot, but had the top of an omnibus constructed in his studio on which his friends posed. In his letter, he refers to the picture as having been

'painted... with very minute detail... the portrait figures on the bus... with almost the finish of a careful portrait minia-

fig. 74
W. Logsdail, ***The Ninth of November***
1890. Guildhall Art Gallery, Corporation of London

ture work... I like to think in the years to come that [its real value] may increase as at least... an historical record of exactly... how the scene looked in 1888 (or 7?).'[120]

. . .

Crowd painting maintained its popular appeal until the end of the century. But from the 1870s onward, a parallel movement had developed in painting, in which urban subjects were tackled by artists whose social conscience had been stirred by the appalling conditions in which a majority of the poorer classes lived, and which were seen at their worst in the cities themselves. In the work of the so-called Social Realists, who will be considered in the next chapter, we see a clear shift of focus. The crowd as spectacle, which is at the heart of the examples considered above, gives way to a closer analysis of its poorer elements, and to a more open condemnation of social injustice.

above: fig. 75
William Logsdail,
The Bank and the Royal Exchange
(Detail) 1887. Richard Green

opposite: fig. 76
Detail of fig. 75

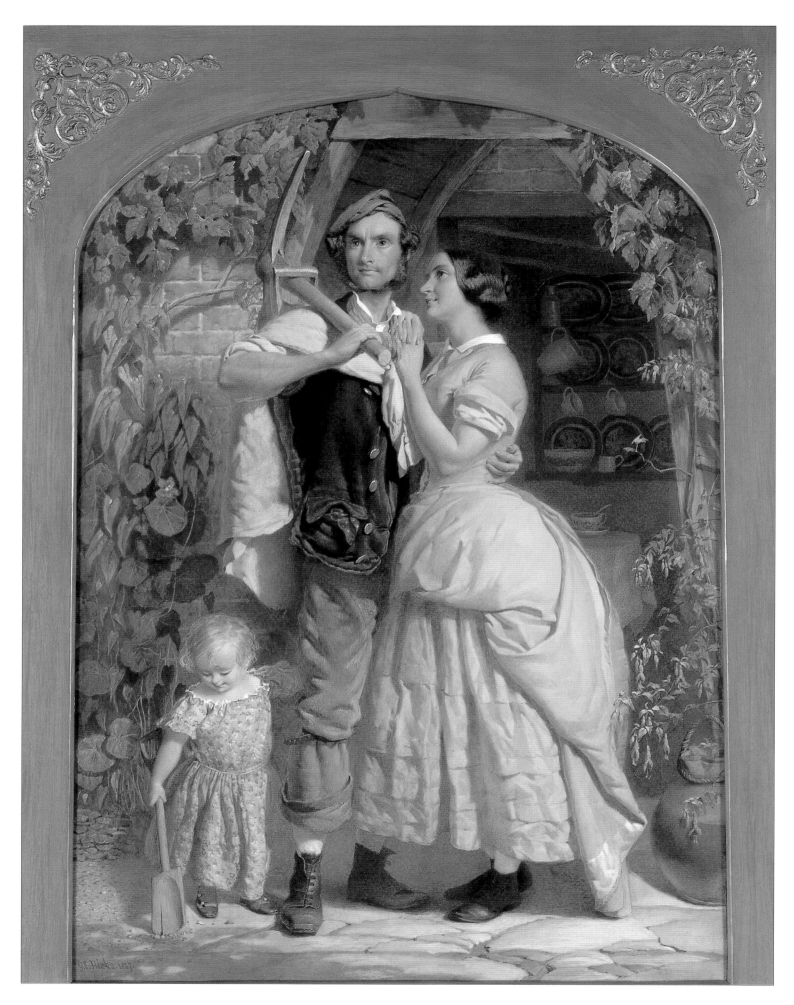

CHAPTER 3

Workers and Poor in Town and Country

'A feeling very generally exists that the condition and disposition of the Working Classes is a rather ominous matter at present'.[1] At the beginning of his essay on 'Chartism' (1839), Carlyle's words thus posited what came to be known as 'the Condition-of-England question': the effects on the poor of the industrial revolution and the economic disasters of the first half of the nineteenth century. The condition of the poor was grave cause for concern in town and country alike, but it was at its worst in the new urban sprawls. Although rural workers suffered badly,

'it was the malign combination of town life and factory life that produced the conditions which horrified the more concerned portion of the nation... The industrial revolution... had packed workers into towns totally unprepared to house them... the old kind of deprivation and suffering was diffused, the new kind was concentrated and its effect upon the beholder intensified. Individual cases, thousands upon thousands of them, coalesced into a mass of misery.'[2]

The squalor of the new cities shocked visitors like Alexis de Tocqueville, who in 1835 described Manchester as a 'foul drain', a 'filthy sewer' from which 'pure gold flows'; a place where 'humanity attains its most complete development and its most brutish'; where civilization creates miracles, yet where 'civilised man is turned back almost into a savage.'[3] It was England's great cities which inspired Friedrich Engels' account of the *Condition of the Working Class in England in 1844*. To this visitor from a pre-industrial Germany, the old city of Manchester was a veritable 'Hell upon Earth'.[4] Conditions continued to worsen as a consequence of economic recession,

high unemployment and the Irish famine. The climatic and economic disasters of what came to be known as the 'Hungry Forties' were devastating and caused widespread alarm even among the more prosperous classes. Charles West Cope recorded in his diary that the 24th. March, 1847 was set aside for a

'General fast and humiliation of the nation before God for repentance of sins, and prayer to be delivered from the scourges of famine and pestilence raging in parts of the kingdom, especially Ireland. Church crowded, shops all closed'.[5]

A state of near-destitution remained the norm amongst a large proportion of the urban working classes until the end of the century (figs.4&5), for the mechanism for dealing with social problems was established only gradually. The drawings which Gustave Doré made of London in 1869 show that little had changed over several decades (figs.2&3). Doré's views of the urban poor have been criticized for what Klingender calls 'a kind of over-dramatized unreality' and 'an element of morbid hysteria'. But Klingender acknowledges their 'extraordinary power and bravura';[6] and indeed, the sense of the rough and tumble chaos, shabbiness and squalor of Doré's London is supplied by no-one else. Doré records the detritus, filth and decay of urban life at its very lowest, where life itself has filtered down to gutter level - like the battered and shabby boots and clothes that are offered for sale in his memorable image of Dudley St., Seven Dials.

The dehumanizing effects of industrialism were thoroughly documented in the Parliamentary Papers and Bluebooks resulting from Royal and Parliamentary Commissions. Edwin Chadwick, Secretary to the Poor Law Commission, led the

page 160: fig 1
George Elgar Hicks, *The Sinews of Old England*
1857. Watercolour heightened with body colour and gum arabic
Private Collection. Photograph, Sotheby's

below: fig.2
Gustave Doré, 'Over London by Rail' *London, a Pilgrimage,* 1872

far below: fig.3
Gustave Doré, 'Dudley St., Seven Dials' *London, a Pilgrimage,* 1872

opposite left: fig.4
Photograph of Fore St., Lambeth
V.&.A. Picture Library

opposite right: fig.5
Bristle pickers, working at home
c1880. Museum of London

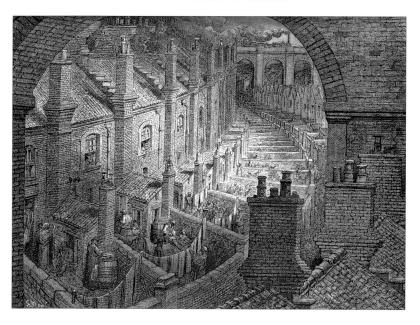

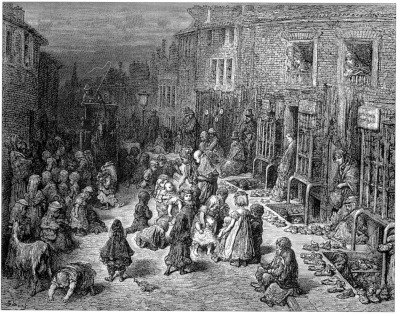

Inquiry into the Sanitary Condition of the Labouring Population of Great Britain (1842) which revealed that foul living conditions produced an 'annual death-rate from typhus alone' which was 'double that of the fatalities of the allied armies at Waterloo.'[7] This documentary approach was adopted by novelists of the period who began to explore contemporary social problems, often with the aid of official Government reports and statistics. Frances Trollope's *Life and Adventures of Michael Armstrong, the Factory Boy* (1840) was written in response to the failure of the Chartists to extend the vote to the working man in 1832, and Charles Kingsley's *Yeast* (1848) to the failure of the second. Elizabeth Gaskell's close acquaintance and sympathy with the movement are apparent in *Mary Barton* (1848) and *North and South* (1855), and Disraeli also makes Chartism the context of *Sybil* (1845). Subtitled *The Two Nations* – the rich and the poor – it was intended, as the author explains in his Preface, 'to illustrate – the Condition of the People' in the industrial North. Culling his information from first hand observation and from Bluebooks, Disraeli showed the same social concern that was emerging in contemporary painting. Readers were no doubt startled to be calmly told that 'Infanticide is practised as extensively and as legally in England as it is on the banks of the Ganges'. Heavily drugged cordials, neglect, starvation, and being 'sent out in the street to "play," in order to be run over' are amongst the methods employed.[8] That the plight of destitute children remained a serious social problem is indicated in George Cruikshank's trenchant commentary on the subject (fig.6).

A new kind of investigative journalism developed in the hands of writers like Henry Mayhew. Mayhew's great project, *London Labour and the London Poor*, began as a series in the *Morning Chronicle* (1849-50) and culminated in an illustrated edition of four volumes (1861-2). Henry Morley's graphic and unsentimental account of the maiming and killing of children – their limbs regularly ripped out by unprotected machinery – must have deeply shocked the respectable readership of Dickens's *Household Words* in 1854.[9] The same hard hitting, documentary approach was adopted by James Greenwood whose first of many social reports, 'A Night in a Workhouse', was serialized in the *Pall Mall Gazette* in 1866. Such reports were to climax in Charles Booth's *Life and Labour of the People in London* which appeared in 1879 and which had extended to seventeen volumes with the 1902-3 edition.

'Labour' became a key word in the nineteenth century, implying something of that severe physical sacrifice that lay behind the maintenance of Britain's power and productivity. The manual worker formed the bedrock of capitalist society and was crucial to the economic transformation of early Victorian England. All the major building projects from railways to sewers were built with

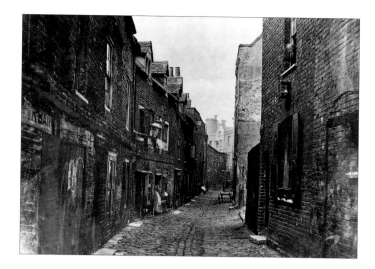
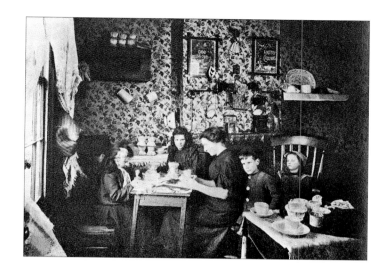

muscle power; and the land continued to be worked largely by hand. Machines were introduced only gradually, man power being cheaper and the majority of landowners conservative in their practices. But the material reward for labour was often a mere subsistence wage – barely enough to sustain the necessities of life; for according to classical economic theory, any pay rise beyond this would reduce profits and discourage capitalist investment. The resulting discontent and suffering among so large a proportion of the population were pregnant with danger. In *Unto this Last*, which he considered the most important of all his writings, Ruskin warned that current economic principles, based on exploitation of the worker, were such as to 'lead straight to national destruction.' 'If you examine into the history of rogues,' he wrote, 'you will find they are as truly manufactured articles as anything else'.[10] But the system did not change significantly. Social order and prosperity remained dependent on a productive and peaceable working class; hence, the constant exhortations as to the importance of steady labour, providence and sobriety in manuals of self-improvement like Samuel Smiles's best-selling *Self-Help* (1859).

In a society where welfare provision was limited to the workhouse, the onus for survival was squarely on the shoulders of the workers themselves. In *Self-Help*, Samuel Smiles was firm on this matter:

'That there should be a class of men who live by their daily labour in every state is the ordinance of God... but that this class should be otherwise than frugal, contented, intelligent and happy, is not the design of Providence, but springs solely from the weakness, self-indulgence and perverseness of man himself.'[11]

It was essential that workers should be ready to adapt to the specific demands of the new machine age. Failure to do so

meant a precarious existence, if not destitution. Henry Mayhew listed 'repugnance to regular and continuous labour... want of providence... inability to perceive consequences' beyond the present moment and lax ideas of property, as amongst the qualities which explained the unsettled lifestyle of the London 'race' of itinerants which he investigated in his mammoth survey.[12] The application of evolutionary theory to society – 'Social Darwinism' – gave substance to the argument that those failing to adapt to modern social requirements must inevitably fall before the inexorable laws of the evolutionary process. William Lecky specified as qualities for survival: 'thrift, steady industry, punctuality... constant forethought with a view to providing for... the future'.[13] Sir Francis Galton identified the instinct for 'continuous steady labour' as a phenomenon to be found only in advanced, civilized races, and concluded that the unsteady, nomadic, bohemian type could no longer survive. As Galton explained: 'Unless a man can work hard and regularly in England, he becomes an outcast. If he only works by fits and starts he has not a chance of competition with steady workmen' and if governed by 'variable impulses, and wayward moods, is almost sure to end in intemperance and ruin.'[14]

The question of the worker's role in society, and related problems of poverty, crime, unemployment and emigration surfaced in a number of major paintings of the period; notably, Madox Brown's *Last of England* (1852-6) and *Work* (1852-63), Henry Wallis' *Stonebreaker* (1857), Bell Scott's *Iron and Coal* (1855-61), and Fildes's *Casual Ward* (1874). Previously, the poorer classes had occurred mainly as picturesque motifs in rural scenes; but beginning tentatively in the 1840s, artists began to admit to the harsh reality of their condition. Such subjects risked controversy, but they resulted in some of the greatest paintings of the century; paintings which show the inhabitants of an essentially modern, industrial world and of a rural England that

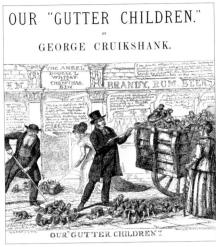

top: fig.6
George Cruikshank, 'Our 'Gutter Children"
(July, 1869). V.&A. Picture Library

middle: fig.7
Belligerent crossing sweepers, *Fun* (20 Sept., 1862)

above: fig.8
John Leech, Thuggish miners and a gentleman
Punch (26 February 1854)

is no idyll. Problems which were all too real were faced by artists prepared to acknowledge and expose them; to grapple, albeit sometimes timidly, with 'the new social and political concerns of the age of industrialisation and democracy.' Although invariably toning down the actual horrors of such scenes, yet they attempted to paint 'crusading pictures, intended to draw attention to the plight of the poor, their housing conditions, the exploitation of their labour and their tragically wasted lives.'[15]

Operating with greater freedom than painters, the press provided an important supplement through the 'new form of pictorial reporting'[16] which began with the *Illustrated London News*, first issued on May 14th, 1842. In the early days of *Punch* - launched on July 17th. 1841 - John Leech's cartoons made some incisive comments on poverty and prostitution which were soon suppressed as incompatible with the journal's entertaining and family orientated image. But its humorous illustrations of lower class types continued, and like those of the more raffish *Fun* are most illuminating. Although exaggerated, the ragged, rough-haired urchins, with their pinched, mischievous features, and the brutish thugs, ring true (fig.7&8). Other magazines like the *Illustrated London News*, and illustrated surveys such as Henry Mayhew's *London Labour and the London Poor* (1861-2), are among the many sources that provide invaluable information about lower class and criminal life. Mayhew's woodcuts were taken from photographs, and actual photographs were to be included in later social commentaries. John Thomson and Adolphe Smith's *Street Life in London* (1877) contained photographs of the poor unmitigated by the sympathy and respect one finds in illustration or in paintings by Fildes, Holl, Walker, and others in the same decade (fig.9).

The position of the 'British Working Man' remained a controversial topic throughout the period. Perceptions of him and responses to the question of his capacity for improvement varied widely. In 1865, John Tenniel parodied this situation at a time when the possibility of extending the franchise was being debated in Parliament (fig.10). Seen as an angelic, refined, water-drinker by John Bright, he becomes a drunken sot in the eyes of another leading Liberal politician, Robert Lowe, who argued cogently against democracy. But Tenniel himself was as much a victim of this kind of prejudice as any other artist and illustrator, as many of his *Punch* cartoons demonstrate. Rarely, if ever, is a representation of the working classes entirely without bias.

George Elgar Hicks provides an image of the working man who fulfils the ideal prescription. *The Sinews of Old England*, 1857 (fig.1) depicts a financially solvent, tea-drinking navvy, devoted to his family and setting a good example to his infant son, who is portrayed as a budding worker, eagerly attacking the

ground with his own little spade. The pretty bower that garlands the doorway suggests that leisure hours are usefully spent in gardening. The three are well fed and well dressed; the interior of the brick-built cottage neatly arranged with its clean, white table-cloth and blue and white crocks; no doubt the pride of the young wife, whose tucked up sleeves and skirt suggest an equal willingness to work. The frank, open features of the navvy himself bespeak his own happiness and sense of achievement in shouldering all responsibility for his little family. This telling image epitomizes the virtuous labourer and his just rewards.

Ideal role models for the working community were regularly included in a monthly magazine launched in 1855 - *The British Workman and Friend of the Sons of Toil* (fig.11). The *Art Journal* (May 1855) was full of praise for the venture, approving its aim

'to instil into the minds of the humbler classes, good morals and healthy feelings... filled with much of the right stuff to form honest and industrious artisans, good fathers, good subjects and good christians.'[17]

Not all workers were amenable to the sort of advice given by the *British Workman*, and there were many who shared Robert Lowe's doubts about his capacity for improvement. It is significant that J. F. Sullivan's caustic representations of the *British Working Man, by one who does not believe in him*, made William Morris feel 'both angry and ashamed'; for while recognizing 'much injustice' in both book and title, Morris acknowledged that there was some truth in them also.[18] Sullivan's idea of married felicity amongst the working classes is at the opposite pole from Hicks's, and George Cruikshank's view of a typical workers' night out is no more encouraging (figs.12&13).

Portrayals of the poor in art and illustration always risked offending the critics who were as incapable as artists of exercising detachment. In 1866, the year in which Gladstone presented his Reform Bill, Erskine Nicol's scruffy Irishmen provoked at least two critics into making a specifically political allusion. The *Art Journal* objected strongly to his unsalubrious types - dirty, ragged and unwashed - taken, he claimed, from 'the class to whom the new Reform Bill transfers the government of the country.'[19] The *Blackwood's* critic in an article entitled 'Art Politics and Proceedings' was equally indignant, declaring that

'The expressly... plebeian, and democratic propensities of the English School are here pushed to an astounding climax. Never has an artist ventured to introduce ragamuffins on so large a scale into polite society... sansculottes guiltless of soap... the people whom Mr. Gladstone wished to reward with political power!'[20]

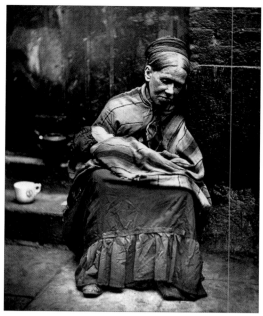

above: fig.9
Photograph of a homeless woman and baby
John Thomson and Adolphe Smith, *Street Life in London,* 1877

below: fig.10
John Tenniel, Contrasting views of the British Working Man
Punch (3 October 1865)

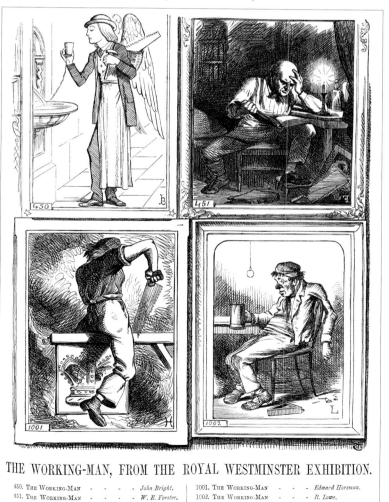

THE WORKING-MAN, FROM THE ROYAL WESTMINSTER EXHIBITION.

| 450. The Working-Man | - | - | *John Bright.* | 1001. The Working-Man | - | - | *Edward Horsman.* |
| 451. The Working-Man | - | - | *W. E. Forster.* | 1002. The Working-Man | - | - | *R. Lowe.* |

top: fig.11
An exemplary workman: a helpful railway station official
The British Workman and Friend of the Sons of Toil (1 Dec. 1864)

middle: fig.12
A murderous carpenter prepares to burn his wife's body (detail)
J.F. Sullivan, *The British Working Man,* 1878

above: fig.13
George Cruikshank, 'The Last Half-Hour'
S.C. Hall, *An Old Story,* 1875

Nicol's Irish and Scottish types – always studied from life – are not intentionally provocative or political; but neither are they idealized. In fig.18 the new arrival is honestly depicted in all his clumsiness and rural simplicity; but he responds to the teasing of the Liverpuddlian urchins, with a quiet dignity. The foremost urchin mockingly points to his muddy boots, suggesting that he might like to have them cleaned, while his companion laughs approvingly, his cheeky, belligerent expression showing to marked disadvantage when compared with the careworn but decent physiognomy of the immigrant. Some years later, an illustration by Frederick Barnard which appeared in the *Illustrated London News* was evidently rather too close to life for comfort (fig.14). St. James's Park was much frequented by inhabitants of the notorious slums of Westminster; places like Strutton Ground which the *Illustrated London News* mentions, and the adjacent Olde Pye St. which features in Doré's London. Barnard's picture recalled all too faithfully the habitual frequenters of the Park: 'the lazy lubbers and dirty drones' who regularly chose to 'snore away' their time on the grass rather than work; just like those in the picture before the band aroused them.[21] When Barnard exhibited a painting of the same subject in 1874, the *Illustrated London News* was more indulgent towards the types represented, but the *Saturday Review* thoroughly disapproved of the 'riffraff of pickpockets, navvies with pickaxes, and old men with wooden legs'.[22] Clearly, the depiction of such types in their natural state was a sensitive issue. The crowd illustrated includes a navvy with pick and shovel, a low-browed ruffian, an Italian organ grinder, a pipe-smoking German, and a gang of street urchins. Even the policeman is ogling a nursemaid.

• • •

It was in the 1840s that painters began, somewhat tentatively, to explore specific social problems relating to the poorer classes of society. Richard Redgrave made the first notable attempt, with his sympathetic image of a poor Sempstress: victim of a notorious and scandalous system of exploitation (fig.15). Exhibited at the Royal Academy in 1844, it was inspired by Thomas Hood's poem, the 'Song of the Shirt' which had appeared in the Christmas number of *Punch* in the previous year. The poem was inspired by recent revelations in the press – including a *Times* leader, and an item in *Punch* itself – commenting on the case of a slopworker charged with theft, who, for a fourteen hour day earned a maximum weekly wage of 7/- (35p) on which she was expected to support herself and two infant children. Widely reprinted in newspapers and journals, Hood's heartrending poem, according to W.M. Rossetti, 'ran like wildfire, and rang

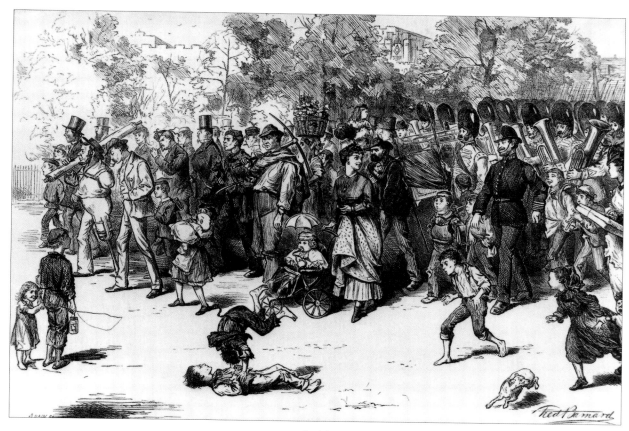

fig.14
Frederick Barnard, 'The Guards' Band in the Park'
Illustrated London News (11 June 1870)

like a tocsin, through the land'[23] – and beyond; for it was widely translated. It was quoted in sermons, turned into a play and printed on cotton handkerchiefs.'[24]

The historical painter, Paul Falconer Poole, wrote to Redgrave that 'If any circumstances could make me wage war against the present social arrangements, and make us go down shirtless to our graves, it is the contemplation of this truthful and wonderful picture.'[25] But not everyone found it so convincing. Thackeray, often accused of sentimentality himself, was always quick to seize on the 'namby-pamby' quality in others. He thought it a feeble interpretation of an 'astonishing poem… to which our language contains no parallel'.[26] Yet again, Cruikshank, shows the enormous freedom which illustrators enjoyed, as compared with painters, in his graphic commentary on the same subject (fig.17).

Redgrave's is a sincere attempt to express the mental anguish and physical suffering of the young woman; but whatever his success, as Thackeray recognized, he was constrained by the traditional limitations of the medium. Understandably, Redgrave could not equal the realism of Hood's poem, or of Mayhew's prose; for, judging by her refined features and expression, Redgrave appears to have chosen a type whom Mayhew also interviewed at length:

the distressed gentlewoman. Mayhew devoted six articles in the *Morning Chronicle* of 1849 to the inhuman exploitation of slop-workers and needlewomen. With all the chilling truth of documentary reportage, his accounts inevitably highlight the difficulties artists faced in attempting such subjects. In summarizing his own achievement, Redgrave noted that many of his 'best efforts in art' had 'aimed at calling attention to the trials and struggles of the poor and oppressed';[27] but had evidently felt it necessary to confine himself to portrayals of attractive and respectable young females in adverse circumstances. His other efforts included portrayals of unhappy governesses, and more dramatically, *The Outcast*, (1851, Royal Academy of Arts), a young girl with her illegitimate baby being turned out of home into the snow. Even so, Redgrave was ahead of his time, and returned to less provocative subjects in the face of the controversy which his social commentaries generated.

The other main social commentator of the 1840s, George Frederick Watts, tackled subjects like the *Irish Famine* (fig.16), a calamitous event which, with its associated pestilence and emigration reduced the population by a quarter between 1841 and 1851. Over-large and crudely painted, the picture understandably never sold; but it illustrates Watts's genuine concern with condi-

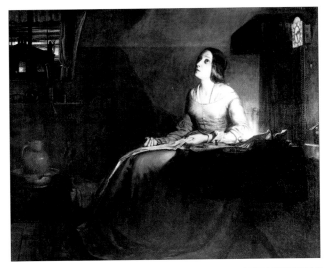

top: fig. 15
Richard Redgrave, *The Song of the Shirt*
(replica) 1846. The Forbes Magazine Collection, New York

above: fig. 16
George Frederick Watts, *The Irish Famine*
c1849-1850. Watts Gallery, Compton, Surrey

below: fig. 17
George Cruikshank, *Our Own Times: Tremendous Sacrifice,*
1846. V.& A. Picture Library

tions in Ireland. *Found Drowned* (Watts Gallery) suggested by Hood's poem *The Bridge of Sighs* (1843) which was again based on fact, is a comment on the familiar sequence of poverty, seduction, abandonment and destitution. Watts also produced his own version of *The Song of the Shirt* (c1850); but he was no realist, and soon abandoned such subjects in favour of allegory. It was left to younger artists and illustrators to develop a more modern idiom with which to register their responses to the contemporary scene. As in the case of Kenny Meadows and Thomas Benjamin Kennington (1856-1916), much of Augustus Edwin Mulready's (c1843-after 1903) most interesting work was devoted to the poor. Mulready had originally been a member of the rural, Cranbrook Colony; but was to develop a special line in pictures of itinerant street children, always with details of the urban scene - particularly posters - which not only add significance to the subject but are interesting in themselves. The example illustrated (fig.21) shows London newsboys and a flower-girl at a time when Anglo-Irish relations were particularly fraught, and Irish nationalists had launched a bombing campaign in England. As in all such subjects, Mulready points to the condition of the street children; implying that their poverty should not be over-looked, even at a time when the political situation threatens to distract attention from social issues; a message perhaps also reinforced in the poster to the left. Their ragged condition is contrasted with that of the affluent citizens in the background, symbolically separated by a rail, and who can afford to patronize the sort of entertainments advertized on the adjacent posters.

Although they tended to concentrate on moral rather than social problems, the Pre-Raphaelite circle produced commentaries which are invariably earnest and thoughtful, whether portraying the more positive, heroic aspects of labour as in Brown's *Work*, or its negative consequences. Henry Wallis' *Stonebreaker* (1857-8, Birmingham City Art Gallery) showing a workhouse inmate who has died by the roadside under the burden of his unendurable task, was exhibited with a sympathetic quotation from Carlyle's *Sartor Resartus*. Some critics found it repulsive, but the *Morning Star* suggested that it should be 'presented to one of our metropolitan workhouses and hung up in the board-room'.[28] Walter Howell Deverell's portrayal of a family of *Irish Vagrants* by the wayside (fig.20), indicates without rhetoric or sentiment a series of related social problems which were to interest artists for several decades: poverty, unemployment and emigration. Holman Hunt records that Deverell's subject may have been suggested by his readings of Carlyle and Kingsley, both of whom took a keen interest in the Irish situation.[29] The failure of the potato crop and the subsequent famine had resulted in massive emigration to England as well as America, often

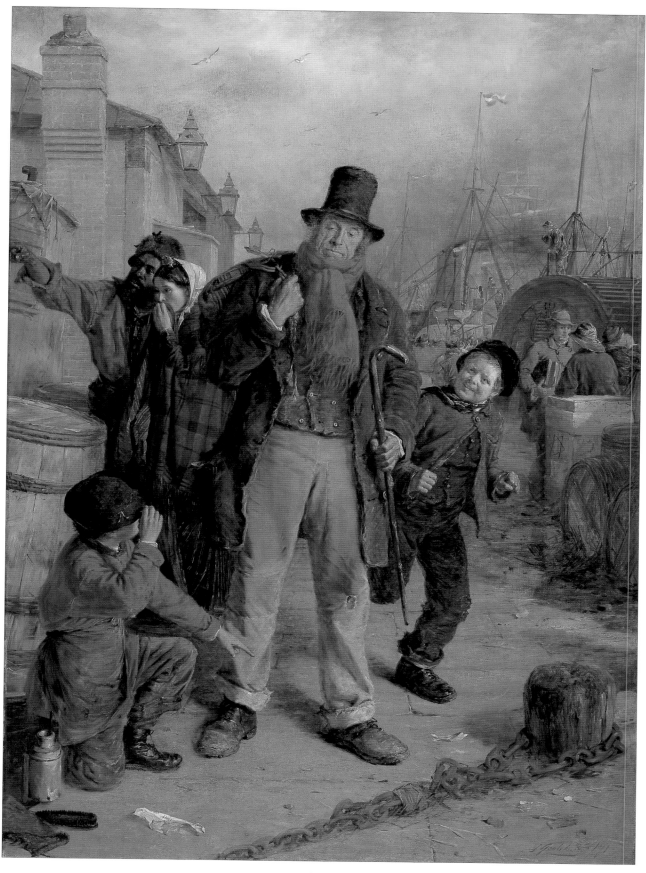

fig. 18

Erskine Nicol, *An Irish Immigrant landing at Liverpool*
1871. National Gallery of Scotland

fig.19
Ford Madox Brown, *The Last of England*
1852-5 (detail). Birmingham Museums and Art Gallery

fig.20
Walter Howell Deverell, *Irish Vagrants*
1853-4. Johannesburg Art Gallery

to already overcrowded towns. While admitting the serious neglect that they had suffered, and sympathizing with their condition, Carlyle recognized the Irish as 'the sorest evil this country had to strive with', a 'ready-made nucleus of degradation and disorder' which was exacerbating the unemployment problem and forcing the native Saxon himself to emigrate.[30] Like Mayhew's itinerants and the gypsies who regularly attended the Derby, the Irish were regarded as a race apart. Carlyle referred to their 'wild Milesian features', and Kingsley made similar remarks about the types he witnessed on his visit to Ireland in 1860.[31] Like his fellow artist, Erskine Nicol, Deverell subscribed to commonly held ideas about what constituted the Irish racial type; especially clear in the woman with black hair, heavy jaw and snub nose, at the centre of *Irish Vagrants*.

Emigration was to supply the theme for a number of interesting paintings. Nicol's *Irish Immigrant arriving at Liverpool* takes the form of a vignette, while Herkomer's *Pressing to the West* (1881, Leipzig) is a much more ambitious response to this central social issue. Paul Falconer Poole's *The Emigrants's Farewell* (1838, Forbes Magazine Collection), James Collinson's *Answering the Emigrant's Letter* (1850, Tate), and its pendant *The Emigration Scheme* (1852, Private Collection) and Richard Redgrave's *The Emigrants Last Sight of Home* (1859, Tate) have rural settings and portray an idealized peasantry, which make them less effective as social commentaries. Poole and Redgrave focus on the psychological drama of leave-taking; James Collinson on the ambiguous reactions to a letter. Madox Brown's unforgettable image registers the numbed feelings of a couple at the actual moment

of departure, as the blue-tinged cliffs of Dover fade behind them; but Brown, as he explained himself, chose to express the experience through the more complex and refined feelings of a middle-class rather than a working-class couple. Brown was sympathetic to the deserving poor and to the development of a more equitable society; but he had no illusions about the 'undeserving' element amongst the working classes. In 1871, William Michael Rossetti noted with some interest that Brown did not support a universal suffrage; subscribing instead to 'an educational franchise.'[32] In this particular painting, Brown shows the lower class element in a decidedly unfavourable light, in the form of two bleary eyed, drunken roughs whose future in the Antipodes promises little improvement on the past (fig.19). The debauched physiognomy of the gap-toothed man clutching a bottle, tells its own history, although he blames his lack of success on his native land, not himself. Egged on by his equally drink-sodden, coarse featured crony, he ignores the placating gestures of his anxious, widowed mother.

But in *Work*, which Brown began to paint concurrently, the navvy - notoriously tough, violent and unruly - was to be the hero. In this painting, as in Bell Scott's *Iron and Coal*, the artist goes far beyond the depiction of a single aspect of working life, to take a much broader philosophical view, and to evaluate the concept and value of work within society as a whole.

Walter Houghton has calculated that 'Except for "God," the most popular word in the Victorian vocabulary must have been "work." Essential to social, personal, and economic progress, Work became something of an obsession with the Victorians,

fig. 21
Augustus E. Mulready, *London News Boys,* 1884. Unlocated. Photograph, Witt Library

fig.22
Ford Madox Brown, *Sketch for Work*
?1852, 1864. Watercolour and pencil. City of Manchester Art Galleries.
This sketch was worked up from the original pencil drawing, and may date entirely from 1864

for moral as well as economic reasons. In many cases a substitute and a solace for loss of religious faith, work 'became an end in itself, a virtue in its own right... The glorification of work as a supreme virtue... was the commonest theme of the prophets of earnestness'.[33] It was only through work that the individual might improve his lot, or even survive in this world; as well as earn a reward in the next. Thomas Arnold, Thomas Carlyle, Charles Kingsley, Cardinal Newman and John Ruskin were amongst the many moralists who urged the virtues of work.

Samuel Smiles believed 'steady application to work' to be 'the healthiest training for every individual… the best test of the energies of men, and [one which] furnishes an admirable training for practical wisdom.' It was, admittedly, 'a burden, a chastisement,' but also 'an honour, and a pleasure'; and 'necessary for the development of intelligence, and for the thorough enjoyment of our common nature.'[34] Carlyle and Kingsley went further than this. Taking as his text, Proverbs, 14 v. 23 - 'In all

labour there is profit' - Kingsley described work as 'a blessing to the soul and character'. He urged his readers to

'thank God every morning... that you have something to do that day which must be done, whether you like it or not. Being forced to work, and forced to do your best, will breed in you temperance and self-control, diligence and strength of will, cheerfulness and content and a hundred virtues which the idle man will never know.'[35]

Carlyle was the major spokesman on this theme. In both *Sartor Resartus* (1833-4) and in *Past and Present* (1843), Carlyle preached the duty and dignity of work, endowing it with a quasi-religious significance; and more than one generation responded with enthusiasm. Many who came of age in the forties and 'fifties saw their own experiences reflected in those of Carlyle's hero, Teufelsdrockh, who traces the familiar Victorian path 'from loss

fig.23
Ford Madox Brown
Work
1852-63. City of Manchester Art Galleries

of faith, purpose, and identity to an affirmation of self through work in this world.'[36] An article on 'The Work of Young Men in the Present Age' which appeared in the *Oxford and Cambridge Magazine* (1856), launched by a like-minded group of students including William Morris, and Edward Burne-Jones, closely echoes the words of Carlyle. Morris and Burne Jones were typical of the high-minded young men of the time who, having lost their conventional religious faith and abandoned their plans to enter the Church, found a substitute in the ideals of Duty and Work. The crux of the article is that the same sense of duty which had guided men during the late Crimean War must be maintained in times of peace. 'In Work, earnest, resolute, patient, constant Work, it will find its satisfaction... To do a certain work each man was born. It is the noble duty of each man, each youth, to learn his particular work'.[37]

But what Carlyle also preached - and he was the first to do so - was the intrinsic nobility and heroism of *manual* as well as men-

tal labour; an idea which was to form the basis of Madox Brown's polemical statement on the subject. In his savage critique of the inhumanity of the modern world, *Past and Present*, Carlyle preached the Gospel of Work as the salvation of mankind:

'The latest Gospel in this world is, Know thy work and do it... a man perfects himself by working... Blessed is he who has found his work; let him ask no other blessedness. He has a work, a life-purpose'.

His words were intended to apply equally to high and low: 'all true Work is Religion... All true Work is sacred; in all true Work, were it but true hand-labour, there is something of divineness.' 'All work, even cotton-spinning is noble... there is a perennial nobleness, and even sacredness, in Work... In Idleness alone is there perpetual despair.'[38] Some years later when the focus of his attention had begun to shift to social

THE POUND AND THE SHILLING.
"Whoever Thought of Meeting You Here?"

above fig.24
John Leech, 'The Pound and the Shilling', *Punch* (14 June 1851)

below: fig.25
John Leech, 'What Our Navvies are Likely to do' [in the Crimea]
Punch (16 December 1854)

bottom: fig.26
John Leech, 'The Real Street Obstructions', *Punch* (13 July 1850)

WHAT OUR NAVVIES ARE LIKELY TO DO.

problems, Ruskin closely echoed Carlyle when he stated that 'A labourer serves his country with his spade, just as a man in the middle ranks of life serves it with his sword, pen, or lancet', and ought to be rewarded accordingly.[39]

Such ideas were novel at the time, but reflected the increasingly conspicuous role of the manual worker in contemporary society; a fact highlighted by the Great Exhibition of 1851 - the culminating celebration of Britain's industrial triumph. The Crystal Palace had been designed by a former gardener's boy, Joseph Paxton, who was knighted for his achievement. The Palace had been conjured out of mass-produced prefabricated parts by 2,000 labourers, working in shifts, day and night, for ten months. It was opened on May 1st. 1851 by Queen Victoria, whose rapturous diary entries record the several visits which she paid each week until its final closure in the following October.

It was duly acknowledged that the role of the manual labourer underlay the whole project, for amongst the exhibits inside the emphasis was also on manufactures. The *Athenaeum* noted that the contribution of the humblest operative gave him an unparalleled importance: 'Here, for the first time WORK, in the presence of all the powers that rule the world, takes its just relations. Over all the assembled aristocracies here, LABOUR is President.'[40] Henry Mayhew, while dismissing the idea of 'manual dexterity or muscular labour' as a pleasure or 'the summum bonum of human existence', believed, with Ruskin and Carlyle that we should honour such exertions

'more than we do; and that, above all, if society would really have the world progress, it should do away with the cheat, which makes those men the most 'respectable' who do the least for the bread they eat. If we wish to make gentlemen of our working men... our first step must be to assert the natural dignity of labour... Let industry be with us "respectable" - as it is really in the natural arrangement of things - and the industrious poor instead of the idle rich will then be the really respectable men of this country... the Great Exhibition, where all these matters are forced upon the mind, rightly considered, is a huge academy for teaching men the true dignity of even what are thought the inferior grades of labour.'[41]

The artisans or skilled workers were largely responsible for the machines and other products exhibited, and came in force as spectators. Before the exhibition opened, widespread concern had been expressed about how the 'shilling people' would behave: 'Would they come sober? will they destroy the things? will they want to cut their initials, or scratch their names on the panes of the glass lighthouses?' The final consensus was that they

had 'surpassed in decorum the hopes of their well-wishers.'[42] The occasion was judged to have been as much a social as an economic success. Britain was proud of the harmony in which the different classes enjoyed the great spectacle together; a harmony which signified a political stability equalled by no other European country. It is this success which forms the subject of a John Leech cartoon, which shows a middle and working class family greeting each other at the Exhibition, in mutual sympathy and delight (fig.24).

Of all artistic responses to the notion of the dignity of manual labour, none was to equal Brown's *Work* (figs.22&23) – the most extensive pictorial commentary on the theme. In a clumsy but stirring sonnet which Brown included in the catalogue note to the painting, he made clear his aim of paying tribute to the Victorian work ethic, and of celebrating 'the heroism, dignity and probity of [that] manual labour'[43] on which the rest of society depended; a fact suggested in the very way in which *Work* is structured. Illustrating as it does 'the value and beneficence of labour', Brown's sonnet was quoted approvingly by Samuel Smiles, propagator of the doctrine of 'Self-Help', in his *Life, Labour, or Characteristics of Men of Industry and Genius*:

'Work! which beads the brow, and tans the flesh
Of lusty manhood casting out its devils!
By whose weird art, transmuting poor men's evils,
Their bed seems down, their one dish ever fresh...'[44]

The British workman had a formidable reputation. In 1854, the *Illustrated London News* commented that British engineering workers had 'been long known as the very elite of England, as to physical power; – broad, muscular, massive fellows, who are scarcely to be matched in Europe.'[45] Five years later, Samuel Smiles confidently asserted that the English labourer worked harder and produced higher quality work than his counterpart in any other country. He recounted how,

'When the first gangs of English navvies went over to France to construct the works of the Rouen Railway, the peasantry used to assemble round them, and gaze with wonder at their energy and dexterity in handling the spade and mattock [pick-axe], and at the immense barrow-loads of earth which they wheeled out. "Voila! voila ces Anglais! comme ils travaillent!" was the common exclamation.'[46]

It was in tribute to the exceptional qualities of this contemporary national type that Brown conceived his picture. In the artist's own lengthy catalogue note written for his 1865 exhibi-

tion, we are told that the picture was suggested by the sight of navvies working on a new drainage system in Brown's native Hampstead. The installation of an efficient water-supply had become a matter of urgency following the massive and often unregulated growth of London in the 1840s and 'fifties, and the frequent cholera epidemics in overcrowded areas caused by contaminated water. As *Household Words* admitted in 1854, London was now 'one of the unwholesomest bits of land in the United Kingdom' and 'Our most pressing concern... as citizens, for the next few years will be with water supply and drainage.'[47] As a prime example of the problem, the writer points to the new houses being thrown up haphazardly between the centre of town and Hampstead and Highgate Hill, by independent builders: the very area where Brown lived and which he chose as the setting for his painting. George Cruikshank had warned of the radical changes which threatened the area as early as 1829 (fig.27); but Brown responded more positively, showing how the subsequent problems might be dealt with.

In his picturesque costume, and glowing through his exertions under a hot sun, the navvy struck Brown as at least as worthy a subject as the 'fisherman of the Adriatic, the peasant of the [Roman] Campagna, or the Neapolitan lazzarone' – the traditional and picturesque inhabitants of Italian genre and landscape. The idea thus evolved of using 'the British excavator for a central group, as the outward and visible type of *Work*.'[48]

The paintings and illustrations to which Brown turned in his search for artistic models, are revealing in themselves. The inspiration of Hogarth's London street scenes is notable. The motif of the navvy downing his pint of beer, closely echoes the figure to the right of Hogarth's *Beer St.* and endorses Hogarth's approval of that 'invigorating liquor'.[49] Brown was a fervent admirer of the great eighteenth century painter of modern life who had spiced his social commentaries with satire and an element of the grotesque. Brown must have known Charles Lamb's essay on Hogarth, in which Lamb favourably compares him with Poussin and Reynolds, as a historical painter; pointing out that his subjects of 'common or vulgar life' are sufficiently unvulgarised by 'The quantity of thought which Hogarth crowds into every picture'.[50] The quantity of thought in *Work* certainly equals anything by Hogarth. Historians have noted that Brown also turned to *Punch* in his determination to escape convention; basing the principle navvy and the incident of the orange seller and policeman, on two of John Leech's cartoons (figs.25&26).[51]

Brown used real navvies as models. In his desire to pay tribute to the men involved in hazardous and even dangerous tasks as they laboured to construct modern Britain, he was, understandably, selective in his choice, and no doubt spoke the truth

when he said that he found them to be 'serious, intelligent men and with much to interest in their conversation'.[52] But not all navvies were as respectable as Brown's. For decades they had led a nomadic life, following the canal and railway building, living in camps and priding themselves as a race apart. Wild, violent and lawless, they terrorized and debauched the neighbourhoods they invaded. Drinking, marauding and ferocious gangfights - often involving marches of many miles to effect a confrontation - supplied their amusements. By the 1850s when large scale construction work had been more efficiently organized, the navvies' condition had begun to improve. The leading public works' contractors of the age, such as Thomas Brassey and Sir Samuel Morton Peto, had recognized the necessity of rectifying 'the anarchic labour conditions of the early boom', and contributed significantly to this. As Peto made clear to the Select Committee appointed to investigate the condition of Railway Labourers in 1846, 'a steady, manageable labour force' was beneficial to both employer and employed.[53]

Brown's clean-limbed navvies offended no-one, despite the unusual emphasis he gave them. The *Illustrated London News* critic congratulated Brown's boldness in 'representing as your principal hero that potent agent in the work of British civilisation, the excavator, or "navvy."'[54] Each is a representative type and Brown took care to distinguish them physiognomically. In first place - slim, blue-eyed, fine-featured, his curly hair confined by a jaunty striped cap, and chewing on a sprig of geranium instead of the more usual parsley - is 'the young navvy in the pride of manly health and beauty... who occupies the place of hero in this group'; tossing back a pint, is 'the strong fully developed navvy who does his work and loves his beer;' in the foreground, 'the selfish old bachelor navvy, stout of limb' and a bit tough-hearted; descending into the pit with his hod of bricks, the navvy whose heavy features indicate a 'strong animal nature' - saved from a criminal life by being taught to work usefully when young; and the inevitable Irishman, smoking a pipe as he rakes the mortar with his 'larry' - a long-handled hoe.[55]

The *Illustrated London News* critic also applauded the 'variously suggestive, and by no means squeamish, way in which the theme "Work" is illustrated, positively and negatively' by means of the various characters - both employed and unemployed - throughout the picture;[56] and it is this which gives the picture its philosophical dimension.

The two prominent figures standing within the rail to the right – Thomas Carlyle and Frederick Denison Maurice – represent the intellectuals and philanthropists who were involved in addressing contemporary social problems. Intriguingly, the sketch for the painting (fig.22) shows that Brown initially intended to include a single figure where the two now stand, presumably 'the artist' (and by implication, himself) whom he mentions in his *Diary* in January of 1856.[57] Carlyle had commented favourably on the role of the artist in *On Heroes and Hero Worship* (1831), which would have gratified Brown and which probably suggested the idea to him. In his most trenchant commentary on modern society, *Past and Present*, Carlyle had also paid tribute to the 'inspired Thinker' – the brainworker who provides spiritual guidance for the generality of mankind;[58] and it is this role which he himself occupies in Brown's painting.

Carlyle's ideas about labour and society in general, underlie the whole image, although it was Brown's patron, the evangelical Thomas Plint, who suggested that Carlyle should be portrayed. Plint also requested that Charles Kingsley be included, but agreed to Brown's request to substitute Maurice instead. Maurice and Kingsley were closely associated. In 1848, after the failure of the second attempt by the Chartists to persuade Parliament to extend the franchise to the working man, and the social disruptions which predictably followed, the two had been amongst the founding members of Christian Socialism, believing that society could not be successfully restructured on an entirely secular basis. Their involvement in extending educational opportunities for working men, through lecture series and evening classes, culminated in the establishment of a Working Men's College in 1854, the aim of which was to provide classes of a broader and more liberal nature than those which were available at the Mechanics' Institutes. Art and design were an essential part of the agenda, and Ruskin, Rossetti and Madox Brown were all to take a turn at teaching there.

Brown's grandson, Ford Madox Hueffer, records that Brown's copy of *Past and Present* showed 'signs of frequent perusal,' and amongst the pencil-marked passages were 'many enunciating the gospel of *Work*'.[59] In his *Diary*, Brown expressed reservations about Carlyle's long-winded and over-heated style, but concluded that his books contained more 'Real gold & solid weight & close packed wisdom... than... any other writing now published.'[60] Carlyle's metaphor of physical labour as

'a free-flowing channel, dug and torn by noble force through the sour mud-swamp of one's existence... draining-off the sour festering water... making, instead of pestilential swamp, a green fruitful meadow with its clear-flowing stream',

evidently impressed Brown. It has a direct bearing on the work which his own navvies are performing: the excavation and laying of new water mains; a task essential to the improvement of the health and well-being of the city's inhabitants.[61]

fig. 27
The builders advance through Islington towards Hampstead
George Cruikshank, 'London Going out of Town – or – the March of Bricks and Mortar!' 1829. Handcoloured etching

Another social commentator whose ideas are pertinent to Brown's painting is Henry Mayhew, whose writings were most influential, and who like Carlyle, had done much to enlist F.D. Maurice's interest in the condition of the poor. Mayhew's classification of the urban worker in *London Labour* into those that will work, those that cannot work, and those that will not work, guided Brown in his own selection as he makes clear in his catalogue entry. As well as the navvies themselves, prominent amongst the working element is the stunted but dandified beer-seller (fig.28) who has triumphed over a deprived childhood to achieve a respectable position in life, aptly displayed in his jaunty bow-tie, fancy waistcoat and shirt-front adorned with prancing ballet girls. Non-workers include, to the left, two prettily dressed ladies, the elder – at Plint's suggestion – distributing temperance tracts; and, physically as well as socially at the apex of this human pyramid, an aristocratic gentleman and his daughter on horseback, accompanied by a glossy black dog. The duties and responsibilities of the aristocracy were a burning issue. Carlyle castigates the idle aristocrat in *Past and Present*; comparing 'A High Class without duties to do' with 'a tree planted on precipices; from the roots of which all the earth has been crumbling.' Never, Carlyle thundered 'in a slothful making others suffer for us, did nobleness ever lie.'[62] Disraeli took up the theme of the aristocrat's role in modern society in *Coningsby* (1844) *Sybil (1845)*, and *Lothair* (1870); in all of which the emphasis is on the duty which the privileged classes owe to society. In his commentary on the painting, Brown hints that the 'good-natured' gentleman on horseback only requires advice and information in order to act rightly. It is the role of brainworkers like Carlyle and Maurice to supply these; but to be effective, they must communicate them to the right people, such as Brown's pair, who at present – as the barrier indicates – remain inaccessible to them.

To the left of the picture is a strangely furtive looking character clutching a basket: a herb-seller who was evidently inspired by one of the illustrations in Mayhew's *London Labour and the London Poor*, and who replaces the dandified little 'gent'

fig.28
Detail of *Work* (Beer-seller)

who appears in the sketch (fig.22). Bare-foot, and clad in ragged robe and floppy hat, he is, as Brown explains, good-natured and harmless but incompetent. Although with an occupation of sorts, he is one of those 'who has never been *taught to work*', and but for his innate docility, might well have turned to crime. Brown refers to him as next in significance to the navvies; representing as he does, a very different element of the lower classes: the neglected millions who teeter on the brink of destitution and who thus constitute a serious threat to society. The possibility of a criminal future certainly hangs over the young children at the front of the picture who have been left to fend for themselves after the recent death of their mother; an event signified in the baby's black ribbons and in the dilapidated appearance of the whole group. They are important too; for they represent the future generation. Brown points out that the pretty but idle young lady to the left might find a worthier project in them, than in her pampered pet greyhound who is quite evidently better dressed and fed than they are.

The scene to the far right gives further glimpses of the present 'condition of England'. Crowded on the bank, others 'who do not work' include the unemployed, travelling in search of it, such as an Irish couple with baby, and sailors and farm-workers in various stages of poverty. Brown indicates the potential danger posed by them by placing them beyond the fence; their marginalization an evident source of discontent, and a reminder of what may happen if the educated classes fail in their responsibilities towards those less fortunate than themselves. In the distance, Brown mocks the irresponsibility of the *nouveaux riches* in the form of an election campaign, conducted on behalf of the sausage maker, Carlyle's Mr. Bobus, from *Past and Present*, whose

motive is a desire for power rather than a concern to improve the condition of his fellow men. In *Past and Present*, Carlyle had deplored the social consequences of capitalist greed; and on a smaller scale, abuse of power is also illustrated in the vignette of a female orange seller being bullied by a policeman. The picture thus raises a number of serious contemporary social issues; but the visual and textual evidence combined would suggest that although Brown took a realistic view of the condition of England, he was not necessarily pessimistic of change for the better.

His lengthy commentary on the painting provides a lively and enthusiastic exposition of every detail, from the navvies themselves to the posters on the red brick wall. What irony there is, is tempered with humour, and Brown's intense engagement with his painted characters is patent. Scattered references in his *Diary* reveal his unmitigated delight in the designing and painting of *Work*. At one point he wrote of the 'ethereal and ecstatic state' which it induced in him. 'I do not hurry with it', he confessed, 'because it is such enjoyment'; and on another occasion he referred to it as 'a species of intoxication.'[63]

Despite the seriousness of the underlying message there is a pronounced comic element in the picture which emerges in certain characters and details: the pugnacious little beer-seller and the naughty urchin with the wheelbarrow; the bulky old woman in the distance to the left of Carlyle who clenches a clay pipe between her teeth and assumes an air of touchy dignity as she is helped on with her sandwich-board; the three scruffy children performing amateur gymnastics on the white railing beyond – the little girl devoid of all underwear; the cats posturing on the roof of the red brick house in the distance, and the contrasting attitudes and characters of the confrontational dogs. Brown took an evident delight in registering details which are rarely seen in art but which help bring the scene to life, such as the ballet girls already mentioned on the shirtfront of the beer-seller; the odd buttons on the dark red waistcoat of the central navvy; and the garland of woodshavings with which the neglected children have adorned their raggedy pet mongrel.

The resulting image is cheerful and affirmative in spirit. For all its philosophical burden its sheer visual power is what strikes one most: the burning blue sky; the almost jet black shadows which shroud the topmost couple and the tree; the brilliant patches of sunlight on the yellow spotted skirt of the lady with the tracts; the bony, sunburned back of the little girl in her outsize dress – is it any wonder that Brown 'growled with delight' as he painted her?[64] Some historians believe that Brown intended to convey a gloomy view of British society and its future; but it seems beyond the bounds of human nature that this, his most ambitious work, over which he laboured intermittently over

eleven years and which formed the focal point of his one-man exhibition in 1865, could have progressed in a spirit of doubt and cynicism. Painted with all the honesty, vigour and enthusiasm that Brown could muster, it has a vitality which is rare in art, as George Bernard Shaw acknowledged.[65]

The only rival to Brown's image of the working man is William Bell Scott's *Iron and Coal: 'In the NINETEENTH CENTURY the Northumbrians show the world what can be done with iron and coal.'* (1855-61, fig.30). A Tynesider himself, Scott (1811-90) who was also a poet and somewhat bitchy friend of the Pre-Raphaelites, painted this as one of a series depicting episodes of Northumberland history for the central courtyard at Wallington Hall, home of Sir Walter and Lady Trevelyan. Beginning with more conventional subjects such as *Building the Roman Wall* - during which Scott had a piece of the real thing sent to him for study purposes[66] - and the *Death of the Venerable Bede at Jarrow Priory*, the series culminated in this scene which focuses on the great contribution which Northumberland had made to the industrial revolution. In the final issue of the Pre-Raphaelite magazine *The Germ* (1850), Frederick George Stephens had urged poets and artists to respond to modern life in modern terms. What is missing from our art, he says, is 'the poetry of the things about us; our railways, factories, mines, roaring cities, steam vessels, and the endless novelties and wonders produced every day'.[67] Of all paintings by members of the circle, William Bell Scott's *Iron and Coal* most closely fulfils Stephens' prescription.

Like *Work*, it pays tribute to manual labour, but the setting is the interior of an engineering workshop in industrial Tyneside; and this time, there is no question of the artist's intentions. *Iron and Coal* expresses the 'civic pride' justifiably felt in 'the town's new-found industrial strength.'[68] It is an allegory of a progressive and harmonious society; and despite the realism of its components, Scott felt free to adjust the actual scene in order to make his point.

The artist visited Stephenson's workshop where he observed workmen engaged in the very action which we see in the painting. But, despite the striking modernity of Scott's subject, both this and the composition were no doubt suggested by a design by Bell Scott's much admired friend, Thomas Sibson (1817-44), a fellow Northumbrian. Although Scott reproduces the design in his autobiography, the connexion between the two images has not been noted previously. Sibson is now forgotten, but Scott pays tribute to him more than once. On Sibson's early death, Scott became the recipient of a large collection of Sibson's drawings, including one which shows a Saxon 'woodcarver's or carpenter's shop... in the period after the Conquest', planned as an illustration to a theme similar to that of Scott's own mural series - a *History of English Civilization*[69] (fig.29). In Sibson's design we

see the Saxon equivalent of tools and manufactured objects, the latter ranging from gargoyles to musical instruments. Sibson presents us with a wide, open-sided view from inside the workshop over the town, divided by a single support, a composition which is closely echoed in Scott's. An early mediaeval crane to the right represents contemporary technology before steam and electricity had ever been thought of; in the Saxon market place, respectable burghers discuss commercial matters, their backs turned to the pillory where summary justice has been meted out. Across the square to the left, appears the motif of workmen hammering at the anvil, muscular arms raised, which was to become a major feature in Brown's own painting. The design for the 'Great Door' of a church or cathedral which the visiting monk and the two craftsmen are discussing, finds its later equivalent in the design for what has been identified as 'a bogie passenger locomotive of the very latest type,' probably one produced at Robert Stephenson's workshop in 1861.[70] Even the mastiff guarding her pups, to the left, prefigures the canine specimen which Scott included.

Scott's painting is filled with indications of Tyneside's industrial achievements and refers also to educational and cultural advances. The colours are subdued. A pale shaft of sunlight filters through the workshop, and the mauves and yellows of the smoke and chemical laden sky, convincingly suggest the polluted atmosphere of a busy industrial town. The spectator is drawn deeply into the cluttered workshop. Scott has emphasized the heroic quality of the men, but they are convincing as working types, and indeed, three of them were painted from Stephenson's own employees.[71] Their rugged faces reveal an intense concentration on their task, a phalanx of muscular forearms raising the hammers in rhythmic unison. In blue working shirts and leather aprons they brave the hot blast of the furnace and its molten iron. The men are in process of manufacturing the kind of machinery seen both inside the workshop and in the industrial scene beyond. Part of a ship's engine and anchor are visible, while the schoolgirl sits on an Armstrong gun, another major item of manufacture. Machinery, anvil, crane, girders, Stephenson's High Level railway bridge, all are built from iron, as are the engine and tugboat. Together with the distant factories, the latter belch the coal-smoke that is the basis of the steampower and wealth of the North.

The busy dockside, with its merchants, passengers and workers, signifies commercial enterprise, travel and trade, as well as new and rising professions and services like photography. The telegraph wires and newspaper point to improved communications and literacy. References to a panorama about Garibaldi, the Italian patriot and soldier who was to visit England in 1864, and an exhibition of work from the new art school of which Bell Scott was director, are signs of the area's cultural progress.

fig.29
After Thomas Sibson, *Saxon Arts*
William Bell Scott, *Autobiographical Notes*, Vol.1, 1892

The little girl has brought her father's food, neatly tied up in a basin which greatly interests her pet dog. Her appearance indicates the benefits of industrial achievement for a younger generation. Well dressed, well fed and educated, she is an optimistic symbol of the future. The sturdy pit-boy, armed with his Davey lamp and surveying the busy quayside, is also smartly dressed and may well have good prospects himself. A *Cornhill* article of 1862 cites the example of an eminent engineer, former workmate of George Stephenson (father of Robert) who had risen from being a pit-lad. Another success story is that of a 'stout, but benevolent-looking man... now a partner in one of the principal [sic] iron-works near the Tyne... risen to his present position from the lowest grade of pit life - that of a trapper boy, earning sixpence a day.'[72] Such are the opportunities which the North provides.

This is an optimistic image of a thriving community. Ironworkers were well-paid and the area was richly productive. In the year following the completion of the picture, the Tyne and Wear coal-field was described in the *Cornhill* as the most famous and intensively mined in the world; 'a source of interest and excitement which cannot be adequately conceived until it is experienced'. The writer might be describing the scene here: 'Newcastle, the true metropolis of coal' rises on the other side of the Tyne from Gateshead, 'and deep down between the two towns rolls the broad black river, with its ships and boats, its "keels and keelmen"'.[73] The excitement which such sights aroused is also recorded by John Brown, essayist and physician. Scorning the finished products of the South Kensington museum, he recommended as more educative and soul stirring, a

visit to a cotton mill or an iron foundry with its 'half-naked men toiling in that place of flame and energy and din', a place where one might see 'the Nasmyth-hammers, and the molten iron kneaded like dough, and planed and shaved like wood'. The visitor, Brown concluded, 'gets the dead and dissected body in the one case; he sees and feels the living spirit and body working as one, in the other.'[74]

The majority of portrayals of working life - whether emphasizing the dramatic aspects of the industrial scene, or its human side, lack the philosophical dimension of these two ambitious paintings; but even those of a more idealized genre type are of considerable interest. One such which provides a rare glimpse into the heart of the industrial working life of the North, is Eyre Crowe's *The Dinner Hour Wigan*, 1874 (fig.32) In the previous year, Crowe had exhibited a pair of pictures: *Brothers of the Brush* and *After Work*; the first showing house painters busily engaged on the facade of a house; the other, a group of labourers relaxing and gossiping outside a public house. One critic of that year was impressed by the humour and 'quaint character' of these works, and responses of this kind may have encouraged Crowe to proceed with the subject for which he is now largely known.

Crowe's family moved to France when he was still a child, and he spent five years in Delaroche's Paris *atelier* before returning to London in 1844 and entering the Royal Academy Schools. His sound academic training is revealed in the firm drawing and dignified aspect of the Lancashire mill-girls whom he chose to portray. Skilled operatives like weavers were well paid, and while single and childless, relatively affluent. In *Sybil*, Disraeli paints an informative picture of young weavers of an earlier generation. Aged sixteen or so, Caroline and Harriet have already left their parents for a rented room and freedom; what they earn is theirs to spend as they wish. 'Gaily dressed, a light handkerchief tied under the chin, their hair scrupulously arranged', wearing coral necklaces and gold earrings, they enjoy nights out at the music hall with their boyfriends, and rather grandly issue invitations to their neighbours to join them for tea.[75] Crowe's girls, no doubt, enjoyed a similar independence. By this date, the Lancashire mills had recovered from the 'cotton famine' caused by the American Civil War (1861-5). In clogs and shawls, bright cotton skirts and overalls, their hair protected from the machinery by snoods, they finish off their lunch or 'bait'. An old woman collects the billy-cans in which the tea has been brewed, and in the distance operatives begin to assemble at the factory door. In the foreground, one young girl reads a letter; others exchange confidences; one nurses her baby; another leans against the gas-lamp as she prepares to throw an orange to her friend. Crowe's workers are more

fig.30
William Bell Scott
Iron and Coal: 'In the NINETEENTH CENTURY the Northumbrians show the world what can be done with iron and coal
1860–61. Wallington Hall, Cambo, Northumberland
National Trust Photographic Library

fig.31
Jean Francois Millet
The Winnower
1848. National Gallery, London

refined and graceful than they would have been in reality, and northern factory towns were far sootier than Crowe's cheerful red brick would suggest. But he has conveyed the undramatic, random effect of a group of rested and contented workers in a suitably mundane setting. The factories and weaving sheds with their tall tapered chimneys rise behind, the clouds tinged a pale sulphurous yellow by the ubiquitous smoke.

· · ·

Crowe's is yet another positive view of working life; but beginning in the 1860s, there was a general reaction against the optimism of the previous decade. Industrialism had always had its critics, but a tendency to dwell on its negative aspects, both social and cultural, became much more widespread. Many agreed with Ruskin that 'order, tranquillity, and harmony' - the virtues central to his own vision of what constituted the good life - were exactly those which 'progress' was destroying.[76] George Eliot was among those who, while acknowledging the inevitability of change, regretted how the growing manufacturing towns had destroyed traditional country life, diffusing smoke and fumes 'over all the surrounding country, filling the air with eager unrest.'[77] For Ruskin, the choice was stark. As Martin Weiner observes, it lay between 'stability and contentment or restless change'; between

'pastoral contemplation or industrial inferno. His hope for the future was "that England may cast all thoughts of possessive wealth back to the barbaric nations among whom they first arose" and turn instead to the cultivation of noble human beings.'[78]

In art, the rural scene had long provided solace for the town dweller. In the eyes of many Victorians, the countryside was not simply a peaceful rural retreat but a place which retained a purer, more innocent and 'natural' form of social order; undisturbed and uncorrupted by the conditions which had transformed the urban landscape. Through paintings of such scenes, the town dweller was able to enjoy country life vicariously. As the *Art Journal* commented, through them, one could

'greet the peasant smiling at the cottage door... walk the humble streets of the rural village, enter the parson's parish school, or the labourer's dwelling... or join the circle of the cottar's Saturday night around the brightly-burning fire.'[79]

It is exactly this sort of image which continued to be promulgated in traditional rural genre painting of the type discussed in Chapter 1. But the reality was different; a fact which emerged when official enquiries began to be made into rural life, and which was to be acknowledged by some artists, at least, in the 1870s and later. In 1862, the great philanthropist, Lord Shaftesbury, had urged the investigation of labour conditions among children, young persons and women involved in agriculture; this was followed three years later by a specific enquiry into the notorious 'gang system'. The condition of the agricultural proletariat became a major social issue, resulting in the Royal Commission of 1867 and four subsequent reports published between 1868 and 1871.

The social and moral revelations which emerged made shocking reading, and unofficial sources tell the same story. The diaries of the Rev. J.C. Egerton, which cover the parish of Burwash, East Sussex, between 1857 and 1888, are among numerous examples which bear witness to the brutishness of rural life. During the depression which followed the close of the Napoleonic wars in 1815, Burwash, like many rural areas, was a centre of great poverty and intense 'social conflict'; its inhabitants 'disrespectful and insolent to their superiors, riotous and turbulent'. They were enthusiastic supporters of the Captain Swing riots of 1830-1, when landworkers turned violently against the new threshing machines and those attempting to introduce them. When Egerton arrived in 1857, Burwash was still notorious as

'the birth place or sheltering place of rick-burners, sheep stealers and thieves". Farmers kept loaded firearms at their bedsides; commercial travellers, and others, went armed along Wealden highways. But Burwash especially, remained prone to "Robbery, violence, and lawlessness of all kinds", the bulk of the inhabitants "wild, ignorant, and lawless'.[80]

fig.32
Eyre Crowe, *The Dinner Hour Wigan,*
1874. City of Manchester Art Galleries

It has been claimed that living conditions in the country were, on average, worse than in the town. For twenty years, the period following the 'hungry forties' had been relatively affluent; but the last quarter-century was a period of great social suffering and disquiet in rural areas. A cattle plague which occurred in 1869 was the first of a long sequence of agricultural disasters. It was followed by a second major depression which, with fluctuations, lasted until 1896. Farm prices collapsed in 1879 and remained depressed under the influx of cheap grain from Canada, North America and Eastern Europe and of wool and foodstuffs from the colonies. Income from land declined by more than thirty per cent. Bad harvests, competition from the better wages that industry offered, a series of Education Acts (1870-6) which ended the supply of cheap child labour, all contributed to the decline of the rural economy. In consequence, rural areas were seriously depopulated and many of the peasants who remained suffered considerable hardship. Only after Joseph Arch's agricultural union made headway during the 1870s, did agricultural wages and conditions begin a fairly steady improvement.

But social problems in rural areas lacked the urgency and newness of those associated with the town. Rural poverty was less of a topical issue than urban. Peasant housing was more dispersed and often remote from the public eye, and thus received less attention. In opposition to the growing prominence of his problematic urban counterpart, the rural worker came to be identified 'as part of a vanishing reality', and in art the rural type wa soften represented as 'a figure of unchanging, unassailable value in the midst of an all-too-swiftly changing... world'.[81] The most humble rural worker was thus capable of fulfilling a symbolic function which the very modernity of the urban worker denied him. As J. H. Phythian put it, in rural life,

'Face to face with nature, and with the labour by means of which men win their subsistence from nature, artificiality is at a discount; and history is of little moment, for here are the great elemental facts of life that, in their main features, antedate history.'[82]

This response is most evident in the work of the Poetic Realists or Idyllists; the first group of Victorian painters to give

new significance to the rural scene. The Poetic Realists were regularly cited as the most important British group of painters to emerge since the Pre-Raphaelites. Dr. Richard Muther, a German historian, was to describe the works of Fred Walker and George Heming Mason as 'the most original productions of English painting during the last thirty years', uniting as they did 'realism and poetic feeling'.[83] Their great achievement was in grappling with the universal questions of life; more particularly, with what Harry Quilter, recognized as a specifically nineteenth century preoccupation: the relationship between 'man and nature... the problem of the why and the whither, the problem of the connection between humanity and the earth'.[84]

The work of the Poetic Realists retains much of the generalized religious feeling and sentiment of the French painter, Jean-Francois Millet who was the originator of this development, and through whose example subjects like 'sowing, or gleaning, or fetching water from the well,' were for the first time rendered 'impressive... generic... monumental' (Fig.31).[85] Millet was to remain legendary amongst people whose acquaintance with art

was slight, through the cheap prints of favourites like *The Angelus* which survived in many a humble home well into the twentieth century. The Poetic Realists learned much from Millet. Rather than addressing the problems of rural life directly, they evoked sympathy by endowing their rural workers with a certain grandeur - a universal quality which points to the symbolic element of man's engagement with the land, through the ever-recurring cycle of the seasons which binds him to it from time immemorial. Although poverty and hardship were freely admitted, through using subdued and sombre colours and avoiding obtrusive detail the Poetic Realists threw a veil of tender feeling over their scenes. The rural labourer is cast in heroic mould; the figures of men and women, elevated and ennobled, sometimes through specific allusions to classical sculpture.

But the example set by the French Social Realists, Jules Breton and Bastien-Lepage, as well as the Dutch artist Joseph Israels - ensured that the poetry was balanced with realism. A great favourite in England, Israels in 1855 had gone to live and paint amongst the poor peasant fishing community of

opposite: fig.33
Frederick Walker, *The Vagrants,* 1868. Tate Gallery, 1999

above: fig.34
George Heming Mason, *Harvest Moon,* 1872. Tate Gallery, 1999

Zandvoort, near Haarlem. In London in 1862, his *Fishermen carrying a Drowned Man* (Fig.35) 1861, London, National Gallery) had made a great impact and his influence was to be felt by all painters of social subjects in the second half of the century. Israels brought a new dimension to the genre tradition, maintaining a sombre and tragic tone while avoiding the pathetic and the trivial. His work is distinguished by an epic quality and 'a grandeur of scale unusual in genre painting.'[86]

The work of the Poetic Realists illustrates the marked change which distinguishes the aesthetically inclined 1860s from the previous decade; and indeed, many of their less important works are in the aesthetic mode. Walker, Mason and Macbeth often painted picturesquely dressed little girls and women in gardens and rural settings, which aimed to be decorative and saleable. More pertinently, their work points to the 1860s as a decade in which, in both art and literature, 'allusiveness began to take precedent over fact.'[87] In the *Magazine of Art* (1884), Robert Louis Stevenson was to comment on the same development in literature, noting that writers were rejecting minute realism, and beginning 'to aspire after a more naked, narrative articulation; after the succinct, the dignified, and the poetic; and as a means to this, after a general lightening of this baggage of detail.'[88] In art, this approach was useful in obviating the perennial problem of dealing tastefully with the poor.

During his relatively short life Frederick Walker was to win great affection and admiration from fellow artists as well as public. His sympathies - and tendency to sentiment - were appar-

ent in his first exhibited picture, *The Lost Path* (1863), showing a young woman with her baby struggling through the snow. In the following year, William Agnew bought the highly finished water-colour *Spring*, a more cheerful and saleable subject showing a little girl enjoying the first signs of the season. Stevenson's comments on tendencies in contemporary literature aptly describe Walker's own development. Beginning with a precise technique which owed much to the Pre-Raphaelites, like all great artists Walker 'learnt with time to distinguish between essentials and superfluity';[89] developing a succinctness, and aptitude for pictorial synthesis, a 'concentration and compactness' which help explain his power.[90]

Largely self-taught, Walker learned more from the antique at the British Museum than he did at the Royal Academy Schools, and a visit to Paris in 1863 confirmed his preference. There is some dispute as to Walker's methods, but his biographer claims that he rarely painted from the model, and that it was in the studio that he gave 'shape to the images which had formed themselves in... his brain' from impressions received elsewhere.[91] His work would certainly suggest this.

As the central figure of the Poetic Realists, Walker epitomizes their failings as well as their achievements; for his technique is by no means flawless. There is a degree of attitudinizing in his figures, and his colour tends to be artificially sombre. Contemporaries admitted these faults; but most thought that they were outweighed by Walker's poetic sense, and the 'deep and earnest sympathy' which he expressed 'with every phase

fig.35
Jozef Israels, *Fishermen carrying a Drowned Man*
1861. National Gallery, London

and condition of human life'.[92] His particular brand of figure painting did, however, remain controversial. Herkomer praised his achievement in 'combining the grace of the antique with the realism of our everyday life in England'; concluding, 'His navvies are Greek gods, and yet not a bit the less true to nature.'[93] But Ruskin was amongst those who saw them as sins *against* nature. Ruskin regretted Walker's classical affectations as seen in figures like 'the ridiculous mower, galvanized-Elgin in his attitude'; and his unconvincing peasants who seemed 'All... got up for the stage.'[94] Such criticisms are even truer of feebler followers of the Poetic Realists who, as Walter Armstrong complained, churned out 'invertebrate productions in which the slightest possible veneer of "feeling" is expected to make up for every kind of technical deficiency.'[95]

Walker's ambitious and dramatic *Vagrants* consolidated his reputation in 1868 (fig.33). The subject was inspired by a group of gypsies which he saw on Clapham Common, and first appeared as an illustration in *Once a Week*. The family has come to a halt in an autumnal wasteland. The men are absent, perhaps gone in search of food, and the elder son - a mere boy - builds a fire. One woman sits behind it, a baby concealed under her shawl, while two younger children look wistfully on, the girl embracing the boy comfortingly. A young, dark-haired woman stands erect to the right, arms folded; her assertive stance and expression setting her apart. She alone appears conscious and resentful of her poverty and of the limitations of her life. Walker's original intention of using genuine gypsy models was prevented by their habit of constantly moving on, and in

the case of the young woman his sister posed. The light is beginning to dim over the heath and night promises little comfort. Walker has caught exactly the atmosphere of the last stages of twilight on a damp evening, and the effect of smoke drifting on the still air, swathing the standing girl. The only element which jars is the stiff, artificial pose of the boy to the left, all too evidently arranged in the studio. In other examples Walker expressed his sympathies in more poetic and broadly humanitarian than overtly social terms. The very titles of the *Old Gate* (1869), the *Plough* (1870), the *Harbour of Refuge* (1872) - all in the Tate - point to the symbolic element in his work.

Even more so than Walker, George Heming Mason (1818-72) was praised for having achieved a convincing synthesis of contemporary British peasant life and the Arcadia of ancient Greece. He was much admired for his ability to express a harmony between figures and landscape which suggested 'that the genius of an ancient rural life is not yet destroyed'.[96]

Mason was a member of the family famous for its ironstone tableware, but he was obliged by a reversal of fortune to make his own way in life. In 1843, with typical Victorian intrepidity, Mason and his brother walked to Italy via France and Switzerland, arriving in Rome two years later and remaining for a further twelve. Mason began sketching scenes of peasant life out of doors under the tuition of Leighton's friend, Giovanni Costa. Nicknamed the 'Etruscan' (after the ancient race which predated the Romans) Costa gave his name to a group of painters who brought a strong poetic element and a degree of abstraction to landscape, but who maintained the practice of

fig.36
After Robert Macbeth, 'A Lincolnshire Gang'
1876. *Graphic* (15 July 1876)

studying it at first hand in the open air. The English artists asso-ciated with the group were predominantly figure painters. Apart from Mason, they included Leighton himself, George Howard and William Blake Richmond. They were much in sympathy with the French artists of the Barbizon School, Costa having worked with Corot and other artists at Fontainebleau in 1862.

Mason had turned to art relatively late in life, and after his return to England in 1857, he suffered a crisis of confidence.[97] Twice during this period, in 1861 and 1863, the ever solicitous Leighton came to the rescue. Costa records how Leighton sought out Mason in his native Staffordshire and taught him to see that the beauties of that 'smoky rainy country' were equal to those of the sunny Campagna; that it, too, was 'idyllic in char-acter and inhabited by a refined race of peasants' reminiscent of 'the Greeks and Etruscans'. Costa credits Mason with having done for England what Millet had done for France, but 'with more nobility and poetry'.[98]

In Mason's *Harvest Moon* (fig.34) the exaggerated frieze shape allows for a processional composition, but also underlines the painting's strong aesthetic element. Under a greyish pink-tinged sky, the harvest moon has almost sunk to the horizon on the left. A warm pink also colours the distant hills, and reaches forward to tinge the fields, the dying leaves and foreground trees, and the white smocks of the workers. A young man, his hair pic-turesquely tied back in a red handkerchief, looks earnestly into his girlfriend's face as he plucks at a violin. There is an elegiac quality about the painting which evokes the poetic resonances of country labour rather than its realities. Despite his indefatigable

studies of nature, Mason's interest lay in 'the sentiment of nature rather than the portrayal of her facts.' A certain lack of articula-tion and definition in his figures allowed him to convey his own impression of the scene with maximum effect, unencumbered with elaborate detail.[99] As in Walker's case, Mason's figures – though criticized – were excused on grounds of poetic feeling. The example illustrated shows the artist's tendency to manipu-late these and every other element for the sake of both poetic and decorative effect. This is evident alike in the sinuous lines of gate and trees, and the attitudes of the figures, such as the stat-uesque white-clad girl who bears a sheaf of wheat, and the two lithe and graceful ploughmen who shoulder parallel scythes.

Robert Macbeth (1848-1910) was another who gave his fig-ures 'something of the reserve and abstraction of classic grace' and 'a splendid dignity to rural life' through his emphasis on aesthetic rather than domestic and popular qualities.[100] This is true of the majority of his works, like *Ferry and Flood* (1882) and the *Cast Shoe*; but in earlier examples like *A Lincolnshire Gang* (Fig.36) his social criticism is positively strident. Perhaps this is why the picture is now missing. More than ten years after the system had been brought to public notice, women and chil-dren are shown being brutally awoken and taken to the fields by the gangers and their dogs. Stirred by the ganger's threaten-ing attitude towards the sick child who is unable to rise from her straw bed, the *Art Journal* wrote that it was

'impossible to look upon this scene of degradation and slavery without asking the questions, Can such sights be seen within

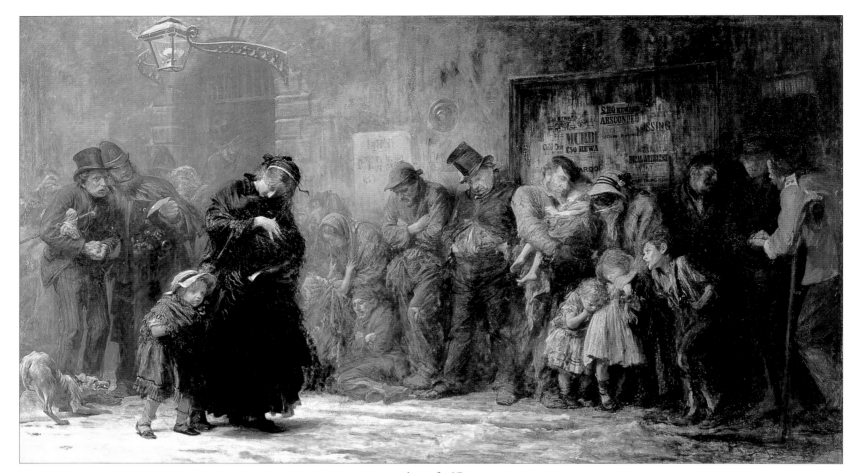

above: fig.37
Luke Fildes, *Applicants for Admission to a Casual Ward,*
1874. Royal Holloway, University of London

opposite: fig.38
Frank Holl, *Sketch for Deserted – a Foundling,* 1873. Private Collection

the four seas at this time of day? Is this old England, merry England, the home of the free, and paragon of the world? So humiliating a representation shows what an immense field yet awaits the sickle of the scientific philanthropist.'[101]

Macbeth's own catalogue entry on the painting gave the bald facts about the cruel exploitation of child labourers in the Fens; but the majority of Idyllist painters, including Macbeth himself, usually approached such problems more obliquely.

• • •

The Social Realists of the 1870s, many of whom had worked with the Poetic Realists as illustrators on the *Graphic*, were more forthright in confronting the suffering of the working classes in both town and country. In 1867, Carlyle had dismissed High Art and Poetry as irrelevant to the needs of contemporary life. 'It is not pleasant singing that we want,' he wrote,

'but wise and earnest speaking: – "Art," "High Art" &c. are very fine and ornamental, but only to persons sitting at their ease: to persons still wrestling with deadly chaos, and still fighting for dubious existence, they are a mockery rather.'[102]

Two years later the *Graphic* was launched. Only a small proportion of the magazine was devoted to serious social commentary, but occasional whole-page illustrations were commissioned, some of which were worked up into major paintings. These included Walker's *Vagrants* and Macbeth's *A Lincolnshire Gang*; but most hard-hitting of all was Luke Fildes' *Houseless and Hungry* which appeared in the first issue in December 1869. Fildes (1843-1927) is chiefly remembered for his essays in Social Realism, most notably his *Applicants for Admission to a Casual Ward* (fig.37), the resulting painting. A savage indictment of urban poverty and homelessness, it shocked the art world on its exhibition at the Royal Academy in 1874.

The problems of poverty and vagrancy were much in the news at this time. Commenting on the recent proposals of the Vagrancy Committee in 1873, the *Graphic* noted that it was 'The great centres of population, above all, London,' which acted as 'the depots where "vagrancy and mendicity are absorbed, recruited, and reissued."' The writer thought that the proposed abolition of Night Refuges and Free Dormitories, leaving only the Casual Wards, was far too harsh a means of discouraging this regrettable phenomenon.[103] Under the Houseless Poor Act of 1864, applicants were obliged to collect a ticket from a police station in order to qualify for a bed for the night in one of the casual wards which were attached to workhouses. Beds were always oversubscribed, and both Fildes and his friend Charles Dickens had been shocked at the sight of the queues of bedraggled humanity awaiting entry. Dickens describes how, in 1855, he saw, 'Crouched against the wall of the [Whitechapel] Workhouse... on the muddy pavement-stones, with the rain raining upon them... five bundles of rags... motion-less... [with] no resem-

blance to the human form.' The 'five ragged mounds' turned out to be young women, who were about to spend their third night in the rain outside the casual ward. Dickens was outraged that such conditions should persist.[104] In the Royal Academy catalogue entry for the picture, Fildes quoted from a letter in which Dickens referred to the 'dumb, wet, silent horrors' which had so shocked him; evidence, he thought, of a social divisiveness which, if unsolved, might easily lead to violent revolution.[105]

Fildes depicted 'a series of types of the most abject forms of London misery'; victims, variously, of 'misfortune, crime, sickness, drunkenness, or ignorance.'[106] They include a young widow with a baby and infant girl; an unemployed artisan with his weeping wife and children; slumped against the wall, semi-comatose, a bloated tramp in battered top hat who has sacrificed everything to drink; to the far right, a professional beggar with his crutch, and beside him, a couple of criminal types lurking in the shadows. Evidently new to this situation, is the poor but refined featured man on the far left, being respectfully advised by a policeman.

fig.39
Jules Bastien-Lepage, *Les Foins*
(The Haymakers, detail), 1878. Musee D'Orsay, Paris. Bridgeman Art Library

But while maintaining the pathos of the scene, Fildes adopts a technique which mitigates the horror; the tones subdued, the touch soft and fragmented. The effects of falling snow and the dim light of evening are cleverly suggested; the mood amongst the characters one of grim self-absorption in the struggle for survival. Fildes invited the homeless people to model for him; although a carefully contrived studio piece, it was painted from select members of the genuinely destitute. The result was too convincing for the comfort of many critics.

It caused a sensation at the Royal Academy, requiring a rail and a policeman to protect it from eager crowds, and was bought by a Wigan 'cotton king,' Thomas Taylor, who was assembling an impressive art collection at his country house in Oxfordshire. Many critics found the subject too painful, and questioned its suitability for art, but the consensus was generally favourable. The *Art Journal* thought that so terrible a subject could not have been handled better, and the *Athenaeum* that it might urge people to ask how such conditions might be improved.[107]

Frank Holl (1845-88) also worked for the *Graphic* in 1871-6, before turning, like Fildes, to social issues and finally to lucrative portraiture. His daughter explains his inclination for tragic subjects as partly the result of his own 'morbidly rigid upbringing'. Holl's first painting was of a beggar woman and her child cowering from the rain on the steps of a London church, and

he early determined never to paint any subject 'which was not absolutely "felt" by him.'[108] It is significant that his trip to Italy on a Travelling Studentship awarded for his R.A. exhibit of 1869, failed to inspire him; he preferred 'the simple, somewhat rugged home-life of the English people... Though the fabric might be grey and forbidding'. From the beginning, his watchwords were 'Sincerity and truth';[109] and in dedicating himself to social subjects, he no doubt hoped

'that, by depicting them forcibly and poignantly... he might bring home to the indifferent eyes and hearts of the public the wretched and iniquitous state of affairs which lies close to our own doors. This may have been the reason why he so nearly always took for his subjects some story of poverty, of sorrow, or of crime.'

Holl became a familiar visitor to the East End in search of subjects, models and accessories, every one of which was genuine; for as he believed, 'the very dirt, the very creases and folds of the rags gave the necessary touch which home-manufactured "rags" could never give.'[110]

All of Holl's social subjects were inspired by real life incidents. *Deserted - a Foundling* (fig.38) was one of several social realist pictures which originated in the *Graphic* (3 May, 1873). The setting is that of the East London docks, where a mother, whose abandoned baby has been rescued by a policeman, pulls back from the brink of suicide. The officer nurses the baby tenderly, followed by a group of sympathetic bystanders. A barefoot little girl clings closely to her own mother; they may be poor, but at least they are together. The *Graphic* read into the original drawing a message about the consequences of illicit passion and illegitimacy: the usual story of utter ruin for the woman while the man escapes. Holl's subjects invariably sold, despite their subject matter - *Deserted* fetched 800g; his largest and most successful painting, *Newgate* (1878, Royal Holloway Collection) sold for a £1,000, and Holl was frequently asked for replicas of his works. Quilter was one of many critics who bitterly regretted that 'this true tragedian, this man who was endowed by nature with the gift of pathos as genuine and simple as it was intense' was to sacrifice it all to fashionable portraiture.[111]

Hubert Von Herkomer (1849-1914) was another who dedicated some significant paintings to 'the struggles and sufferings of the poor'; two of his best known, *The Last Muster and Eventide*, showing his 'intimate sympathy with the pathos of rugged and toil-worn old age'.[112] Born in Bavaria, Herkomer came to England as a small child, and was later taught by Fildes at the South Kensington School of Art. Herkomer, like his par-

ents before him, fought hard to establish himself in his early years. His talents were many and varied; gifted in both music and drama, he lived long enough to design for the cinema as well as the stage. Like Fildes and Holl, Herkomer was later in great demand as a portrait painter, and like Fildes, was to include a knighthood amongst his many honours. He is now best remembered for a few Social Realist pictures, such as *On Strike* (fig.42) and *Hard Times* (1885, Manchester City Art Gallery), one of the more favourable critics hailing the latter as 'a cry for humanity' in times which were, indeed, hard.[113]

In his essay on 'Chartism', Carlyle had written that 'A man willing to work, and unable to work, is perhaps the saddest sight that Fortune's inequality exhibits under this sun.'[114] The consequences of unemployment figured large amongst the social commentaries of the last three decades of the century, showing the worker as helpless victim of economic fluctuations and of an unfair and exploitative system. By definition, strikes showed the worker in more militant mood, exerting co-operative strength in order to fight for basic rights. Trade Unions had been established since the mid-century. They received legal recognition in 1871 and in 1875, members were given the right to strike peacefully. In the case of less skilled workers, attempts to form unions did not succeed until the later 1880s, but though slow and gradual, progress was made. In this later period, the increasing militancy of the workers in face of unacceptable conditions of employment was reflected in a number of paintings on the theme of strikes. It was a hard-hitting choice which addressed a serious social problem.

In *On Strike*, Herkomer has chosen to focus on the implications of strike action through the experience of one small family. The almost life-size figure of the striker dominates the canvas. Standing at the door of his brick terraced house, he fumbles with battered cap and pipe, his shabby, work-worn clothes pointing to the mere subsistence which his work brings, and which is now at risk. Revealed in his decent pudding face is something of the confusion, bewilderment and concern which he feels about the possible consequences of his actions; his expression a mixture of defiance and fear for the consequences of what the conservative *Morning Post* called 'the senseless strife between labour and capital.'[115] Hopelessly and helplessly, his thin-faced wife leans on him, all arguments - like herself - exhausted. An older child watches anxiously from inside the house, and even the baby seems infected by the parents' mood.

Inevitably, given the subject, the critical reception was not entirely favourable; but its immediacy and psychological realism make *On Strike* one of the most unforgettable images of the period. It fulfils what Herkomer himself emphasized in a lec-

ture to Royal Academy students in 1900: that the kind of 'art that brings a living individual before our eyes is great art', and that 'we paint and write for future generations to dream over and wonder.'[116]

• • •

In the last important group of peasant painters, a greater degree of objectivity and a reduced emphasis on narrative and sentiment is evident. These were the British painters who embraced French techniques and subjects, and the practice of working in rural colonies. This had begun in the 1830s when Theodore Rousseau, Henri Diaz and their associates abandoned the art life of Paris for the villages of Barbizon and Chaillot in the Forest of Fontainebleau, aided by an important technical development: the invention of ready-mixed paint in tubes which made outdoor painting much easier.

The best known British practitioners were the Newlyn Group, whose central figure was Stanhope Forbes, and there were others, notably George Clausen and Herbert La Thange who worked individually. All of them looked to the new realism which had been developed on the Continent. They shared an enthusiasm for the peasant subjects of the Hague School - the group of Dutch peasant painters already mentioned, which included Jacob Israels and Anton Mauve; and for the similar subjects and plein air methods popularized by French Realists; in particular, Jules Bastien-Lepage (1848-84) - the enthusiasm for whom, in the 1880s, amounted to 'Bastienomania'.[117] Although his 'democratic' subjects were inevitably criticised, there is an element of humanity in Bastien's work which made it particularly attractive to British artists. Edmond Gosse acknowledged his art as

'full of sympathetic qualities to a modern mind. It is the finest expression which the new school of unflinching realism has found in any of the arts, because, with all its severity, it never becomes brutal or cynical'.

Gosse even hazarded the possibility that from a future perspective he might appear 'nearer to Wordsworth than to Zola.'[118] It is significant that Bastien-Lepage was insufficiently radical both in technique and choice of subject for the taste of the New English Art Club, members of which included Sickert and Whistler, and who favoured Impressionism rather than Realism.

It was not only in subject-matter but in technique that the British painters imitated the French. The called 'Square-brush' technique of Bastien-Lepage and other French painters was

enthusiastically adopted by a wide spectrum of British artists. This in-volved the use of straight-ended brushes, which encouraged a method of painting where flat patches of paint allowed for a broad but precise means of modelling and of registering tonal effects. It was ideal for covering large areas of canvas, relatively quickly, while working out-of-doors.

The power of Bastien-Lepage and his followers rested on a combination of sound academic training and a realism derived from *plein-air* painting aided by photography. Bastien-Lepage reinvigorated the tradition of peasant painting through a degree of objectivity which was quite new (Fig.39). Eschewing the overt sentiment of Millet, he recorded the daily grind of peasant life sympathetically but dispassionately. Focusing on the external appearance of things, he aimed, in George Clausen's words, to give 'the true effect of people in the open air, with the light and actual colour of nature'.[119] The results were, as another English painter Norman Garstin succinctly put it, that 'His men and women breathe air, not linseed oil.'[120]

Naturalists in both France and England were to adopt the practice of painting in specially constructed glass studios, so that a natural light was always accessible, whatever the weather. Glass studios were not new. In his *Autobiography* Herkomer says that he had built one in his garden in late 1872, and John Millais's son records his father's use of one in the same decade. But its widespread adoption in the late 1880s consolidated the development of a style which was robust and substantial in form, and characterized by a striking luminosity. Cool, grey colours and strong tonal contrasts were important elements in the new style.

The British also followed the French in adopting the practice of working in colonies. The seeking out of isolated, rural communities in order to concentrate on the humble, timeless pursuits of peasant life, was an important feature of artistic life throughout Europe in the later part of the century. R.A.M. Stephenson, a pupil of Carolus-Duran, described artistic colonies as places 'where more than half the ideals of the nineteenth century have been hatched';[121] and Stanhope Forbes looked back on it as 'one

of those distinct waves of feeling which occur occasionally in Art, as in Literature,' in this case, the tide turning 'strongly in favour of out-of-door work, and of a very thorough study of all its changing effects. It was a breath of fresh air in the tired atmosphere of the studios'.[122] These later colonies differed from earlier rural groups, such as the one including Birket Foster which had gathered around Witley. They too had been inspired by country life, but had remained spectators; relatively uninvolved with the rural life around them. What happened, as Forbes explains was that

'painters began to see that it needed more than an occasional visit to the country to get at the heart of its mysteries; that he who wished to solve them must live amongst the scenes he sought to render'.

Inspired by Millet and the still living Bastien-Lepage, 'most of us young students were turning our backs on the great cities, forsaking the studios with their unvarying north light, to set up our easels in country districts, where we could pose our models and attack our work... under the open sky.'[123]

Through his French mother, from childhood Forbes was fluent in French and a regular visitor to the continent, while the collection of his paternal uncle familiarized him with the work of the Hague and the Barbican painters. In 1880, Forbes followed his Royal Academy training by joining Leon Bonnat's Paris studio. The french academic system was an arduous one, but Forbes learned even more through painting in the open air in Brittany, at various times in 1881-3, sometimes with his old school friend, Henry La Thangue (1859-1929) who had first suggested the idea to him. Among his first outdoor works was the *Street in Brittany* (1881), a remarkable production for a young man of twenty-four, which was purchased by the Walker Art Gallery, Liverpool, in the following year.

Seeking a similar area nearer home, in January, 1884, Forbes discovered Newlyn, Cornwall, where the mild climate was suited to outdoor painting all the year round, with the assistance of the glass and portable studios which were now *de rigeur* for all *plein-air* painters. The area had been popular with visiting artists since the early years of the century, but the first to settle there permanently was Walter Langley in 1882. Other members of the colony included Frank Bramley, Thomas Cooper Gotch (who was to turn to Symbolism in the early 1890s), Henry Scott Tuke, Chevallier Tayler, Frank Bramley, and Elizabeth Armstrong whom Forbes married in 1889. The colony was swelled regularly by visiting artists.

A somewhat retiring personality, and one who often chose to paint in watercolour rather than oil, Langley has been over-looked until recent years. His first exhibited oil painting at the Royal Academy appeared in 1892, and between 1894 and 1897, four of his most important large oils followed. Fig.40 shows the first of these, and the titles of the others, *Motherless* (1895) *Breadwinners* (1896) and *Charity* (1897) - much praised by Tolstoy for its humanity[124] - indicate Langley's deep and geniune sympathy with the poor and oppressed. '*Never morning...*' takes its title from Tennyson's valedictory poem, *In Memoriam*. Langley has chosen a subject which is the one most associated with fisherfolk: loss. The elderly mother comforts her daughter who now joins her in widowhood. Dawn breaks over the still sea waters and all hope is gone. The old woman stares into space, recalling a similar scene many years ago, her crumpled face agonized but resigned. She has lived through this pain and grief herself and knows that nothing can be done but to await the healing effects of time. It is an extraordinarily beautiful scene; the sea radiant in the early morning sun; the tones otherwise subdued, and the colours confined to a sombre range of browns, greys and lilacs.

Langley's work is only occasionally dramatic. He often chose to paint groups of figures at rest, or quietly conversing; or single figures, absorbed in their thoughts or their work. There is also a series of carefully observed portraits, especially of old peasant models, every inch of their weather-beaten faces recorded with sympathy and scrupulous honesty (fig.41). The example illustrated was the result of a productive visit to Holland, in 1905, and reveals alike Langley's humanity and his superb technique. He recognized that such models require no idealization; rather, that their value lies in an ability to realize them as truthfully as possible.

The primitive lives of the Cornish fisher folk, and the stoicism with which they embraced a traditional way of life and its elemental struggles, gave them a certain natural grandeur from an artistic viewpoint. Involved in hard and dangerous work, its rewards a mere subsistence, these people were inescapably wedded to their environment, to their work and simple pleasures, with neither the variety nor the mobility which a more sophisticated city life allowed. Their emotional lives, too were simple - but perceived as all the more powerful for that. In 1883, a writer for the *Magazine of Art* gave as one reason for the attraction of peasants for artists 'the absence of complex and trivial emotion',[125] resulting in a primitive form of facial expression which made such models an easy starting point for studying the passions. The *Art Journal* also touched on this subject, observing how

'The springs of tragedy and happiness and the expressions of the milder emotions are discovered so readily in the primitive simplicity of the Scotch and Irish peasant life, that it

fig. 43
After Stanhope Forbes, *A Fish Sale on a Cornish Beach*
1885. Electrotype. City of Plymouth Museums and Art Gallery

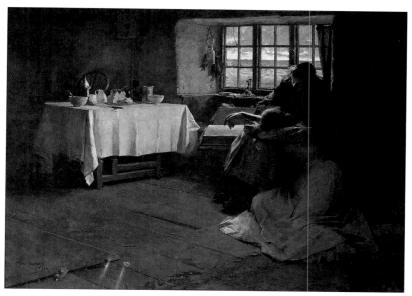

fig. 44
Frank Bramley, *A Hopeless Dawn*
1888. Tate Gallery, 1999

forms a good school for the inexperience of a young painter, and leads him on to understand and reproduce the same expressions from the subtle forms of a more conventional and highly civilised life.'[126]

Whatever the pictorial value of the locality, the Newlyn artists had no illusions about the reality of it. Frank Richards, while acknowledging the attractions of the bright atmosphere, described it as 'dirty underfoot in the winter - fishy, smelly, and some what of a lazy place' in the way of most fishing communities; its inhabitants included 'dribbling infants' with patently 'unkindled intellects'; not to mention, the armless Mrs. Barrett, a huge, tough woman who manipulated the potatoes and turnips which she sold, with her teeth.[127] In a private letter to his father, Forbes admitted that he found the peasants 'dirty, untidy looking people' compared with those of Brittany; but appreciated the fact that Newlyn was far enough from the more fashionable and sophisticated Penzance 'to be quite primitive and suitable for artistic purposes.'[128] By nature, the locals were 'well knit and comely,' and the fact that in person and dress they were 'weatherstained, and tanned into harmony by the sun and the salt wind', also recommended them to the artist.[129]

Despite Langley's priority, it was Forbes who put Newlyn on the map and who became 'without doubt, the centre and rallying point' of the Newlyn colony.[130] Forbes painted a variety of local scenes, both indoor and outdoor; the former including domestic activities as well as work. *Forging the Anchor* (fig.47) makes an interesting comparison with Bell Scott's *Iron and Coal*. More sub-dued in tone and randomly composed, it lacks the heroic and

rhetorical element which underlies Scott's tribute to the urban worker. Absorbed in their tasks, Forbes's men and a young apprentice are shown confined within a humble workshop; its one small window giving no indication of a wider horizon beyond.

Forbes's most typical Newlyn works illustrate fisherfolk and peasants out of doors. After his arrival there, the whole of his first year and more was occupied with what was widely recognized as his greatest success so far: *A Fish Sale on a Cornish Beach* (Fig.43). Gleeson White described it as marking 'an epoch in British painting... not merely... the first picture formally recognised as "of the Newlyn School," but as the first important uncompromising "plein air" picture which obtained wide recognition that had until then been hung in the Royal Academy.'[131] To the public of 1885, the *Fish Sale* appeared as a strikingly 'luminous open-air picture... painted in the grey, equable light' that so distinguished Newlyn. Forbes had quite evidently 'felt the wind and the moist sunshine' and was thus able to bring a real whiff of fresh Cornish air into the Royal Academy exhibitions of the late 1880s.[132] In similar words, the artist and critic Norman Garstin commented on how

'The fresh vitality of it seemed like a wholesome breeze from the sea breathed in a studio reeking with oil and turpentine, while its brilliant new technique fell upon the younger painters as a revelation.'[133]

As one critic asked, looking back on the impact it made, 'Who can forget its gradations of greys, its air of pearls?... If it did not make an era in English art, it began to make one.'[134] Forbes had

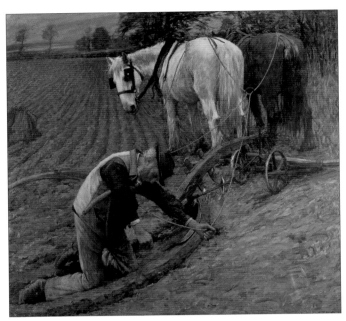

fig. 45
Herbert La Thangue, *The Last Furrow,*
1895. Oldham Art Gallery

fig. 46
Sir George Clausen, *Ploughing,*
1889. Aberdeen Art Gallery and Museums

been struck forcibly by the scene at low water, - especially by the beauty of the wet sand and the effect of figures set against the 'shining mirror-like shore'.[135] The pale grey sky reflected in the calm, shallow stretches of seawater, adds to the chill, open air quality which is the painting's most striking feature. It is an ideal demonstration of the kind of precision, in both drawing and modelling, which might be achieved by the square brush technique.

The foreground is occupied by three major figures, a family perhaps. On the left, a plain young woman, in woollen headscarf and dun coloured apron, leans against a battered green dinghy, while an older woman in straw hat and shawl rests on an ancient wicker basket opposite. A bearded man, white-haired man strides forward carrying a square reel, a sack thrown over his shoulder. In the distance are depicted various activities relating to the fishing economy. Crates of fish are carried from fishing boats to shore in dinghies, while to the right, buyers and sellers gather around the auctioneer as he rings his bell. Various species of fish are strewn on the sand, their raw flesh flaccid and palely luminous in the dull glare, and making up a magnificent still-life in themselves. The faces of the fisher-folk are inert. The young girl stands immobile, her shoulders hunched, her heavy boots placed squarely on the sand, showing no reaction to the familiar scene around her. But despite the superb drawing and modelling, the convincing out-of-doors feeling which Forbes evokes, and his skilful rendering of the perspective of the scene, it is evident that the figures have been posed in the studio, and they appear slightly detached from the background.

It is significant that the Chantrey Bequest decided against buying *A Fish Sale* on the grounds that it was 'too positively the outcome of a foreign school'.[136] Forbes's debt to French art is unmistakable, but his sentiment remains English. There is a refinement in his figures which is quite absent from the work of French painters like Bastien-Lepage, who was frequently criticized for his Neanderthal physiognomies. Forbes also attached great importance to the aesthetics of picture making: those elements, he remarked, which make pictures more than 'mere records of the age we live in'.[137]

Forbes stayed in Newlyn until 1900, adding interiors of local life to his repetoire, of which *The Health of the Bride* (1889, Tate Gallery) is by far his most successful. Like many Newlyn paintings, this example qualifies more as pure genre. Frank Bramley's more tragic *Hopeless Dawn* (fig.44) shows the despair of a young wife, comforted by her mother, on her husband's failure to return from sea. Forbes admitted the 'thorough sympathy' which the Newlyn group felt for the lives of these people, and which they thought it 'more or less our duty to transcribe, and to leave the record of for posterity.'[138]

Henry Herbert La Thangue (1859-1919) - a friend of Forbes since their schooldays - pursued the same route, following an academic training in London and Paris with *plein-air* painting in artists' colonies at Brittany and elsewhere. La Thangue felt a deep sympathy for the poor peasantry and its gruelling struggle for existence, and returned to England in 1882 ready to apply his acquired understanding of peasant life and *plein-air* techniques, to

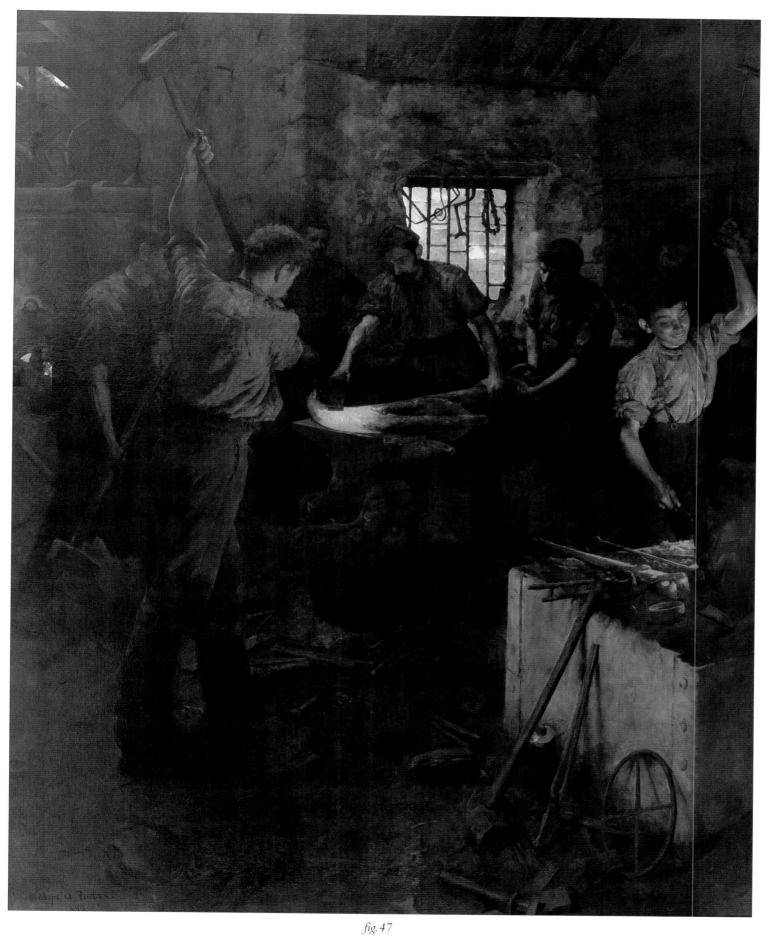

fig.47
Stanhope Forbes, *Forging the Anchor,* 1892. Ipswich Museums & Art Galleries

top: fig.48
**Sir George Clausen,
Photograph used in the
completion of *Winter Work*,**
The Royal Photographic Society, Bath

above: fig.49
**Sir George Clausen,
Winter Work,**
1883. Tate Gallery, 1999

English subjects. It was a time when rural areas were undergoing profound social change, and when poverty and unemployment were forcing many inhabitants to move to the towns in the hope of a better life. In La Thangue's early works, detail and contour are subordinated to impressionistic colour, which at times completely dissolves them; but in the later 1880s and 1890s his social sympathies are stated more overtly, in a style which is at once more naturalistic and symbolic. In *Leaving Home* (c1890, Forbes Magazine Collection, New York) the artist shows a weeping young girl being driven away from her rural home and sorrowing family, to her first situation in service; and in his best known work, *The Man With the Scythe* (c1896, Tate Gallery) he illustrates the tragic but common episode of the death of a small child in a poor but respectable peasant family. Death, also, is the theme of the *Last Furrow* (fig.45). An old ploughman sinks to his knees on the ground, his head falling forward and his left hand just beginning to

slacken on the guide-rope. His fuzzy white hair contrasts with his sunburnt, wrinkled skin, and his features are already swathed in the shadow that is at this moment engulfing his mind. A white carthorse turns to look at him, instinctively aware that something is wrong in this unexpected halt. The furrows behind the man sweep to the distant horizon, its pale light signifying a new world beyond, at an opposite pole to the uncouth and inhospitable earth in which he has worked and which now receives him in death.

George Clausen (1852-1944) took the lessons in objectivity and technique, learned from the French, a stage further. He too had practised *plein-air* painting in Belgium and Holland in the early 1880s as well as at the attractively situated art colony of Quimperle in Brittany, while continuing his academic training at the Paris studios of the successful classicist Bougereau, and of Robert Fleury. In his pursuit of naturalism, Clausen, who - like La Thangue - was an admirer of the rural photographer Peter Henry Emerson, began to make use of a portable camera in 1881. Clausen produced some of the earliest unposed photo-graphs of field labourers, many of which have been closely linked with specific paintings; and the photographic element was to be fundamental to his major naturalist exhibits later in the decade. It certainly assisted him in his *Winter Work* (figs.48&49) exhibited at the Grosvenor Gallery in 1883. An unglamourized image which portrays the harvesting of sugar beet as 'a dirty process carried out in desolate fields', Clausen had produced in it a work which was 'on the cutting edge of Naturalist creativity.'[139] The furrows and heaped vegetables relentlessly into the distance; the sky is grey and overcast, and the trees leafless; a background which fittingly reflects the hard lives of the peasant family in the foreground.

Successfully as Clausen has captured the chill and gloomy atmosphere of a winter's day, the relationship between figures and background in *Winter Work* is not fully resolved; a fault which he was soon to overcome. *Ploughing*, which dates from six years later, is a much more sophisticated piece (fig.46) in which a striking sense of reality is equalled by Clausen's superb sense of line, form and colour. Here, man, animal and inanimate nature are joined together in the slow, steady rhythm of seasonal activity. The carthorses plod the furrows in unison, the old wooden plough guided by an elderly man. At the head of the procession, a small boy, clad in a rough sack cloak, looks wistfully out at the viewer. His mud covered clogs bind him to the earth, and to the great panorama of the countryside that spreads behind him. The mildly oppressive chill of a dull March day is suggested in the pale palette of bluish greens. The precision with which Clausen's painterly technique registers every facet and detail, his sensitivity to both abstract and solid form, suggest what he has learned from Impressionism, *plein-air* painting and photography as well as from the academic tradition.

The allegiance to French subjects and techniques in the case of Clausen and others was by no means universally approved. James D. Linton, who was seriously perturbed by the results, perceived such works as merely superficial imitations of French techniques, lacking the convincing response to life of the French originals.[140] For many critics, Naturalism was to remain an essentially alien element in British art.

Neither did the degree of objectivity which painters like Clausen brought to peasant life recommend them to more conservative critics. Clausen was abused for representing 'the facts of the model's actuality' and nothing more.[141] But as mature paintings like *Ploughing* illustrate, like Degas and even Monet in later life, Clausen was conscious of the distinction between art and life. He recognized the impossibility of registering the fleeting moment, accepting that the 'snapshot' view would not produce a truthful effect and that representation must always comprise a synthesis of many observations and direct study from nature, supplemented by what was retained in the memory. Clausen was aware that the age of idealism was past, and that modern artists were better 'to keep within the limits of man's experience, of things we can actually see;'[142] but he dismissed mere surface realism, 'The realism of externals', as 'a fault too common in our work today.' A finer sort of realism is to be won from a subordination of detail to 'a grasp of the broad structural features and movements which give expression', and which involves 'an analysis and abstraction of the simple forms.' In this way, the true realist moves beyond the surface to suggest 'something of the significance of the thing painted'; an achievement common to all great art.[143]

But realistic depictions of peasant subjects would always remain controversial. Bastien-Lepage's types - more extreme than those of British artists - with their low foreheads, prognathous jaws and blank expressions, were often attacked as coarse and repulsive. There was no doubt a political element in this perception - a factor which occasionally emerges in reviews and which has been mentioned above with reference to Erskine Nicol and others. With improved education, expectations amongst workers had increased. They were more articulate, more politically informed, more militant; their wrongs more widely publicized by themselves and by their supporters. Artisans in towns had won the vote in 1867, and in 1884, the Third Reform Bill extended the franchise to the agricultural labourer. Also in 1884, the newly founded Social Democratic Federation became the Socialist League, its members including leading artists and designers like William Morris and Walter Crane. Such developments help explain the outcry from J.B. Atkinson, the *Blackwoods* critic, who in the same year named Morris and Ruskin as among those authorities who 'foretell that in England, as in France, the arts will find new birth under socialism, communism, and other forms and forces of democratic rule.' Atkinson complained that

'the lower orders throughout Europe are using means both legitimate and illegitimate to obtain power, and the surging masses play conspicuous parts on canvas as preliminary to their approaching political career! Democracy in art has made itself conspicuous in every capital'.

From at St. Petersburg to London,

'the rough coat, the wooden shoe, the weather-beaten visage, the labour-hardened band of peasant and artisan, assert their native rights in picture-galleries... the... result is, that high art degenerates into low art, that history descends into genre, that poetry sinks into plainest prose. And it might seem too sanguine to hope that the lowest depth in politics or in art has yet been touched.'

For conservative critics like Atkinson, peasant art had become too close to life for comfort, given the political situation. In comparing the current 'debased naturalism' with the more noble interpretation of earlier generations, he regretted the loss of the softening touch, the kindly picturesqueness which had made it palatable in the art of such painters as Breton and Millet who always suggested 'the harmony of existence between meadows, woods, and those that dwell therein.' In such pictures 'the tenants and the tillers of the soil are as the aspects of nature'; they are generalized and elevated to the level of universal symbols. Atkinson described as 'Immeasurable' the distance which separated painters of this sort 'who might have sketched in Arcadia or in Eden, and the artists who under pretence of naturalism wallow in the mire.'[144] Atkinson's reservations are understandable; but seen from the perspective of more than a century later, it is possible to appreciate the aesthetic - and humane - value of the kind of art he criticized while remaining unperturbed by its political implications at the time.

The achievement of British art in the last quarter century was remarkably diverse, not least among those who addressed themselves to the problems of the poor. The Pre-Raphaelites and other artists from the earlier period, the Poetic Realists, Social Realists and Naturalists alike, succeeded in creating art which not only offered serious social commentary, but which was, in varying degrees, academically sound, aesthetically satisfying and unsentimental; to such an extent that some of the great masterpieces of Victorian art fall within this genre. For a time, social issues, though never uncontroversial, took centre stage, and showed that real engagement of this kind was compatible with great art.

ENDNOTES

Chapter 1
Painters of Incident and Domestic Life

1 Sydney Colvin, 'English Painters and Painting in 1867', *Fortn. Review* (Oct. 1867), 466-7.
2 Harry Quilter, 'The Royal Academy', *The Universal Review* (May - August, 1888), 61).
3 Frederick Wedmore, 'Genre in the Summer Exhibitions', *Fortn. Review* (June 1883), 864.
4 Wedmore, *The Masters of Genre Painting*, 1880, vi.
5 Wedmore, op. cit. (3) 864; J.B. Atkinson, 'The Decline of Art', *Blackwds Mag.* (Jly 1885) 15.
6 Atkinson, Ibid.
7 Alan Cunningham, *Life of Sir David Wilkie*, 1843, 163.
8 Dianne Sachko MacLeod, 'Art Collecting and Victorian Middle-class Taste', *Art History*, (Sept. 1987) 328.
9 'Recent Art-Collectors', *A.J.* (Oct 1872), 265.
10 W.P. Frith, *Autobiography*, Vol.11, 1887, 228-9, 220-1.
11 'Picture Dealing', *A.J.* (May 1852), 151.
12 Benjamin Disraeli, *Coningsby* (1844), n.d., 172.
13 *A.J.* (Oct. 1861), 319.
14 *A.J.* (April 1860), 149.
15 Tom Taylor, 'English Painting in 1862,' *Fine Art Qutly Review* (May 1863), 17.
16 Ibid. 15
17 C.R. Leslie, ed. Tom Taylor, *Autobiographical Recollections*, Vol.1, 1860, xxi.
18 W.M. Thackeray, 'May Gambols' (June 1844) *Misc. Essays, etc., Works*, XXV, 1886, 194.
19 W.M. Thackeray, 'Picture Gossip' (June 1845), ibid. 1886, 222.
20 'The London Art Season' *Blackwood's Mag.* (Aug. 1869), 230.
21 Robin Hamlyn, *Robert Vernon's Gift*, 1993; R.A. of Arts, *Lord Leverhulme*, 1980; Edward Morris, *Victorian & Edwardian Paintings in the Lady Lever Gallery*,1994; Dianne Sachko Macleod, op. cit. (8).
22 J.C. Horsley, *Recollections*, 1903, 224.
23 Charles Lamb, 'On the Genius & Character of Hogarth', *Works of William Hogarth*, 1873, Vol.1, 22.
24 H. Taine, *Notes on England* (1850-60), 1957, 260.
25 *Hogarth*, op. cit. (23) Vol. 1, 2.
26 'Sir David Wilkie', *Art Union* (Jly 1841) 116.
27 D. Wilkie, *Remarks on Painting*, qu. L. Lambourne, *Introduction to Victorian Genre Painting*, 1982, 12.
28 B.R. Haydon, *Autobiography*, 288-9; E.D.H. Johnson, *Paintings of the British Social Scene*, 1986, 149-53. Christopher Hibbert's *Wellington A Personal History* (1997), 1998, 204-6, includes examples of Wellington's generosity to artists.
29 B.R. Haydon, *Autobiography and Journals* (1853), 1950, 36.
30 W.M. Thackeray, 'Picture Gossip' (June 1845) *Misc. Essays, etc., Works*, XXV, 1886, 223.
31 *A.U.* (Jly 1842), 159.
32 Thackeray, 'A Second Lecture on the Fine Arts,' (June 1839), op. cit., 1886 (30) 117.
33 *A.J.* (Nov. 1860), 330.
34 'The Fine Arts', *I.L.N.* (June 18 1842), 83.
35 Ruskin, 'Pre-Raphaelitism' (1851), *Works*, Vol.X11, 364.

36 H. Taine, op. cit. (24) 263.
37 F. Wedmore, *The Masters of Genre Painting*, 1880, 226.
38 *A.J.* (Jly 1862), 150.
39 *Hogarth*, op. cit. (23), Vol.1, Preface.
40 'The R.A. Exhibition', *A.J.* (June 1864), 164.
41 *New Monthly Mag.* (1824), 159, qu. Marcia Poynton, *W. Mulready*, 1986, 147.
42 J. Ruskin 'Pre-Raphaelitism', *Works*, X11, 364, qu. ibid 147-8.
43 *A.J.* (March 1850), 76.
44 J.C. Horsley, *Recollections*, 1903, 20; Richard Redgrave, *A Memoir*, 1891, 278.
45 *A.J.* (Aug. 1865) 240; see also James Dafforne, 'William Henry Knight', *A.J.* (Jly 1863), 133-5.
46 Ruskin *Academy Notes* (1855), *Works*, Vol.X1V, 21.
47 C.R. Leslie, *Autobiographical Recollections*, 1860, Vol.11, 112.
48 F. Wedmore, op. cit. (37) 231.
49 *A.J.* (Nov. 1860), 330.
50 Thackeray, op. cit. (32), 118.
51 Leslie, op. cit. (47) Vol.1, xv.
52 Ibid. Vol.11, 73.
53 Ibid. Vol.11, 259
54 Mappin Art Gallery, Sheffield, *Victorian Paintings*, 1986, 35; Arts Council, *Victorian Paintings*, 1962, Introduction.
55 *A.J.* (Jly 1898), 202.
56 *A.J.* (June 1863), 111.
57 *A.J.* (June 1866), 166.
58 H. Taine, *Notes on England* (1850-60), 1957, 263.
59 *A.J.* (Jly 1894), 196.
60 J.E. Phythian, *Fifty Years of Modern Painting*, 1908, 313.
61 Frank Davis, 'The Victorian Scene,' *I.L.N.* (6 March 1965), 30.
62 David Masson (1852), 'Pre-Raphaelite Art and Literature', J. Sambrook, *Pre-Raphaelitism*, 1974, 85.
63 John Ruskin, *Academy Notes* (1858), *Works*, Vol.X1V, 151.
64 Thomas Arnold, *Introductory Lecture on Modern History*, 1842, 96.
65 Henry Morley, 'Recent Literature', *Nineteenth Century* (Aug. 1877), 124.
66 F. Wedmore, 'Genre in the Summer Exhibitions', *Fortn. Review*, 1883, 864-5.
67 *A.U.* (Oct. 1840), 163.
68 Peter Cunningham, 'Wilkie and his Works', *Fraser's Mag.* (Sept. 1842), 270; Ballantyne, qu. A.Y.- R.S., 'Pre-Raphaelitism from Different Points of View', *Frasers Mag.* (June 1856), 689.
69 Frederick George Stephens, 'William Henry Hunt, water-colour painter', *Fraser's Mag.* (Oct. 1865), 530.
70 W.P. Frith, *Autobiography and Reminiscences*, 1887, 11, 18, 277; *Further Reminiscences*, 1888, 138-9.
71 F. Wedmore, op. cit. (66), 864.
72 Ernst Chesneau, *The English School of Painting*, 1885 (1882), 169.
73 W.P. Frith, *Further Reminiscences*, 1888, 9.
74 J.Jackson Jarves, 'The Nude in Modern Art and Society,' *A.J.* (March 1874), 65.
75 qu. Anthony Trollope, *Autobiography* (1859), 1947, 122-23.
76 Lindsay Errington, *Sunshine and Shadow, the*

David Scott Collection of Victorian Paintings, 1991, 17, 20.
77 Christie's, *Victorian Pictures...* (12 June, 1992), Lot 118, 108.
78 Maxime Du Camp, qu. *A.J.* (March 1856), 77
79 *A.J.* (June 1863), 110.
80 Maxime Du Camp, op.cit. (78), 77.
81 Keith Bendiner, *Introduction to Victorian Painting*, 1985, 40.
82 James Dafforne, 'Thomas Faed', *A.J.* (Jan. 1871), 3.
83 Wilfred Meynell, *The Modern School of Art*, n.d., Vol.11, 231.
84 Mary McKerrow, *The Faeds*, 1982, 89.
85 *A.J.* (June 1863), 110.
86 William Shakespeare, *Troilus and Cressida*, Act 111 Sc 111.
87 J. Dafforne, 'Thomas Webster', *A.J.* (Nov. 1855), 295.
88 McKerrow, op. cit. (84), 105.
89 *A.J.* (June 1861), 163.
90 ibid.
91 McKerrow, op. cit. (84), 107.
92 Meynell, op. cit. (83), 11, 231.
93 *A.J.* (Aug. 1872), 220.
94 Meynell, op. cit. (83) 11, 232.
95 M. Betham-Edwards, *Reminiscences*, 1903, 33, 37.
96 Samuel Smiles, *Thrift*, 1889 (1875), 326.
97 Henry Mayhew, 'Home is Home be it never so Homely' (1852), qu. Linda Nead, *Myths of Sexuality*, 1988, 33.
98 Mrs S.C. Hall, 'Memorials of Jane Porter', *A.J.* (Jly 1850) 221.
99 Mrs. Hall, qu. S.C. Hall, *Retrospect of a Long Life*, Vol. 2, 1883, 437.
100 Samuel Smiles, *Life and Labour*, 1897 (1887), 406; *Self-Help* (1859), n.d., 267.
101 W.E. Aytoun, 'Rights of Woman,' *Blackwoods Mag.* (Aug 1862), 190.
102 Frederic Harrison, 'Future of Women' in *Ideals and Realities*, 1908, 73.
103 Arabella Kenealy, 'Woman as an Athlete: A Rejoinder', *Nineteenth Century* (June 1899), 927.
104 qu. James Paget, 'The Physiognomy of the Human Form', *Qutly Review* (Sept. 1856), 474.
105 J. McGrigor Allan, 'The Real Differences between the Minds of Men and Women', *Journal of the Anthropological Society*, Vol.V11 (June 1 1869), cxcvii.
106 'Woman as Athlete', *Nineteenth Century* (April 1899), 643.
107 G.J. Romanes, 'Mental differences between Men and Women', *Nineteenth Century* (May 1887), 668.
108 Patrick Geddes and J. Arthur Thomson, *The Evolution of Sex* (1889), 286.
109 E.Lynn Linton, 'The Wild Women (Part 1): as Politicans', *Nineteenth Century*, (Jly 1891) 80.
110 *A.J.* (Dec. 1867), 272.
111 *I.L.N.* (7 May 1864) 455.
112 F.G. Stephens, *James Clark Hook, R.A.*, 1888, 17.
113 W. Maw Egley, MSS Catalogue, Vol.1, 119A. National Art Library.
114 Sir William Acton, *Functions and Disorders of the Reproductive Organs*, 1870 (1857), 143.
115 *The Times* (27 May 1863), 6; qu. R. Allwood, *George Elgar Hicks*, 1982, 32. Two

of the original three paintings are now missing, but the three oil sketches survive at Dunedin Art Gallery, New Zealand.
116 Rev. W. Cunningham, *True Womanhood*, 1896, 55-6.
117 (23 June 1900), qu. Allwood, *G.E.Hicks*, 1982, 33.
118 S.R. Wells, *Physiognomy of the Human Form*, 1866, 115.
119 James Grant, *Pictures of Popular People*, c1845, 5.
120 George Henry Lewes, 'Currer Bell's Shirley', *Edinburgh Review* (Jan. 1850), 155.
121 *A.J.* (Aug. 1866), 232.
122 Smiles, *Thrift*, 1889 (1875) 161.
123 *A.J.* (June 1862), 134.
124 C.W. Cope, *Reminiscences*, 1891, 384.
125 John Ruskin, 'Of Queens' Gardens', *Sesame and Lilies*, *Works*, XV111, 122.
126 W.P.Frith, *Further Reminiscences*, 1888, 141-2.
127 *Art Journal* (1 May 1858), 172, qu. Arts Council, *Great Victorian Pictures*, 1978, 32; Ruskin, qu. ibid.
128 *Athenaeum* (1 May 1858), qu. ibid.
129 Ruskin, qu. ibid.
130 *Morning Post* (10 May, 1858), 2; *Daily News* (May 3 1858) 3; *Sun*, (7 May 1858), pp. unnumbered.
131 William Shakespeare, *Troilus and Cressida*, Act 111 Sc 111.
132 Arts Council, *Great Victorian Pictures*, 1878, 45.
131 J.C. Horsley, *Recollections*, 1903, 340.
132 Andrew Greg, *The Cranbrook Colony*, 1977, pages unnumbered.
133 Lionel Lambourne, *Introduction to Victorian Genre Painting*, 1992, 19.
134 E.M. Ward, *Memories of Ninety Years*, (1924), n.d., 97.
135 J. Dafforne, 'Thomas Webster', *A.J* (Nov. 1855), 293.
136 *A.J* (June 1862), 138.
137 James Dafforne, 'The Works of F.D. Hardy' *A.J* (March 1875), 75.
138 Roger Sellman, 'The Country School', G.E. Mingay (ed.) *The Victorian Countryside*, 1981, Vol.11, 543.
139 Arts Council, *Landscape in Britain*, 1983, 23.
140 P.H. Ditchfield, *The Charm of the English Village* (1906), 1994, 2.
141 Charles Dickens, *The Old Curiosity Shop*, 1902 (1841), 6.
142 Gladys Storey, *All Sorts of People*, 1929, 52ff.
143 ibid. 53; Stacey Marks, *Pen and Pencil Sketches*, 1, 147. See also, Bevis Hillier, 'The St. John's Wood Clique', *Apollo* (June 1964), 493.
144 *Mag. of Art* (1898), 238.
145 G.D. Leslie, *The Inner Life of the R.A.*, 1914, 53.
146 *Athenaeum* (May 12 1860), 654.
147 Andrew Greg, op.cit. (132), pages unnumbered. The date of sale was 1872, not 1882, as cited here.
148 qu. J.C. Horsley *Recollections*, 343.
149 qu. W. Meynell, *The Modern School of Art*, n.d., Vol.111, 111.
150 *I.L.N.* (9 May 1874), 446.
151 qu. Meynell, op.cit. (149) 107-108.
152 Gleeson White, *The Master-Painters of Britain*, 1898, Vol.111, 4.
153 Harry Quilter, *Preferences in Art*, 1892, 306
154 Gleeson White op.cit. (152), Vol.11, 15.

155 Claude Phillips, qu. Edward Morris, *Victorian and Edwardian Paintings in the Lady Lever Art Gallery*, 1994, 34.

156 John Eagles, 'Historical Painting', *Blackwoods Mag.* (Nov. 1836), 663.

157 Charles Lamb, 'The Genius and Character of Hogarth', *The Works of Hogarth*, 1873, Vol.1, 7.

158 W.M. Rossetti, 'London Exhibitions of 1861', *Frasers* (Nov. 1861), 588.

159 F. Wedmore, 'Genre in the Summer Exhibitions,' *Fortn. Review* (June 1883), 865.

160 Richard Ormond, Tate Gallery, *Edwin Landseer*, 1982, 203.

161 W.M. Rossetti, 'The R.A. Exhibition', *Fraser's Mag.* (Jly 1862), 72.

162 Holman Hunt, *Pre-Raphaelitism*, 1905, Vol.11, 105; Jenny Spencer-Smith, 'The Art of War', *The Victorian Soldier*, ed. Marion Harding, 1993, 64-73.

163 J. B. Atkinson, 'London Exhibitions and London Critics,' *Blackwds Mag.* (Aug. 1858), 196-7.

164 H.H. Dodwell and R.R. Sethi, *Cambridge History of India*, Vol. 6, 1958, 183-4.

165 Mark Girouard, *The Return to Camelot*, 1981, 220.

166 R. Redgrave, *Memoir*, 1891, 181-2.

167 M.H. Noel-Paton and J.P. Campbell, ed. Francina Irwin, *Sir Joseph Noel-Paton*, Ramsay Head Press, 1990, 20.

168 J.B. Atkinson, 'London Exhibitions & London Critics', *Blackwoods Mag.* (Aug. 1858), 197.

169 *I.L.N* (15 May 1858), 498.

170 W.M. Rossetti, op. cit. (158), 587.

171 *I.L.N* (22 May 1858), 521.

172 *Athenaeum* (30 April 1859), 587.

173 *Athenaeum* (8 May 1858), 596.

174 *I.L.N* (6 May 1858), 470.

175 Ernst Chesneau, *The English School of Painting*, 1885, 273-5.

176 Julia Cartwright, 'The Pictures of the Year', *Nat. Review* (June 1891), 468.

177 Luke V. Fildes, *Luke Fildes*, 1968, 46.

178 Rev. Thomas W.M. Lund, *The Religion of Art*, 1891, 43.

179 Fildes, op. cit. (177), 121.

180 Lund, op. cit. (178), 47.

181 'The R.A. First Notice', *Morning Post* (2 May 1891).

182 *Daily News* (2 May 1891), 2.

183 qu. Fildes, op.cit. (177), 118.

184 'Clinical Art', *British Medical Journal* (11 April 1891), 816.

185 Lund, op. cit. (178) 54.

186 E. I. Barrington, 'Is a great school of art possible in the present day?' *Nineteenth Century* (April 1879), 724-725.

187 Edward Knoblock (1933), qu. K. Matyjaszkiewicz, 'Costume in Tissot's Pictures', *James Tissot*, 1984, 68-9.

188 Ibid. 66.

189 A.L. Baldry, 'Marcus Stone' (1896), 5, *Victorian Art*, Vol.1, n.d.

190 Ibid. 21.

191 James Stanley Little, 'W, Quiller Orchardson', 9, *Victorian Art*, Vol.1, n.d.

192 Simon Houfe, *Fin de Siècle*, 1992, Chapter 9.

193 F.G. Stevens (A.J., Jly 1895), qu. *Great Victorian Pictures*, 1978, 73.

194 Ibid.

195 Gleeson White, *Master Painters of Britain*, n.d., Vol.111, 20.

196 qu. *Great Victorian Pictures*, 1978, 64.

197 Walter Armstrong, 'The Art Harvest of the Year', *Nat. Review* (Jly 1884), 673.

198 Gleeson White, op. cit. (195) Vol.111, 19.

199 H. Quilter, *Preferences*, 1892, 351; J.B. Atkinson, 'Decline of Art', *Blackwoods Mag.* (Jly 1885), 7.

200 *A.J.* (June 1896), qu. *Great Victorian Pictures*, 1978, 30.

201 Charles Marriott, *Dictionary of National Biography*.

202 F. Wedmore, 'Genre in the Summer Exhibitions', *Fortn. Review* (June 1883), 866.

203 Meynell, *Modern School of Art*, Vol.11, 185, 184.

204 Walter Armstrong, op. cit. (197) 674.

205 Information supplied by Stella Mary Newton to Edward Morris, *Victorian and Edwardian Paintings in the Lady Lever Art Gallery*, 1994, 42.

206 Ibid. 43.

207 *N.A.C.F. Review*, 1987, 147.

208 Mark Girouard, *The Return to Camelot*, 1981, 233.

209 Robin Simon and Alastair Smart, *The Art of Cricket*, 1983, 49.

210 George R. Halkett, 'John Robertson Reid', *A.J.* (Sept. 1884), 266.

211 Ibid. 267.

212 Robin Simon and Alastair Smart, *Art of Cricket*, 1983, 49.

213 Ibid. 98.

214 F. Wedmore, *The Masters of Genre Painting*, 1880, 12.

Chapter 2
The Urban Scene: Painters of the Crowd

1 W.P. Frith, *Autobiography and Reminiscences*, Vol.1, 1887, 285.

2 *Works of William Hogarth*, 1873, xiv.

3 H. Mayhew and John Binny, *Criminal Prisons of London*, 1862, 28.

4 The Ethnological Society of London was formed in 1843, and the Anthropological Society from a breakaway movement in 1863. They were reunited in 1871 as the Anthropological Institute of Great Britain and Ireland.

5 [R.H. Patterson] 'The Ethnology of Europe', *Blackwds Mag.* (Aug. 1854), 180.

6 Mayhew and Binny, op. cit. (3) 59.

7 'Passing Faces', *Household Words* (14 April 1855), 261.

8 Henry S. Drayton and James McNeil, *Brain and Mind*, 1880, 308.

9 George Elgar Hicks, *Guide to Figure Drawing*, 1853, 187.

10 Op. cit. (7) 263; S.R. Wells, *New System of Physiognomy*, 1866, 116-17.

11 Hector MacLean, 'On the Comparative Anthropology of Scotland', *Anth. Review* (Jly 1866), 218-19.

12 Daniel Mackintosh, 'On the Comparative Anthropology of England and Wales', *Anth. Review* (Jan. 1866), 15-16.

13 G.A. Simcox, 'The Transformation of the British Face', *A. J.* (Nov. 1874), 345.

14 Tom Taylor, *The Railway Station* [1862], 13.

15 Samuel George Morton, ed. J.C. Nott and G.R. Gliddon, *Types of Mankind*, 1854, 80-1.

16 Hyppolite Taine, *Notes on England* (1850-60), 1957, 39.

17 Mackintosh, op. cit. (12) 8ff; Elizabeth Eastlake, *Journals and Correspondence*, 1895, Vol.1, 146-7.

18 Mayhew and Binny, op. cit. (3) 45

19 John Ruskin, 'The Fireside: John Leech and John Tenniel', *Art of England*, *Works*, Vol.XXX111, 364-5.

20 Taine, op. cit. (16) 39.

21 Information supplied by James Dunhill & Co., based on research by George Nash.

22 Frith, op. cit. (1) Vol.1, 1887, 246.

23 Benjamin Disraeli, *Sybil* (1845), 118-19.

24 Newspaper cutting, W.M. Egley, *MSS Diary*, 1859, National Art Library, V. & A. Museum.

25 Phiz [Hablot K. Browne], *The Derby Carnival*, 1869, 3.

26 *I.L.N.* (23 May 1863), 566.

27 248 *Sat. Review* (7 June 1862), 652; 26 May 1860), 671.

28 L. Blanc, *Letters on England* (1866), Vol.1, 46.

29 Frith, op. cit. (1) Vol.1, 272, 269.

30 Gambart & Co. Frith's 'Derby Day', n.d. 5.

31 Taine, op. cit. (16) 39.

32 Taylor, op. cit. (14) 5.

33 *The Era* (20 April 1862), 12.

34 *A.J.* (March 1862), 95.

35 Frith, op. cit. (1), Vol. 11, 233.

36 Albert Smith, *Natural History of the Gent*, 1847, 10.

37 Charles Kingsley, 'Great Cities and their Influence for Good and Evil', *Miscellanies*, 1859, Vol.11, 335.

38 N. MacNamara, *Origin and Character of the British People*, 1900, 231-2.

39 *Athenaeum* (1 May 1858), 565.

40 Gambart & Co., Frith's Derby Day, 6; *Guardian* (12 May 1858, 379); *Morning Herald* (1 May 1858), 6; *Morning Post* (10 May 1858), 2; *Sun* (7 May 1858, pp. unnumbered).

41 *I.L.N.* (11 June 1842), 77.

42 R. Brabazon, 'The Health and Physique of Our City Populations', *c19th.* (Jly 1881), 82.

43 *Sun* (8 May 1858); *Athenaeum* (1 May 1858), 565.

44 *Art Review* (30 April 1858), qu. Gambart & Co. Frith's Derby Day, 14.

45 Mayhew and Binny, *Criminal Prisons of London*, 1862, 45.

46 Harriet Martineau, 'Life in the Criminal Class', *Edinb. Review* (Oct. 1865), 341-2.

47 Henry Maudsley, 'Responsibility in Mental Disease' (1874), qu. Hon. Richard Vaux, 'Some Remarks on Crime Cause', Appx M, N. Capen, *Reminiscences of Spurzheim*, 1881, 255.

48 'The Physiognomy of Murderers', *B.M.J.* (14 Sept. 1889), 612.

49 'Faces', *Household Words* (16 Sept. 1854), 97.

50 Martineau, op. cit. (46) 342.

51 Charles Dickens, 'A Visit to Newgate', *Sketches by Boz*, 1902 (1836-7), 149.

52 Frith, *Autobiography & Reminiscences*, Vol.1, 1887, 183.

53 ibid.

54 The Council of Four, *R.A. Review*, 1858, 14.

55 *The Athenaeum* (1 May 1858), 565.

56 Tom Taylor, *The Railway Station* [1862], 13.

57 Cesare Lombroso, *Criminal Man* (1876), 1911, 16.

58 *St. James's Chronicle* (17 April 1862), 8.

59 Taylor, op. cit. (56) 13.

60 *Athenaeum*, op. cit. (54) 565; *I.L.N.* (3 May 1862), 3; *Guardian* (30 April 1862), 428.

61 *St. James's Chronicle* (17 April 1862), 8; W.M. Rossetti, *Fine Art Chiefly Contemporary*, 1867, 270.

62 *I.L.N* (23 May 1863), 567.

63 Phiz [Hablot K. Browne], *The Derby Carnival*, 1869, 10-11.

64 R. Doyle and P. Lee, 'The Derby Day', *Manners and Customes of Ye Englyshe*, 1849-50, Vol.1, note to no. 12.

65 *I.L.N.* (22 May 1858), 514.

66 *Select Committee on the Laws Respecting Gaming* (1844), qu. W. Vamplew, *The Turf*, 1976, 130.

67 J.E. Ritchie, *The Night Side of London*, 1869, 61.

68 Henry O' Neil *Two Thousand Years Hence*, 1868, 334.

69 C.F. Greville, *Memoirs*, 1938, Vol.V1, 290-1; qu. S. Bradford, *Disraeli*, 1985 (1982), 276.

70 'Slaves of the Ring', *All the Year Round* (29 Sept. 1860), 584.

71 *I.L.N.* (23 May 1863), 547.

72 D. Lieven, 'Through the G.W.R. Museum, no. 2, Frith's '"Railway Station"', *Grt. Western Railway Mag.* (March 1930), n. 110.

73 H. Mayhew, *London Characters*, 1874, 20.

74 *The Era* (11 May 1862), 6.

75 A. Polson, 'Good Looks', *Cornhill Mag.* (Sept. 1866), 341.

76 [Grant Allen], 'The Human Face Divine', *New Qutly Mag.* (Jly 1879), 181.

77 J. Ruskin, 'The Dabchicks', (1873), *Love's Meine*, *Works*, XXV, 129, 128.

78 J. Ruskin, 'On Vulgarity', *Modern Painters, V (1860)*, *Works*, V11, 349-50.

79 Gambart & Co., Frith's Derby Day, n.d., 8.

80 *Sun* (7 May 1858); *Daily News* (3 May 1858), 3.

81 *I.L.N.* (8 May 1858), 222.

82 *Morning Herald* (1 May 1858), 6.

83 J. Ruskin, op. cit. (78), *Works*, V11, 349, 359, 360, 359, 345.

84 P. Mantegazza, *Physiognomy and Expression*, 1890, 188.

85 Ruskin to Lady Waterford (15 Oct. 1863); qu. V Surtees, *Sublime and Instructive*, 1972, 55-6.

86 W. Holman Hunt, 'Notes of the Life of A.L. Egg', *Reader* (9 Jan., 1864), 57.

87 *Athenaeum* (1 May 1858), 565; *Examiner* (8 May 1858), 292; Gambart & Co. Frith's Derby Day, 8; *Athenaeum* (1 May 1858), 565; *Morning Herald* (1 May 1858), 6.

88 *Daily News* (3 May 1858), 3; Gambart & Co., Frith's Derby Day, 8; *Examiner* (8 May 1858), 292.

89 *Daily Telegraph* (16 April 1862), 3; *Critic* (19 April 1862), 397.

90 W. M Rossetti, *Fine Art Chiefly Contemporary*, 1867, 268.

91 H. Mayhew and J. Binny, *Criminal Prisons of London*, 1862, 58.

92 [Robert Lamb], 'Manchester and its Exhibitions', *Fraser's Mag.* (Oct. 1857), 381.

93 Sir Francis Galton, *Hereditary Genius*, 1892 (1869), 332, 348.

94 *Morning Post* (17 April 1862), 2; *Daily News* (18 April 1862), 2.

95 Anon, *Familiar Things*, c1845, Vol.1, 117.

96 D. Mackintosh, 'Comparative Anthropology of England and Wales', *Anth. Review* (Jan. 1866), 17.

97 Tom Taylor, *The Railway Station* [1862], 17; *Observer* (20 April 1862), 6.

98 [A. Austin] 'On the Decay of Fine Manners', *Cornhill Mag.* (March 1878), 333.

99 Taylor, ibid., 7.

100 *Standard* (17 April 1862), 3.

101 Taylor, op. cit. (97), 7.

102 N. Macnamara, *Origin and Character of the British People*, 1900, 231-2.

103 Charles Dickens, *Bleak House*, 1903 (1852-3), 246-7.

104 *Daily Telegraph* (16 April 1862), 3.

105 *Era* (11 May 1862), 6.

106 Taylor, op. cit. (97), 21.

107 *Athenaeum* (12 April 1862), 503; *Daily News*

(18 April 1862), 2; *Morning Post* (7 April 1862), 2.

108 Ford Madox Ford, 'Creatures Frail but Awful' (1911), *Memories and Impressions* (1971), 1979, 48-50.

109 *Daily Telegraph*, op. cit. (104), 3.

110 Taylor, op. cit. (97), 15.

111 Roger Fry, *Reflections on British Painting*, 1934, 109.

112 'Valentine's Day at the Post-Office', *Household Words* (30 March 1850), 6.

113 Holman Hunt, *Pre-Raphaelitism*, 1906, 11, 243.

114 Tate Gallery, *The Pre-Raphaelites*, 1984, 202.

115 *Saturday Review* (18 June 1864), 751.

116 Tate Gallery, op. cit. (114), 201-202.

117 Christie's, *Fine Victorian Pictures* (25 Oct. 1991), Lot 51, 92.

118 Christie's, *c19th. Century Pictures*, (20 June 1990), lots 84 & 85, 109-11.

119 'Mr, Logsdail and Lincoln', *Art Journal* (Nov. 1892), 324.

120 Robert Upstone and Rosalyn Thomas, Catalogue entry no.5, Richard Green, *The 19th. Century Through Painter's Eyes*, 1998.

Chapter 3
Workers and Poor in Town and Country

1 Carlyle 'Chartism' (1839), *Essays*, 1888, Vol.V1, 109.

2 Richard D. Altick, *Victorian People and Ideas*, 1973, 40-1.

3 qu. *Industrialization and Culture*, ed. Christopher Harvie, et al., 1970, 42.

4 Friedrich Engels, *The Condition of the Working Class in England in 1844*, Transl F.K. Wischenewetzk, 1887, 37.

5 Charles West Cope, *Reminiscences*, Bentley, 1891, 168.

6 Francis D. Klingender, *Art and the Industrial Revolution*, 1972 (1947), 157-8.

7 Pauline Gregg, *A Social and Economic History of Britain*, George G Harrap, 1965 (1949), 193.

8 Benjamin Disraeli, *Sybil*, (1845), n.d., 113.

9 Henry Morley, 'Ground in the Mill', *Household Words* (22 April 1854), 224-7.

10 John Ruskin, 'The Roots of Honour' (Aug. 1850), *Unto This Last*, *Works*, Vol.XV11, 42; 'The Veins of Wealth' (Sept. 1860), ibid. 47-48n.

11 Samuel Smiles, *Self-Help* (1859), nd. 206.

12 Henry Mayhew, *London Labour and the London Poor*, Vol.1, 1-2.

13 W.E.H. Lecky, *The Map of Life*, Longmans, 1899, 51.

14 Francis Galton, 'Hereditary Talent and Character', *Macmillan's Mag.* (August 1865), 325.

15 Julian Treuherz, *Hard Times*, 1987, 9.

16 Francis D. Klingender, op. cit. (6) 156.

17 *A.J.* (May 1855), 168.

18 William Morris, 'The Art of the People' (1879), *Hopes and Fears for Art*, Thoennes Press, 1994, 44.

19 *A.J.* (June 1866), 167.

20 [J.B. Atkinson], 'Art Politics and Proceedings', *Blackwoods Mag.*, (Aug. 1866), 193.

21 *I.L.N.* (11 June 1870), 606.

22 *Sat. Review* (13 June 1874), 748.

23 Thomas Hood, ed. W.M. Rossetti, *Poetical Works*, n.d., xxvi.

24 Walter C. Jerrold, *Thomas Hood: his life and times*, 1907, 336-7.

25 (1 June 1844), qu. F.M. Redgrave, *Richard Redgrave, a Memoir*, 1891, 45.

26 W.M. Thackeray, 'May Gambols' (June 1844), *Misc. Essays, etc.*, *Works*, XXV, 1886,

198 & n.

27 qu. Julian Treuherz, *Hard Times*, 1987, 24, 26.

28 qu. ibid. 36.

29 qu. *The Pre-Raphaelites*, Tate Gallery, 1984, 112.

30 Carlyle, 'Chartism', *Essays*, 1888, Vol.V1, 127-8.

31 Charles Kingsley, *Life and Letters*, 1876, Vol.11, 107.

32 *The Diary of W.M. Rossetti* (19 April 1871), ed. Odette Bornand, 57.

33 Walter E. Houghton, *The Victorian Frame of Mind*, 1973 (1957), 242-3.

34 Samuel Smiles, *Self Help*, 1859, 30-1; *Thrift*, 1875, 6.

35 Charles Kingsley, 'Work', *Village Sermons and Town and Country Sermons*, Macmillan, 1891 (1877), 273.

36 Frank M. Turner, 'Victorian Scientific Naturalism and Thomas Carlyle', *Victorian Studies* (March 1975), 329.

37 [Cormell Price] 'The Work of Young Men in the Present Age', *Oxford and Cambridge Mag.*, 1856, No. 1X Sept. 1856, 559.

38 Thomas Carlyle, *Past and Present*, 1885 (1843), 165, 169-70, 129, 165.

39 Ruskin, 'The Accumulation and Distribution of Art' (13 Jly, 1857), '*A Joy for Ever*', Addenda, *Works*, Vol.XV1, 113.

40 'The Great Industrial Exhibition', *Athenaeum* (May 3 1851), 478.

41 Henry Mayhew, 1851; or the Adventure of Mr and Mrs Sandboys; qu. *Industrialization and Culture*, ed. Chris. Harvie et al., 1970, 245-6.

42 Ibid., 248.

43 Linda Nochlin, *Realism*, 1971, 127.

44 Samuel Smiles, *Life and Labour*, 1897 (1887), 4.

45 *I.L.N.* (9 Dec. 1854), 575.

46 Samuel Smiles, 'Strikes,' *Quarterly Review* (Oct 1859), 485.

47 'Piping Days', *Household Words* (14 Oct. 1854), 196-8. Gerard Curtis examines the social implications of the new water supply in 'Ford Madox Brown's *Work*: An Iconographic Analysis, Art Bulletin, Vol.LXX1V (Dec. 1992), 623-36.

48 F. Madox Brown, Catalogue Note to *Work*, 1862, qu. J. Treuherz, *Pre-Raphaelite Paintings from Manchester*, 1993 (1980), 48. Brown's catalogue is very scarce. The note to *Work* is reproduced in full by Treuherz, 41-9.

49 *The Works of Hogarth*, Vol.11, 1873, note to *Beer Street* (no. 73). For a discussion of Brown's debt to Hogarth, see, E.D.H. Johnson, 'The Making of Ford Madox Brown's *Work*, Victorian Artists and the City, ed. Ira Bruce Nadel, 1980, 145-6.

50 Charles Lamb, 'On the Genius and Character of Hogarth', ibid. 1873, 5.

51 Identified, respectively, by E.D.H. Johnson, op.cit. (49) 150, and Albert Boime, 'Ford Madox Brown, Thomas Carlyle, and Karl Marx: meaning and mystification of work in the nineteenth century', *Arts Magazine* (Sept. 1981), 121.

52 qu. J. Treuherz, op.cit. (48), 48.

53 Kellow Chesney, *The Victorian Underworld*, 1974 (1970), 40-42. See also, Terry Coleman, *The Railway Navvies*, 1965.

54 *I.L.N.* (18 March 1865), 266.

55 Brown qu. Treuherz, op.cit. (48), 44.

56 *I.L.N.* (18 March 1865), 266.

57 F.M. Brown, ed. V. Surtees, *Diary* (1 Jan. 1855), 1981, 114. See also entries by Mary Bennett, Tate Gallery, *The Pre-Raphaelites*, 1984, 164, 258.

58 Thomas Carlyle, *Sartor Resartus*, 1885 (1833-4), 154-5.

59 Ford Madox Ford [Hueffer], *Ford Madox Brown*, 1896, 195.

60 Brown (15 Dec. 1855) op.cit. (57), 158.

61 Thomas Carlyle, *Past and Present*, 1885 (1843), 167. See Gerard Curtis, op. cit. (47).

62 Carlyle, Ibid. 151-2.

63 F. Madox Brown (29 April 1855), *Diary*, ed. V. Surtees, 1981, 113, 135.

64 Ibid. (29 April 1855), 135.

65 George Bernard Shaw, 'Madox Brown, Watts, and Ibsen,' *Saturday Review* (13 March 1897), 266.

66 J. Cornforth, 'Wallington, Northumberland', *Country Life* (30 April 1971), 988.

67 F.G. Stephens, 'Modern Giants,' *Germ* No.4 (May 1850), 1979, 170.

68 Paul Usherwood, 'W.B Scott's *Iron and Coal*: northern readings', *Pre-Raphaelite Painters and Patrons in the North East*, 1989, 47.

69 W. Bell Scott, *Autobiographical Notes*, 1892, Vol.1, 207.

70 Usherwood, op. cit. (68) 46.

71 Klingender, *Art and the Industrial Revolution*, 1972 (1947), 155.

72 J.R. Leifchild, 'Life and Labour in the Coalfields', *Cornhill Mag.* (March 1862), qu. Royston Pike, *Human Documents of the Victorian Golden Age*, 1974 (1967), 66.

73 Ibid. 65.

74 John Brown, 'Notes on Art', *Horae Subsecivae*, 1906, 163.

75 Disraeli, *Sybil*, Longmans, (1845), n.d., 102-4ff.

76 Martin Weiner, *English Culture and the Decline of the Industrial Spirit*, 1985 (1981), 39.

77 George Eliot, *Felix Holt, the Radical* (1867), qu. *Industrialisation and Culture*, ed. C. Harvie, et al, 1970, 33.

78 Weiner, op. cit. (76) 39; John Ruskin, *Works*, XV11, 56,

79 *A.J.* (Jly 1862), 150.

80 Roger Wells (ed.), *Victorian Village: The Diaries of the Rev. J.C. Egerton*, 1857-88, 1992, 7-8.

81 Linda Nochlin, *Realism*, 1971, 115.

82 J.H. Phythian, *Fifty Years of Modern Painting*, 1908, 60.

83 cited J.M. Ady, 'English Art in the Victorian Age', *Quarterly Review* (Jan. 1898), 223.

84 Harry Quilter, *Preferences in Art*, 1892, 178.

85 ibid., 179.

86 J. Treuherz, *Hard Times*, 1987, 47.

87 Frances Spalding, Arts Council, *Landscape in Britain*, 1850-1950, 1983, 13.

88 R.L. Stevenson, 'A Note on Realism.' *Mag. Art*, 1884, p.26.

89 Walter Armstrong, 'Victorian Fine Art', *A.J.* (June 1887) 172.

90 'Society of Painters in Watercolours', *A.J.* (June 1868), 111, qu. James Dafforne 'Works of Fred Walker', *A.J.* (Oct. 1876), 299.

91 S.C.[Sidney Colvin], 'Frederick Walker, A.R.A.', *Cornhill Mag.* (Jly 1875), 34.

92 J. Dafforne, op. cit. (90) 300.

93 qu. Treuherz, op. cit. (86) 49.

94 Ruskin, 'The Frederick Walker Exhibition' (1876), *Works*, Vol. X1V, 346.

95 Armstrong, op. cit. (89) 172.

96 William Davies, 'The State of English Painting', *Quarterly Review* (April 1873), 312.

97 Simon Reynolds, 'Fred Walker', *Apollo* (Feb. 1981), 106-91.

98 Giovanni Costa, *Notes on Lord Leighton*, *Cornhill Mag.* (March 1897), 377-8.

99 Davies, op. cit. (96) 313.

100 F. Wedmore, 'Genre in the Summer Exhibitions', *Fortn. Review* (June 1883), 871.

101 *A.J.* (Jly 1876), 214.

102 Thomas Carlyle, 'Shooting Niagara: and After?', *Essays*, 1888, Vol.V11, 220.

103 *The Graphic* (17 May 1873), 455.

104 Charles Dickens, 'A Nightly Scene in London' (Jan. 26, 1856), *Miscellaneous Papers*, 1908, 572-6.

105 qu. Jeannie Chapel, *Victorian Taste*, Zwemmer, 1982, 85.

106 *I.L.N.* (May 9 1874), 446.

107 qu. Chapel, op.cit. (105) 85-6.

108 A.M. Reynolds, *The Life and Work of Frank Holl*, 1912, 13, 20, 44.

109 Ibid. 62.

110 Ibid. 108-9, 110.

111 Harry Quilter, *Preferences*, 1892, 130.

112 A.L. Baldry, *Sir Hubert Von Herkomer*, 1901, 54.

113 qu. Treuherz, *Hard Times*, 1987, 98.

114 Thomas Carlyle, 'Chartism' (1839), *Essays*, 1888, Vol.V1, 124.

115 'R.A.'. *Morning Post* (2 May 1891).

116 qu. J. Treuherz, *Hard Times*, 1987, 103.

117 Gabriel P. Weisberg, *Beyond Impressionism*, 1992, 108.

118 Edmond Gosse, 'The Salon of 1882.' *Fortnightly Review* (June, 1882), 737.

119 Clausen, *Six Lectures on Painting*, Elliot Stock, 1904, 107.

120 Typescript summary of Garstin's lecture notes, made by Michael Canney, qu. C. Fox & F. Greenacre, *Artists of the Newlyn School*, 1979, 16.

121 qu. Caroline Fox, *Stanhope Forbes and the Newlyn School*, 1993, 9.

122 Stanhope Forbes, 'Cornwall from a Painter's Point of View', *Annual Report of the Royal Cornwall Polytechnic Society*, 1900, 49-50.

123 ibid., 50.

124 See, Roger Langley, *Walter Langley*, 1997, 107-8.

125 'An Exotic', *Mag. of Art* (1883), 43.

126 J.W. Mollett, 'Peasant Models', *A.J.* (Sept. 1881), 265.

127 Frank Richards, 'Newlyn as a Sketching Ground', *Studio* (Aug. 1895), 175, 180.

128 Stanhope Forbes, letter to his father (17 Feb. 1884), qu. K. Bendiner, *An Introduction to Victorian Painting*, 1985, 111.

129 Forbes, 'Cornwall', op.cit. (122), 53.

130 *Art Journal* (Feb. 1896), 58.

131 Gleeson White, *Master Painters of Britain*, n.d., Vol. 1V, 19.

132 C. Lewis Hind, 'The Art of Stanhope Forbes, R.A.', *Art Annual*, no. 331, 1911, 5-6.

133 Norman Garstin, 'The Work of Stanhope Forbes, R.A.', *Studio*, Vol.23 (July 1901), 84.

134 Wilfred Meynell, 'Stanhope Forbes', *Art Journal* (March 1892), 68.

135 Stanhope Forbes, letter to his mother (17 March 1884), qu. Bendiner, op.cit. (128), 111.

136 qu. Caroline Fox, *Stanhope Forbes and the Newlyn School*, 1994 (1993), 25.

137 qu. ibid. 24.

138 Forbes, 'Cornwall', op.cit. (122), 49.

139 Gabriel P. Weisberg, *Beyond Impressionism*, 1992, 111.

140 *Magazine of Art*, 1887, 158, qu. ibid. 113.

141 *Magazine of Art*, 1885, 133, qu. ibid. 111.

142 George Clausen, *Six Lectures on Painting*, 1904, 119.

143 Ibid. 121, 125.

144 J.B. Atkinson, 'The State of Art in France', *Blackwoods Mag.*, (April 1884), 444, 443, 439.

BIBLIOGRAPHY

Manuscripts

William Maw Egley, Catalogue of Paintings (4 Vols.), Vol.1 1840-67.

William Powell Frith, Correspondence (1842-95), National Art Library.

William Logsdail, letter to Sir Alfred Newton (13 May 1917), Richard Green. London.

Newspapers

Daily News
Daily Telegraph
Era
Examiner
Guardian
Morning Herald
Morning Post
Observer
Standard
St. James's Chronicle
Sun
Times

Periodicals

All the year Round
Annual Report of the Royal Cornwall Polytechnic Society
Anthropological Review
Apollo
Art Bulletin
Art History
Art Journal
Art Quarterly
Art Union
Artist
Arts' Magazine
Athenaeum
Blackwood's Magazine
British Medical Journal
Burlington Magazine
Contemporary Review
Cornhill Magazine
Country Life
Edinburgh Review
Fine Art Quarterly Review
Fortnightly Review
Fraser's Magazine
Germ
Graphic
Great Western Railway Magazine
Household Words
Illustrated London News
Journal of the Anthropological Society
Lancet
Listener

Macmillan's Magazine
Magazine of Art
National Art Collections Fund Review
National Review
New Quarterly Magazine
Nineteenth Century
Oxford and Cambridge Magazine
Punch
Quarterly Review
Reader
Saturday Review
Spectator
Studio
Universal Review
Victorian Studies

Catalogues: Permanent Collections:

Birmingham Museums and Art Gallery, Catalogue of Drawings, Derby, Bemrose & Sons Ltd., 1939.

David Blayney Brown, Sir David Wilkie: Drawings and Sketches in the Ashmolean Museum, Morton Morris & Co., 1985.

Jeannie Chapel, Victorian Taste, Royal Holloway, University of London, Zwemmer, 1982.

Mireille Galinou and John Hayes, London in Paint: Oil Paintings in the Collection at the Museum of London, M.o.L., 1996.

John Hayes, Catalogue of Paintings in the London Museum, H.M.S.0., 1970.

Vivien Knight, The Works of Art of the Corporation of London, Cambridge, Woodhead-Faulkner, 1986.

Edward Morris, Victorian and Edwardian Paintings in the Lady Lever Art Gallery, H.M.S.O., 1994.

Victorian and Edwardian Paintings in the Walker Art Gallery & at Sudley House, H.M.S.O., 1996.

Ronald Parkinson, V.& A. Museum: Catalogue of British Oil Paintings, 1820-60, H.M.S.O., 1990.

Exhibition Catalogues

Arts Council, Great Victorian Pictures, 1978.

Landscape in Britain, 1850-1950, 1983.

Victorian Paintings, 1962.

Barbican Art Gallery: K Matjaskiewicz (ed.), James Tissot, Barbican/Phaidon, 1984.

Djanogly Art Gallery: Christian Payne, Rustic Simplicity, University of Nottingham/Lund Humphries, 1999.

Geffrye Museum: Rosamund Allwood, George Elgar Hicks, 1982.

Laing Art Gallery: Newcastle upon Tyne, Pre-Raphaelites: Painters and Patrons in the North East, 1989.

Manchester City Art Gallery: Julian Treheurz, Hard Times, Manchester City A.G./Lund Humphries, 1987.

Mappin Art Gallery, Sheffield: Victorian Paintings, 1986.

Newlyn Art Gallery: Caroline Fox and Francis Greenacre, Artists of the Newlyn School, 1979.

National Gallery of Art, Washington, The Victorians, 1997.

Victoria & Albert Museum: Marcia Pointon, William Mulready, 1986.

Richard Green: Claire I.R. O'Mahony, The c19th. Century through Painter's Eyes, London, 1998.

Royal Academy: Patricia Connor & Lionel Lambourne, Derby Day 200, 1979.

Tate Gallery: Richard Ormond, Edwin Landseer, 1982.

Patricia Allderidge, The Late Richard Dadd, 1974.

The Pre-Raphaelites, 1984.

Wolverhampton Art Gallery: Andrew Greg, The Cranbrook Colony, 1977.

Books

Sir William Acton, Functions and Disorders of the Reproductive Organs, 5th. ed., J. Churchill, 1870 (1857).

R.D. Altick, Victorian People and Ideas, Dent, 1973.

Anon, Familiar Things, 2 Vols., c1845.

John H.G. Archer (ed.), Art and Architecture in Victorian Manchester, Manchester U. P., 1985.

Thomas Arnold, Introductory Lectures on Modern History, J. H. Parker, Oxford, 1842.

A. Lys Baldry, Hubert von Herkomer, George Bell, 1902.

John Beddoe, The Races of Britain, Trubner, 1885.

Kenneth Bendiner, Ford Madox Brown, Pennsylvania State U.P., 1998.

An Introduction to Victorian Painting, Yale U.P., 1985.

M. Betham-Edwards, Reminiscences, Unit Library, 1903.

Mrs. Lionel Birch, Stanhope A. Forbes and Elizabeth Stanhope Forbes, Cassell & Co., 1906.

Louis Blanc, transl. J. Hutton, Letters on England, Samson & Low, 1866.

Jerome H. Buckley, The Triumph of Time, Cambridge, Massachusetts, Harvard U.P., 1966.

Sarah Bradford, Disraeli, Grafton Books, 1985 (1982).

Chris Brooks, Signs for the Times, George Allen & Unwin, 1984.

Ford Madox Brown, Diary, ed. Virginia Surtees, Yale U.P., 1981.

[Hablot K. Browne], Phiz, The Derby Carnival, H. Vickers, 1869.

John Brown, Horae Subsecivae, Oxford U.P., 1906.

Ford Madox Brown, ed. Virginia Surtees, Diary, Yale U.P., 1981.

Nahum Capen, Reminiscences of Spurzheim, New York, Fowler & Wells, 1881.

Thomas Carlyle, Essays, 7 Vols., Chapman & Hall, 1888.

Works, Ashburton Edition, 17 Vols., Chapman & Hall, 1885-88.

Susan P. Casteras, Images of Victorian Womanhood in English Art, Associated Univ. Presses, 1987.

Robert Chambers, Vestiges of the Natural History of Creation, J. Churchill, 1844.

Ernst Chesneau, The English School of Painting, transl. E.N. Etherington, Cassell & Co., 1885 (1882).

Kellow Chesney, The Victorian Underworld, Harmondsworth, Penguin, 1974 (1970).

George Clausen, Six Lectures on Painting, Elliot Stock, 1904.

Terry Coleman, The Railway Navvies, Harmondsworth, Penguin, 1965.

Brenda Colloms, Victorian Visionaries, Constable, 1982.

Charles West Cope, Reminiscences, Bentley, 1891.

The Council of Four, Royal Academy Review, 1858.

Mary Cowling, The Artist as Anthropologist: the Representation of Type and Character in Victorian Art, Cambridge U.P., 1989.

Alan Crawford (ed.), By Hammer and Hand, Birmingham Museums and Art Gallery, 1984.

Alan Cunningham, Life of Sir David Wilkie, 3 Vols., John Murray, 1843.

Rev. W. Cunningham, True Womanhood, Swan Sonnenschein, 1896.

Alan Dale, The Victorian Critic and the Idea of History: Carlyle, Arnold, and Pater, Harvard, 1977.

W.J. Dempster, Evolutionary Concepts in the Nineteenth Century, Durham, Pentland Press, 1996.

Charles Dickens, Miscellaneous Papers, Chapman & Hall, 1908.

Works, Biographical Ed., 19 Vols., Chapman & Hall, 1902-3.

Benjamin Disraeli, Coningsby, Longmans, n.d. (1844).

Sybil, Longmans, n.d. (1845)

P.H. Ditchfield, The Charm of the English Village, Guernsey, Guernsey Press, 1994 (1906),

Austin Dobson, The Ballad of Beau Brocade, Kegan Paul et al, 1892.

Coridon's Song, Macmillan, 1894.

Proverbs in Porcelain, Kegan Paul, et al, 1893.

H.H. Dodwell and R.R. Sethi, Cambridge History of India, Vol.6, Cambridge U.P., 1958.

Richard Doyle and P. Lee, Manners and Customs of Ye Englyshe, 2 Vols., Bradbury & Evans, 1849-50.

Henry S. Drayton and James McNeil, Brain and Mind, New York, S.R. Wells, 1880.

Elizabeth Eastlake, Journals and Correspondence, 2 Vols., J. Murray, 1895.

F. Engel's The Condition of the Working Class in England in 1844, transl. F.K. Wischenewetzk, New York, John W Lovell Co., 1887.

Rodney Engen, Kate Greenaway, Macdonald, 1981.

Lindsay Errington, Sunshine and Shadow: the David Scott Collection of Victorian Paintings, Edinburgh, National Galleries of Scotland, 1991.

Ford Madox Ford [Hueffer], Ford Madox Brown, Longmans, 1896.

Memories and Impressions, Harmondsworth, Penguin Books (1971), 1979.

Caroline Fox, *Stanhope Forbes and the Newlyn School*, David and Charles, 1993.

W.P. Frith, *Autobiography and Reminiscences*, 2 Vols., R. Bentley, 1887

Further Reminiscences, 1888.

Roger Fry, *Reflections on British Painting*, 1934.

Francis Galton, *Hereditary Genius*, Macmillan, 1892 (1869).

Gambart & Co., *Frith's Derby Day*, n.d. [c1858].

Patrick Geddes and J. Arthur Thomson, *The Evolution of Sex*, Ellis, 1889.

The Germ, Preface by Andrea Rose, Ashmolean Museum & Birmingham Art Gallery, 1979 (1850).

Mark Girouard, *The Return to Camelot*, Yale University Press, 1981.

James Grant, *Pictures of Popular People*, G. Virtue, c1845.

Pauline Gregg, *A Social and Economic History of Britain*, George G. Harrap, 1965 (1949).

James Hall, *Dictionary of Subjects and Symbols in Art*, John Murray, 1974.

Samuel Carter Hall, *Retrospect of a Long Life*, 2 Vols., R. Bentley, 1883.

Philip Gilbert Hamerton, *Man in Art*, Macmillan, 1892.

Robin Hamlyn, *Robert Vernon's Gift*, Tate Gallery, 1993.

Marion Harding (ed.), *The Victorian Soldier*, National Army Museum, 1993.

Frederic Harrison, *Ideals and Realities*, Macmillan, 1908.

Christopher Harvie, et al. (eds.) *Industrialization and Culture*, Open University Press, 1970.

Benjamin Robert Haydon, *Autobiography and Journals*, ed. Malcolm Elwin, Macdonald, 1950 (1853).

Anthea Hayton, *A Sultry Month*, Faber, 1965.

Hubert von Herkomer, *Autobiography* (privately printed), 1890.

Sir Hubert von Herkomer, *The Herkomers*, 2 Vols., Macmillan & co., 1910-11.

My School and Gospel, A. Constable & Co., 1908.

Christopher Hibbert, *Wellington: A Personal History*, Harper Collins, 1997.

George Elgar Hicks, *A Guide to Figure Drawing*, G. Rowney, 1853.

William Hogarth, The Works of, Bell and Daldy, 1873.

Thomas Hood, ed. W.M. Rossetti, *Poetical Works*, Bell & Daldy, n.d.

John Calcott Horsley, *Recollections*, J. Murray, 1903.

Simon Houfe, *Fin de Siècle*, Barrie & Jenkins, 1992.

Walter Houghton, *The Victorian Frame of Mind*, Yale U.P., 1973 (1957).

William Holman Hunt, *Pre-Raphaelitism and the Pre-Raphaelite Brotherhood*, 2 Vols., 1905.

David and Francina Irwin, *Scottish Painters*, Faber & Faber, 1975.

Walter C. Jerrold, *Thomas Hood, his Life and Times*, Alston Rivers Ltd., 1907.

E.D. H. Johnson, *Paintings of the British Social Scene*, Wiedenfeld and Nicolson, 1986.

Charles Kingsley, *Letters & Memorials of His Life*, 2 Vols., Kegan Paul & Co. 1876.

Miscellanies, 2 Vols., J.W. Parker & Son, 1859.

Village Sermons and Town and Country Sermons, Macmillan, 1891 (1877).

Francis D. Klingender, *Art and the Industrial Revolution*, Paladin, 1972 (1947)

Robert Knox, *The Races of Man*, Miami, Mnemosyne, 1969 (1850).

Samuel Laing, *Modern Science and Modern Thought*, Chapman & Hall, 1885.

Lionel Lambourne, *Introduction to Victorian Genre Painting*, V. & A., 1982.

Roger Langley, *Walter Langley*, Bristol, Sansom & Co., 1997.

W.E.H. Lecky, *The Map of Life*, Longmans, 1899.

C.R. Leslie, *Autobiographical Recollections*, 1860, 2 Vols., John Murray.

George Dunlop Leslie, *The Inner Life of the Royal Academy*, John Murray, 1914.

Cesare Lombroso, *Criminal Man*, G.P. Putnam, 1911 (1876).

David Lowenthall, *The Past is a Foreign Country*, Cambridge University Press, 1985.

Rev. Thomas W. May Lund, *The Religion of Art*, Edward Howell, Liverpool, 1891.

Sir Edward Bulwer Lytton, *England and the English*, Chicago U.P., 1970 (1833).

Jeremy Maas, *Gambart*, Barrie & Jenkins, 1975.

Victorian Painters, Barrie & Jenkins, 1974 (1969).

Thomas Babbington Macaulay, *Essays*, Longmans, 1899.

History of England, 2 Vols., Longmans, Green, & Co., 1889 (4 Vols., 1849-1855).

Mary McKerrow, *The Faeds*, Edinburgh, Canongate Press, 1982.

Duncan Macmillan, *Scottish Art*, Edinburgh, Mainstream Publishing, 1990.

N. MacNamara, *Origin and Character of the British People*, Smith, Elder, 1900.

Sarah Macready and F.H. Thompson (eds.), *Influences in Victorian Art and Architecture*, Society of Antiquaries, 1985.

P. Mantegazza, *Physiognomy and Expression*, 1890.

Henry Stacey Marks, *Pen and Pencil Sketches*, 2 Vols., Chatto & Windus, 1894.

John George Marks, *Life and Letters of Frederick Walker*, Macmillan, 1896.

Henry Mayhew and John Binny, *Criminal Prisons of London*, Griffin, Bohn, & Co., 1862.

Henry Mayhew, *London Characters*, 1874.

London Labour and the London Poor, Griffin, Bohn, & Co., 4 Vols., 1861-2.

Wilfred Meynell, *The Modern School of Art*, 4 Vols., Cassell & Co., n.d.

J. Saxon Mills, *Life and Letters of Sir Hubert Von Herkomer*, 1923.

George Mingay (ed.), *Rural Life in Victorian England*, Book Club Associates, 1976.

The Victorian Countryside, 2 Vols., Routledge, Kegan Paul, 1981.

William Morris (ed.), *Hopes and Fears for Art*, Thoemmes Press, 1994 (1882/1888).

Samuel George Morton, ed. J.C. Nott and G.R. Gliddon, *Types of Mankind*, Trubner & Co., 1854.

Linda Nead, *Myths of Sexuality*, Oxford, Blackwell, 1988.

Linda Nochlin, *Realism*, Harmondsworth, Penguin, 1971.

M. H. Noel-Paton & J.P. Campbell, *Sir Joseph Noel-Paton*, ed. Francina Irwin, Edinburgh, Ramsay Head Press, 1990.

Cedric Oldacre [John W.D. Warter], *The Last of the Olde Squires*, Longman, et al, 1854.

J.C. Olmsted, *Victorian Painting: Essays and Reviews*, Vol.1., Garland Publishing, 1980.

Henry O'Neil, *Two Thousand Years Hence*, Chapman & Hall, 1868.

Leslie Parris (ed.), *Pre-Raphaelite Papers*, Tate Gallery, 1984.

J.E. Phythian, *Fifty Years of Modern Painting*, Grant Richards, 1908.

Royston Pike (ed.), *Human Documents of the Victorian Golden Age*, Allen and Unwin, 1974 (1967).

Walter Herries Pollock, *The Hon. John Collier*, Virtue, 1914.

Pre-Raphaelite Painters and Patrons in the North East, Newcastle-upon-Tyne, Tyne and Wear Museums, 1989.

Harry Quilter, *Preferences in Art, Life and Literature*, Swan Sonnenshein, 1902.

Sententiae Artis, Isbister, 1886.

Lucy Rabin, *Ford Madox Brown and Pre-Raphaelite History Painting*, New York, Garland Publishing, 1978.

Charles E. Raven, *Christian Socialism, 1848-54*, Frank Cass, 1968.

F.M. Redgrave, *Richard Redgrave, a Memoir*, Cassell, 1891.

Richard and Samuel Redgrave, *A Century of Painters*, Smith, Elder & Co., 1866.

Gerald R. Reitlinger, *The Economics of Taste*, 3 Vols., Barrie and Rockliff, 1961, 1963, 1970.

A.M. Reynolds, *The Life and Work of Frank Holl*, Methuen, 1912.

J.E. Ritchie, *The Night Side of London*, Tinsley Bros., 1869 (1857).

Leonard Roberts, *Arthur Hughes: a Catalogue Raisonne*, Antique Collectors Club, 1997.

David Robertson, *Sir Charles Eastlake and the Victorian Art World*, New Jersey, Princeton U.P., 1978.

Frederick William Roe, *Thomas Carlyle as a Critic of Literature*, New York, Columbia U.P., 1910.

W.M. Rossetti, ed. Odette Bornand, *Diary, 1870-3*, Oxford, Clarendon, 1977.

Fine Art Chiefly Contemporary, Macmillan, 1867.

John Ruskin, *Works*, ed. E.T. Cook and A. Wedderburn, 39 Volumes, George Allen, 1903-12.

James Sambrook (ed.), *Pre-Raphaelitism*, University of Chicago Press, 1974.

William Bell Scott, *Autobiographical Notes*, 2 Vols., R. Osgood, McIlvaine & Co., 1892.

James Simmons, *The Novelist as Historian*, Mouton & Co., The Hague & Paris, 1973.

Robin Simon and Alastair Smart, *The Art of Cricket*, Secker and Warburg, 1983.

Samuel Smiles, *Life and Labour*, John Murray, 1897 (1887).

Self-Help, S.W. Partridge, n.d., (1859).

Thrift, John Murray, 1889 (1875).

Albert Smith, *The Natural History of the Gent*, David Bogue, 1847.

Juliet M. Soskice, *Chapters from Childhood*, Selwyn & Blount, 1921.

M.H. Spielmann and G.S. Layard, *Kate Greenaway*, Charles Black, 1905.

M.H. Spielmann, *Millais & His Works*, Will. Blackwood & Sons, 1898.

Frederick George Stephens, *James Clark Hook, R.A.*, 1888.

Gladys Storey, *All Sorts of People*, Methuen & Co., 1929.

Virginia Surtees, *Sublime and Instructive: Letters from John Ruskin to Louisa, Marchioness of Waterford, et al*, Michael Joseph, 1972.

Tom Taylor, *The Railway Station* [1862].

Hippolite A. Taine, *A History of English Literature*, John W. Lowell, New York, 1873.

Notes on England, Thames & Hudson, 1957.

W.M. Thackeray, *Critical Papers on Art*, Macmillan, 1911.

Works, 26 Vols., Smith, Elder, 1878-86.

Anthony Trollope, *Autobiography*, Oxford U.P., 1947 (1859).

W. Vamplew, *The Turf*, Allen Lane, 1976.

Victorian Art (collected *Art Annuals*),Vols.1 & 2, Art Journal Office, n.d.

Mrs. E.M. Ward, *Memories of Ninety Years*, 2nd.ed., n.d. (1924).

Eden Warwick (G.Jabet), *Notes on Noses* R.Bentley (1862), 1848.

Frederick Wedmore, *The Masters of Genre Painting*, C. Kegan Paul & Co., 1880.

Gabriel P. Weisberg, *Beyond Impressionism*, Thames & Hudson, 1992.

Martin Wiener, *English Culture and the Decline of the Industrial Spirit*, Harmondsworth, Penguin, 1985 (1981).

Roger Wells (ed.), *The Diaries of the Rev. J.C. Egerton*, 1857-88, Stroud, Alan Sutton, 1992.

S.R. Wells, *New System of Physiognomy*, New York, Fowler & Wells, 1866.

Gleeson White, *The Master-Painters of Britain*, 4 Vols., T.C. & E.C. Jack, 1898.

Christopher Wood, *Dictionary of Victorian Painters*, 2 Vols., Antique Collectors' Club, 1995.

The Pre-Raphaelites, Book Club Associates, 1983 (1981).

INDEX

Abbey, Edwin Austin 86
Academie Julian 82
Agnew, Thomas 10
Agnew, William 185
Albert Hall 55
Albert, Prince 100
Alexandra, Princess 147
Allen, Grant on *Punch* artists – accuracy of class
 types 128
American Civil War 180
Anderson, Sophie *No Walk Today* 20 **21**
 22/3?
Anglo-Saxon race/type 132
Animal physiognomy 129
Anthropology of Britain 89-91
 & art 91
 & Derby Day 110
 & railway stations 118
 & London crowd 91-97
Antwerp Academy 155
Arch, Joseph 183
Aristocratic physiognomy 94 125 128-30
Aristocracy, duties of 177
Armitage, Edward *Retribution* 62
Armstrong, Elizabeth 194
Armstrong, Walter 18 73 80 186
Arnold, Thomas 19 172
Artists' colonies 82 191-2 194-196 198
Arts & Crafts Movement 83
Atelier Picot 51
Atkinson, J.Beavington 199
Atkinson, W.A.
 Upset Flower Cart **8** 11
 historical value of 22
Bacon, Francis 122
Balzac, Honoré de 42
Barbizon School 187 191 194
Barnard, Frederick 166-**167**
Barnes, Edward Charles *The Seducer* 39-**41**
Barret, Jerry
 *Florence Nightingale receiving the Wounded at
 Scutari* 59;
 *Queen Victoria and Prince Albert visiting the
 Crimean wounded* 59
Barwell, Frederick Bacon *Unaccredited Heroes*
 59
Bastien-Lepage, Jules 82 86 184 191-2 194
 Primitive types 199
 Les Foins **190** 196
'Bastienomania' 191
Battersea Gardens 150
Beddoe, John **90**
Bennett, Charles 97
Binny, John 89 91 97 132
Birmingham Group 83
Bishop, John 122
Blanc, Louis 110
Blue Books 44 161-2
Bonnat, Leon 194

Booth, Charles *Life and Labour of the People in
 London* 162
Bougereau, Adolphe W. 198
Boughton, G.H. 70
Bowkett, Jane Maria *Young Woman in a
 Conservatory* 37 **38**
Brabazon, Hercules B.
 On the 'Gent' 121
Braddon, Mary E. 42
Bramley, Frank 155
 A Hopeless Dawn **194 195** 196
Brassey, Thomas 176
Breton, Jules 184 199
Brett, James 136
Brett, John *The Stonebreaker* 6
Bright, John 164
Brighton, day trips 102-4
British Medical Journal 122
British Impressionists 9 155
The British Working Man 164
The British Working Man 95 122-3 165
The British Workman 165
Britons, Ancient 94
Brittany, artists' colonies 196 198
Brock, Charles 70
Brock, Henry Matthew 70
Brown, Ford Madox
 Last of England **170**
 Work 7 23 99 163 168 **172 173**
 175-179
Brown, John 180
Browne, Hablot K. (Phiz) 96 110
Bull-dog type 126 129-30 142
Bulwer-Lytton, Sir Edward 100
Buonaparte, Napoleon 70
Burgess, John Bagnold 55
Burne-Jones, Edward 173
Burns, Robert 23
Burwash 182
Buss, Robert William 100 102
 The Crowd 104 **105**
Butler, Lady Elizabeth
 The Defence of Rourke's Drift 59
 The Role Call after an Engagement, Crimea 59
 Scotland for Ever 59
Byron, George Gordon, Lord 16
Caldecott, Randolph 70
 'To See a fine Lady Get on a White Horse' **72**
Calderon, Philip H. 51
 Broken Vows 36-7 **36**
 Captain of the Eleven **86**
Calkin, Lance 156
Callcott, Sir J.W. 10
Campbell, James *Waiting for Legal Advice* 51
 52 **53** 120
Camper, Pieter 93
Canine physiognomy 130
Captain Swing Riots 182
Carlyle, Thomas

& Madox Brown 176-8
 on art 188
 on society 7 161 168-70 172-174 191
Carolus-Duran, Charles E.A. 70 192
Carpaccio 55
Caucasian race 122 130
Cawnpore Massacre 63
Celt 90 94-5 121
Chadwick, Edwin 161
Chalmers, George P. 86
Chantry Bequest 196
Chartism 161-2 176 191
Cheap Trains Act, 1844 126
Chesneau, Ernest 63
Christian Socialism 176
City of London Police 136
Clarke, Joseph *The Labourer's Welcome* 28 **29** 31
Clausen, George 191-2
 on realism 199
 Ploughing **196**
 Winter Work **198** 199
'The Clique' 16 70
Collier, The Hon. John
 The Prodigal Daughter **75** 77
Collins, Charles Allston 51 147
Collins, William 13
Collinson, James
 Answering the Emigrant's Letter 170
 The Emigration Scheme 170
Colvin, Sydney 9 18 87
Combe, George 92
Combe, Thomas 147
Condition of England 161
Constable, John 16
Cope, Charles West *Mothers: Life Well Spent*
 30 38-9 **40** 42 161
Corot, J.B.C. 187
Costa, Giovanni 186
Coutts, Lady Burdett 27
Craig, Inspector 136
Cranbrook Colony 23 43-6 168
Crane, Walter 199
Cranford School 70 72
Cremorne Gardens 150
Crimean Tom 59
Crimean War 59 62 63 121 173
'Criminal Conversation' 39
Criminal type 94-6 121-6
Cross-breeding of social classes 131
Crowd, growth of in urban centres 89
 Anthropological interest in 89-91
Crow, Jim 100
Crowe, Eyre
 After Work 180
 Brothers of the Brush 180
 The Dinner Hour Wigan 180 182 **183**
Cruikshank, George 96-**97** **113** 162 **164**
 165 **166 168** 175 **177**
Cruikshank, George (the younger) **113** 124

Crystal Palace 174
Cunningham, Alan 10
Cunningham, Rev. William 37
Cuyp, Albert 10
Dadd, Richard 16
 Suspense or Expectation **18**
 The Child's Problem **19**
Dafforne, James 48
Dame Schools 48
Degas, Edgar 68 199
Delaroche, Paul 180
Democratic subjects 191 199
Denmark 147
Derby Day event 103 110 112-13 121
 124-5 131
Derby, fifteenth Earl of 125
De Tocqueville, Alexis 161
Deverell, Walter Howell *Irish Vagrants* 168-9
 170
Deville, James 123
Diaz, Henri 191
Dickens, Charles, (Mr. Bucket)
 Bleak House 136
 Household Words 143 162
 The Old Curiosity Shop 50
 Sketches by Boz 96
 on homelessness 189
 on the physiognomy of murderers 122
 on John Thurtell 123
Dicksee, Sir Frank 76-7
 The Confession **77**
 Harmony 76
Disraeli, Benjamin *[Coningsby]* 10 177
 Lothair 177
 Sybil 103 162 177 180 103-4
Ditchfield, R.H. 50
Domenichino 10
Doré, Gustave *London* 161-**162** 166
Doyle, Richard **113** 124 **136**
Du Maurier, George 97
 & criminal type 123
 & aristocratic type 129
Dunlop, James 16
Dutch genre 6 11-13 16 44 89
Dyce, William 19
Dyck, Sir Anthony van 10
Education Acts 28 48 183
Eagles, John 55 58
Earl, George
 Going North, King's Cross Station **154**
 Going South, Perth Station **155**
Eastlake, Charles Lock 55 22
Eastlake, Elizabeth on physiognomical
 types 96
Eaton Hall 55
Egerton, Rev. J.C. 182
Egg, Augustus 16 30
 Past and Present 6 **42**-43 121 132
 The Travelling Companions **33**

Egley, William Maw 30
 Omnibus Life in London 104 106-**107** 120
 The Talking Oak 33 **34** 36
Egremont, George O'Brien Wyndham, third
 Earl of 16
Eliot, George 37 182
Elmore, Alfred *On the Brink* 40
Emerson, Peter Henry 198
Emigration 168-70
Engels, Friedrich, *Condition of the Working*
 Classes in England in 1844 161
Ethnological Society of London 89
Ethnology 89
The 'Etruscans' 186-7
Etty, William 10
Euston Station 155
Evolution,
 of 'the Gent' 120-1
 of human types 95
 of the sexes 30
 of ugliness in upper and lower classes 128
 of workers in machine age 163
Faed, Thomas 6 9 23
 From Dawn to Sunset **26**-27 58
 Home and the Homeless 27
 The Last of the Clan 27
 The Poor the Poor Man's Friend 27
 Worn Out 27
Fake old masters 6 10 **11**
Feeny, Patrick 156
Feminine ideal 28-39 106
Fildes, Sir Luke 51 164
 An Alfresco Toilet 55
 A Casual Ward 65 163 **188**-9 190 191
 The Doctor 11 **65** 68 70
 Houseless and Hungry 188
 The Village Wedding 58
Fisk, William Henry *The Secret* **35**-36
Flatow, Louis Victor 10 27 103 118
Fleury, Robert 198
Fontainbleau 82 187 191
Forbes, Stanhope 191-2
 A Fish Sale **195**-196
 Forging the Anchor 195 **197**
 The Health of the Bride 196
 A Street in Brittany 194
Forth Bridge 154
Foster, Myles Birket 194
Fowler, N.L. **95**
Franco-Prussian War 68
French Impressionism 68 82 86 191
French painting techniques 70 82 155
 191-2 196
French Realism 86 184 191
Frith, W.P.
 & 'The Clique' 16
 & family as Saxon types 132
 & physiognomy 120
 & John Leech 146
 & value of authenticity in art 22
 Derby Day 6 7 9 89 100 102-104
 108-9 **111-13** 120-21
 aristocratic type **128**-131 132

criminal type 123-4
the 'Gent' 112 120-1
middle-class type 132-6
mixing of classes 124-5
thimble-riggers 112 120-1
working classes/itinerants 112 136
variety of characters 112-13
Key to the *Derby Day* 110
Her Husband's Friend 42
Life at the Seaside (Ramsgate Sands)
 historical value of 22 102-3
Race for Wealth 89
Railway Station 10 89 96 98 102-103
 113-20 **114-15** 118-**19** 120-1 143 154
 aristocratic type 132 **133**
 bull-dog type 126 129-30 138 142
 criminal type 123-4 **125**
 Frith family 118
 middle-class type 132 **134** 137
 mixing of classes 126-8
 working-classes 136-8 142
 Key to the *Railway Station* 116
Road to Ruin 22 89
Salon d'Or, Hamburg 22
The Times of Day 142
The Times of Day: Noon, Regent St. **142**
Froude, James Anthony 63
Fry, Roger on Frith's *Railway Station* 142
Fun 164
Gaelic physiognomy 95
Gainsborough, Thomas 10 11 72
Gair, William 59
Gall, Franz Josef 92 **93**
Galton, Sir Francis 132 163
Garibaldi, Giuseppe 179
Garstin, Norman 192 195
Gaskell, Elizabeth
 Mary Barton 162
 North and South 162
Gateshead 180
Geddes, Patrick & J. Arthur Thomson
 Evolution of Sex 30
The 'Gent' 51 113 104 120-1
Gere, Charles March *The Tennis Party* **82-83**
The Germ 179
Genre painting,
 historical value of 6 19 22 55 58 87
 nature & style of 9 18
 & psychology 12-13
 significance of 7
Georgian School of illustrators 70 72
Gillot, Joseph 51
Girouard, Mark 83
Gladstone, William Ewart 106 110 126 165
Glass studios 192
Gliddon, G.R. 96
Goldsmith, Oliver 6 16
Goodall, Frederick *The Campbells are coming:*
 Lucknow 62
Gordon, General 48
Gosse, Edmund 191
Gotch, Thomas Cooper 194
The Graphic 80 95 188 189

Grant, James 37
Graves, Henry 103
Gravesend 63
Great Exhibition 96 74-5 118
Green, Aaron, after Alfred Hunt,
 Epsom Downs **112**
Greenwood, James 162
Gregory E.J. 7 155
 Boulter's Lock 11 80 **81** 82 87
 Intruders 80
 Piccadilly: Drawing-Room Day 58
Greville, Charles 125-6
Grez-sur-Loing 82
Grimshaw, John Atkinson
 Il Penseroso 37
 The Rector's Garden 37
Grosvenor Gallery 198
Hague School 184-5 191 194
Hall, Mrs. Samuel Carter 30
Hampstead, growth of 175
Hardy, Frederick Daniel 23 27
 Playing at Doctors 48
 The Young Photographers **45**-46 48
George Hardy 23
Hardy, Heywood 70
Harrison, Frederick 30
Hartley Colliery accident 59
Havelock, Sir Henry 63
Hawthorne, Nathanial 22
Haydon, Benjamin Robert 13
Haydon, Michael 136
Hayllar, Edith
 A Summer Shower 30 **80** 82
Heine, Heinrich 89
Herbert, George 50
Herkomer, Hubert von 7 80 192
 Eventide 190 191
 Hard Times 191
 The Last Muster 190
 On Strike 191 **193**
 Pressing to the West 170
Hicks, George Elgar 30
 On physiognomy 94
 Billingsgate Fish Market 143
 Changing Homes 37 **39** 143
 Dividend Day 143
 The General Post Office **96** 123 **144**
 The Sinews of Old England **160** 162 164-5
 Swindon Station 143
 Woman's Mission 37
Hilton, William 31
Hogarth Club 12 51
Hogarth, William
 compared with Poussin 58
 & Frith 89
 & Madox Brown 175
 & physiognomy 12
 Victorian censorship of 13-14
 & Victorian genre 6 11-13 89
 Four Times of Day: Noon **90**
 Gin Lane 58
Holl, Frank 7 164 191
 Deserted - A Foundling 188 **189** 190

Newgate 190
Holmes, James *Charing Cross* 100 **101**
Homer 23
Hood, Thomas 48
 'Ballad' 48
 'The Bridge of Sighs" 168
 'Song of the Shirt' 166-8
Hook, James Clarke
 Finding of the Body of Harold 31
 From Under the Sea **32** 33
 Luff Boy! 31
Horseguards 143
Horsley, John Callcott 10 12 43 44 51
Houghton, Walter Boyd 30 102 150
 The Deserter 151
 Holborn in 1861 151 **152**
 Itinerant Singers 151
 Recruits 151
Houseless Poor Act, 1864 189
Howard, George 187
Howlett, Robert **102**
Hueffer, Ford Madox 138 176
Hughes, Arthur *The Font* 46 48-**49** 50
Hughes, Thomas
 Tom Brown's Schooldays 147
Hungry Forties 161 183
Hunt, Alfred 98 **99**
 Derby Day 100 **112** 136
Hunt, Charles
 A Plea for Mercy **43** 48
 Horpittal for Woonded Solgers 48
Hunt, William Henry 13 22
Hunt, William Holman **51** 59 70
 & physiognomy 131
 Hireling Shepherd 50
 London Bridge by Night 147 **148-9** **150**
Ibsen *A Doll's House* 76
Imray, John 16
Impressionism, British 9
Impressionism, French 68 82 86 191 198
Indian Mutiny 6 62 63 142
Irish Famine 161 168
Irish Nationalism 168
Irish as separate race 124 170
Irish types 178
Israels, Joseph 184-5
 Fishermen carrying a Drowned Man **186**
Italian genre subjects 55
Itinerants as separate race 95 124 163
Jarves, J. Jackson 22
Joy, G.W. *The Bayswater Omnibus* 110
Junior Etching Club 50
Kenealy, Arabella 30 37
Kent, William 143
Kennington, T.B. 168
Kingsley, Charles 168 172 176
 On the 'Gent' 120-1
 Alton Locke 131
 Yeast 162
Klingender, Francis D. 161
Knight, W.H. *Boys Playing Draughts* 15
 The Broken Window 15 **17**
'Labour', Victorian ideal of 162 170-4

Lady Lever Gallery 57
Lamb, Charles 12 58 175
Lancashire cotton famine 180
Lancashire mill-girls 180
Lancastrians as collectors 10 11
Landseer, Sir Edwin 10
 Flood in the Highlands 58 59
 High Life and Low Life **130**
Langley, Walter 195
 '*Never Morning…*' **192** 194
 An Old Inhabitant **192** 194
La Thangue, Henry Herbert 191 194
 The Last Furrow **196** 198
 Leaving Home 198
 The Man with the Scythe 198
Lauder, Robert Scott 72
Lavater, Johann Casper **92**-3
Lavery, Sir John *The Tennis Party* 82 **84-85**
Lawrence, Sir John 63
Lawrence, Sir Thomas
 & criminal physiognomy 123
Lecky, William 163
Lee, John 150
 The Bookstall 151-2 **153**
Leech, John 51 97 102 **104 120** 123
 128-9 146 **164 174** 175
Leigh P. 124
Leighton, Edmund Blair 37 70 **71** 72
Leighton, Sir Frederic
 Garden of the Hesperides 11 12 70 186-7
Leslie, Charles Robert 10 11 12 16 51
 Fair at Fairlop 16 **20** 59
 Pot-Pourri 54
 School Revisited 54
 Sir Roger de Coverley Going to Church 16
 Sun and Moon Flowers 54
Leslie, George Dunlop 51
 Pot-Pourri 54 **56** 70
Le Sueur, Hubert equestrian statue of *Charles 1* 100
Lever, William Hesketh, Lord Leverhulme 11
Levin, Phoebus
 Covent Garden 132 **146** 150
 Cremorne Gardens **145** 150 **151**
Lewes, George Henry 37
Lewis, John Frederick 13 55
 Hhareem 55
 Lilium Auratum 55 **57**
Lincoln Art School 155
Eliza Lynn Linton 30
Linton, James D. 199
Liverpool, population explosion 89
Liverpool Pre-Raphaelites 51
Lloyd, Tom 156
Logsdail, William 7
 The Bank and Royal Exchange 155 **158-9**
 Ninth of November 100 155 **157**
 The Piazza, Venice 55 80
 St Martin-in-the-Fields 155
Lombroso, Cesare *Criminal Man* 122 123-4
London, population explosion 89
London slums 161
Long, Edwin 55

Louis Philippe 100
Lowe, Robert 164-5
Luard, John Dalbiac
 The Call to Duty 59
 Nearing Home 59
 A Welcome Arrival **60** 62
Luard, Richard Amherst 59
Lund, Rev. Thomas 68
Lucknow, Siege of 63
Macaire, Robert 100
Macaulay, T.B. *History of England* 19
Macbeth, Robert 185
 The Cast Shoe 187
 Ferry and Flood 187
 A Lincolnshire Gang **187**-8
Mackintosh, Daniel 90 **91** 95-6 132
MacLean, Hector 90 95
Maclise, Daniel 18-19
Macready, William Charles 45
MacTaggart, William 86
McConnell, William **98** 116 **117**
Madresfield Chapel, Malvern 83
Manchester slums 161
Manet 87
Mann, J.H.S. *Hush! - Asleep* 38
Marks, Henry Stacey 54-5
 The Ornithologist 55
 Toothache in the Middle Ages 54
 A Treatise on Parrots **54** 55
Martineau, Harriet 122
Martineau, R.B. 147
 Kit's Writing Lesson 50-1 **52**
 The Last Chapter **28** 31
 The Last Day in the Old Home 51
Mason, George Heming 7 184-7
 Harvest Moon 187 **185**
Masson, David 19
Matrimonial Causes Act, 1857 39
Maudsley, Henry 122
Maurice, Frederick Denison 176 177
Mauve, Anton 191
Mayhew, Henry 28 89 91 132 167
 & Madox Brown's work 177
 Criminal Prisons of London 97
 London Labour & the London Poor 95 97
 113 162-4 174 177
 London Characters 126
Meadows, Kenny 168
Mechanics Institutes 176
Medical Adviser 123
Meynell, Wilfrid 54 80
Middle-class type 132 134 136
Millais, Sir John Everett 51 150 192
 & John Leech 146
 Autumn Leaves 50 59
 The Blind Man 146 **147**
 Bubbles (A Child's World) **154**
 Derby Day: The Race 146
 Ophelia 11
Millet, Francois 187 192 194 199
 The Angelus 184
 The Winnower **182**
Monet, Claude 199

Monkeyana 59
Morgan, John **106** 110
Morland, George 11
Morley, Henry 96
Morris, Phil 70
Morris, William 173 199
Morton, S.G. 96
Morton, W. Scott 118
Mulready, A.E. 43 99 168
 London News Boys **171**
Mulready, William 11 12 16 45
 & criminal physiognomy 123
 & psychology 13
 The Widow **14**
Muther, Richard 184
Napoleonic Wars 182
National Army Museum 59
National Gallery of British Art 11 68
Naturalism 70 82 199
The navvy 170 174-7
Negro Minstrels 100 113 156
Newcastle 180
New English Art Club 191
Newlyn, primitive nature of inhabitants 195
Newlyn School/colony 77 80 155 191 196
Newman, Cardinal John Henry 172
Newton, Sir Isaac 37
Nicol, Erskine 9 165-6
 Primitive types 199
 Irish Emigrant arriving at Liverpool **169** 170
Norman race/type 90 94 128 131-2
Nott, J.C. 96
'Oldacre, Cedric'
 The Last of the Old Squires 50
Old Watercolour Society 55
Omnibus 103-4 106 110
O'Neill, George Bernard 43
O'Neil, Henry & 'The Clique' 16
 on the mixing of social classes 125
 Eastward Ho! 6 62 63 **64**-5 72
 Home Again 65
Orchardson, Sir W.Q. 7 70 72-3 87
 After! 76
 Mariage de Convenance 73 **76**
 Napoleon on Board the Bellerophon 73
 The Rivals **74**
Organic quality 130
Ornithological Society 143
Ostade, Adrian von **11** 13
Paddington Station 102 118? 126 138
Paget, Sir James 30
Palace of Westminster Competition, 1843 31
Paris International Exhibition, 1855 59
 1867 73
Parry, Orlando *Street Scene* **88** 99
Partridge, J. Bernard 70
Paton, J.N.
 Home 63
 In Memoriam 6 60 **61** 62-3 72
Patronage
 aristocratic 6 59
 middle-class 10 11
Paxton, Sir Joseph 174

Pear's Soap 154
Penzance 195
Peasant types
 attraction of 194-5
 objections to 199-200
Perth 154
Peto, Sir Samuel Morton 176
Petronius, *Satyricon* 14
Pettie, John 70 72
Phillip, John 16
 The Early Career of Murillo 55
Photography 198
Phrenology 92-3 123
Physiognomy
 canine 129
 of murderers 122-3
 & social class 94-6 128ff
 Victorian revival of 91-4
Phythian, J.H. 51 183
Pickpockets 96 102 112 123 125 143 146
 150
Plebeian type 94-6 130
Plein-air painting 87 155 191-2 195-6 198
Plint, Sir Thomas 176-7
Poetic Realists 7 183-8 199
Poole, Paul Falconer 167
 The Emigrant's Farewell 170
Port Sunlight 11
Poussin *Plague at Athens* 58 175??
Poynter, Sir Edward 77
Pre-Raphaelites 142 c178??
 influence on genre painting 6 18-19 23
 51 59 146 199
 as genre painters 9
 & Frank Dicksee 76
 & Charles march Gere 83
 & Hogarth Club 12
 & J.F. Lewis 13
 & F. Smallfield 48 50
 & social subjects 168 199
 & Fred Walker 185
Problem pictures 72
Prophets of Earnestness 172
Prostitutes 131-2 150
Public Schools, Royal Commission on, 1864 85-6
Punch 7 51 97 166 102 120 128-9 175-6
Punjab 63
Queen Anne Revival 70 72
Quilter, Harry 9 55 76
Quimperle, Brittany 198
Racial stereotypes 90 94
Railway, Derby Day, special trains 103
 extension of system 98-9 103
Railway Labourers, Select Committee on, 1846 176
Rankley, Alfred
 Old Schoolfellows 48
 The School Room **46** 48
Raphael 13
Raumer, Frederick von 89
Realism, French 86 184 191
Redfield, James 93 **94**

Redgrave, Richard 7
 The Emigrants Last Sight of Home 170
 The Outcast 39 58 63 167
 The Poor Semptress 166-7 **168**
Reform Bill, 1832 10; 1866 165; 1884 199
Reid, John Robertson
 A Country Cricket Match 86-**87**
Reynolds, Sir Joshua 175
Richards, Frank (author) 86
Richards, Frank (Newlyn artist) 195
Richmond, William Blake 187
Ritchie, J.E. 125
Ritchie, John
 A Summer Day in Hyde Park 142 **143**
 Winter's day in St James's Park **140-1** 142-3
Romanes, George J. 30
Romanticism & changing perception of child
 nature 44
Rossiter, Charles *To Brighton and Back* 102 **103**
Rossetti, Dante Gabriel
 The Blessed Damozel 11 42
Rossetti, William Michael 58 59 63 166
 170 124
Rotten Row, Hyde Park 125
Rousseau, Theodore 191
Royal Academy
 Schools 13 22 51 185
 opposed by 'The Clique' 6
 Summer Exhibition 19 26 31 59 89 62
 102 188 189 190 195
 Winter Exhibition 10
Rural areas, social conditions 182-3
Rural poverty, 182-3 198
Artists' colonies 191-2 196 198
Ruskin, Euphemia 42
Ruskin, John 199
 on Augustus Egg 42-3
 degeneracy 130
 gentlemen - racial heritage of 130
 W.H. Knight 16
 J.F. Lewis 13 55
 medical profession 68
 W. Mulready 14
 Pre-Raphaelite influence on genre 19 51
 Punch artists (Leech, Tenniel, Du Maurier)
 - accuracy of human types 97 128
 James Tissot 69
 roles of men and women 28 37 39
 social issues 163 182
 vulgarity & racial heritage 130
 Fred Walker 186
 work, importance of 172 174
Sadler, Dendy 70 72 **73**
Sahib, Nana **63**
St. John's Wood Clique 51 68
St. Valentine's Day 146
Sanitary Condition of the Labouring
 Population of Great Britain, Inquiry into,
 1842 162
Sass, Henry 123
Saxon race/type 90 94 132 134 170
Science of Mankind 89

Scott, William Bell
 Building the Roman Wall 179
 Death of the Venerable Bede at Jarrow Priory 179
 Iron and Coal 163 170 c179-80 **181** 195
Sebastapol, Siege of 59
Seven Dials 161
Shaftesbury, Antony Ashley Cooper, seventh
 Earl 182
Shakespeare, William 6 26 100
Shaw, George Bernard 179
Shaw, Norman 44 70
Sheepshanks, John 11 59
Sibson, Thomas
 & W.Bell Scott's *Iron and Coal* 179
 Saxon Arts **180**
Sickert, Walter 191
Simcox, G.A. 95
Slade School of Art 77
Small, William **95**
Smallfield, Frederick *Early Lovers* 46 **47** 48-50
Smiles, Samuel 28 30 38
 on virtues of work 172
 Life, Labour 174
 Self-Help 163
Smirke, Robert 16
Smith, Albert 97
 Natural History of the Gent 120
Smith, George
 Musing on the Future 27
 A Sewing Lesson by the Fire **24** 27
Snape, William *The Cottage Home* **25** 27
Social Darwinism 163
Social Democratic Federation 199
Social mixing on Derby Day 124
Social Realism 7 9 59 188 199 157
Social stereotypes 94-6
Socialist League 199
Society of Painters in Tempera 83
Solomon, Abraham *The Flight* 62
South Kensington Museum 11
Spanish genre subjects 55
The Spectator 16
Spurzheim, Johann Georg 92
Square-brush technique 82 155 191-2 196
Stanfield, Clarkson *Abandoned* 43
Stanhope, J.R. Spencer *Thoughts of the Past*
 40-1 **40**
Stanley, Edward Henry, fifteenth Earl of Derby
 125
Steele, Sir Richard 16
Steen Jan 13 *Dissolute Household* 14 **15**
Stephens, Frederick George 179 104
 Mother and Child **62** 72
Stephenson, Robert 179
Stephenson, R.A.M. 192
Stephenson, Robert Louis 185
Stone, Frank 51 70
Stone, Marcus 7
 In Love **66** 70 73
 In the Shade 70
 On the Road from Waterloo 70
 There is Always Another 70

Storey, George Adolphus 51 70
Stothard, Thomas 16
Sudan 48
Sullivan, J.F. *The British Working Man* **95**
 122-3 165 **166**
Taine, Hippolyte
 on British genre painters 12-13 18
 on physiognomical types 96
 on railway stations as vantage points 118
Tate Gallery 11
Tate, Sir Henry 11 68
Tayler, Albert Chevallier 194
 Sisters 77 **78** 80
 The Yellow Ribbon 77-**79**
Taylor, Tom (journalist) 10 11 16 124
 on railway stations as vantage points 118
Taylor, Thomas (cotton king and collector) 190
Tenniel, John 97 128 164 **165**
 & criminal type 123
Teniers, David 11
Tennyson, Alfred Lord 'The Talking Oak' 36
Teutonic race 90 94
Thackeray, William Makepeace 11 13 16 167
Thompson, John and Adolphe Smith
 Street Life in London 164
Thomson, Hugh 70 **72**
Thornycroft, Hamo 70
Thurtell, John 123-4
Tintoretto 55
Tissot, James 7
 The Bridesmaid 66 **67** 68
 On the Thames **69**-70 73
Tolstoy, Leo 194
Trade Unions 191 199
Trevelyan, Sir Walter and Lady 179
Trollope, Anthony *The Bertrams* 22
 The Small House at Allington 36
Trollope, Frances
 Life and Adventures of Michael Armstrong 162
Trustees Academy, Edinburgh 72
Tuke, Henry Scott 194
Turner, J.M.W. 10
Turnley, Joseph 93
Tussaud, Madame 124
Tyne and Wear coal-field 180
Type,
 anthropological observation of 96 98
 concept of 96
Uwins, Thomas 55
Vagrancy, Parliamentary
 Committee on, 1873 189
Van Eyck 55
Vaughan, Henry 'Childe-hood' 50
Venice 155
Vernon, Robert 10 11 59
Veronese 55
Victoria, Queen 16 30 59 63 100 102
Villiers, Fred 156
Walker, Fred 7 51 164
 The Lost Path 185-6 **184**
 The Old Gate 186
 The Plough 186

 The Vagrants **184** 185-6
Wallington Hall 179
Wallis, Henry *The Stonebreaker* 6 163
Ward, Mrs. E.M. 45
Warwick, Eden 93
Waterhouse, John William *The Lady of Shalott* 11
Waterloo, Battle of 13 59 162
Watson, J.B. 143
Watts, George F. 7
 Found Drowned 39 70 168
 Irish Famine 167 **168**
Waugh, Evelyn 22
 & Atkinson's *Upset Flower Cart*
Webster, Thomas 9 11 12 15 27 43
 Going to School **44**-5 48
 Good Night 23
 Village Choir 44
Wedmore, Frederick 9 22 58 87
Wellington, first Duke of 13
Wells, S.R. **94**
Wells, William 10 59
West, Benjamin 16
Westminster, first Duke of 55
Westminster slums 166 124
Wheeler, Sir Hugh 63
Whistler, J.A. M. 12 70 191
White, Gleeson 55 72 73 195
Whitechapel Workhouse 189
Wilkie, David 6 10 11 22
 Chelsea Pensioners **12** 13 44 48
 Penny Wedding 13
 Pitlessie Fair 13
 Rent Day 13
 Village Politicians 13
Wingfield, Walter Clopton 82
Women's Rights Movement 30
Wood, Mrs Henry, *East Lynne* 132
Woods, Henry
 Venetian Christening Party 55
Wordsworth, William 191
Work, ideal of, see Labour
Working-class types 136 138
Working Men's College 176
Wyatt, Matthew Cotes
 equestrian statue of *George 111* 100
Wyllie, William Lionel *Toil, Glitter, Rime and
 Wealth* 58
Yeames, William Frederick 51 *Rescued* 59
Zandvoort 185
Zola, Emile 191

ERATA

Page 126, 1st column, line 19:
Replace 'before' with 'after'.

Page 194, 1st column, line 22:
Replace 'Barbican' with 'Barbizon'.